Love
GRANDPA

Bradbury Thompson The Art of Graphic Design

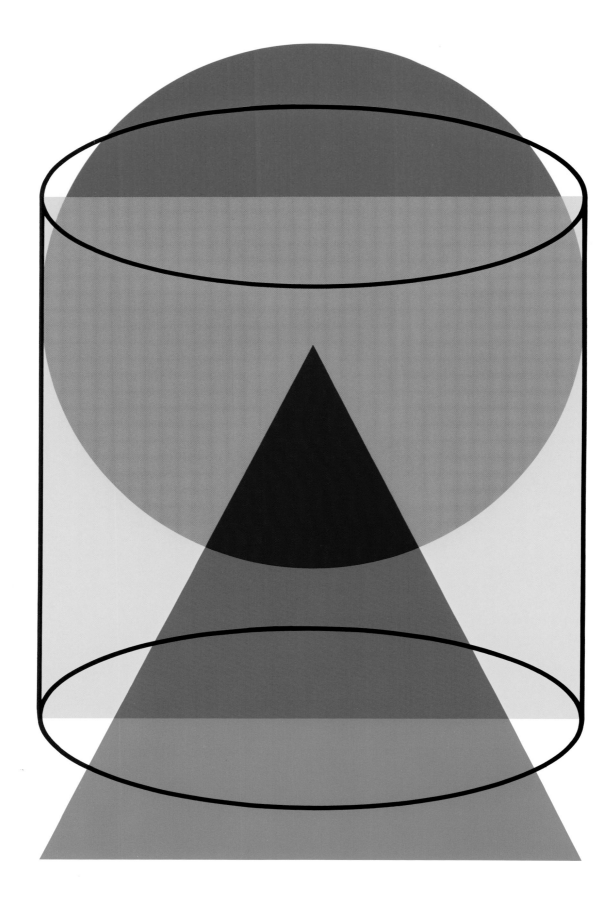

Yale

Bradbury Thompson The Art of Graphic Design

With contributions
by noteworthy designers, critics,
and art historians

Yale University Press
New Haven and London
1988

Publisher's note:
The publication of this splendid book
was aided by the generosity and support
of Westvaco Corporation.
We are grateful to David L. Luke III, chairman of the board,
and his colleagues at Westvaco, especially
Harold A. Sutphen, Jr., John C. Callihan, and Karen M. Bloom,
who recognized that in producing a book
of this special nature
the highest reproduction standards must prevail.
We are also indebted to the following people,
whose enthusiastic support and
technical inventiveness contributed mightily
to the finished work:
Stephen Stinehour of Meriden-Stinehour Press;
Larry Keavey, Eli Gukich, and John Boyd of Anagraphics, Inc.;
William Schlicht of Finn Typographic Service;
and Rob Carlson of Zahrndt, Inc.
All who know and admire
the work of Bradbury Thompson
are in their debt.

Author's acknowledgments:
A multitude of people and organizations
have contributed generously of their time and skills
to the successful completion of this volume,
and the author wishes to thank them all.
He is grateful to Judy Metro, his editor at Yale University Press,
and to D. Dodge Thompson and Deen Thompson
for special editorial assistance.
For technical assistance and supervision
he thanks Karen Bloom of Westvaco and Ken Botnick of Yale.
For their earlier contributions
the author is also grateful to Jean A. Bradnick,
with whom he collaborated for many years
on corporate projects at Westvaco,
including the American Classic Book series;
and to M. Joseph McCosker and Carl W. Drepperd
for their writing for *Westvaco Inspirations*.
He is also grateful to Stevan Dohanos,
with whom he coordinated many designs
for the United States postage stamp program.
Finally, he wishes to thank Ruth Garvey Fink,
without whose steadfast support the *Washburn College Bible*
would not have been published.

Library of Congress Cataloging-in-Publication Data:
Bradbury Thompson: The Art of Graphic Design
with contributions by noteworthy designers, critics, and art historians. p. cm.
ISBN 0-300-04301-5 (alk. paper)
1, Book design; 2, Magazine design; 3, Printing, Practical-Layout; 4, Graphic arts.
I, Title. II, Title: The Art of Graphic Design.
Z116.A3T45 1988 686-dc19 88-210 CIP.

The paper in this book meets the guidelines
for permanence and durability of the Committee
on Production Guidelines for Book Longevity
of the Council on Library Resources.

10 9 8 7 6 5 4 3 2 1

Contents

By J. Carter Brown

An appreciation

J. Carter Brown
is Director of the National Gallery of Art
Washington

The classic definition of printing was written in the sixteenth century: *Ars artium omnium conservatrix*, "the art that conserves all the arts." This phrase is also a succinct definition of museums, and printing and the museum have recently converged in a mutuality of interest. There has been a revolution in printing since the Second World War, allowing the prolific production of full-color art books, veritable museums in their own right.

Bradbury Thompson participated in this revolution as the design director of *Art News* magazine and *Art News Annual*, as well as of exhibition catalogues such as *Painting Toward Architecture* (Museum of Modern Art, 1948). But more significantly, Brad Thompson adapted the fine arts to his own use in innovative ways: exploring new combinations of type and image in *Westvaco Inspirations*; reusing period engravings to illustrate classic American books; and illustrating with Old Master paintings the King James Bible.

Brad Thompson has not limited himself to the traditional fine arts in looking for visual inspiration. As the chapter titles of this volume attest, he has explored and expanded the relationship of type with photography, with primitive and folk art, and even with the evanescent patterns of the performing arts and children's play.

Bradbury Thompson's formidable career as a graphic designer spans more than fifty years. My association with him dates back to the early 1960s, when we worked together on the Citizens' Stamp Advisory Committee. Since that time he has designed more than ninety stamps, making him the most prolific of American stamp designers.

Brad's frequent trips to Washington from his studio in Connecticut for stamp committee business also brought him into closer contact with the National Gallery. Recognizing his sure sense of the relation of typography to the history of fine arts, the Advisory Committee asked him to design the first of several annual Christmas stamps from Old Master paintings in the Gallery collection. Brad has now designed a total of sixteen Christmas stamps based on paintings in the Gallery, a collection itself.

Stamps are only a small part of Brad Thompson's graphic production. One of his first loves is the design of books, and every Christmas his friends looked forward to receiving the limited edition volumes published by Westvaco. His portfolio *Homage to the Book*, 1968, brought together contributions from the leading book designers and provided unassailable proof of the transcendence of the printed word in the electronic age.

In 1969 Brad asked me to select sixty-six images of religious art to introduce the chapters of the innovative *Washburn College Bible*, and the project proved to be a thoroughly rewarding and instructive collaboration. While the present volume beautifully indicates the full range of the art of this talented designer, it can only suggest his encompassing humanity. I would like to relate a little-known incident that describes the spirit guiding the hand. Our collaborator on the *Washburn College Bible*, Josef Albers, died in 1976, not long after he had signed the frontispieces for the Bible. Several of his admirers proposed to the U.S. Postal Service that a stamp be issued to honor this influential teacher and artist. However, there is a statute that prohibits the issue of a commemorative stamp until at least ten years after the subject's death. Brad did not forget his friend. A few years later when the postal service commissioned a stamp to honor the newly established Department of Education, he jumped at the chance to remember a great teacher. Brad adapted a vibrant painting by Albers from his *Homage to the Square* series and added the motto "Learning Never Ends," thereby giving loyal tribute to a fellow teacher and artist.

Brad Thompson's influence on American and international graphic design is pervasive. When I read the latest issue of *Smithsonian* magazine (one of the many magazines designed by him) or just open the day's mail bearing the latest postage stamp by Brad, I am reminded of a career dedicated to the art of communication. Despite the fact that he has been honored with every laurel his profession can bestow, including the Gold Medal of the American Institute of Graphic Arts, he has remained a quiet, self-deprecating individual. For Brad, a quintessentially modest man in spite of a lifetime of communicating to millions, a publication well done is its own reward, and this magnificent volume is no exception.

By Alvin Eisenman

Foreword

The graphic designer's fundamental task is to transform a pile of manuscript pages into a useful and beautiful document. The task begins with a set of choices. Selection of type, illustration, paper, format, dimension, kind of printing and binding. In this century the number of possibilities in each of these categories is enormous; to make the best choices the designer must be guided by both intuition and principle. When these chosen elements are brought together, a process called layout comes into play, and again the designer must be led by both intuition and principle.

The book you are holding has been compiled by a designer who has a strong intuitive sense of his art, but who also has a deep interest in design principles—precepts to guide his own work and also (because he is a born teacher) principles to guide the work of the next generation of designers.

Bradbury Thompson's first commission when he came to New York in late 1938 was the design of *Westvaco Inspirations for Printers,* a periodical published by the Westvaco Corporation between 1925 and 1962 as a showcase for its printing papers. The title, *Inspirations for Printers,* had a slightly old-fashioned flavor by 1939 (it was changed to *Westvaco Inspirations* in 1957), but there was nothing old-fashioned about its form and content; under Thompson's direction it became one of the leading avant-garde publications in the field, its influence reaching from San Francisco to Milan. Its bold young designer from Topeka was one of the most determined modernists of his generation.

In 1939 traditional design with its longtime dependence on historical models was finally running out of steam, and modernism was beginning to take over—as it had twenty-five years earlier in painting. Thompson had been a modernist even in his early work in Kansas, but unlike the archetypal modernists, he was always at peace with the past. He never imitated antique layout styles but at the same time he never hesitated to include work of the past in his pages. Most modernists, particularly those under the influence of Futurism, considered the past absolutely taboo; readers of *Inspirations,* however, were apt to find Miró and Matisse next to Leonardo and Botticelli. What brought these images together was the consistently modern layouts.

The second pivotal publication in Brad's career was *Art News* and its yearly thematic issue, *Art News Annual.* He served as its design director between 1945 and 1972, working at first with editor Alfred M. Frankfurter and later with his successor, Thomas B. Hess. For Thompson, *Art News* was always a labor of love, a lunch-hour-and-weekend job, but it represented an extraordinary opportunity. It brought him into the midst of the modern movement in painting and sculpture, giving him the opportunity to work with artists such as Miró and Matisse as well as with artists closer to home. It was the golden age of the New York school of painting and *Art News* was its magazine.

The principles Thompson developed in his work for *Inspirations* and *Art News* were later refined and restated in the books he designed in the sixties and seventies—particularly the celebrated *Washburn College Bible* of 1979. The design of the Bible was his own in every detail, but it was also a collaboration with his friend and longtime Yale colleague, Josef Albers, who contributed three frontispieces. It was also a collaboration with Jan Tschichold, who made the new typeface *Sabon* available for the Bible before it was generally released for phototypography. The effect of the Bible's typography on the graphic design community was immediate. It was the climax of a revolution against the tyranny of Gutenberg's perfect rectangles, which had dominated Western texts since 1455. While the Bible was not the first flag raised in that revolution it was probably the most influential. The perfection of detail in Thompson's pages and the warmth and grandeur of *Sabon* made it a powerful demonstration of a new principle in typography.

When Bradbury Thompson began teaching at Yale in 1956, it was really a continuation of the teaching he had been doing by example since 1939. Like all designers, he depends on intuition as well as principle, but intuition by definition is innate and cannot be taught. It has been Thompson's search for principles and his generosity in sharing his discoveries that make both his teaching and his work as a designer so remarkable.

Alvin Eisenman
is Augustus Street Professor
of Painting and Design and director of
studies in graphic design,
Yale University School of Art

Typography

Type is a thing of constant interest to me.

It is sometimes a serious and useful tool,
employed to deliver a message,
sell a specific article,
or give life to an idea.

At other times it is a plaything
that affords personal amusement and recreation.
It is fun to produce fresh designs and spontaneous ideas
with letters and numbers—
by themselves,
or together with other graphic objects.

Type is a medium of philosophical enjoyment.
It is interesting to discover typographic rules
containing inconsistencies in logic,
which are in use only because of tradition.
It is also interesting to ponder the origin of these errors,
the practical reasons for their perpetuation,
and to suggest remedies.

An interest in Type
provides a broader knowledge of history,
including the appreciation of such related arts
as painting, architecture and literature—
and even business and politics.
This affords opportunity for pleasant romantic indulgence.
At the same time,
it develops confidence in one's practical ability
to specify appropriate typefaces
to accompany creative works of specific periods.

In short,
Type can be a tool, a toy, and a teacher;
it can provide a means of livelihood,
a hobby for relaxation,
an intellectual stimulant—
and a spiritual satisfaction.

I believe an avid interest in Type
necessarily includes a zest for everyday life.

Inspired Typography,
International Graphic Design Conference,
New York City,
1956

Introduction

The thoughts at left, recorded in 1956, provide a concise summary of my personal involvement with typography and graphic imagery. From a vantage point three decades later, it is satisfying to reflect that type is still a thing of constant interest. By means of this volume, I am pleased to have an opportunity to relate my experience to those who share an enthusiasm for books, magazines, and other forms of printed communication.

The first twelve chapters of this volume are based on designs for *Westvaco Inspirations* over a twenty-four-year period. *Inspirations* was a periodical established in 1925 for the graphic arts community and published by the Westvaco Corporation, a paper manufacturer of international repute. The wide circulation of *Inspirations* assured its influence: it was distributed to 35,000 printers, art directors, advertising agencies, art schools, universities, and museums. The preponderance here of work from *Inspirations* is a testimony to the rare opportunity for experimentation provided a receptive designer by that corporation. There are only a handful of corporations that have tried to encourage the growth of education and innovation in the graphics community through the design of their published materials, and Westvaco uniquely provided enormous incentive in both magazine and book design.

My involvement with *Westvaco Inspirations* began in late 1938, when the tumult of the Second World War began to give rise to a spirit of innovation in graphic design [see chapter 1]. It was at this time, for example, that the treatment of adjacent pages as parts of a unified design began to break down the convention of the discrete, single-page layout. The reader will see an early appreciation for compositional unity echoed throughout this volume in the form of recurring two-page spreads.

Many typefaces have been used in *Westvaco Inspirations* over the years. As a rule, however, the typeface and typographic style have been consistent within each issue of the publication. Despite this constant, the page designs include varied typographic explorations, providing evidence that "type can be a toy, a tool, and a teacher."

Toward the end of the war I experimented with the interaction of process inks to create the effect of motion on the printed page [chapter 2]. The graphic images employed in this chapter were gathered from a wide variety of sources: advertising art, photographs, engravings, and fine art. The effect of technical experimentation summarized in this chapter was made more apparent by contrast between centuries-old engravings and state-of-the-art printing processes.

The Monalphabet [chapter 3] recounts my explorations in 1944 and 1945 to achieve a typographically simplified alphabet. If one considers different letterforms such as A and 'a' as two separate symbols, the traditional alphabet for the English language has forty-five symbols. I experimented with and modified the earlier Bauhaus model of all lowercase type in a number of ways, with the goal of reducing the alphabet to twenty-six symbols. Alphabet 26 [chapter 6] occasions a discussion of this experiment's reemergence in 1950 with a specific proposal for a twenty-six symbol alphabet. The alphabet was later manufactured in both Monotype and Photo-Lettering in limited production, although it is yet to be produced in all sizes of phototype.

It is said that humor is the sudden marriage of ideas or images which before their union were not perceived to have any relation. It seemed to me that the letters of the alphabet, in combination or individually, had equivalents in the physical world. Since the principal vehicle was type, the use of letters in humorous ways became a personal toy [chapter 4]. Several of the toys were suggested in play with my children, who were at once the most demanding and embracing of critics. The printed page literally became a playground.

After collaborating on a volume on modern art in 1948 with the renowned architectural historian Henry-Russell Hitchcock, I appropriated the work of seven influential twentieth-century painters for

an issue of *Westvaco Inspirations*. The challenge of interpreting the spirit of these artists, while creating a new work of art altogether, is reproduced in full in chapter 5. Similarly, I studied and learned from the unlettered, but unfettered, ability of primitive and folk artists to communicate directly, and incorporated these lessons in my layouts [chapter 7].

Chapter 8 records an appreciation for the compositional possibilities of the letters of the alphabet, beyond their usual symbolic or phonetic value. Here letters become the designer's brush and palette.

From my earliest association with graphic art I have believed it to be important in its own right. In 1940 I had the good fortune to study its distinguished history in order to produce an illustrated history of printing for *Inspirations* on the occasion of the 500th anniversary of Gutenberg's invention of printing.

My education in art history was further advanced when I became design director of *Art News* magazine in 1945. Through frequent dialogue with the scholar-editors of *Art News*, a fuller knowledge of the history of the visual arts developed. This appreciation is expressed in chapter 9, and the desire to share this understanding with students is recorded in chapter 12.

Chapter 10 examines how the medium can provide new direction for the message by exploring its underlying technology. No medium has revolutionized printing in this century more than photography, which is the subject of chapter 11.

In chapter 13 the author explores a specialized corner of graphic design, that of postage stamps. Stamps are a visual *haiku*, distilling a great deal of history, emotion, and information. Many of the stamps I have designed honor the nation's arts and humanities. In the United States alone, there are more than twenty million collectors and more than forty billion stamps printed each year. While the art is small, the audience and its expectations are large.

Chapter 14 includes a variety of magazine covers and spreads from 1935 to the present. These representative samples can only hint at the underlying comprehensive systems and specifications that I once developed for such publications as *Harvard Business Review*, *Smithsonian*, and *Progressive Architecture*. Magazines provided an opportunity for continuous and rewarding discourse with publishers, editors, writers, photographers, and artists. At *Mademoiselle* alone, I commissioned illustrations from artists as diverse as Joan Miró and Andy Warhol, and reproduced the work of William Baziotes, Jean Carlu, Marc Chagall, Joseph Cornell, Mary Faulconer, Joseph Glasco, Jasper Johns, E. McKnight Kauffer, Rico Lebrun, Richard Lindner, Walter Murch, Isamu Noguchi, Larry Rivers, and Theodoros Stamos.

Chaper 15 includes fascinating portions of a portfolio entitled *Homage to the Book* that brought together the graphic philosophies of fifteen distinguished designers from this country and abroad. It includes a comprehensive foreword, with speculation about the future of the printed word, by the director of the Pierpont Morgan Library. Also reproduced are portions of Westvaco's American Classics books designed in contemporary typographic style. In spite of the continuing development of new forms of electronic communication, the evidence is that printing is here to stay. In this regard, it is comforting to read the foreword to *Homage to the Book* by Frederick B. Adams, Jr., republished in this section.

Chapter 16 includes facsimile pages from a Holy Bible that reconsiders the fundamental traditions of typographic design and has been described as "representing the most thorough reassessment of the printed Bible format since Gutenberg." The *Washburn College Bible* was an opportunity to try out an array of new ideas on a scale rarely available to the graphic designer.

This volume can provide only a time-lapse camera glimpse of an involvement with the graphic arts. Yet it is hoped that the retrospective may inspire thoughts about possible rewards with typography as a tool, a toy, and a teacher in the graphic design of this computer age.

Introduction

To
Deen
&
Leslie
Mark
Dodge
Elizabeth
&
My Parents
Sisters
Grandparents

Bradbury Thompson
Riverside, Connecticut
Spring 1988

1 Peace and war

PEACE

Oh wonder of wonders! A picture and a word can change a mood—set up new trains of thought—work a miracle in our minds as we shift our glance in the fraction of a split second! What mysterious power is this that can lift us from the horror of war to the restfulness of peace? No mystery. No magic. No miracle. Just printing at work—mirroring peace on paper, in type and ink—translating the ideas of artists and writers into sheer delight—to sell us that which is good for us...that which is good to us...and which does good by us. Peace! the hope of every normal man and woman...the delight of youth and the deliverer of old age...peace can and will be the heritage of the earth when the thought controlling force of printing is used constructively by nations everywhere under the sun.

Courtesy of Canron Mills, Inc.
Prepared by N. W. Ayer and Son, Inc.
Four color process engraving, 120 line screen.

Courtesy of World Peaceways, Inc. Prepared by Young and Rubicam, Inc. Four color process engraving, 133 line screen.

WAR

Eagles from hell drop eggs of death on an unsuspecting city. Hell comes from where heaven is supposed to be and war, that three letter word for the Devil's Homeland, is expressed in type and pictures that leave little to the imagination. War! Terror for babies, mothers and sons—who wants to sell it—glorify it? Only those whom the gods would finally destroy. But, who would sell against it—fight it? Every man and woman in this land. It is being done—this war against war—by the one method that makes all forward movement possible—by printing and its many millions of paper messengers of mercy!

2296 Printed on BLENDFOLD ENAMEL, 25 x 38 — 100

1 *War & Peace.* An illustration of devastation by Robert Fawcett, left, and one of beauty by Buk Ulreich, right, are given meaning with graphic design.

1

Peace and war

Amid the tumult of 1940-45, a more profound
approach to graphic design evolves

Let no man mistake the full and blessed meaning
of what is here exposed.
These bombshells of type and ink and paper
derive from a free press;
from a vital root of the Tree of Liberty which,
in turn, grows evergreen only
where and when the minds of men are free.
This is America at war.
A giant of peace, now ready
for a deadly blast of cosmic wrath and indignation.
Now printing shops are armories.
Now paper mills are arsenals.
We have undertaken the greatest task in our,
and the world's, history.
[*Carl W. Drepperd, Westvaco Inspirations 138, 1942*]

The two-page graphic design opposite appeared in *Westvaco Inspirations 115,* the first issue of 1939 and the first that the designer, at age 27, was privileged to conceive.

The picture of devastation was prepared for the World Peaceways, Inc., an organization striving to deter this country's involvement in horrors of the European conflict. The idyllic art deco picture was prepared for Cannon Mills, Inc., striving to foster the use of its pretty bed sheets. Graphic design brought them together with the combined effectiveness of word and image to visualize the thought of the nation in 1939, more than two years before its entry into what we now know as World War II. The designs on the

following three spreads are from *Westvaco Inspirations 134,* which was published early in 1942 but was only three-quarters completed editorially before the December 7, 1941 attack on Pearl Harbor. These record the quick transition from peace to war as reflected in the advertising and publishing community.

Advertising illustrations of tennis games and railroad trains were quickly supplemented in this issue with two spreads that dramatized the different meanings of *Good Earth* to the peaceful farmer and to the war-time paratrooper. As can be seen from the miniaturized version of issue 134 on pages 8-9, both the title and colophon spreads include peacetime scenes which were quickly transformed into graphic design ideas touting *Victory!* in a war just declared. The cover, a peaceful New England scene, had already been printed two months previously and could not be updated with a more timely picture.

The spirit and activity of the USA fully at war were recorded in the designs with advertising illustrations from 1942-44. And the designs for the 1944 issue foretold optimistically the end of the war and the coming peacetime blending of nations and cultures.

In retrospect, despite this four-year period of world upheaval, there was evolving then on the printed two-page magazine spread, quite unlike anything before, a new communicative graphic process that interfused word and image into a single art. It was often referred to at that time as typographic design, but what we call it now is graphic design.

Opposite: A two-page design from *Westvaco Inspirations 115* published early in 1939. This was nearly two years before the United States' entry into World War II, which followed the Pearl Harbor attack on December 7, 1941.

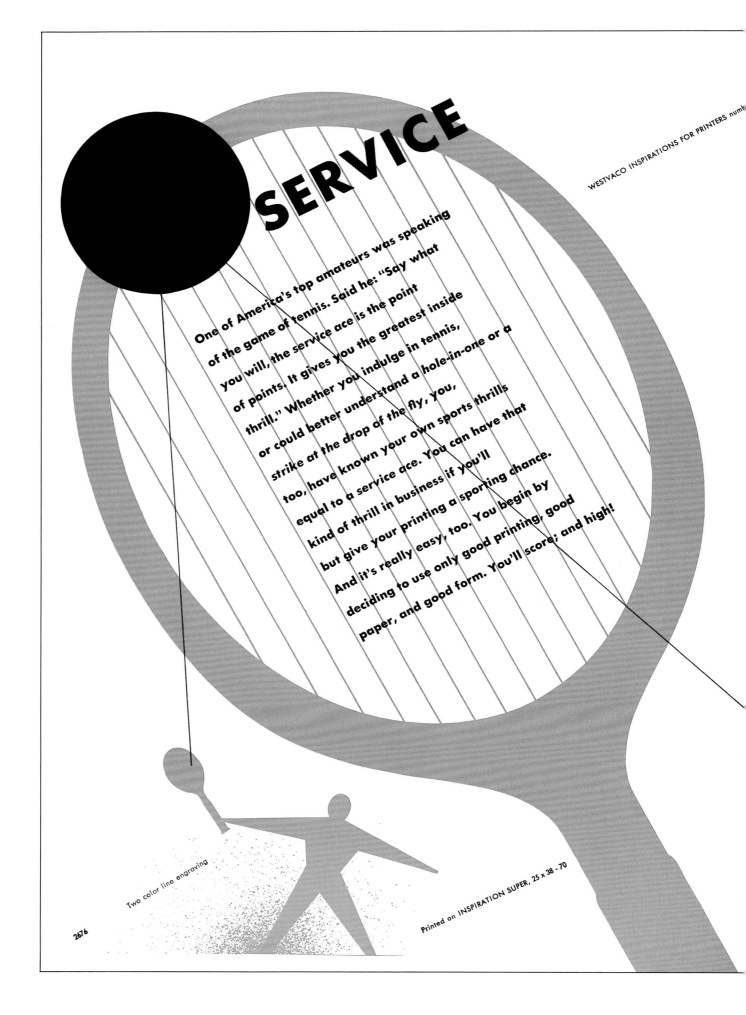

SERVICE

One of America's top amateurs was speaking of the game of tennis. Said he: "Say what you will, the service ace is the point of points. It gives you the greatest inside thrill." Whether you indulge in tennis, or could better understand a hole-in-one or a strike at the drop of the fly, you, too, have known your own sports thrills equal to a service ace. You can have that kind of thrill in business if you'll give your printing a sporting chance. And it's really easy, too. You begin by deciding to use only good printing, good paper, and good form. You'll score; and high!

Two color line engraving

2676

Printed on INSPIRATION SUPER, 25 x 38 - 70

One of the factors influencing a new integrated approach
in publication design was the modern poster,
which had to convey an immediate message with image and word.
This 1942 Westvaco Inspirations spread fusing heading, text, and pictures
recalls A.M. Cassandre's well-known tennis poster of 1932.

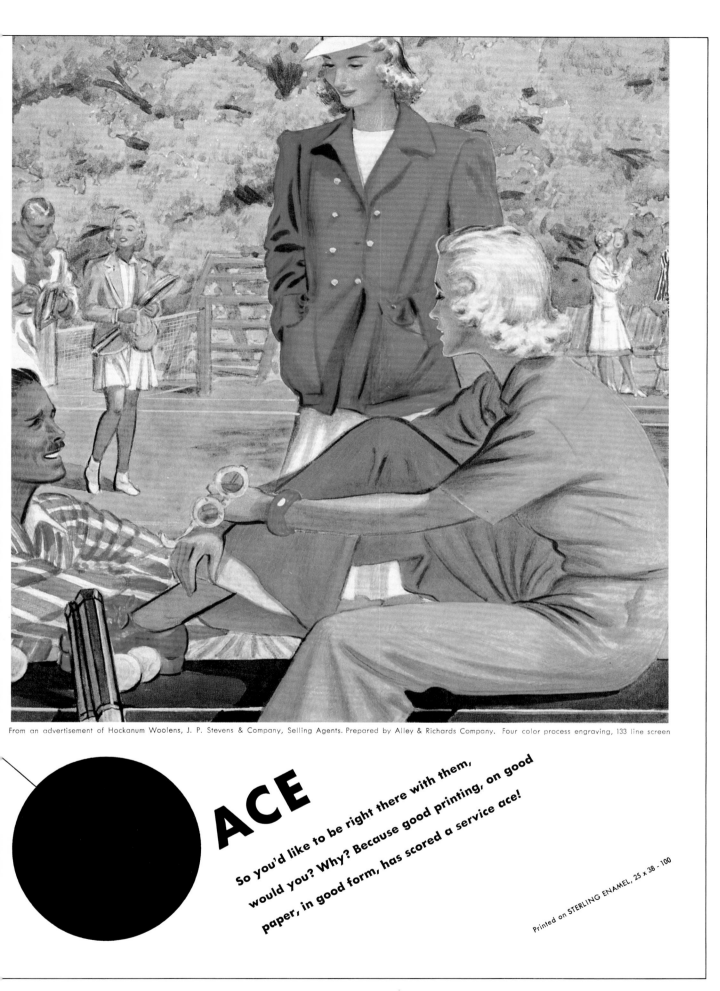

From an advertisement of Hockanum Woolens, J. P. Stevens & Company, Selling Agents. Prepared by Alley & Richards Company. Four color process engraving, 133 line screen

ACE

So you'd like to be right there with them, would you? Why? Because good printing, on good paper, in good form, has scored a service ace!

Printed on STERLING ENAMEL, 25 x 38 - 100

2 *Service Ace.* "'The *service ace* is the point of points. It gives you the greatest inside thrill.' Whether you indulge in tennis or could better understand a *hole-in-one* or a *strike at the drop of a fly,* you, too, have known your own sports thrills equal to a *service ace,*" reads the text above. And it is the same kind of thrill when you join word and image together effectively with graphic design.

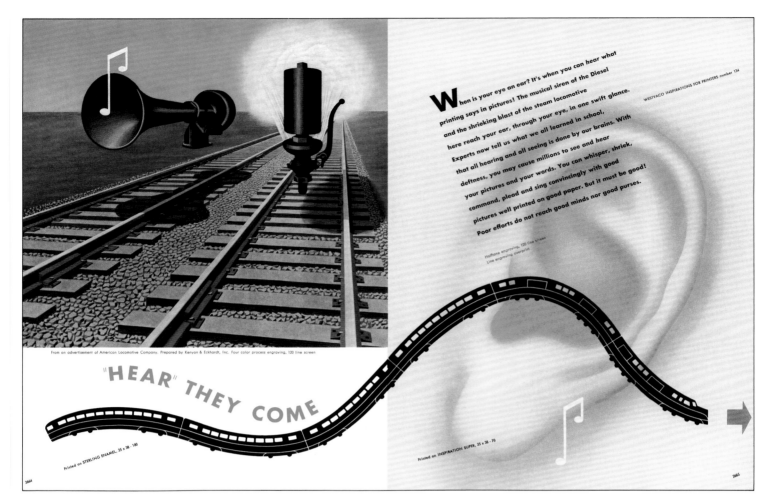

From an advertisement of American Locomotive Company. Prepared by Kenyon & Eckhardt, Inc. Four color process engraving, 120 line screen

"HEAR" THEY COME

Printed on STERLING ENAMEL, 25 x 38 - 100

When is your eye an ear? It's when you can hear what printing says in pictures! The musical siren of the Diesel and the shrieking blast of the steam locomotive here reach your ear, through your eye, in one swift glance. Experts now tell us what we all learned in school, that all hearing and all seeing is done by our brains. With deftness, you may cause millions to see and hear your pictures and your words. You can whisper, shriek, command, plead and sing convincingly with good pictures well printed on good paper. But it must be good! Poor efforts do not reach good minds nor good purses.

WESTVACO INSPIRATIONS FOR PRINTERS number 134

Halftone engraving, 120 line screen
Line engraving overprint

Printed on INSPIRATION SUPER, 25 x 38 - 70

3 *Hear They Come.* "When is your eye an ear? When you can hear what printing says in pictures!" reads the text. "The siren of the Diesel and the blast of the steam locomotive here reach your ear, through your eye, in one glance."

5 *Good Earth I.* "The good earth gives. This is a fact so simple that it hurts; especially those who ignore it," reads the text below. "There are two good earths. The soil and the minds of people. Both respond to cultivation."

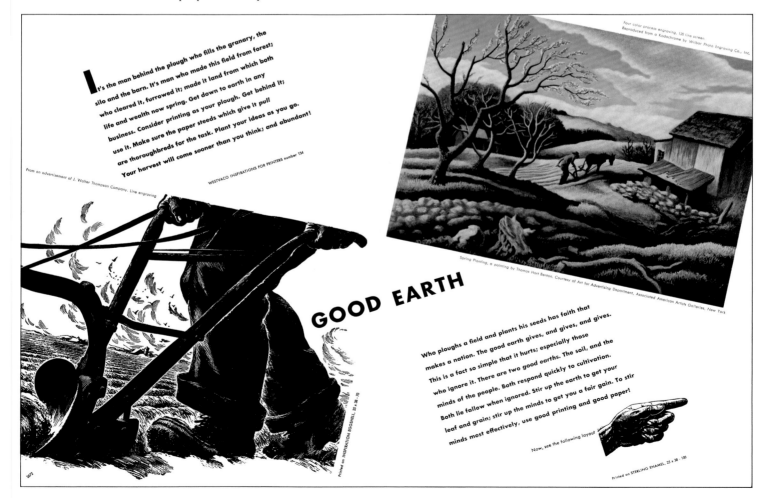

It's the man behind the plough who fills the granary, the silo and the barn. It's man who made this field from forest; who cleared it, furrowed it; made it land from which both life and wealth now spring. Get down to earth in any business. Consider printing as your plough. Get behind it; use it. Make sure the paper steeds which give it pull are thoroughbreds for the task. Plant your ideas as you go. Your harvest will come sooner than you think; and abundant!

From an advertisement of J. Walter Thompson Company. Line engraving.

WESTVACO INSPIRATIONS FOR PRINTERS number 134

GOOD EARTH

Four color process engraving, 120 line screen.
Reproduced from a Kodachrome by Wilbur Photo Engraving Co., Inc.

Spring Planting, a painting by Thomas Hart Benton. Courtesy of Art for Advertising Department, Associated American Artists Galleries, New York

Printed on INSPIRATION ESQUIRE, 25 x 38 - 70

Who ploughs a field and plants his seeds has faith that makes a nation. The good earth gives, and gives, and gives. This is a fact so simple that it hurts; especially those who ignore it. There are two good earths. The soil, and the minds of the people. Both respond quickly to cultivation. Both lie fallow when ignored. Stir up the earth to get your leaf and grain; stir up the minds to get you a fair gain. To stir minds most effectively, use good printing and good paper!

Now, see the following layout

Printed on STERLING ENAMEL, 25 x 38 - 100

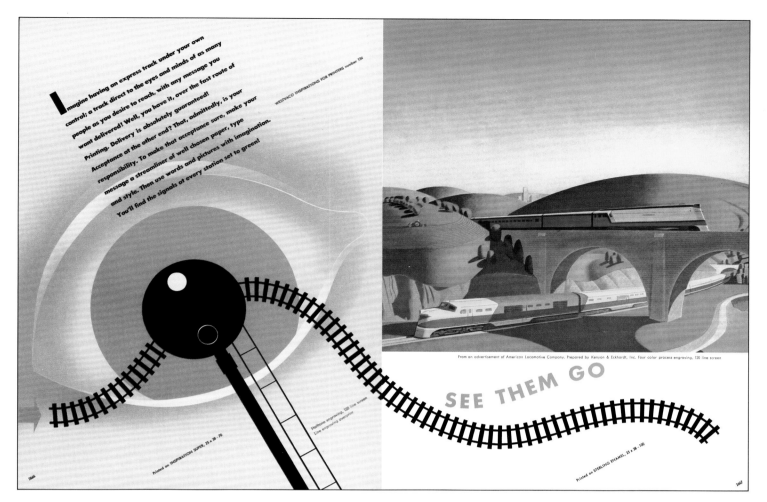

4 *See Them Go.* "An express track to the eyes and minds of as many people as you desire to reach! Well, you have it, over the fast route of Printing," says the text. Also, a graphic design idea may be effective in multiple spreads.

6 *Good Earth II.* "How an illustrated idea can change a trend of thought! *Good Earth!* The words are the same on this layout as on the preceding pages but what a contrast of meaning!" World War II is here! It is a nation in conflict.

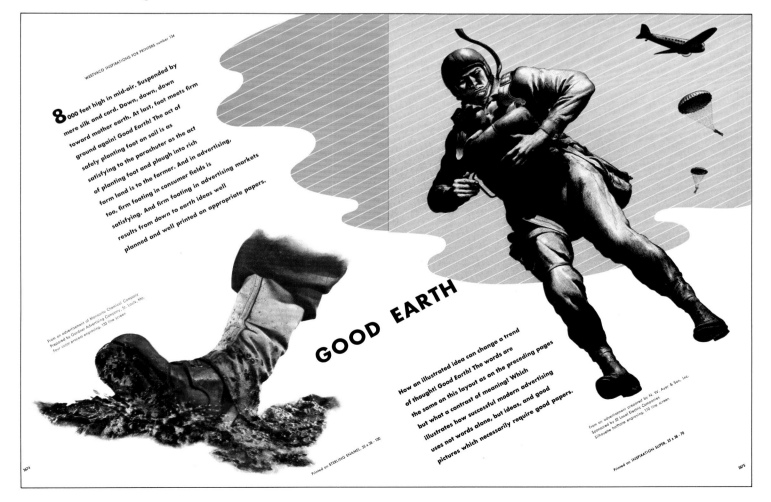

Peace and war: chapter 1

Westvaco Inspirations 134 was conceived in mid-1941 in a nation at peace, or in retrospect, a nation not yet at war. The issue was completed and distributed in early 1942, after the Pearl Harbor attack in December 1941. It included images and graphic ideas concerning a nation in transition, with scenes of civilian life paired against those of men in uniform.

The complete issue of *Inspirations* presented in miniature on these pages was 20 pages in number and 9 by 12 inches in size. A typical issue included four kinds of paper; usually eight pages of four-color, four pages of two-color, and four pages of one-color presswork, with the cover printed in four or six colors. The saddle-stitched binding provided the designer with interesting graphic problems of different papers, color combinations, and presswork on facing pages which were conceived as two-page units.

Printing plates of the color illustrations were loaned generously by advertising agencies, publishers, museums, and corporations. The illustrations of peace and war in this chapter recall a vital story of a tumultuous era of history.

A toast to Victory,
here symbolized by the V,
the dome of the Capitol
and the silver cup of triumph.
To Victory that must be speeded
through the sale of Victory Bonds and Stamps,
with the aid of printed words
and pictures.
[From the colophon spread, fig. 16]

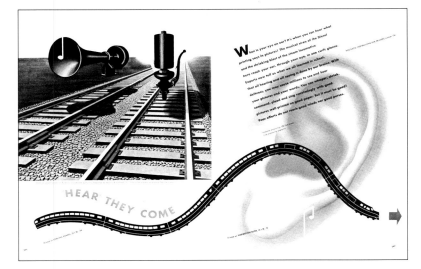

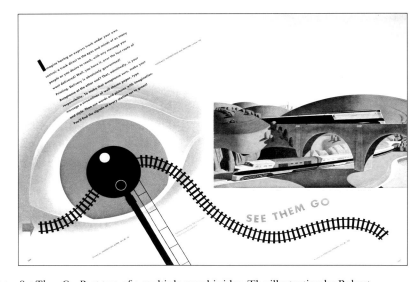

9 *Hear They Come,* above. A miniature reproduction of the design on page 6. The full-color illustration was painted by Fred Chance and Paul Smith.

10 *See Them Go.* Part two of a multiple graphic idea. The illustration by Robert Fawcett and Paul Smith, the background artwork as usual by the designer.

13 *Good Earth I,* below. Peaceful pictures of the proverbial ploughman, as on page 6, by artists Bertrand Zadig, left, and Thomas Hart Benton, right.

14 *Good Earth II.* A nation newly at war! And a graphic idea symbolized change. The photograph, left, was by La Driere, and drawing, right, by Robert Riggs.

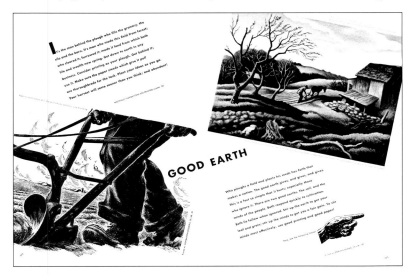

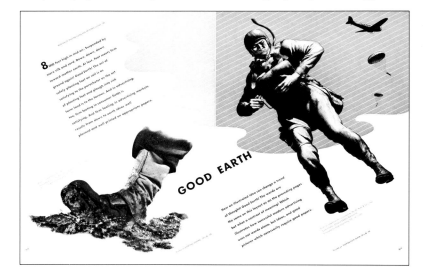

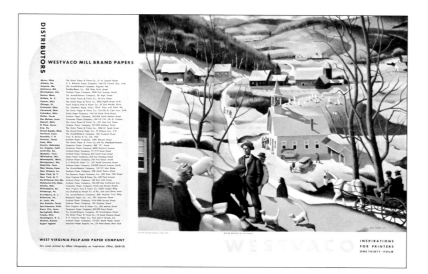

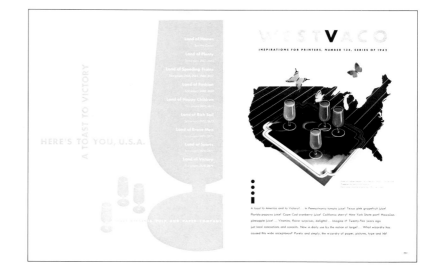

7　*Inspirations 134 Cover,* above. This peaceful landscape by Paul Sample was printed early in 1941, months before Pearl Harbor. The typographic list at left was superimposed upon an abstract shape of gray that was created by visually relating it to the typography itself. This relationship of type appears on spreads 8, 11, 16, and less obviously on *all* images in the issue.

8　*A Toast to Victory.* The title pages of issue 134 featured an elegant illustration by Joseph Binder, with a congenial tray of beverages, and of butterflies blending into a map of the USA. Then, with the nation at war, the heading and text proposed a toast to Victory; the V in westvaco was emphasized and the wartime Morse code symbol for V substituted as an initial letter.

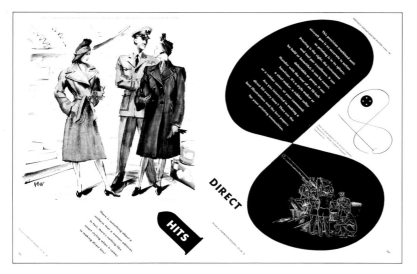

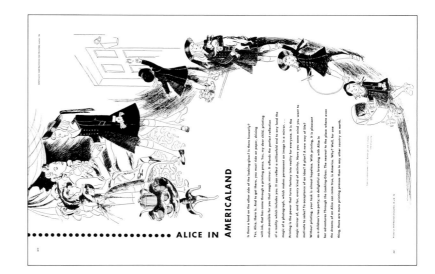

11　*Direct Hits.* Here, war brought a pun to the title of the page, in describing fashions with *war talk.* The illustrations, by R.B. Willaumez and Alex Ross.

12　*Alice in Americaland.* The war inspired a nationalistic title for a centerfold drawing, turned dramatically on its side. The artist was Eric Mulvaney.

15　*Service Ace.* Miniature of pages 4-5, on a theme of peace-time recreation. The large full-color fashion illustration was painted by Edwin Georgi.

16　*Victory.* "A Victory that must be speeded through sale of Victory Bonds and Stamps, with printed words and pictures." Photography by Ivan Dimitri.

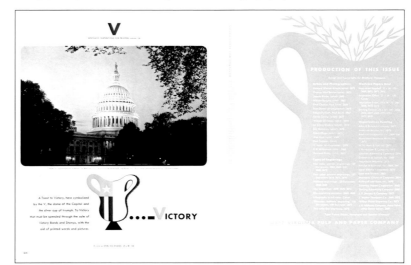

The quotation at right was the first part of the text in the spread below. The illustrations were a part of advertising's contribution to the war effort by a trust company, an insurance company, a locomotive works, and a watchmaker. The artists are among the distinguished of the war period.

With superior eyesight or a magnifying glass the names of the institutions and the artists may be read, as well as those of the advertising agencies that created the advertisements.

The three Thomas Hart Benton paintings, below right, showing the horrors of aggression were commissioned by a laboratory company to inspire its users to contribute to the war effort. Benton's own words regarding his purpose in creating them are contained in the design:"I have made these pictures with the hope that I might be of help in pulling some Americans out of their shells of make believe. The pictures are not technically realistic. They do not represent accurately anything that I have seen. I believe that they are true representations of the moment even though the symbols used are imaginative."

The typography of *Inspirations 138* employed the large poster-like headings that were modified with white inlines to suggest the immediacy of stenciled letters. The subheads are *Futura Demibold*. The body type is *Bodoni Book* with the newslike excerpts in blocks of justified roman, and the text in unjustified italic. The unjustified italic was arranged in discrete phrases, an experiment which anticipated the style of the *Washburn College Bible* published four decades later.

*Before dusk fell on December 7, 1941,
grim-faced advertising men were voluntarily starting
to plan combat of the Axis here at home.
These men developed campaigns against fear,
tactics to raise morale and maintain it at its peak.
Their battlefield is paper;
their ammunition, words and pictures;
their howitzers are printing presses.
[From the text of the design, below]*

18 *To Arms!* Five illustrations and four different typefaces, and all arranged on an angle: the designer's problem was to meld each of the graphic components with all the others into a cohesive two-page publication unit.

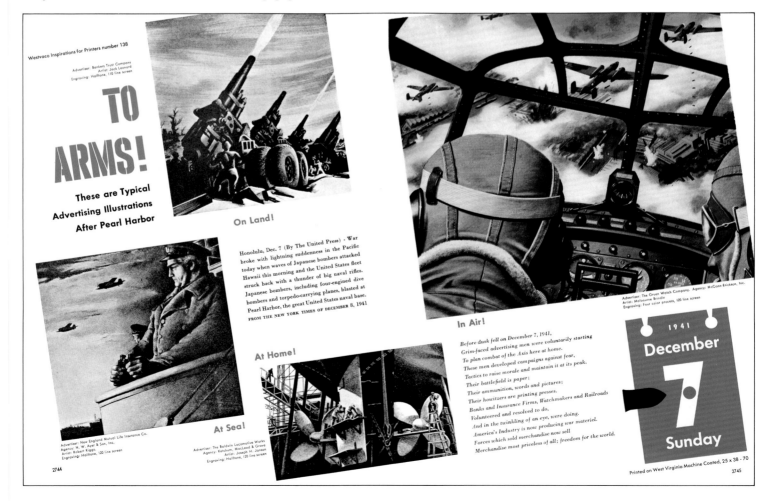

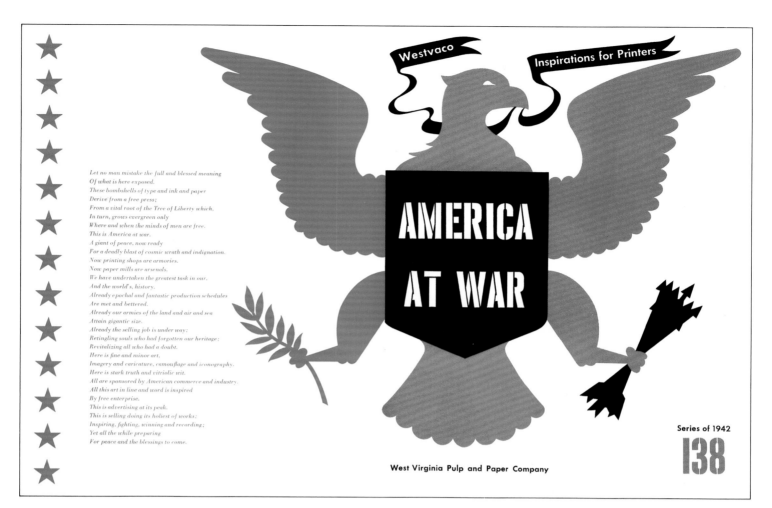

17 *America at War.* The challenge for the designer, to make a patriotic two-page design limited to one color for the left page and two colors for the right, was met with a cubist solution; a familiar symbol but with a new dimension.

19 *Halt!* "Here," reads the text below "in three creations of art, multiplied by printed paper, millions will perceive…see and feel and be inspired to action in a manner that could not be accomplished with a million words."

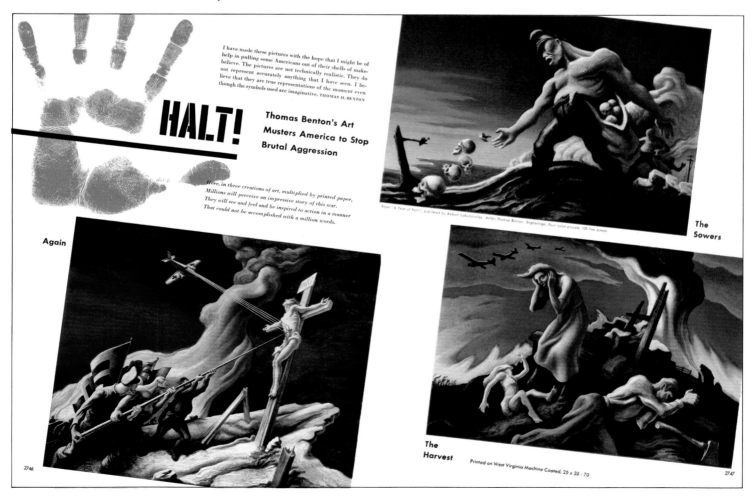

Peace and war: chapter 1

In wartime advertising the illustrator, photographer, painter, and designer experienced an unusual opportunity for personal creativity. Advertising suddenly had a new purpose: to serve only the victory goal of the nation and to preserve the institutional name of the company and its products in an economy with few products to market competitively.

During this period, *Westvaco Inspirations* reproduced the work of many illustrators, such as the ones on these facing pages: James R. Bingham, Harrison Miller, Robert Riggs, Werner B. Schmidt and Ben Stahl; also, Melbourne Brindle, Stevan Dohanos, Albert Dorne, John Falter, Glen Grohe, Jack Leonard, Fred Ludekens, Walter Richards, Norman Rockwell and Noel Sickles. Also, the work of poster artists and designers such as Herbert Bayer, Lester Beall, Joseph Binder, Jean Carlu, E. McKnight Kauffer, Herbert Matter, and Howard Scott. As we have seen, painters, as distinguished from illustrators, produced numerous scenes of both war and peace upon assignment.

Most persons in the nation aided in the war effort. Women in all occupations replaced men who had entered the military or government. There were many worthwhile contributions that could be made. *Inspirations 141* participated in this war effort in 1943. Six distinguished guests — M. F. Agha, Alexey Brodovitch, George Giusti, Nelson Gruppo, E. McKnight Kauffer, and Tobias Moss joined the designer in this special issue to encourage blood donation, V-Mail to the armed forces, and Victory Gardens. The cover was by Doris Lee.

*Why is America's public morale
at its peak?
Why are epochal production schedules
met and bettered?…
Because American Business, Free Enterprise,
has turned all of its arts
and its powers of advertising
to those objectives!
Here is a fantasy of righteous anger
and the undying will
to win, protest and disperse Liberty.
Here is the wonder story of people fighting
so that peace and happiness
will rule the land of tomorrow.*
[*From the text of the design, opposite page*]

20 *W is for War.* The first spread of *Inspirations 148,* designed in primer-like style, with eight spreads featuring the letters w-e-s-t-v-a-c-o. Typefaces were *Century Schoolbook* and *Expanded* but were set innovatively in all lowercase.

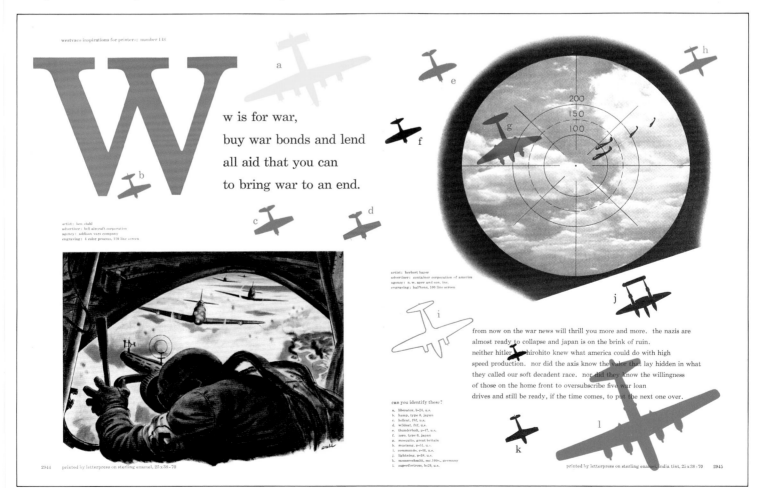

Westvaco Inspirations for Printers number 139

When at long last, the poet, dreamer, creator and gentleman of business turn to the defense of the world they have made, then let tyrants tremble and thieves quake! § Grain for feeding the world now flies the skies. The skill of a master watchmaker dooms a despot's city. A poet liquidates a thousand killers. A painter captains a battle cruiser. § That's the fantastic tale of a land where liberty dwells, where freedom of thought and freedom of enterprise are civilization's capstones. Why is America's public morale at its peak? Why are epochal production schedules met and bettered? Not because of beaurocratic mouthings, or fatuous ideas amateurishly expressed; but because American Business, Free Enterprise, has turned all its arts and its powers of advertising to those objectives! § Here is a fantasy of righteous anger and the undying will to win, protect and dispense Liberty. Here is the wonder story of people fighting so that peace and happiness will rule the land of tomorrow. Who are among the heroes? You guessed correctly; paper, pictures, type and ink!

Battle Land

Printed by letterpress on Inspiration Super, 25 x 38 - 70

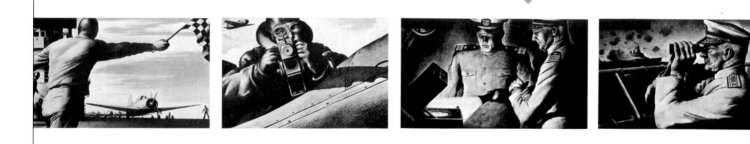

21 *Battle Land.* Bombs in a sky of type, above; seaweed and fish in an ocean of type, below. In *Inspirations 139,* headings were factual sans serif type, text was fanciful italic; for a theme based upon *both* real warfare and fiction.

22 *Land Beneath the Sea.* Handsome advertising illustrations from the nation's free enterprise system. In time of war and with few products to sell, American industry turned its energy to aiding the morale of the people.

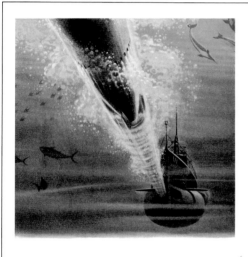

Westvaco Inspirations for Printers number 139

Advertiser: United States Steel Subsidiaries
Agency: Batten, Barton, Durstine & Osborn, Inc.
Artist: Werner E. Schmidt
Engraving: Four color process, 133 line screen

Advertiser: The American Rolling Mill Company.
Agency: N. W. Ayer and Son, Inc.
Artist: Harrison Miller.
Engraving: Duotone, 120 line screen

Land beneath the Sea

Jules Verne dreamed about it and wrote "20,000 Leagues Under the Sea." Robert Fulton and Simon Lake also dreamed about it, but they made it come true! § And here, combining the fantasy of Verne and the realism of Fulton and Lake, an American advertiser takes you down to the depths of the sea on paper; projects you from wherever you may be, to the ocean's bottom, and does things to you. It's as if you were in a wonderland, but it's true. § Every minute, somewhere, a man or woman plans a piece of printing designed to do impossible, but nice things to somebody, and for somebody. What they accomplish, and their way of doing it, would make the soul of Jules Verne sigh with envy, and would win applause from Fulton and all other great inventors in Valhalla. § The secret is as simple as rolling off a log! You just ask a creative artist and a creative writer to look at the products you have to sell. Imaginatively, they collaborate on a realistic tale. Then a printer with presses and inks does the rest on paper. Every conservative, die-hard mad-hatter throws a cosmic fit, because another visionary tale of business has come true.

2764 Printed by letterpress on Inspiration Super, 25 x 38 - 70

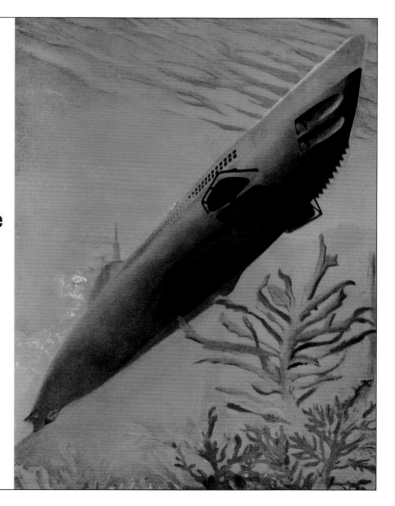

Victory in World War II by the Allied forces was won through the defeat of Italy in September 1943, Germany in May 1945, and Japan in August 1945.

The issues of *Westvaco Inspirations* for 1944 reflected the mood of approaching victory and peace in the USA. The designs include two illustrations from an advertising campaign that forecast a new world of communion among nations. Five illustrations, created by natives of the countries represented, were selected for *Inspirations 150:* China, Greece, India, Norway, and Russia. Typical statements of good will appear on the Chinese and Russian spreads that are reproduced below.

A few artists who were prominent for their military illustrations of the war have been mentioned on a preceding page. Illustrators too portrayed in *Inspirations* a more pleasant and sophisticated life – advertising's reminder of the life the nation enjoyed prior to the war and the life the nation intended to recreate when the war would be over. These were a few of those illustrators: Boris Artzybasheff, John Atherton, R. R. Bouche, Miguel Covarrubias, Salvador Dali, Andre Dugo, James Flora, Edwin Georgi, Bernard Lamotte, Doris Lee, Jean Pages, Paul Rand, Allen and Leslie Saalburg, Arthur Szyk, Buk Ulreich, R. B. Willaumez.

As a unit all six issues of *Westvaco Inspirations* for the year 1944 were honored in the spring exhibition of 1945 with the annual gold medal of the Art Directors Club of New York.

Here and there, through the fires of this Hell,
we glimpse the Heaven of Peace to come;
only because righteous men in War destroy
only that Peace may come;
and sanity, and happiness.
We, too, can be cosmic surgeons.
We, too, can destroy our share of evil.
Not by guns, and bombs
but by messages of faith, of high morale:
by appeal to the highest part of man,
his mind.
[Carl W. Drepperd, Inspirations 146, 1944]

24 *China, Greetings from the USA.* This two-page design is given graphic integrity by the circular red Chinese sun symbol which is twice repeated in black and white, and by the related large circle that unifies the whole.

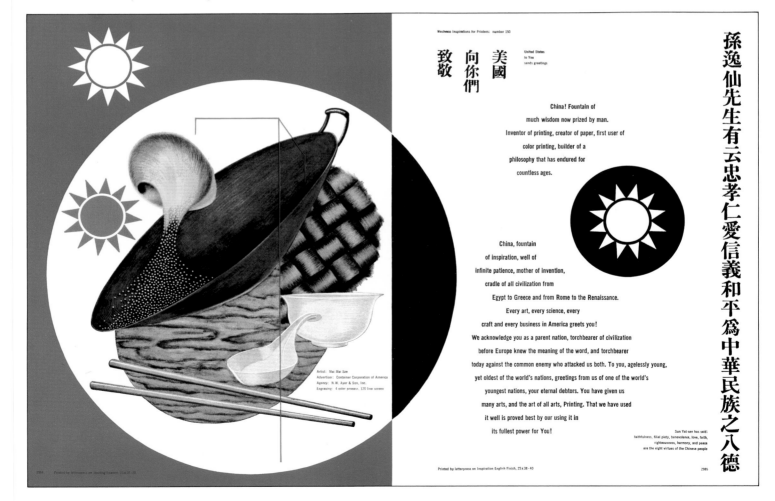

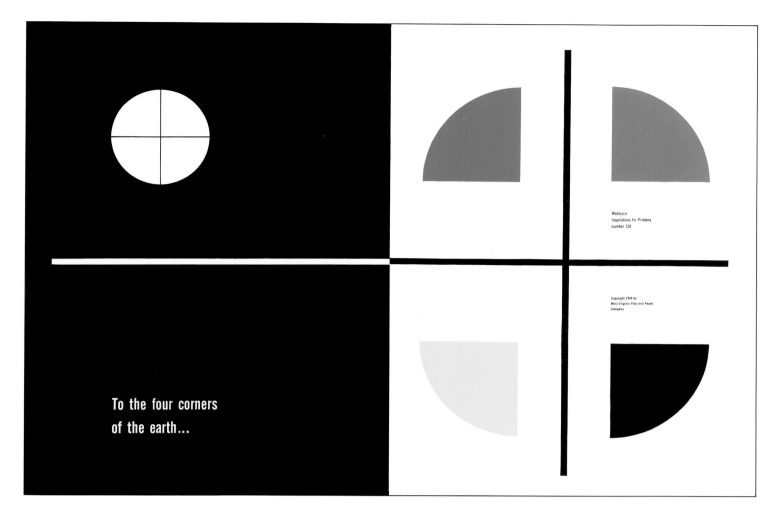

23 *To the Four Corners of the Earth.* The primary colors of printing, in geometric
 parts, here symbolize the divergent components that realistically can unify
 a world of graphics, and idealistically a world of people of different colors.

25 *Russia, Greetings from the USA.* This two-page design also is given a graphic
 integrity by the symbolic Russian star, in evidence on the man's cap and
 repeated boldly at left, and by the large triangle that closely relates to the star.

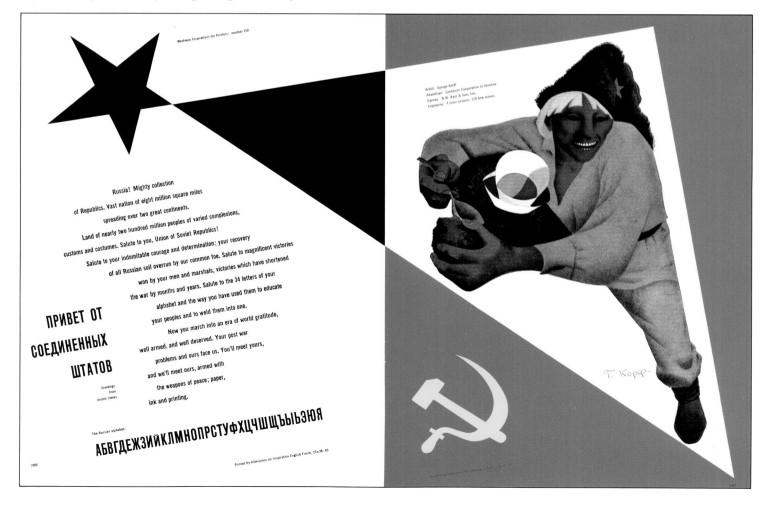

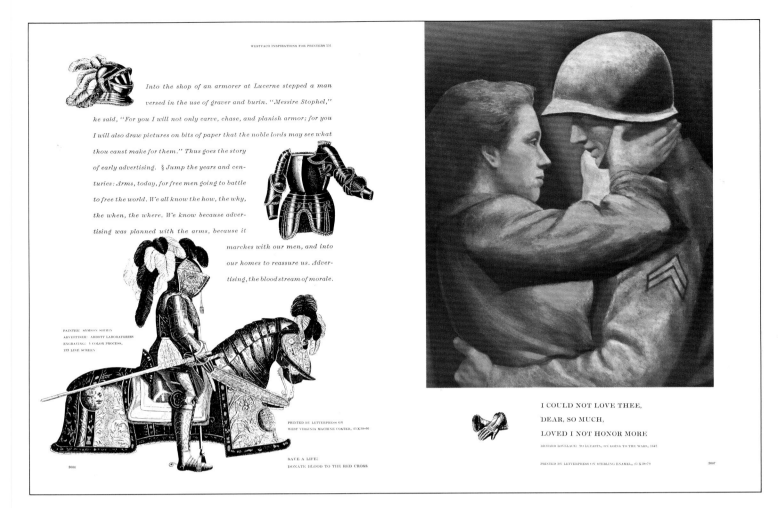

26 *I Could Not Love Thee, Loved I Not Honor More.* In *Inspirations 151,* issued in
the last year of World War II, the subject of conflict was treated quite
romantically, with old engravings, classic verse, and contemporary art.

27 *The Trident of Neptune Is the Sceptre of the World.* This truism from 1775 was now
only a sentimentalism; the plane had replaced the ship as ruler of commerce
and war. *Scotch Roman* and *Law Italic* types, too, were from a bygone age.

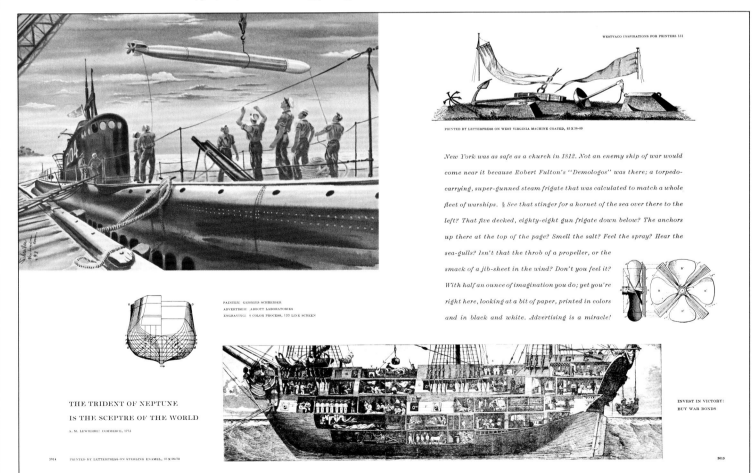

2 Graphics in motion

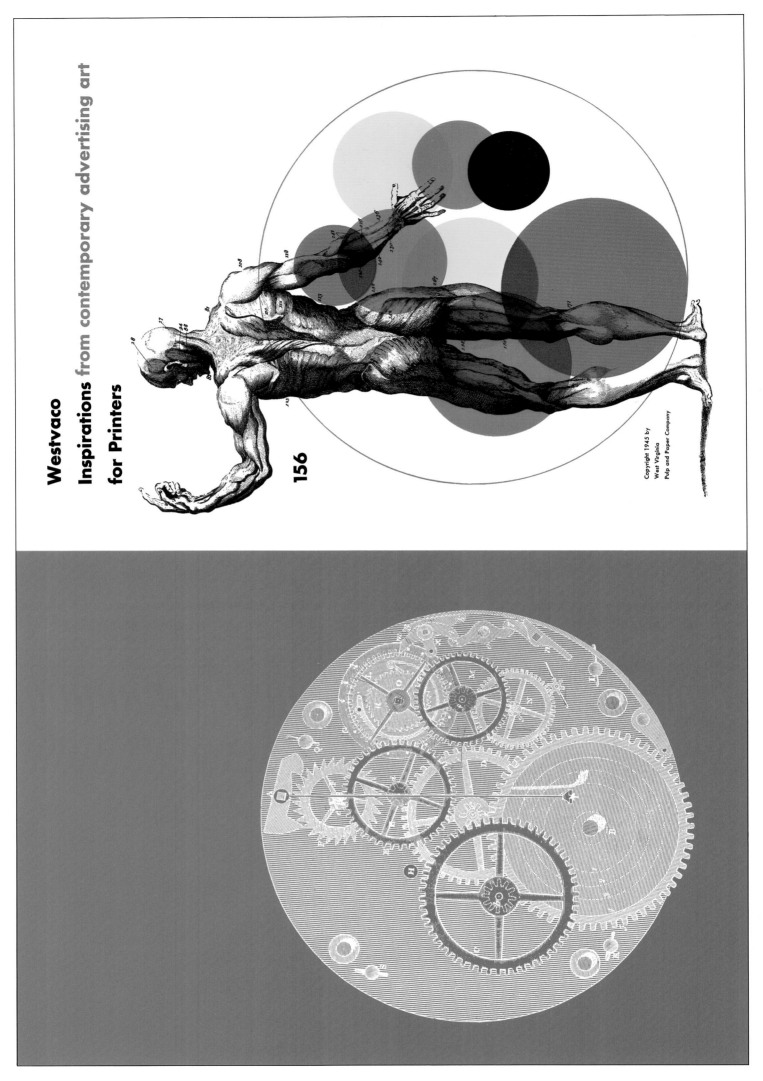

Westvaco

Inspirations from contemporary advertising art

for Printers

156

Copyright 1945 by
West Virginia
Pulp and Paper Company

28 *Man, Time and Motion.* The title spread of
Inspirations 156, published in 1945.

2

Graphics in motion

On the printed page in 1945,
process inks are given a vital role in graphic design

With the arrival of Christmas 1944 and New Year's Day 1945 came a realization throughout the nation that peace on earth soon would be returning. For the author this optimistic atmosphere spurred a new desire to produce fresh graphic design ideas.

Westvaco Inspirations provided a graphics laboratory, an incentive, and an eager audience. It was the perfect medium for exploration, and forward-looking ideas served the essential purpose of the papermaker-publisher and its audience of 35,000 printers, art directors, designers, artists, teachers, and students.

Inspirations traditionally had a generous budget for type-setting and the printing of plates or separations that were themselves often gratuitously loaned by museums, publishers, and agencies. However, funds for the commissioning and reproduction of new artwork were minimal. Thus the author relied increasingly upon a practical knowledge of printing and engraving to satisfy creative desires. The printing press, type case, and print shop were his canvas, easel, and second studio.

Out of these desires and fortunate restraints came a number of personal solutions to graphic design, among them the one in this chapter for which the author has given the title "Graphics in Motion."

The author's discovery in 1945 that a design on two facing pages could be enlivened by printing a single black illustration in four process colors [page 20] opened a new world of personal exploration; this basic technique is in use today. The process inks in another later 1945 issue [opposite] abstractly brought to life the movement of clockworks and man's universal preoccupation with time.

With the war at an end, 1945 was a special year in several ways. The author's affiliation with *Art News* and *Mademoiselle* brought additional resources of reproducible images and fresh ideas to the pages of *Inspirations*. And as always, it was his privilege to decide upon the concept and all graphic ingredients of the issues of *Inspirations* for which he was the designer and art director.

Allen F. Hurlburt, distinguished art director, writer, and teacher wrote about the work in an illustrated article in *Communication Arts* magazine, January-February 1980, parts of which are republished in this chapter:

"In his own quiet way, Bradbury Thompson has expanded the boundaries of the printed page and influenced the design of a generation of art directors. Unfortunately…many of the young designers who are in his debt are hardly aware of his presence.

"To correct that impression and demonstrate the extent of his involvement in graphic design, it is only necessary to take a look at a single year. 1945 was the year that the war ended and Thompson wound up his tour of duty with the Office of War Information (OWI). He designed the final issues of three wartime magazines including *Victory* and *USA,* publications that were produced in several languages and with worldwide distribution. [Continued on page 24]

Opposite: Four-color process inks, together with engravings of clockworks and a human figure, brought time and motion to life on the printed page, through the use of line plates and without the problems of color registry.

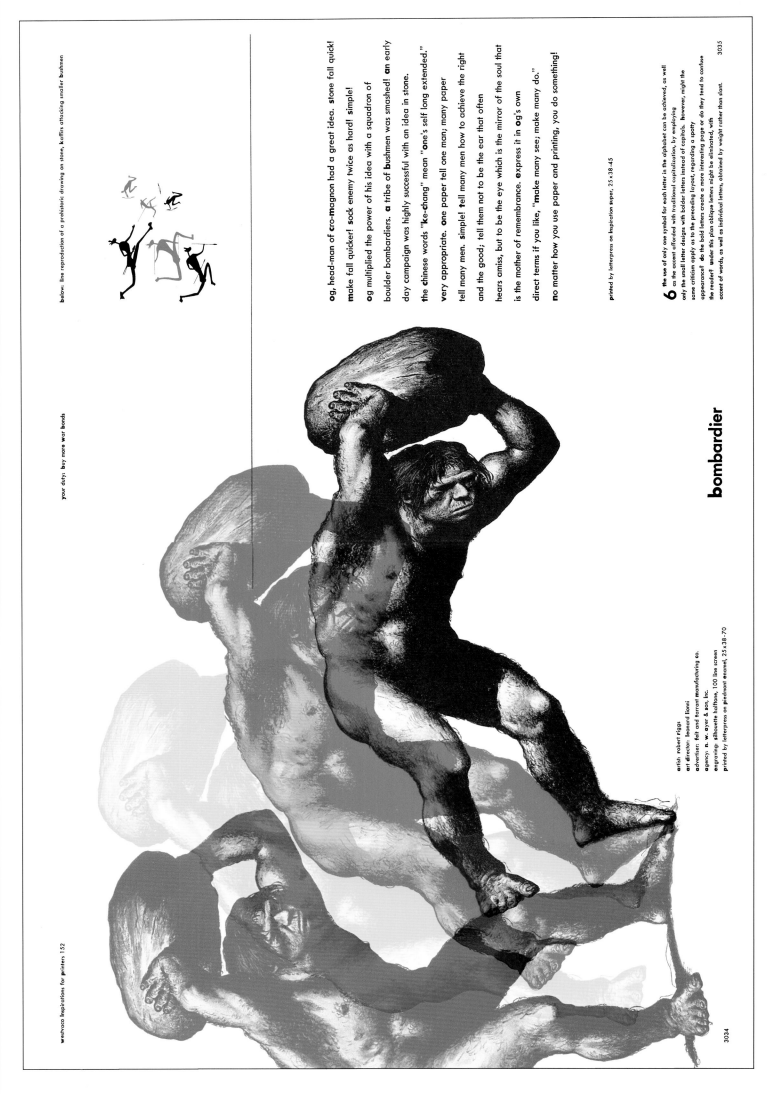

your duty: buy more war bonds

below: line reproduction of a prehistoric drawing on stone, kaffirs attacking smaller bushmen

og, head-man of cro-magnon had a great idea. stone fall quick! make fall quicker! sock enemy twice as hard! simple! og multiplied the power of his idea with a squadron of boulder bombardiers. a tribe of bushmen was smashed! an early day campaign was highly successful with an idea in stone. the chinese words "ke-chang" mean "one's self long extended." very appropriate. one paper tell one man; many paper tell many men. simple! tell many men how to achieve the right and the good; tell them not to be the ear that often hears amiss, but to be the eye which is the mirror of the soul that is the mother of remembrance. express it in og's own direct terms if you like, "make many see; make many do." no matter how you use paper and printing, you do something!

printed by letterpress on inspiration super, 25 x 38-45

6 the use of only one symbol for each letter in the alphabet can be achieved, as well as the accent afforded with traditional capitalization, by employing only the small letter designs with bolder letters instead of capitals. however, might the same criticism apply as to the preceding layout, regarding a spotty appearance? do the bold letters create a more interesting page or do they tend to confuse the reader? under this plan oblique letters might be eliminated, with accent of words, as well as individual letters, obtained by weight rather than slant.

3035

bombardier

artist: robert riggs
art director: leonard lionni
advertiser: fell and torrant manufacturing co.
agency: n. w. ayer & son, inc.
engraving: silhouette halftone, 100 line screen
printed by letterpress on piedmont enamel, 25 x 38-70

3034

29 *Bombardier.* Graphic action moves left to right, with a single black illustration in four process colors. Opposite, graphic action moves foreground to background, also with four process colors. 1945

30 *A Little Too Late.* The type of this design is in all capital letters; the design opposite is in all lowercase, with bold letters *for* caps. Typographically, both are parts of *The Monalphabet*, chapter three.

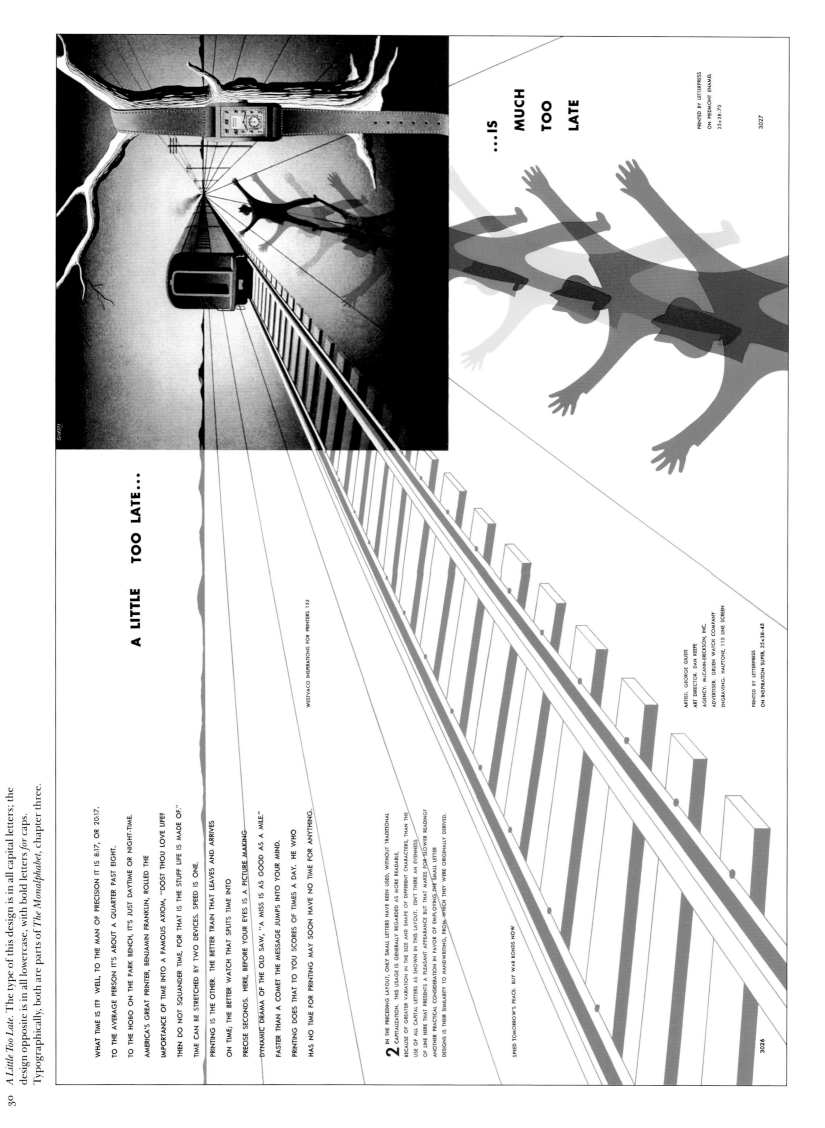

A LITTLE TOO LATE...

WHAT TIME IS IT? WELL, TO THE MAN OF PRECISION IT IS 8:17, OR 20:17.

TO THE AVERAGE PERSON IT'S ABOUT A QUARTER PAST EIGHT.

TO THE HOBO ON THE PARK BENCH, IT'S JUST DAYTIME OR NIGHT-TIME.

AMERICA'S GREAT PRINTER, BENJAMIN FRANKLIN, ROLLED THE

IMPORTANCE OF TIME INTO A FAMOUS AXIOM, "'DOST THOU LOVE LIFE?

THEN DO NOT SQUANDER TIME, FOR THAT IS THE STUFF LIFE IS MADE OF."

TIME CAN BE STRETCHED BY TWO DEVICES. SPEED IS ONE.

PRINTING IS THE OTHER. THE BETTER TRAIN THAT LEAVES AND ARRIVES

ON TIME; THE BETTER WATCH THAT SPLITS TIME INTO

PRECISE SECONDS. HERE, BEFORE YOUR EYES IS A PICTURE MAKING

DYNAMIC DRAMA OF THE OLD SAW, "A MISS IS AS GOOD AS A MILE."

FASTER THAN A COMET THE MESSAGE JUMPS INTO YOUR MIND.

PRINTING DOES THAT TO YOU SCORES OF TIMES A DAY. HE WHO

HAS NO TIME FOR PRINTING MAY SOON HAVE NO TIME FOR ANYTHING.

WESTVACO INSPIRATIONS FOR PRINTERS 152

2 IN THE PRECEDING LAYOUT, ONLY SMALL LETTERS HAVE BEEN USED, WITHOUT TRADITIONAL CAPITALIZATION. THIS USAGE IS GENERALLY REGARDED AS MORE READABLE, BECAUSE OF GREATER VARIATION IN THE SIZE AND SHAPE OF DIFFERENT CHARACTERS, THAN THE USE OF ALL CAPITAL LETTERS AS SHOWN IN THIS LAYOUT. ISN'T THERE AN EVENNESS OF LINE HERE THAT PRESENTS A PLEASANT APPEARANCE BUT THAT MAKES FOR SLOWER READING? ANOTHER PRACTICAL CONSIDERATION IN FAVOR OF EMPLOYING THE SMALL LETTER DESIGNS IS THEIR SIMILARITY TO HANDWRITING, FROM WHICH THEY WERE ORIGINALLY DERIVED.

SPEED TOMORROW'S PEACE. BUY WAR BONDS NOW

ARTIST: GEORGE GIUSTI
ART DIRECTOR: DAN KEEFE
AGENCY: McCANN-ERICKSON, INC.
ADVERTISER: GRUEN WATCH COMPANY
ENGRAVING: HALFTONE, 110 LINE SCREEN

PRINTED BY LETTERPRESS
ON INSPIRATION SUPER, 25×38-45

3026

...IS MUCH TOO LATE

PRINTED BY LETTERPRESS
ON PIEDMONT ENAMEL
25×38-70

3027

21

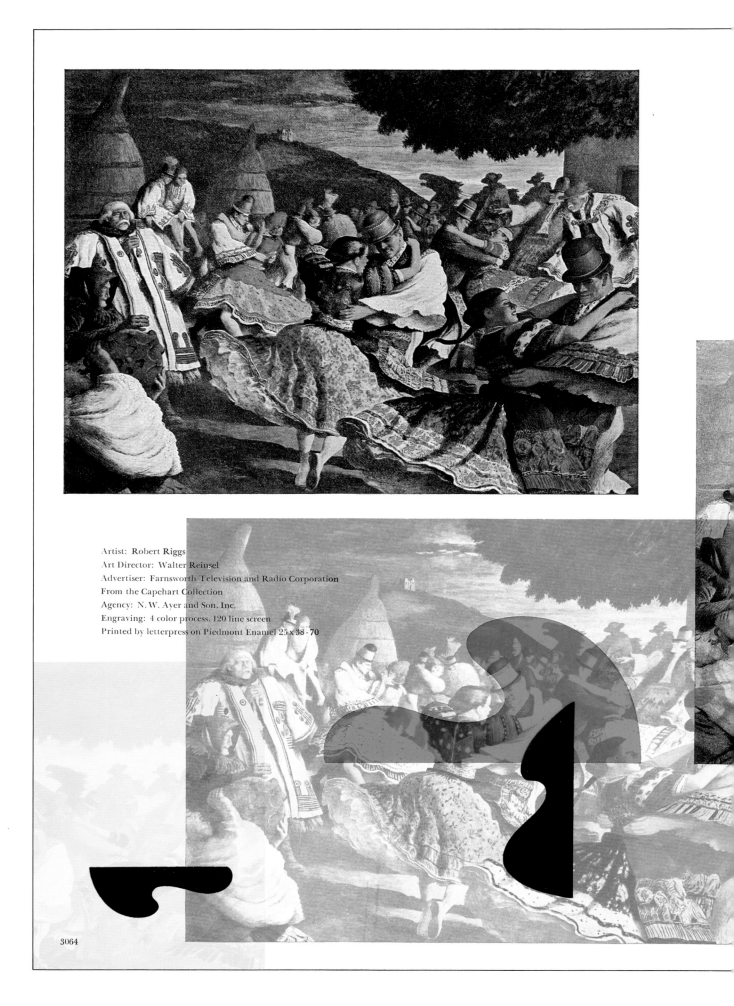

Artist: Robert Riggs
Art Director: Walter Reinsel
Advertiser: Farnsworth Television and Radio Corporation
From the Capehart Collection
Agency: N. W. Ayer and Son, Inc.
Engraving: 4 color process, 120 line screen
Printed by letterpress on Piedmont Enamel 25 x 38 - 70

3064

*Graphic design can explore
the inside of reproduction itself.
A picture of dancing people can be transformed
into a design of dancing printing plates,
which were essential to its own reproduction.*

Westvaco Inspirations for Printers
number 154

The mystery, the magic and the science of color spring from the radiant energy

we call light. And light, we are told, is about the fastest thing

there is; it travels at the rate of 186,000 miles a second. That is the speed

then at which this whirling mass of color travels to your eyes.

See the primary color plates together, presenting a dance that radiates every color

in the spectrum! All this to your eyes in less time than it takes

to set one letter of this message in type. The speed of light, almost the fastest

thing there is! But the speed of thought is faster! Within these two

elements of super-speed resides the answer to the miracle of printed advertising.

Printed by letterpress on West Virginia Machine Coated 25 x 38 - 60

Dance of color

3065

31 *Dance of Color.* Recipe for a graphic design: 1. A reproduction of a lively
painting of dancers. 2. A controlled arrangement of process printing plates such
as observed on random pressroom trial sheets. 3. Five small abstract shapes inspired
by musical instruments. 4. Mix the ingredients together with three key title words.
5. Cost: nothing other than for printing the borrowed process plates. 1945

"Before the year was out, he had become art director of *Mademoiselle,* a youth oriented fashion magazine, that he served for nearly 15 years. He also accepted the role of design director for *Art News* and *Art News Annual,* a position he held for 27 years. As if this were not enough, he designed a brochure for the Ford Motor Company called "Freedom of the American Road" and began his experiments in typographic reform by creating his *Monalphabet* which broke the tradition of separate letterforms for capital and lowercase letters. He first introduced this typographic innovation in an issue of *Westvaco Inspirations,* one of four issues that he produced that year.

"1945 was not all that unusual. Throughout his career Thompson demonstrated an ability to take on a volume of work that would smother most other designers and still find time to take on one more project.

"The 61 issues of *Westvaco Inspirations* that he designed between 1939 and 1962 not only became a landmark in American graphic design, but they provided a unique showcase of his ability to balance restrictive constraints with creative freedom.

"The combination of the enforced improvisation of many elements into a rhythmic pattern created pages for *Westvaco Inspirations* that in many ways invited comparison with the jazz music of the period. It is also interesting to equate his improvisations on the design themes of Dada, deStijl, and Constructivism with George Gershwin's sophisticated translation of the jazz [continued on page 32]

Action to produce a specific result.
That's the definition of motion,
whether by a Persian nabob on a war-horse, or by you
planning to sell a specific idea or product.
Whatever it is that wants doing, or needs doing,
it cannot be done without motion.
Minds in motion, bodies in motion, machines in motion…
Motion to produce a specific result
must start with you…
[*M. Joseph McCosker, from the design below*]

32 *Persian Horse I.* Motion was visualized, below, with triangles that echo the prancing horse opposite. The shape of the large Caslon initial echoes the silhouette of the horse's head and neck. Text is all lowercase with bold letters for capitals. 1946

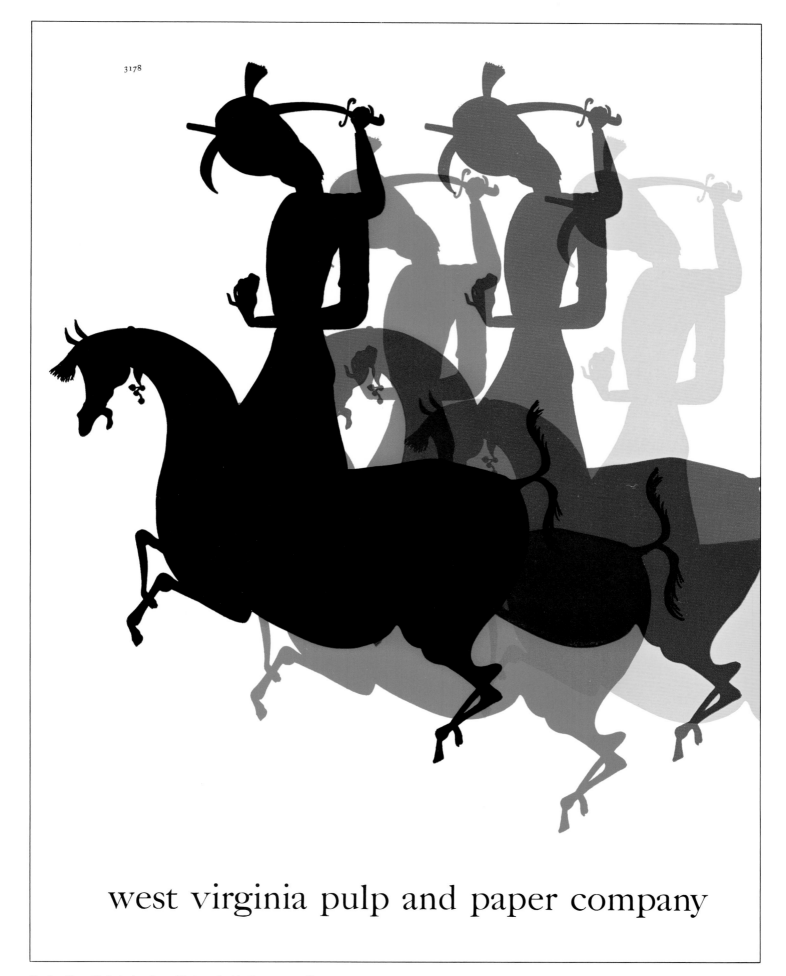

3178

west virginia pulp and paper company

33 *Persian Horse II.* A design from *Westvaco Inspirations 159.* 1946

The painting of a staid Persian horse, opposite,
was transformed into the design of a colorful prancing horse
by means of a simple silhouette tracing
and the four process inks used to reproduce the painting.
[An Art Directors Club Medal recognized its originality in 1947.]

L i

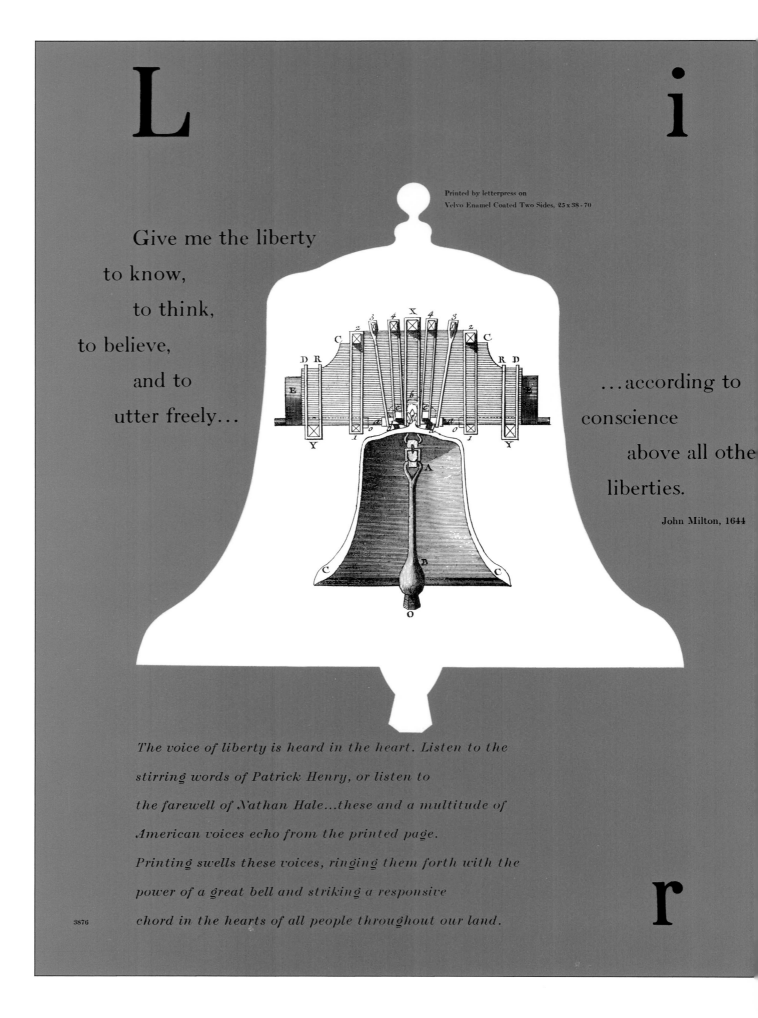

Give me the liberty

to know,

to think,

to believe,

and to

utter freely...

Printed by letterpress on
Velvo Enamel Coated Two Sides, 25 x 38 - 70

...according to

conscience

above all othe

liberties.

John Milton, 1644

The voice of liberty is heard in the heart. Listen to the

stirring words of Patrick Henry, or listen to

the farewell of Nathan Hale...these and a multitude of

American voices echo from the printed page.

Printing swells these voices, ringing them forth with the

power of a great bell and striking a responsive

3876 *chord in the hearts of all people throughout our land.*

r

The swinging motion of a bell
and even the illusion of its once colorful sounds
can be brought to life again on the printed page
to revive the spirit of 1776
in the 20th century.

b e

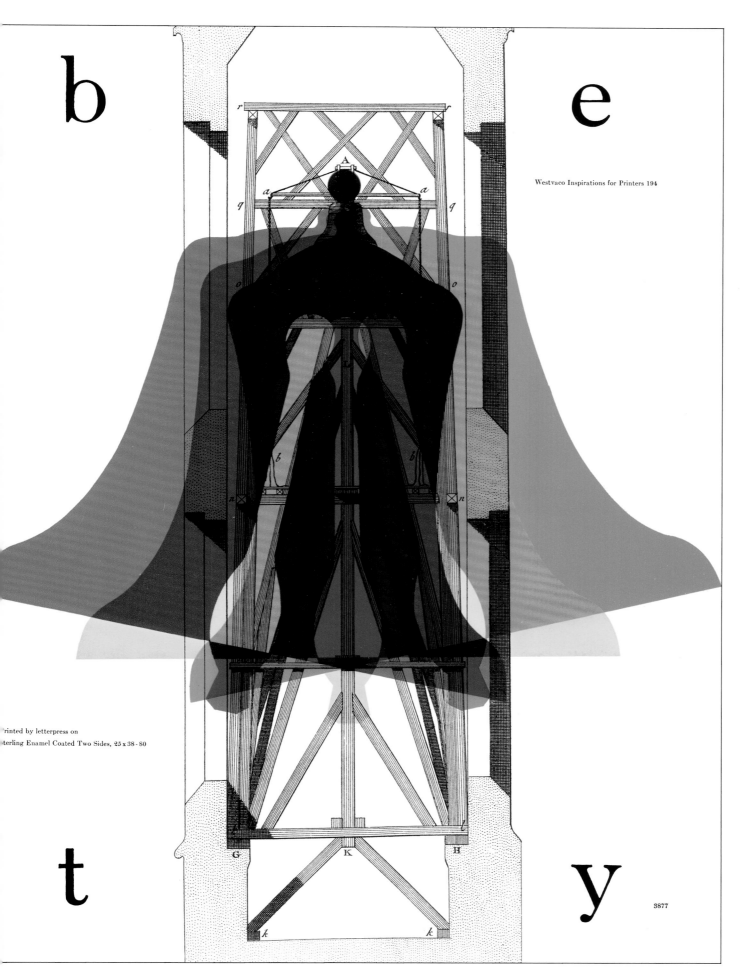

Westvaco Inspirations for Printers 194

rinted by letterpress on
terling Enamel Coated Two Sides, 25 x 38 - 80

t y

3877

34 *Liberty.* These engraved illustrations are not actually of the Liberty Bell
but date from the same historic era. They are from the French *Encyclopédie*
of Denis Diderot, as were all engravings in *Inspirations 194*.1953

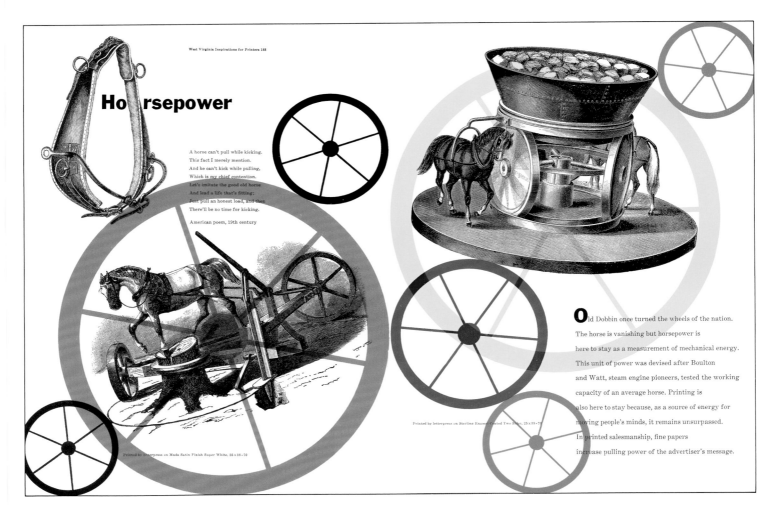

35 *Horsepower.* The effect of many wheels in motion was produced with wheels of various bright colors, coordinated with the wheels in the two illustrations of horsedrawn machinery moving in circular fashion.

36 *Fire! Fire!* A collage of fire-fighting apparatus, combining bright inks of process printing. The illustrations are from one of the most intriguing and profusely illustrated 19th century magazines, *Scientific American*. 1952

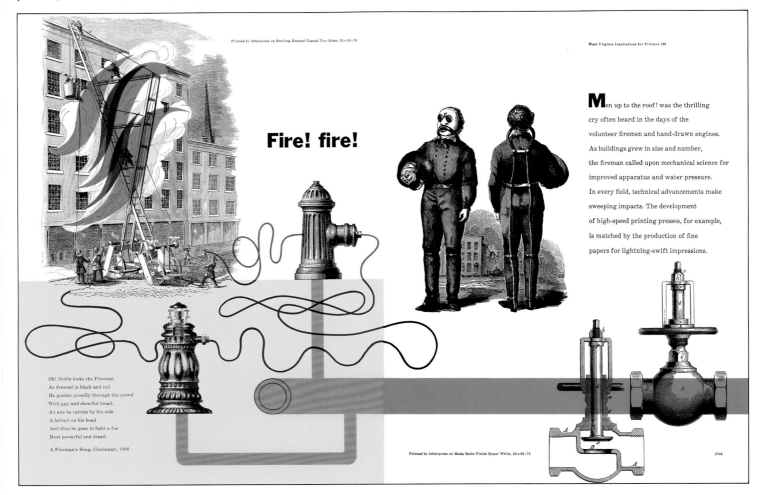

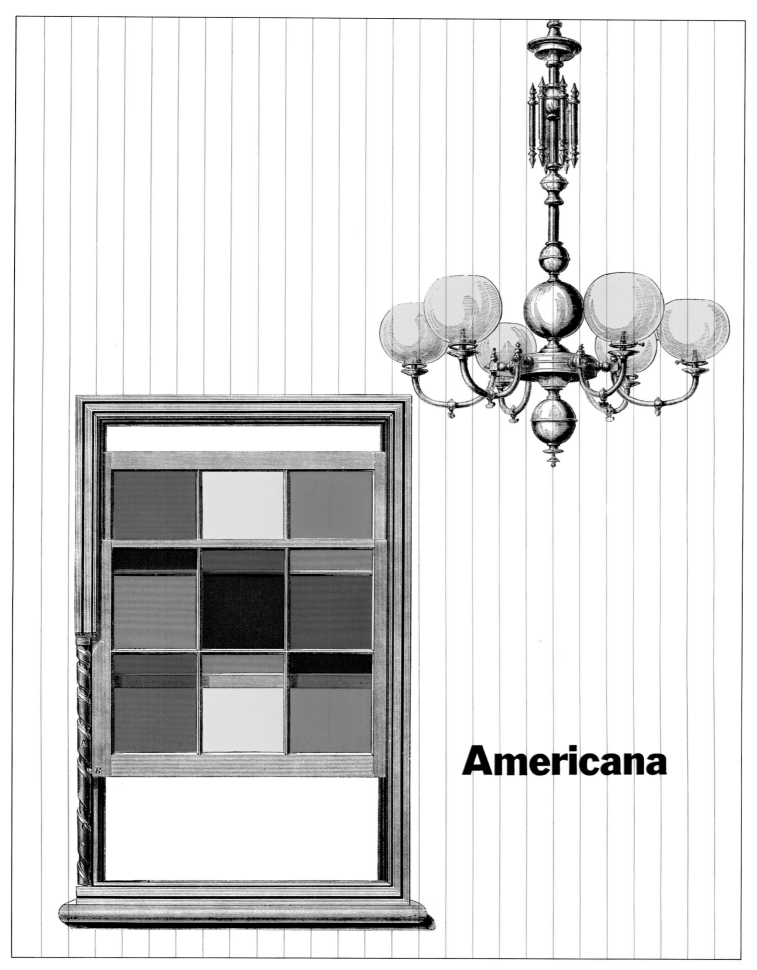

Americana

37 *Americana.* The title page of *Westvaco Inspirations 188*, published in 1952.

*A colored glass window with its overlapping panes
provides a demonstration of the technique
of overprinting with transparent process inks.
Engravings are from the pages of mid-19th century issues
of Scientific American.*

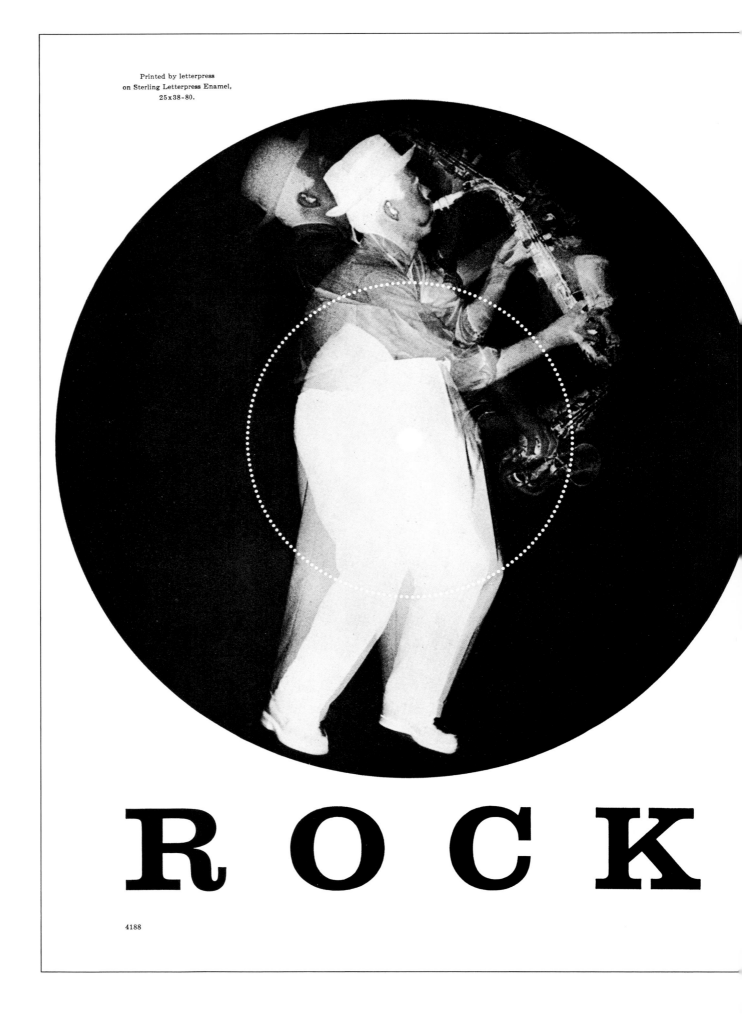

Printed by letterpress
on Sterling Letterpress Enamel,
25 x 38 – 80.

R O C K

4188

The black record on the left comes alive
with the colorful music of a spinning record on the right,
and the words too become a part of the visual music
as graphic design brings together
the arts of photography, typography, and printing.

Photograph: Rollie Guild.
Engraving: Halftone, 120 line screen,
printed in three colors of ink.

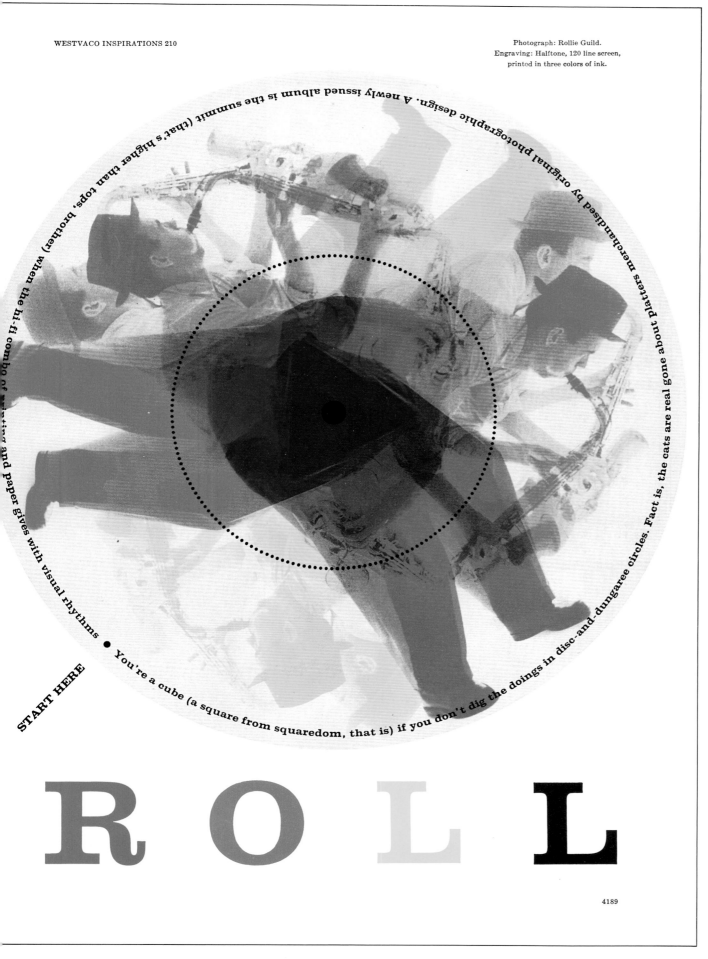

START HERE

• You're a cube (a square from squaredom, that is) if you don't dig the doings in disc-and-dungaree circles. Fact is, the cats are real gone about platter merchandised by original photographic design. A newly issued album is the summit (that's higher than tops, brother) when the hi-fi combo of printing and paper gives with visual rhythms

ROLL

4189

38 *Rock'n'Roll.* This graphic design puts forth the illusion of color in motion as the saxophonist comes alive on the whirling record. Technically, process printing plates were not employed, as just one halftone plate was printed in three process inks and on three different angles to avoid a moiré pattern. 1958

Graphics in motion, continued from page 24

ideas that had originated in New Orleans and in Chicago.

"Thompson first became involved in magazine design in 1934, but his style in publication design didn't mature until his wartime interlude designing magazines for the OWI. It was in his work on these publications that he developed his coherent approach to page design and his sense of typographic unity, and this was among the work that came to the attention of Dr. M. F. Agha, art director of *Vogue* and *Vanity Fair,* who became instrumental in Brad's appointment as design director of *Art News.* In addition to his work on *Mademoiselle* and *Art News,* he designed the formats of three dozen other publications.

"Books and book design have formed a critical part of his career from the time he went to Washburn College, where he edited and designed two yearbooks. Since then he has designed many important books including at least three that had a direct bearing on the graphic arts. His ninth volume of the *Graphic Arts Production Yearbook* is still a valuable reference work on that subject. His design for the *33rd New York Art Directors Annual* was one of the handsomest volumes in this important series.

"In all of his work, but particularly in his books, Thompson has demonstrated a talent for fusing the newest ideas with traditional illustrative material.

"This involvement with tradition and ephemera has not meant that Brad Thompson's book designs were conservative or lacking innovation. Every book has its own new point of departure from the conventions of bookmaking."

With graphic design
the illusion of motion on the printed page
can be expressed
in four primary colors
or black and white images and words,
and in horizontal
or circular directions,
and in ancient symbols and engravings
or 20th century photography.

39 *Rain, Rain, Rain.* A young *Mademoiselle* model moves through a rainstorm of typographic text. The rain reads logically from sky to ground, and she is walking *into* it, so the reader must turn the page in order to read the text. 1958

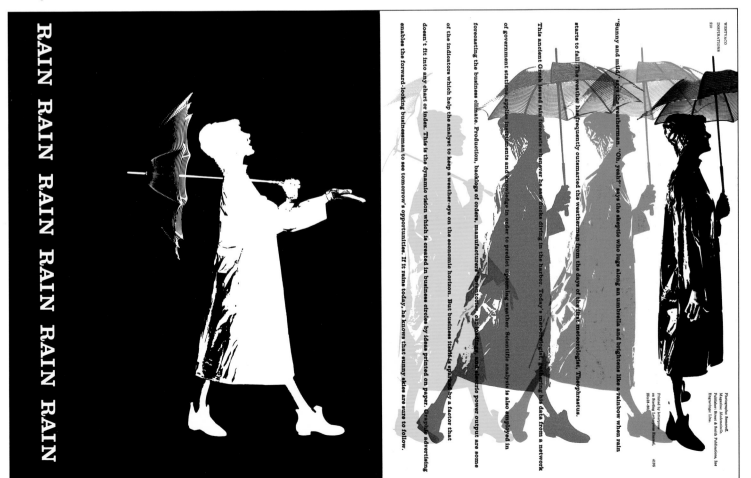

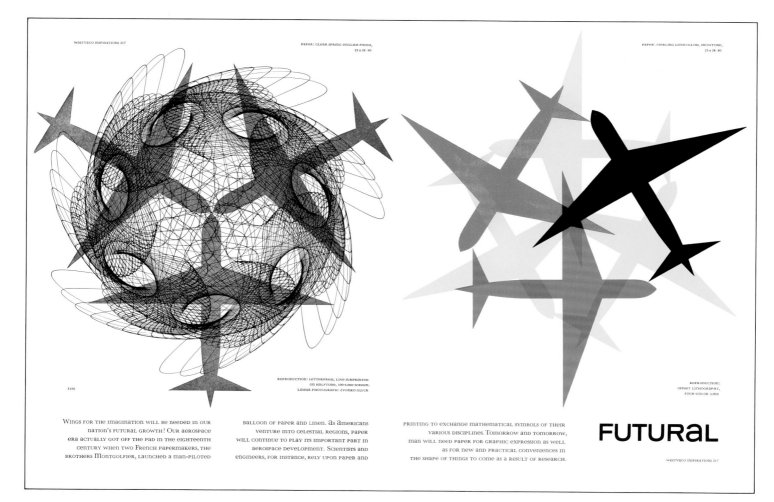

REPRODUCTION: LETTERPRESS, LINE SURPRINTED ON HALFTONE, 100-LINE SCREEN. LINEAR PHOTOGRAPH: ZVONKO GLYCK

REPRODUCTION: OFFSET LITHOGRAPHY, FOUR-COLOR LINE

WINGS FOR THE IMAGINATION WILL BE NEEDED IN OUR NATION'S FUTURAL GROWTH! OUR AEROSPACE ERA ACTUALLY GOT OFF THE PAD IN THE EIGHTEENTH CENTURY WHEN TWO FRENCH PAPERMAKERS, THE BROTHERS MONTGOLFIER, LAUNCHED A MAN-PILOTED BALLOON OF PAPER AND LINEN. AS AMERICANS VENTURE INTO CELESTIAL REGIONS, PAPER WILL CONTINUE TO PLAY ITS IMPORTANT PART IN AEROSPACE DEVELOPMENT. SCIENTISTS AND ENGINEERS, FOR INSTANCE, RELY UPON PAPER AND PRINTING TO EXCHANGE MATHEMATICAL SYMBOLS OF THEIR VARIOUS DISCIPLINES. TOMORROW AND TOMORROW, MAN WILL NEED PAPER FOR GRAPHIC EXPRESSION AS WELL AS FOR NEW AND PRACTICAL CONVENIENCES IN THE SHAPE OF THINGS TO COME AS A RESULT OF RESEARCH.

FUTURAL

WESTVACO INSPIRATIONS 217

40 *Futural.* The excitement of air flight was symbolized here in both black and colored inks. The collision of airplanes in turbulent air was technically a composite negative photograph of a swinging light bulb in the dark. 1962

41 *Neoclassic.* A melding of classic and modern worlds: a speeding sports car is propelled by the colorful symbolic triskelion legs of the Greek god of Victory. Turn to chapter 6, *Alphabet 26*, for an explanation regarding the typeface.

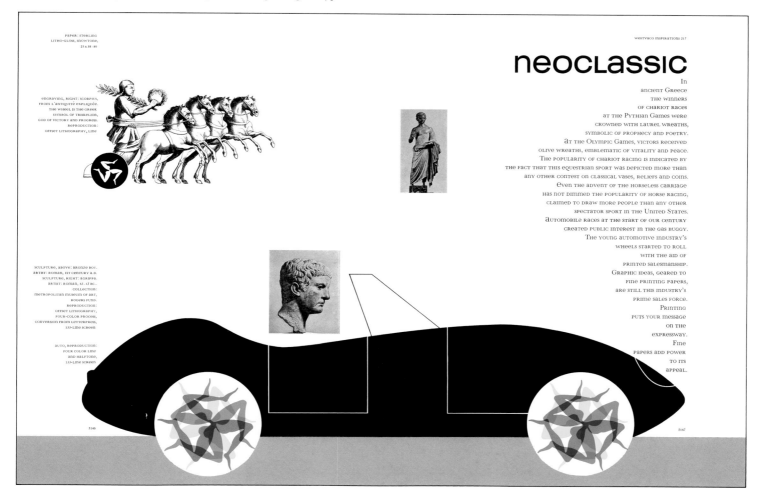

neoclassic

ENGRAVING, RIGHT: SCORPIUS, FROM L'ANTIQUITÉ EXPLIQUÉE. THE WHEEL IS THE GREEK SYMBOL OF TRISKELION, GOD OF VICTORY AND PROGRESS. REPRODUCTION: OFFSET LITHOGRAPHY, LINE

SCULPTURE, ABOVE: BRONZE BOY. ARTIST: ROMAN, 1ST CENTURY A.D. SCULPTURE, RIGHT: AGRIPPA. ARTIST: ROMAN, 63 - 12 BC. COLLECTION: METROPOLITAN MUSEUM OF ART, ROGERS FUND. REPRODUCTION: OFFSET LITHOGRAPHY, FOUR-COLOR PROCESS, CONVERSION FROM LETTERPRESS, 133-LINE SCREEN

AUTO, REPRODUCTION: FOUR COLOR LINE AND HALFTONE, 133-LINE SCREEN

In ancient Greece the winners of chariot races at the Pythian Games were crowned with laurel wreaths, symbolic of prophecy and poetry. At the Olympic Games, victors received olive wreaths, emblematic of vitality and peace. The popularity of chariot racing is indicated by the fact that this equestrian sport was depicted more than any other contest on classical vases, reliefs and coins. Even the advent of the horseless carriage has not dimmed the popularity of horse racing, claimed to draw more people than any other spectator sport in the United States. Automobile races at the start of our century created public interest in the gas buggy. The young automotive industry's wheels started to roll with the aid of printed salesmanship. Graphic ideas, geared to fine printing papers, are still this industry's prime sales force. Printing puts your message on the expressway. Fine papers add power to its appeal.

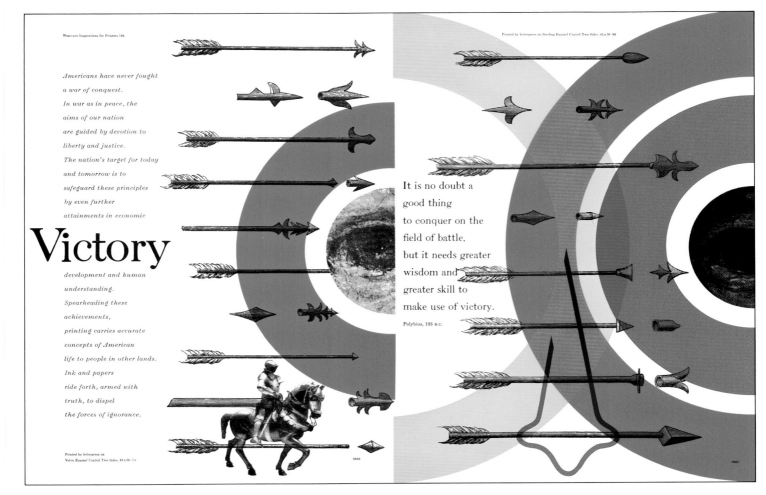

42　*Victory.* An illusive collage, with bright colors and with engravings from
　　Diderot's *Encyclopédie.* Two ghostly eyes as well as the nose of a Renaissance
　　warrior are within the bull's-eye targets under attack by arrows. 1953

43　*A Great Battlefield.* A surrealist conception of the overpowering confusion
　　of a civil war bombardment of cannonballs upon a foot soldier caught between
　　opposing armies. Engravings are from 1864 illustrated newspapers. 1961

3 The Monalphabet

is only one alphabet desirable?

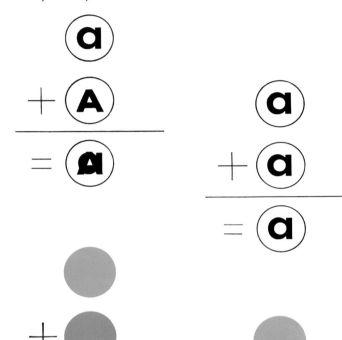

a = O

b = b

c = C

numerals

1 2 3 4 5 6 7 8 9 0

the numerals of the most widely used
sans-serif types are the
same height as the capital letters.
because of this they generally assume
too much prominence when several appear
together, as example the date 1945.
this spotty effect may be noted
throughout this issue and illustrates
the need for numerals that go
well with small or lower case
letters as shown in the diagram above.

traditional alphabet		alphabet using one graphic symbol per character		
	a A	a	a	in handwriting, lower case design now used for large letter
	b B	b	b	
Same design	c C	c	C	identical symbols already used for both letters
	d D	d	d	
	e E	e	e	
	f F	f	f	
	g G	g	g	in handwriting, lower case design now used for large letter
	h H	h	h	
	i I	i	i	large dotted i avoids confusion with lower case l
	j J	j	j	
	k K	k	k	essentially identical symbols already used
	l L	l	l	
	m M	m	m	in handwriting, lower case design now used for large letter
	n N	n	n	in handwriting, lower case design now used for large letter
Same design	o O	o	O	identical symbols already used for both letters
	p P	p	p	essentially identical symbols already used
	q Q	q	q	in handwriting, lower case design now used for large letter
	r R	r	r	
Same design	s S	s	S	identical symbols already used for both letters
	t T	t	t	
Same design	u U	u	U	identical symbols already used for both letters
Same design	v V	v	V	identical symbols already used for both letters
Same design	w W	w	W	identical symbols already used for both letters
Same design	x X	x	X	identical symbols already used for both letters
	y Y	y	Y	essentially identical symbols already used
Same design	z Z	z	Z	identical symbols already used for both letters

44 *Is Only One Alphabet Desirable?* A childlike visualization of the confusion
caused by having two symbols for letters in our alphabet. Also, an
example of how lowercase letters may be designed to function as capitals.

3

The Monalphabet

Toward a graphically
logical and consistent alphabet

In this country in the late thirties and early forties the Bauhaus school, especially in the person of Herbert Bayer, espoused the typographic theory that the lowercase alphabet should be used exclusively without the uppercase. Bayer's main concerns were for the practical economies of a good simplified alphabet.

Westvaco Inspirations 145 in 1944 followed this Bauhaus idea throughout its pages, using *Futura,* a fashionably appropriate typeface. It was apparent, however, that for traditional readability there still was the need for a method to indicate the beginning of sentences and to designate proper nouns. In terms of graphic logic, the 26 symbolic letters should be uniform in appearance, just as the symbol for the Red Cross is constant regardless of size. The reader should be reminded that the present alphabet has two different symbols for the majority of its 26 characters. For example, the large or uppercase letter A has little visual similarity to the small or lowercase letter 'a'.

Nine months later in 1945 in *Westvaco Inspirations 152* the author experimented with ways of combining readability and graphic logic in seven different spreads. These spreads are reprinted in miniature on the following pages along with their explanatory footnotes in larger type. The typeface is *Futura* as was the original setting of the experiments.

Experiment number 1 was set entirely in lowercase style. Number 2 was set all in uppercase style, which was less easy to read and even more remote from handwriting. Number 3 was set in traditional upper- and lowercase style, which gave clear identification to sentence beginnings and proper nouns but used the alphabet in which 19 of the 26 characters are represented by two different symbols.

Experiment number 4 was set entirely in lowercase letters with a typographic "bullet," which signaled the start of a sentence but did not provide for the designation of proper nouns. Number 5 was also set in lowercase letters but used underlining to identify the would-be capital letters.

Experiment number 6 was set completely in lowercase type but with bold letters in place of traditional capital letters. This idea had some merit, for it could be adapted immediately to any type font with a boldface companion alphabet. As a further test, experiment number 6 was used in *Inspirations 184* and also in the entire design of the *33rd Annual of Advertising Art* in 1954. *Bodoni Book* and *Bodoni Bold* were used; these typefaces showed the possible need of heavier, more contrasting bold letters. Today even bolder letters are generally available in many of the new phototype fonts.

Experiment number 7 continued the notion that lowercase symbols could be used for all 26 letters of the alphabet, only here the 19 dissimilar letters were enlarged to function as capitals. [See opposite page.] As practical, esthetically pleasing letters were not available at the time, the larger size of lowercase letters had to be employed where needed. This idea has still not been completely tested but remains as research, experiment, or play for an enterprising type designer. Certainly the new world of phototype provides an easier and much quicker means to this end than did the world of metal type.

Although many typographic critics today may view the Monalphabet experiment as a futile waste of time, it is an idea that remains to be tested and played with, just as the author did four decades ago and as he encourages his younger colleagues to do in chapter four, "Type as a Toy."

the monalphabet, experiment number 7

Uppercase

lowercase

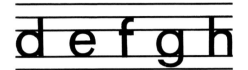

the monalphabet, experiment number 6

uppercase

abcdefghijklmnopqrs

lowercase

abcdefghijklmnopqrs

don't these layouts illustrate the possibility of simplifying our alphabet to only one graphic symbol for each character? is experiment number 1 successful, using only one size of letter? are bold or large accent letters replacing the capitals, an asset to reading? experiment 6 has merit because its application is immediately practical for typesetting. perhaps the ultimate solution will be based upon experiment 7, an alphabet having accent letters of the same weight and design as the small letters but larger. [from the original summary of 1945. this is reprinted in the style of experiment 6.]

4

• how desirable is it to employ an all lowercase letter design along with an accent device at the start of each sentence, as in this layout? • the bullet affords a satisfactory symbol for the beginning of a thought, but it does not provide for the designation of proper names such as bret harte or sapolio in the text. • the text, below, reads:" • relax in advertising now and then. • a drowsy kitten sold a railroad. • bret harte's tomfoolery sold sapolio. • fun opens channels to minds closed to fustian. • that's why this nonsense has intrigued you right down to here, period."

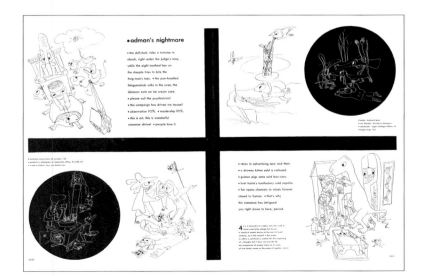

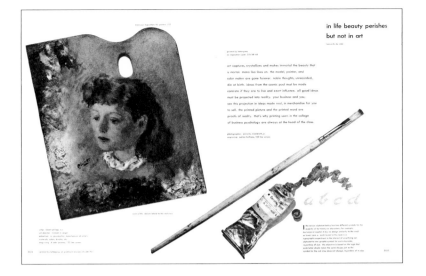

1

the roman alphabet has two different symbols for the majority of its 26 characters; for example, the large or capital A has no design similarity to the small or lowercase a. each layout in this issue is an experiment in the interest of simplifying our alphabet to one graphic symbol for each character. this objective is based upon the logic that each letter should retain its design, just as the symbol for the red cross does not change, regardless of size.

5

by means of underlining, as in this layout, it is possible to create accents at the beginning of sentences and to designate proper nouns. however, this results in a spotty appearance evident in the text copy below, which reads: "there is ethereal loveliness about me. i am charm, i am fragrance, grace. woman incarnate. i am ageless. all women know. men are never sure. they wonder am i paragon, paradox, or person? one man will know, one day! you'll buy perfume for a flesh and blood lady because a picture sets up a train of reflections in your head. the power of printing is truly infinite, isn't it?"

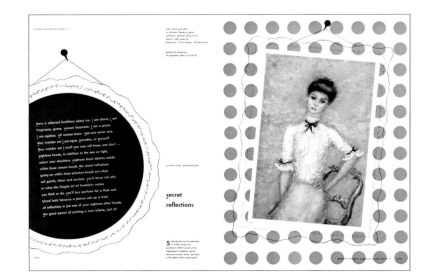

2

IN THE PRECEDING LAYOUT, LOWERCASE LETTERS HAVE BEEN USED WITHOUT TRADITIONAL CAPITALIZATION. BECAUSE OF THE GREATER VARIATION IN SIZE AND SHAPE OF LOWERCASE LETTERS, THEY ARE GENERALLY REGARDED AS MORE READABLE THAN COPY SET IN ALL CAPITAL LETTERS. ISN'T THERE AN EVENNESS HERE IN THIS LAYOUT THAT PRESENTS A PLEASANT APPEARANCE BUT THAT MAKES FOR SLOWER READING? ANOTHER CONSIDERATION IN FAVOR OF EMPLOYING THE LOWERCASE LETTER DESIGNS IS THEIR SIMILARITY TO HANDWRITING, FROM WHICH THEY WERE DERIVED.

3

It was because ancient capital letters were angular and lacked calligraphic qualities as handwriting that free-flowing small letters were devised by early manuscript writers. The capitals were retained for the sake of tradition and the need for accent letters. In observing the text of the above layout set in our traditional upper- and lowercase style, it is apparent that the capitals serve a dual function as signals at the start of sentences and as designations for proper nouns. However, the problem remains that 18 *Futura* characters are represented by two *different* graphic symbols.

6

it is possible both to use only one symbol for each letter in the alphabet and to retain the traditional function of capital letters by replacing the capitals with bolder lowercase letter designs. **w**hile the same criticism regarding a spotty appearance might apply to this layout, the bold letters do appear to create a more interesting page. [**v**ersion number 6 of the **m**onalphabet has an added advantage. **i**ts application is practical in today's world of photo typesetting.]

7

instead of using all traditional capitals we could use 26 large letters essentially identical with the small or lowercase letters. **e**ight of the present **f**utura characters are now identical in both upper- and lowercase (c-o-s-u-v-w-x-z) and several more are nearly so. **t**his strategy would be enhanced with newly designed rather than just enlarged lowercase letters, as was necessary in this experiment (note diagram opposite above). **a**lthough the **m**onalphabet is part of an idealistic movement in design and departs from tradition, by the same token it has much in common with the world of art and science.

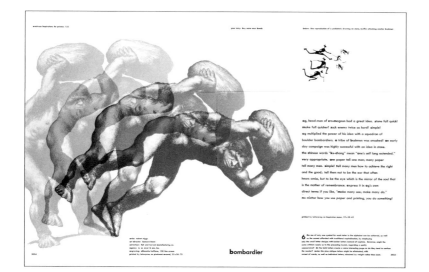

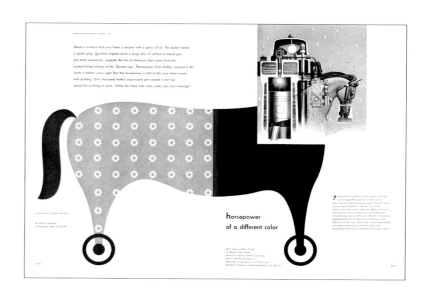

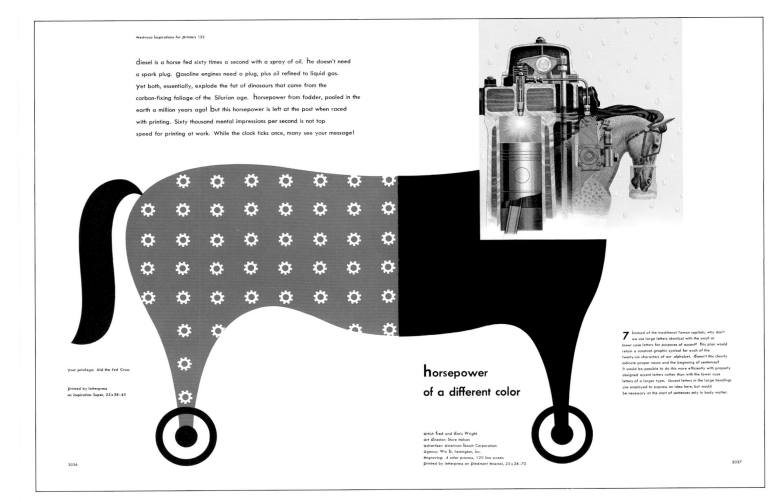

52 *Horsepower.* The typographer here employs lowercase letter designs of a
larger font in place of capitals for those 18 letters that are not identical in
both upper- and lowercase. New more compatible designs followed later.

53 *Cigars, Barber.* The Monalphabet experiment 6 with light *Bodoni Book* text
and *Bodoni Bold* lowercase letters serving as capitals was used in *Inspirations
184* in 1951, and used also throughout the *33rd Annual of Advertising Art.*

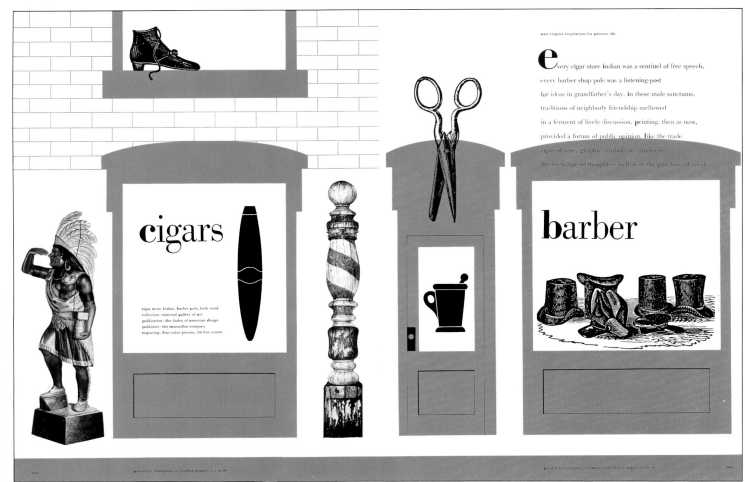

4 Type as a toy

54 *Westvaco Mask.* Without two symmetrical letters for eyes, the author had only to resort to the letter S for one, which fortunately produced a *winking* eye that also brought action to the printed page. 1958

Photograph: Somoroff.
Magazine: *Look.*
Publisher: Cowles Magazines, Inc.
Art Director: Allen Hurlburt.
Engraving: Four-color process, 120 line screen.

WINK

Quick as a wink, a typeface can express the creative mood and spirit of a photographic idea printed on fine paper.

WESTVACO

WESTVACO INSPIRATIONS 210

Printed by letterpress on Sterling Letterpress Enamel, 25 x 38 - 80.

4184

4

Type as a toy

Graphic design conceived in the spirit of play
and a sentiment for childhood

The designs throughout this chapter were conceived in a relaxed atmosphere without time limitations. They were also produced without specific editorial objectives other than to please and to serve an audience seeking new thoughts and techniques regarding the printed page.

A home environment with happy young children was a favorable one in which to record fresh and enjoyable typographic ideas. Here, there was a sense of freedom, a place to forget the columns and grid patterns of typographic tradition. This was an atmosphere in which to mix words and images playfully together, and to satisfy the goal of the publisher and the enjoyment of the designer as well.

The layouts in this chapter include the work produced between 1944 and 1961. Martin Spector, the editor of *Type Talks* magazine, commented in 1952 on this playful approach to graphic design in an illustrated article:

"Your *Type Talks* editors asked Bradbury Thompson where he got his inspiration for certain work, and received such an illuminating reply that we asked his permission to write of his experiences. The story, we believe, is one of the most intriguing and valuable articles ever offered to the readers of *Type Talks* magazine.

"The probabilities are that if you tripped and fell over one of your son's toys, you'd do some quiet little complaining and then forget the matter. Most people would. Perhaps that's because most people aren't Brad Thompson. When he did it, he tripped into an idea that inspired a magazine spread.

"Helping his son learn to read from a child's primer [page 74], drawing railroad tracks for him with two pencils held together by a rubber band [page 48], opening the door to his house when he came home at night – what to most people are just ordinary experiences in living, quickly forgotten – have produced endless inspirations for Mr. Thompson leading to some of the most refreshing work in design.

"Brad Thompson's own words probably describe the process best: 'A constant interest in work plus an interest in everyday things,' he said, 'can give the artist and designer endless numbers of fresh ideas.'

"Tripping over his son's toy horse sparked the idea for a two-page spread [page 40]. Here the toy horse on wheels combined with an internal combustion engine made graphic the idea of horsepower on wheels.

"One night as he was opening the door of his home, the idea of doors opening into rooms, each one of which revealed some aspect of life or living, occurred to him, and that became the unifying idea for another issue [page 118].

"Let's not get the impression that ideas came from only such homespun sources. The point is that they came from any and every possible source.

"In one instance, ordinary type and its possibilities for giving different impressions when combined with graphic images furnished the ideas. Developing this possibility for one issue, the spacing of lines of type on a two page spread, enabled him to give the impression of still water in a pond [fig. 57]. Illustrations of men in rowboats on top added to

Opposite. The idea for the speaking mask came from a six-year-old child who brought home from school the drawing of a large face with her first printed words in its large mouth, where words do emanate.

Ker r

Printed by letterpress on West Virginia Machine Coated, 25 x 38 - 70

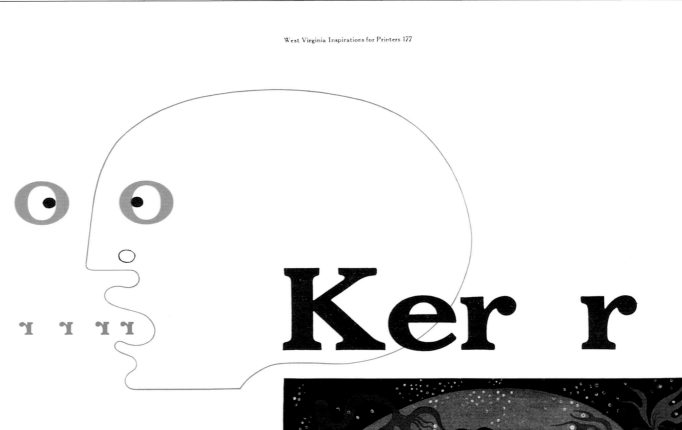

Even the murmur of a sigh or the
hush of a whisper can be
interpreted by the graphic arts.
Type and design on this page
suggest the tantalizing, flattened-
out moment of suspense
when a sneeze is about to happen.

*The explosion of a sneeze
comes to life on the printed page,
as the interfusion of word and image
produces a shattering human noise
on pages of mute white paper.*

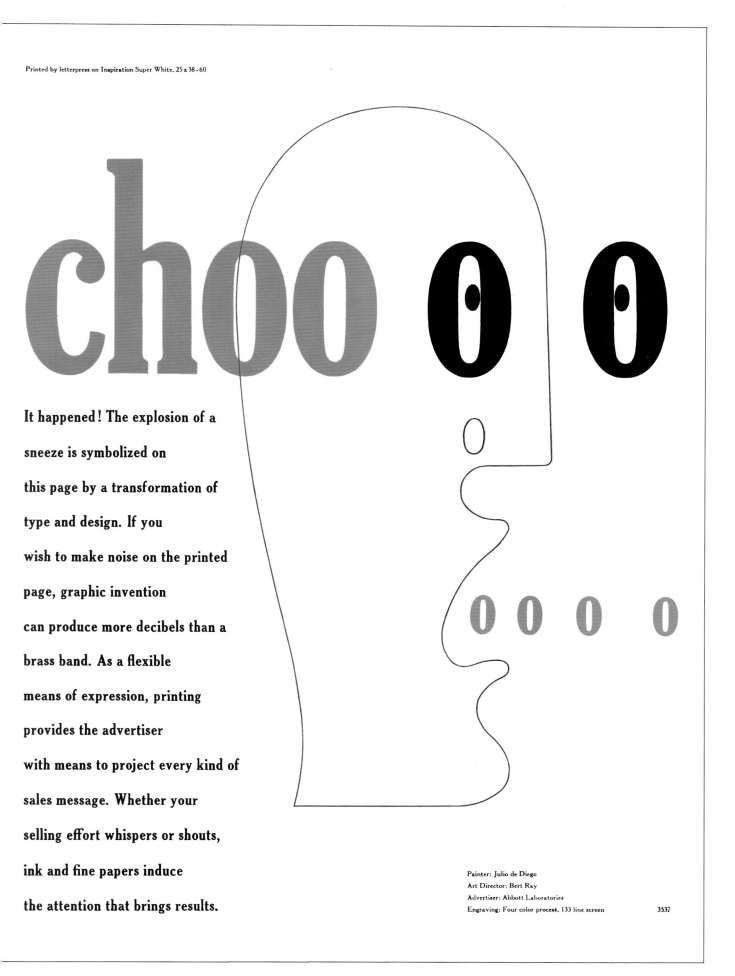

Printed by letterpress on Inspiration Super White, 25 x 38 - 60

45

choo o o

o o o o

It happened! The explosion of a sneeze is symbolized on this page by a transformation of type and design. If you wish to make noise on the printed page, graphic invention can produce more decibels than a brass band. As a flexible means of expression, printing provides the advertiser with means to project every kind of sales message. Whether your selling effort whispers or shouts, ink and fine papers induce the attention that brings results.

Painter: Julio de Diego
Art Director: Bert Ray
Advertiser: Abbott Laboratories
Engraving: Four color process, 133 line screen 3537

55 *Kerr-choo-oo.* The fortunate availability of an extended typeface in a small size, and a compatible condensed typeface in a larger size, combined with amusing visual art by Julio de Diego, provided a playful graphic design that mimicks the element of sound. 1949

Type as a toy, continued from page 43

the illusion of the pond's surface. Depth of the water was achieved by graduated spacing of type lines. Fish swimming beneath added to the impression of depth. The letter O spread around in various sizes gave the impression of air bubbles in the water, and a vertical line of type with a large capital letter J answered to the idea of a fishing line and hook.

"In that same issue, the idea of 'running your eye along a line of type' inspired another page in which greyhounds were running around the border of the page, and the type itself ran around the center of the spread, requiring the reader to turn the book round and round to read [fig. 58]. Here, too, the type was actually part of the illustrative material, as much so as the pictures of the hounds running. Almost anything he looks at is likely to give him graphic ideas with almost endless possibilities for development.

"After many years of working with artists and designers, we believe that inspiration is, psychologically, perhaps a form of habit. Almost every artist knows that at the beginning of his experience in art, he usually 'struggles to get his inspirations.' They don't come easily at the start. As he goes along, however, he becomes more sensitive in perceiving relationships between things that can be expressed in picture or other graphic form. He develops habits of sensitive perception, and the more he develops them the easier it becomes to see those relationships and the more inspirations he then gets. [Continued on page 56]

Space and Time:
The graphic designer as artist
does not need
an abundance of space
but does need
an abundance of time.
[Reflections upon daily work
in a bedroom studio]

56 *Recreation.* A family croquet set inspired this design, with text defining the route of the ball. The wickets are the letter U and the stakes the letter I. Winslow Homer's *Croquet Scene* provides a realistic visualization. 1955

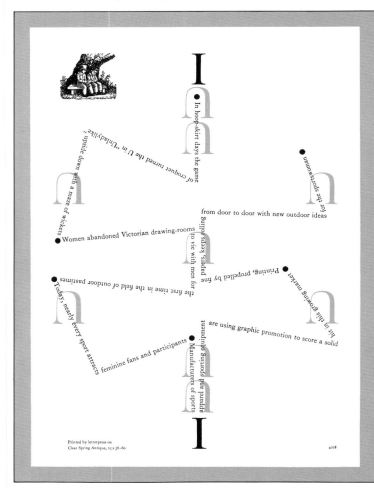

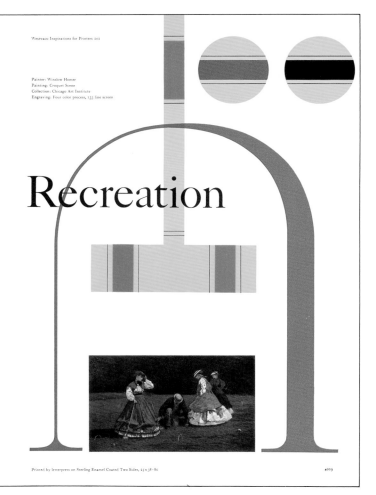

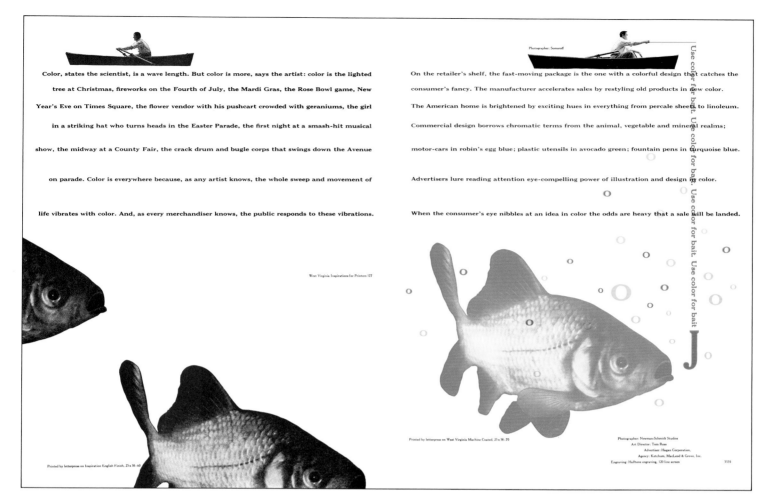

57 *Fishing in Typography.* A lake of type, a fishing line of type, and a large letter J
for a hook. The fisherman is the author photographed on Central Park Lake by
Ben Somoroff. The idea came from a similar scene drawn by a child. 1949

58 *Run Your Eyes.* It was the design below that again reminded the author that
typographic text does not always need to be in traditional lines and columns.
The greyhounds tell a reproduction story, in two, three, and four colors. 1949

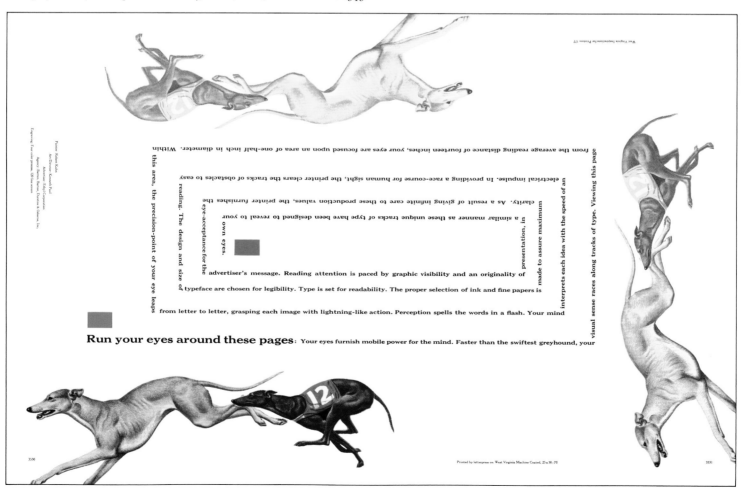

47

Printed by letterpress on Marva Satin Finish Super 25 x 38 · 50

Westvaco Inspirations for Printers 161

you realize printing for you is idea extension unlimited,

comes the call "We want"! Then

whatever you have to offer,

unham-

erable, non-

stop, express, double track! Out from you as

effect and back to you as effect!

far

wide

and

To wherever you are, for

Good printing is not merchandise.

It is just paper

and ink traveling to minds at the speed of light. It is the winged sandals

proclaims "This is for you". § And then comes the reward.

carries the message that

Deep into the mind it penetrates and, if it is good,

printing finds a haven.

there your

understanding,

of Mercury at your service. Wherever there's a person capable of

Good

travels

printing

Drawing: Winkler, Keller, Krause, Feldweg
Publication: Iconographic Encyclopedia
Engravings: line, from steel engravings

59 *Good Printing Travels Far and Wide.* A railroad track of type, with buildings and
bridges from an 1851 encyclopedia, as described on the opposite page. 1946

A childhood love of trains, an adult love of type

*The play experience did much
for the designer's ideas
and for the child's growing up.
A gratifying aspect of such play
was the number of times
the children became collaborators.*

In 1946 before the era of airplane travel, the railroad was a plaything of wide interest and a hobby for persons of all ages.

This railroad track design of type opposite was inspired by a father's play with a five-year-old son on a weekend morning in a New York apartment.

A half-dozen pieces of large layout paper were spread on the floor, and tracks for toy trains were delineated with two bold layout pencils held together with sturdy rubber bands. The route was arranged and rearranged, placing bridges and villages, and plotting turns until a railroad system emerged that was satisfactory to both father and son.

The following day at the drawing board the pattern of tracks was still in mind as the father began a design for a *Westvaco Inspirations* spread. The layout was similar to the one that the playmates had worked out on the living room floor the preceding day, but the track itself became the text, in lines of *Law Italic* type. Steel engravings were selected from the *Iconographic Encyclopedia of Science and Art*, and the *Alternate Gothic* type heading, "Good printing travels far and wide," completed the spread.

The *Westvaco Inspirations* spreads were often translations of a young daughter's or son's drawing. The play experience was as enriching for the designer as it was vital for the children, who often became collaborators in the process.

Every familiar thing around could be incorporated to express happy, vital new ideas: New York itself, memories of a past in the nation's heartland, and especially the family.

60 *Inspirations Via USA.* Below is the title page of *Westvaco Inspirations 171*, a development of the graphic design play described in the text of this chapter. 1948

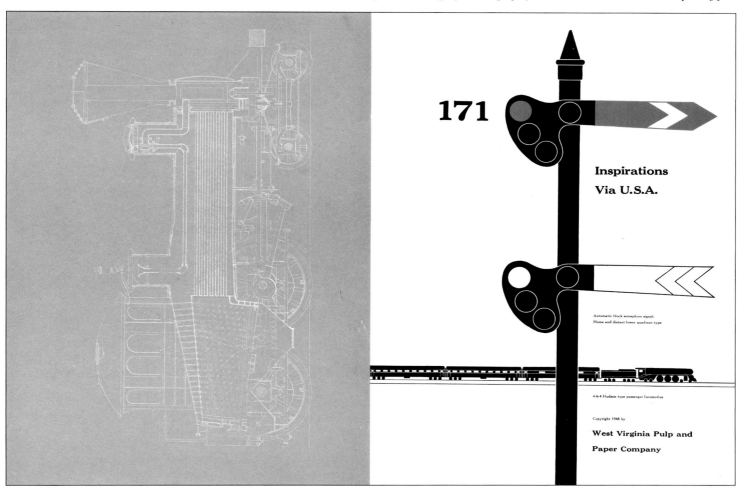

171

**Inspirations
Via U.S.A.**

Automatic block semaphore signal:
Home and distant lower quadrant type

4-6-4 Hudson type passenger locomotive

Copyright 1948 by

**West Virginia Pulp and

Paper Company**

West Virginia Inspirations for Printers 171

J.E.McConnell's coal burning boiler

J.Patrick's variable exhaust

Cheltenham

Printed by letterpress on West Virginia Machine Coated, 25x38-80

J.Patrick's variable exhaust

Automatic b

Engraved details of an 1861 locomotive,
a color drawing of a mid-twentieth-century diesel,
and mellowed typefaces
with an affinity for railroading
provide an example of modern graphic design.

W.S.G.Baker's variable rotary exhaust

Below, eight of the more than thirty members
of the Cheltenham type family:

ABCD Express

Cheltenham Bold

ABCD Express

Cheltenham Oldstyle

ABCD Express

Cheltenham Bold Extended

ABCD Express

Cheltenham Medium

ABCD Express

Cheltenham Bold Condensed

ABCD Express

Cheltenham Bold Outline

ABCD Express

Cheltenham Wide

ABCD Express

Cheltenham Bold Extra Condensed

2700 HP Diesel-electric freight locomotive

Type is a locomotive to carry your ideas over rails of paper.

Look upon your printer as the keeper of a roundhouse.

Send your copy to him with type designated, type that will

do all the needful pulling. Fix your own time-table,

designate the destination, and watch your printing go there.

60a *Cheltenham.* Shown above are eight of more than thirty members
of the *Cheltenham* type family, which was originally designed by
Bertram Goodhue in 1896. Both the text and heading on this page
are in the *Bold Extended* version; the small type is the *Oldstyle.* 1948

The art of graphic design plus the art of play

The designer imagined the fun of a cross-continental rail trip, constructing the route and roadbed, and selecting the various locomotives and cars, the signals, and switches.

Along with that was the fun of selecting the appropriate *Cheltenham* type, with its earthy affinity to railroading itself, and of setting the type in flush left and ragged right style to create a graphic unison with the horizontal direction of the wind and the earth.

In its day of metal typefaces, *Cheltenham* was a remarkable type family with more different members than any other. A few of these varieties can be seen on pages 50-51. *Cheltenham* was designed by Bertram Goodhue for Mergenthaler in 1896 and introduced in conjunction with American Type Founders Corporation.

There is no creative aspect of graphic design more enjoyable or rewarding than the indulgence in play. And there are scholarly sources from which to learn more about "the art of play." But one must first resolve to provide the time in which to have fun and to record the ideas that will come one's way.

There is no creative aspect
of graphic design
more enjoyable or rewarding
than the indulgence in play.
But one must first resolve
to provide the time in which to have fun
and to record the ideas
that will come his or her way.

63 *Steelburgh*. First stop on the railroad game. The picture is a painting by Adolph Dehn, commission by Gimbel Brothers-Philadelphia-Pittsburgh.

64 *Farmvale*. A delightful Pennsylvania Dutch country scene by Doris Lee, also painted for Gimbel Brothers-Philadelphia-Pittsburgh in the 1940s.

67 *Shantytown*. Sights of all kinds are on the express route. This painting by Alexander Brook was from the *Encyclopaedia Britannica* collection.

68 *Plainville*. Across the flat lands of the midwest. A painting by Thomas Hart Benton, from an advertisement by the National City Bank of New York.

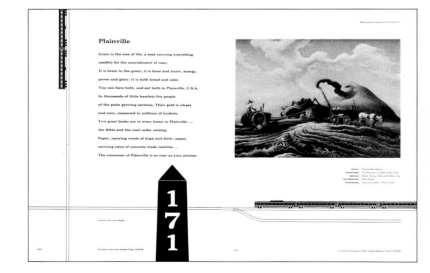

61 A railroad system conceived in the spirit of play. The painting by Ogden Pleissner was from the collection of International Business Machines.

62 *Inspirations Via USA.* For the railroad devotee, this locomotive is a 4-6-4 Hudson type and the semaphore a Home and Distant Lower Quadrant type.

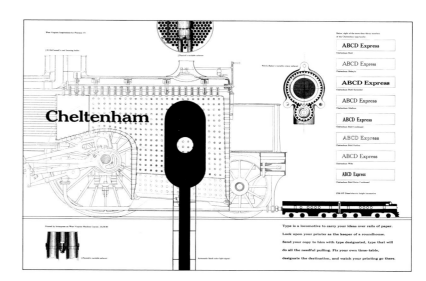

65 *Suburbana.* Passing a suburban commuter stop on the express. This scene by Aaron Bohrod was from the *Encyclopaedia Britannica* collection.

66 *Cheltenham.* For the railroader, this engine is a 2700 HP Diesel-Electric freight locomotive; the semaphore is an Automatic Block Color Light signal.

69 *Port City.* An imaginary rail system can extend from ocean to ocean. This painting by Joe Jones was from Gimbel Brothers-Philadelphia-Pittsburgh.

70 The end of the line for the imaginary railroad, built in the spirit of play on twenty pages of durable white paper by graphic designer and printer.

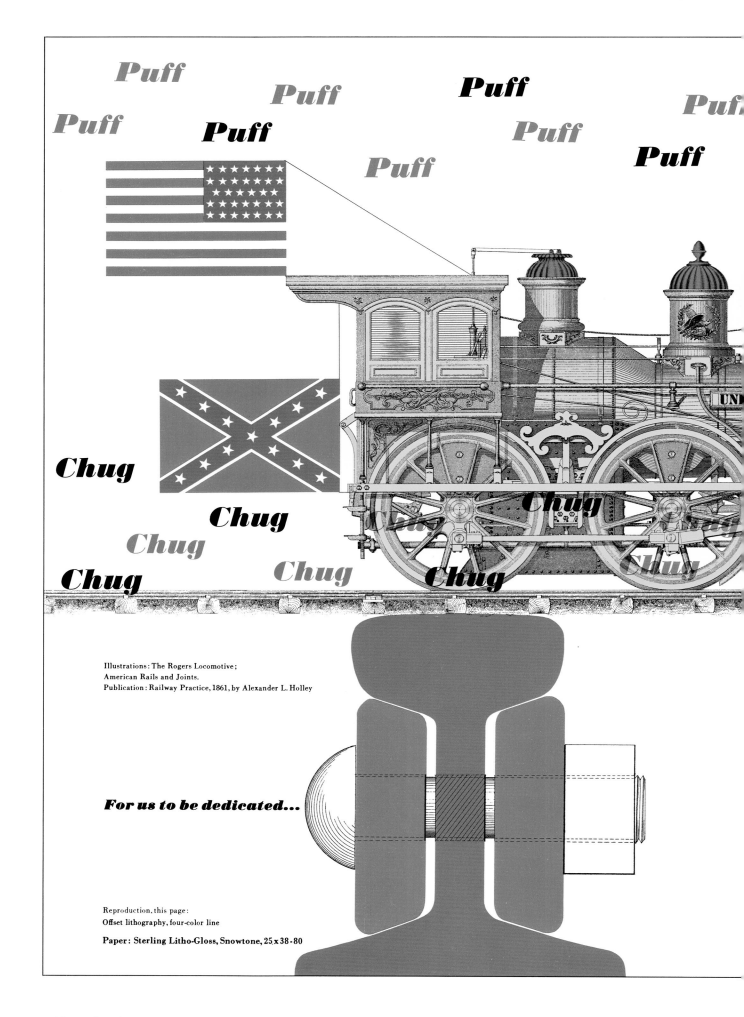

Puff Puff Puff Puff Puff Puff Puff Puff Puff

Chug Chug Chug Chug Chug Chug Chug

Illustrations: The Rogers Locomotive;
American Rails and Joints.
Publication: Railway Practice, 1861, by Alexander L. Holley

For us to be dedicated...

Reproduction, this page:
Offset lithography, four-color line

Paper: Sterling Litho-Gloss, Snowtone, 25 x 38 - 80

*With word and image working together,
graphic design can produce the illusion
on the printed page
of sound and smoke and even odor,
and perhaps a decibel of humor.*

Puff

Puff

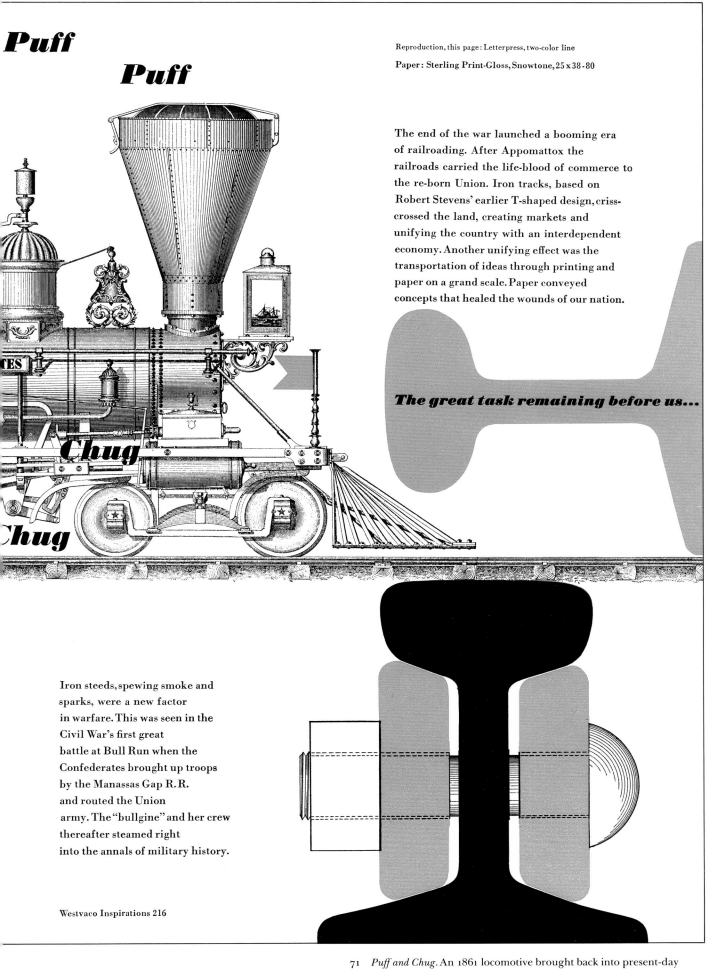

Chug

Chug

Reproduction, this page: Letterpress, two-color line

Paper: Sterling Print-Gloss, Snowtone, 25 x 38 - 80

The end of the war launched a booming era of railroading. After Appomattox the railroads carried the life-blood of commerce to the re-born Union. Iron tracks, based on Robert Stevens' earlier T-shaped design, criss-crossed the land, creating markets and unifying the country with an interdependent economy. Another unifying effect was the transportation of ideas through printing and paper on a grand scale. Paper conveyed concepts that healed the wounds of our nation.

The great task remaining before us...

Iron steeds, spewing smoke and sparks, were a new factor in warfare. This was seen in the Civil War's first great battle at Bull Run when the Confederates brought up troops by the Manassas Gap R.R. and routed the Union army. The "bullgine" and her crew thereafter steamed right into the annals of military history.

71 *Puff and Chug.* An 1861 locomotive brought back into present-day graphic interest simply by enlarging the shape of its rails into lively flat patriotic colors and arranging them in logical positions in relation to the train itself and the outer edges of the printed page. These were the rails and the bolts over which the engine chugged and puffed its routes in supporting strategic battles of the American Civil War. 1961

Type as a toy, continued from page 46

"Undoubtedly, artists differ widely in their sensitivity to experience, as proved by aptitude tests, or else their work and abilities would all be very much alike. Yet, at the root of all such inspirations is, we believe, a common denominator, and for lack of a better word it might be called habit – the habit of 'seeing' relationships.

"Anyone who has studied graphic design knows that there is a problem involved in giving free play to one's imagination that every person, of course, has to work out alone – the problem of making ideas practical and useful, and that is a matter of judgment. It is easy, perhaps, to let one's imagination run wild, and to come up with ideas that may not be useful for the purpose to be served. That might be healthy for an artist to do sometimes, but when art is to be used for graphic design, it must apply in some clear way to a practical purpose – if only to win attention.

"It also seems to us to be equally true that excessive caution in the use of graphic ideas cripples the artist's inspiration and may result in his being unimaginative and dull. The greater he develops his freedom in conceiving usable and effective ideas, the better he becomes as an artist.

"We're happy to come across such clear-cut examples of how inspirations come to the artist. The work of Bradbury Thompson seems to reveal clearly that it is life itself that really inspires!"

Here there was a sense of freedom;
a place to forget the columns and grid patterns
of rigid typographic tradition and practicality.
Here there was an atmosphere
in which to mix words and images
playfully together.

72 *Letters, Shapes, and Colors.* A graphic exercise brings together eight disparate letter designs (w-e-s-t-v-a-c-o) from the magazine's cover with basic graphic components to form an integral frontispiece, *Westvaco Inspirations 149* in 1944.

73 *Printing is Music.* Representing the theme of typography, the eight disparate
 letter forms opposite are interfused with the themes of music and printing.

74 *Type or Bolt.* The bolts and letters of this surrealist drawing are playfully sent
 by rail to their various destinations identified by the disparate letters. 1944

75 *United States.* When the strife-torn United States on the front cover of *Westvaco Inspirations 216*, right, were finally restored on the back cover, left, the land shape and its visible identification to the world were restored. 1961

76 *Move Over Michelangelo!* This painting by a child of six named Elsie inspired the other graphic components on this spread. The result illustrates the joyful possibilities of design as a toy. From *Westvaco Inspirations 149* in 1944.

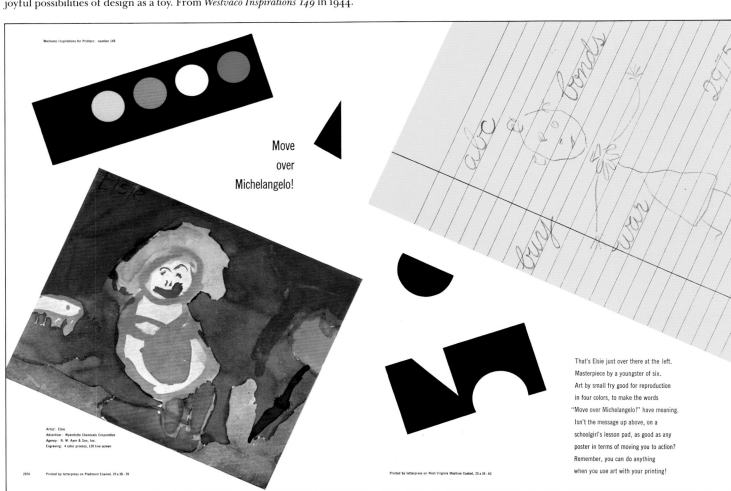

5 The painter's world

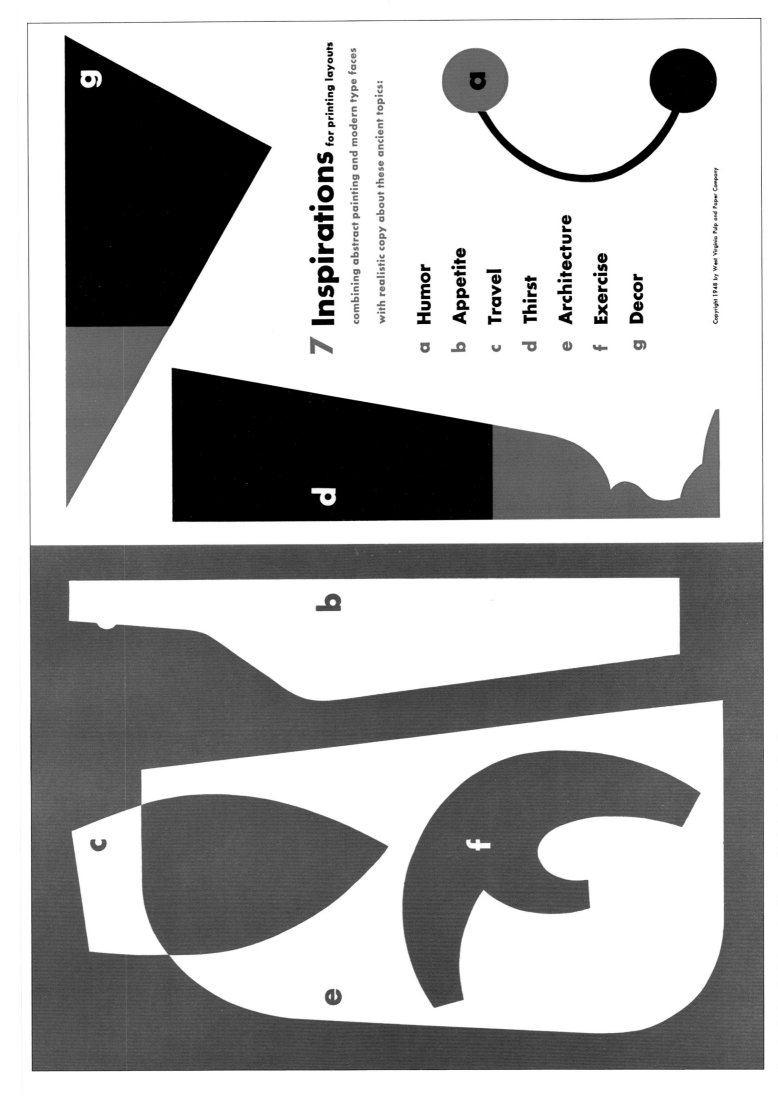

7 Inspirations for printing layouts

combining abstract painting and modern type faces

with realistic copy about these ancient topics:

a Humor
b Appetite
c Travel
d Thirst
e Architecture
f Exercise
g Decor

77 *Seven Inspirations.* Symbols translated into graphic design by the author, from paintings by Miró, Braque, Helion, Le Corbusier, Tunnard, Léger, and Gris. 1948

5

The painter's world

The graphic designer explores freedom
of form and expression in another visual art

Pictured throughout this chapter are visual records of the graphic designer's seeking new directions in typographic expression through exploration of the painter's work, an art which traditionally affords greater freedom of expression and less restraints of time than his own.

In *Westvaco Inspirations 172* [pages 60-68], the designer chose the works of seven influential modern painters and placed them on white layout paper for the purpose of translating the spirit of their painterly art into typographic format. He sought the essence of the whimsical surrealism of Joan Miró, the analytical cubism of Georges Braque, the inventions of Jean Helion, Le Corbusier, John Tunnard, Fernand Léger, and Juan Gris.

This painterly exploration was made with the intention of interfusing word and image as an art without sacrificing the graphic designer's visual concern both for readability and for printability.

In 1948 when *Inspirations 172* was published there was not yet a general appreciation for modern abstract painting. Because it seemed well to add an ingredient of familiarity into a context of pure art, the author used titles and text including more commonplace subject matter such as humor, appetite, travel, thirst, architecture, exercise, and decor.

The text for the Miró spread entitled *Humor* begins "Art and humor are bosom companions. Rollicking rondos of great music have counterparts in the dynamic synthesis of a Miró painting." The text for the Braque spread entitled *Appetite* reads "'He was an ingenious man that first found out

eating and drinking.' But even after an appetite is satisfied at the table, the human spirit still hungers for beauty."

Large lowercase letters of the alphabet ('a' through 'g') were employed in each of the compositions to remind the reader that these were graphic works to honor both the art of painting and the art of typographic design. Only one typeface was selected to accompany the seven paintings. It was *Futura*, itself a modern art work by German designer and typographer Paul Renner.

From each of the spreads featuring the work of the seven painters, the designer selected a symbolic graphic shape to integrate into a constructivist-like table of contents [page 60 opposite]. Similarly, he arranged together as a closing spread the seven large alphabetical letters that identified the seven painters individually and colorfully throughout [page 68].

This arrangement of lowercase letters prompted the idea for the complete issue of *Inspirations 192* five years later in 1953. It was based upon designs with large roman capital letters dominating the seven spreads in colorful geometric patterns. It appears in this volume in the chapter entitled *The Alphabet as Visual Art*.

The seven paintings reproduced in *Inspirations 172* were originally illustrated in the book *Painting Toward Architecture*, published in 1947 by The Miller Company of Meriden, Connecticut, from works of modern art with architectural relationships in its collection. The text was by Henry Russell Hitchcock and the design by Bradbury Thompson.

Opposite: This frontispiece design provided a visual table of contents for seven following spreads, with graphic images from the *designer's* works taken from or related to the *painters'* works. Seven letters play only a minor role.

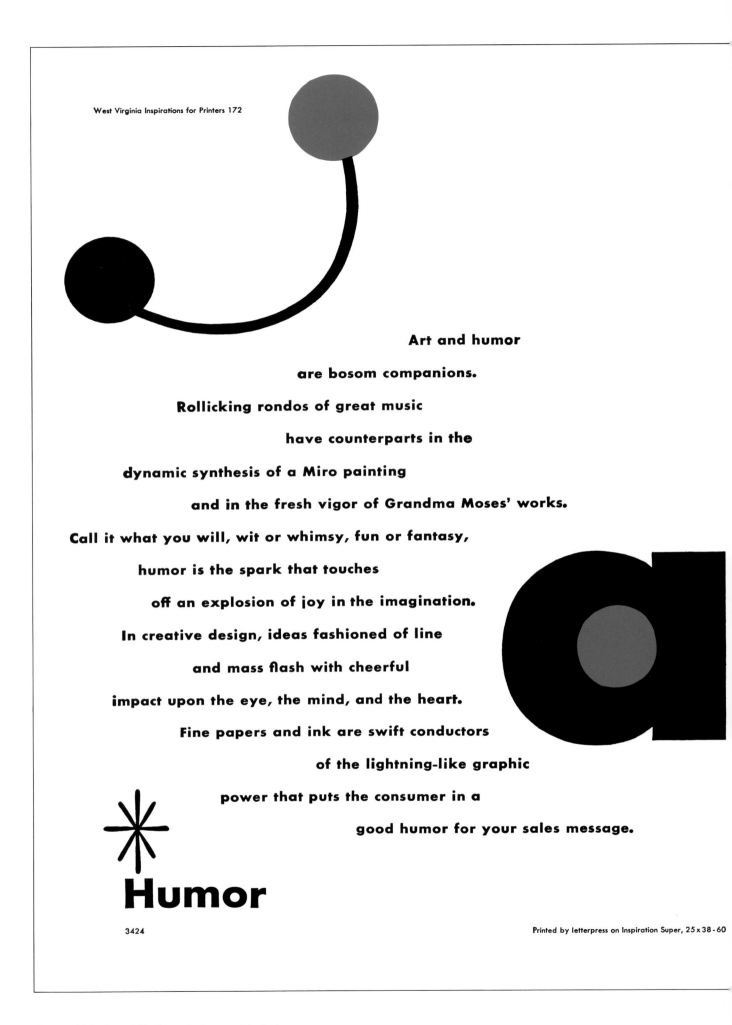

Art and humor

are bosom companions.

Rollicking rondos of great music

have counterparts in the

dynamic synthesis of a Miro painting

and in the fresh vigor of Grandma Moses' works.

Call it what you will, wit or whimsy, fun or fantasy,

humor is the spark that touches

off an explosion of joy in the imagination.

In creative design, ideas fashioned of line

and mass flash with cheerful

impact upon the eye, the mind, and the heart.

Fine papers and ink are swift conductors

of the lightning-like graphic

power that puts the consumer in a

good humor for your sales message.

Humor

3424

Printed by letterpress on Inspiration Super, 25 x 38 - 60

*From within Joan Miró's work the graphic designer
has selected symbols of the painter's happy, carefree art
and arranged them onto his own pages
with seemingly carefree lines of typography
to integrate them as graphic design.*

Printed by letterpress on Sterling Enamel, 25 x 38 - 80

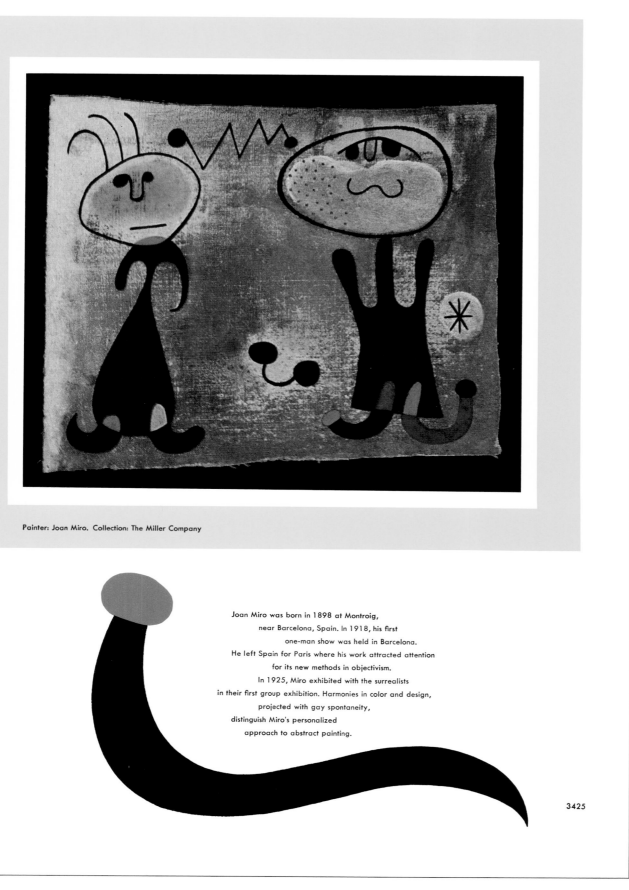

Painter: Joan Miro. Collection: The Miller Company

Joan Miro was born in 1898 at Montroig,
near Barcelona, Spain. In 1918, his first
one-man show was held in Barcelona.
He left Spain for Paris where his work attracted attention
for its new methods in objectivism.
In 1925, Miro exhibited with the surrealists
in their first group exhibition. Harmonies in color and design,
projected with gay spontaneity,
distinguish Miro's personalized
approach to abstract painting.

3425

78 *Humor.* The work of Joan Miró possesses an entrancing spirit. A calligraphy
 of decorative images and amusing faces provides universal symbols of his own
 which are captivating without being burdening as to meaning. This personal
 idiom came into being during his early association with the Surrealists.

Printed by letterpress on Sterling Enamel, 25 x 38 - 80

Appetite

Painter: Georges Braque. Collection: The Miller Company

3426

The famed modernist, Georges Braque, was born at Argenteuil, France in 1882. He spent his youth in Havre, and studied painting at the Academy Julian. In 1905, he joined the Fauves, the self-styled "wild animals," who revolted against academic tendencies as well as in defiance of neo-impressionism. Pioneering in the analytical phases of Cubism, he has faithfully explored this aspect of painting, especially in his abstract still lifes that display a mastery of simplification in color and in form. Braque served as Lieutenant during World War I.

*The images of painters such as Miró and Braque,
integrated with the typography of the graphic designer,
produced the pure design of abstract symbols on page 60,
which in turn inspired
the pure design of letters on page 68.*

Printed by letterpress on Inspiration Eggshell, 25 x 38 - 60

"He was an ingenious man that first found out eating and drinking," said old Jonathan Swift, whose wit was matched by a good appetite. But even after an appetite is satisfied at the table, the human spirit hungers for beauty. An artist, through creative expression, fulfills this need by providing the essence and the savor of life itself. Good taste in art never cloys. Valid design in advertising is always relished with delight. Depend upon fine printing to whet the public's appetite for a product.

West Virginia Inspirations for Printers 172

3427

79 *Appetite*. Georges Braque's cubist still-life painting with fruit and tableware suggested the pear- and bottle-like shapes to the designer, who integrated them with sympathetically shaped typography in a cubistic arrangement.

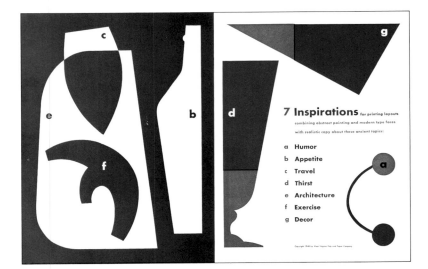

*The works
of seven influential modern painters
were placed on white layout paper
for the purpose of translating
the spirit of their painterly art
into typographic format.
As always,
part of the game was to keep readability
on a par with invention.*

80 The frontispiece design, repeated here in miniature, enables the viewer
 to relate its seven graphic shapes to spreads from which they were taken.

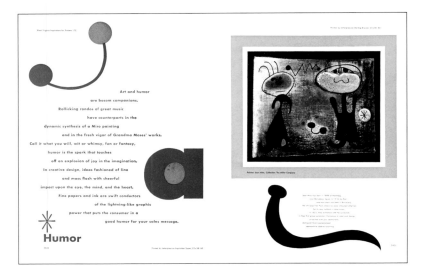

81 *Humor.* Joan Miró was born in 1898 in Montraig near Barcelona, Spain.
 Color and design projected with spontaneity distinguish his painting.

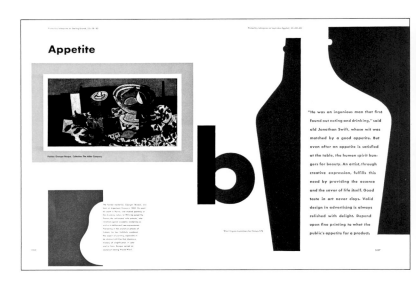

82 *Appetite.* Georges Braque was born in France in 1882. Pioneering in ana-
 lytical phases of Cubism, he faithfully explored this aspect of painting.

85 *Architecture.* John Tunnard was born in 1900 in England. His paintings
 suggest mechanical objects in an interplay of abstract transparent planes.

86 *Exercise.* Fernand Léger was born in France in 1881. A draftsman in the
 early part of his career, he painted stimulating images of the machine age.

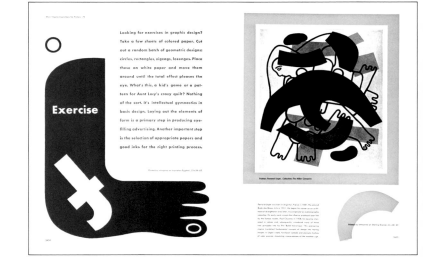

On this one spread the reader may view the complete eighteen interior pages of an issue of *Westvaco Inspirations* in miniature. For this exploration of the painter's work, the author found special enjoyment in seeking typographic arrangements that were in the spirit of the paintings. There was also satisfaction in bringing pure graphic shapes from within the paintings to the areas outside them, and in relating formations of type that had integrity with both. As always, part of the game was to keep readability on a par with the graphic invention.

The response to Miró's work [fig. 81] was natural and easy; it incorporated fluid, seemingly carefree lines of text with the repetition of several playful symbols from his painting. Braque's work too [fig. 82] was inviting, and his pleasantly distorted cubism, repeated in simplified shapes of flat color and type, was effective. Jean Helion's work [fig. 83] was also intriguing and suggested boatlike shapes with text

and caption type to fuse with components in the painting.

Le Corbusier's painting [fig. 84] was placed in the center-fold of the publication, which made it possible to use one of his cubistic bottles as part of the gutter itself. A type-constructed martini glass with transparent glasslike lines of type and a black olive within the blue fluid became an integral part of the whole page design. Borrowing one of John Tunnard's shapes [fig. 85] in white on black afforded a highly visible area in which to place the text for the spread that is entitled *Architecture*.

One of the arms from within Léger's painting [fig. 86] is repeated outside his work to give a coordinated graphic impact to the whole spread; the text type is appropriately arranged in a geometrical Léger manner as a simple, strong rectangle. The Juan Gris still-life painting [fig. 87] lent its angular, checkered background to a tabletop-like page design, blending into a candle appropriate for the still life.

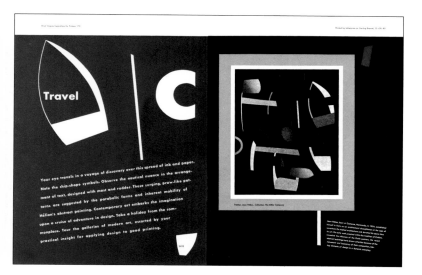

83 *Travel.* Jean Helion was born in Normandy in 1904. His early painting was in the tradition of cubism. Later work was buoyant and dynamic.

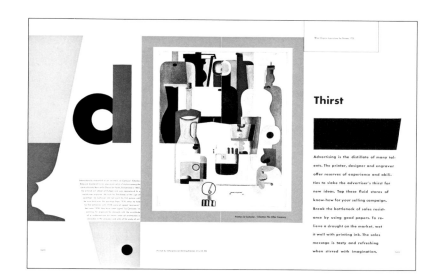

84 *Thirst.* Le Corbusier was born in 1887 in Chaux-de-Fonds, Switzerland. Renowned as architect, his paintings reveal a sense of unity and precision.

87 *Decor.* Juan Gris was born in Madrid in 1887. With Picasso and Braque he founded cubism. Perspective did not matter when harmony prevailed.

88 *Alphabet as Image.* This final design, with seven letters of the alphabet, follows the concept of the frontispiece, which uses seven graphic shapes.

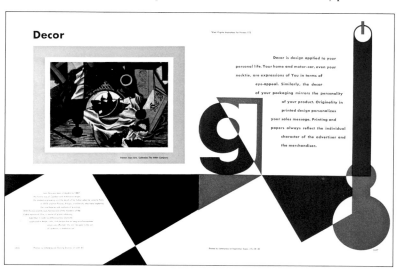

West Virginia
Mill Brand Papers

Clear Spring Higloss Litho
Clear Spring Offset
Clear Spring Plate
Clear Spring Super Plate
Clear Spring Text Laid
Clear Spring Text Wove
Convent Tablet
Inspiration Bond
Inspiration Eggshell
Inspiration English Finish
Inspiration Envelope
Inspiration Index Bristol
Inspiration M. F. Poster
Inspiration Map Bond
Inspiration Offset
Inspiration Super
Inspiration Tablet
Marva Satin Finish
Marva Satin Finish Super
Marva Super Rotogravure
Penink Mimeograph Wove
Sterling Enamel
Vac-Cup-Bac Poster
West Virginia Bond
West Virginia Drawing
West Virginia English Finish Music
West Virginia English Finish Rotogravure
West Virginia English Finish School Book
West Virginia Extra Strong End Paper
West Virginia Hibulk
West Virginia M. F. Antique Laid
West Virginia M. F. Antique Wove
West Virginia M. F. Gumming
West Virginia M. F. Lining
West Virginia M. F. Litho
West Virginia Machine Finish
West Virginia Playing Card
West Virginia Post Card
West Virginia Super Litho
West Virginia Super Rotogravure
West Virginia Super School Book
West Virginia White Writing
West Virginia Machine Coated
West Virginia Bleached Cup and Container Stock
West Virginia White Converting
West Virginia File Folder
West Virginia Ivory Tag

Asphalting Kraft
Bag Kraft
Converting Kraft
Envelope Kraft
Gumming Kraft
Impregnating Kraft
Multi-Wall Sack Kraft
Waxing Kraft
Wet Strength Kraft
Counter Board
Insulating Board
Cylinder and Fourdrinier Container Board

Design and typography of this issue: Bradbury Thompson

Paintings

The seven paintings reproduced in this issue are from
the collection of the Miller Company of
Meriden, Conn., manufacturers of industrial and
commercial lighting equipment. They appear
in the book just published, "Painting Toward Architecture,"
that includes text by Henry-Russell Hitchcock.

The collection of painting and sculpture was made
by Mrs. Burton G. Tremaine, Jr., art director
of the Miller Company and the wife of the president.

West Virginia Papers

Inspiration Eggshell, 25 x 38 - 60. 3427, 3428, 3433, 3434
Inspiration Offset, 25 x 38 - 120: Cover .
Inspiration Super, 25 x 38 - 60: 3423, 3424, 3437, 3438
Sterling Enamel, 25 x 38 - 80: 3425, 3426, 3429
3430, 3431, 3432, 3435, 3436

Engravings

Four color process 133 line screen:
3425, 3426, 3429, 3430, 3432, 3435, 3436
Line engraving in linocut
Offset lithography in full color: Cover

Typefaces: Futura, Spartan, Twentieth Century

Artists

Georges Braque: 3426
Juan Gris: 3436
Jean Hélion: 3429
Le Corbusier: 3430
Fernand Léger: 3435
Joan Miro: 3425
Grandma Moses: Cover
John Tunnard: 3432
Marvin Warshaw: Layout assistant

Cover artist

Grandma Moses (Anna Mary Robertson Moses) was
born in Washington County, New York,
September 7, 1860. A primitive artist, she began
painting about ten years ago the
pictures which have since been bought by museums
and important private collections.

She was discovered by an art collector who saw her
paintings displayed in a drug store
window near her home in Hoosick Falls, New York.
Her first one-man exhibition was
held in November 1940 at the St. Etienne Gallery.

West Virginia Pulp and Paper Company

89 *Alphabet as Image.* Seven asymmetrical lowercase letters from seven preceding
spreads form an integrated asymmetrical design in this 1948 *Inspirations.*

*Designs with letters,
such as at left in 1948
and on pages 94-101 in 1953,
perhaps provided some of the appreciation
of the alphabet
as expressed by painters
on their canvases
in the late 1950s and 1960s.*

This cover by Joan Miró for *Westvaco Inspirations 200* was painted especially for the publication in 1955. Its commissioning took place from the author's studio at *Mademoiselle* magazine located at the corner of 57th Street and Madison Avenue in New York, directly across from the gallery of Pierre Matisse, who was Miró's representative. The author contacted Mr. Matisse, just as he had done several months earlier in commissioning a painting by Miró [page 174] to illustrate some fiction in *Mademoiselle*. On these occasions Mr. Matisse met with the artist soon after in Paris and discussed briefly the essential details of the assignments.

The two spreads reproduced on the following page are from *Inspirations 164*, published in 1947. The motive for doing both issues 164 and 172 was similar, except that in the earlier issue a different typeface was selected for each painter's work to encourage an even closer aesthetic relationship with it. The two painters' works selected for page 70 are Stuart Davis and Vincent Van Gogh. The text copy for issue 164 was written by Aline Loucheim Saarinen, then the managing editor of *Art News*. Her comments on the artists are quite readable even in their reduced size. A paragraph about the choice of each typeface and its configuration was provided by the designer. Incidentally, the two circular typographic devices in the Van Gogh title, which blend with the painter's swirling clouds, predated by some twenty years the fad of substituting round non-letter objects for the letter 'o' in trademarks and such.

90 *Joan Miró's Westvaco 200.* This cover painting including its title was created especially for *Westvaco Inspirations 200* in 1955 for a retrospective issue to celebrate the anniversary of the magazine which was first issued in 1925.

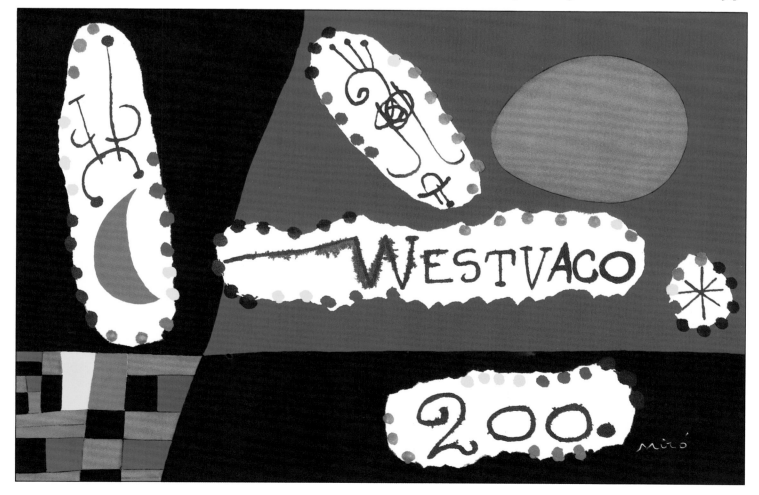

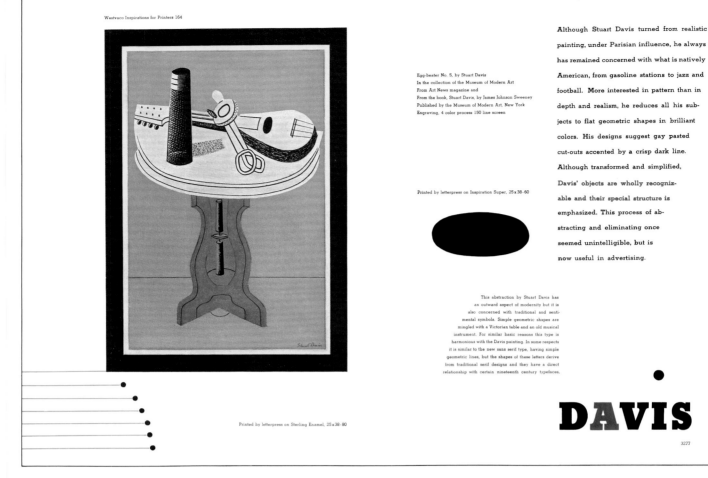

91 *Stuart Davis.* This bright, modern abstraction of simplified Victorian objects inspired typography in similar flat images and type less modern than Victorian.

92 *Starry Night.* This vital, restless painting prompted the author to use with it an italic 19th century typeface, set ragged, and with rotating typographic devices.

6 Alphabet 26

West Virginia Inspirations for Printers

6

Alphabet 26

Experiments provide a readable and practical
simplified alphabet, 1950

The plan for simplifying and improving our alphabet, entitled *Alphabet 26*, was first presented in *Westvaco Inspirations 180* in 1950. It recommended the use of only one symbol, upper- and lowercase, for each of the 26 letters. Our conventional alphabet contains 19 letters having dissimilar symbols (such as A and 'a') and 7 letters (c-o-s-v-wx-z) having symbols that are identical.

The plan pointed out how misleading it is for a letter, or for any graphic symbol, to have two different designs [page 74]. It illustrated the confusion that might set in when school children are taught to recognize words even before they have learned to recognize different symbols for the same letter [page 74]. To remedy this, *Alphabet 26,* a plan based upon the logic of consistency, made this recommendation for the 19 letters that have dissimilar symbols: 15 letters should use the uppercase designs (black letters opposite) and 4 letters should use the lowercase designs (red letters). The other 7 letters already have identical symbols (blue letters).

Only 6 lowercase letters (a-e-m-n-r-u) could be used in typesetting because all others have ascenders or descenders that would protrude above or below the type body if enlarged for uppercase usage. The uppercase R design was preferred because enlargement of the lowercase 'r' would make an awkward fit next to lowercase letters. The uppercase U and the lowercase 'u' are almost identical, the former design having been selected for its simplicity.

The lowercase letter symbols a-e-m-n have key characteristics that will contribute to the *Alphabet 26* plan. They do not have the severely angular appearance of the A-E-M-N and the majority of the other uppercase letters. Because of this and their relatively frequent use in the language, they contribute variety and individuality to the shapes of words.

Alphabet 26 provides the necessary large letters for emphasis at the beginning of the sentence and for denoting proper nouns, an advantage over the exclusive use of an all lowercase alphabet, as recommended at the Bauhaus.

The original showing of *Alphabet 26* in 1950 [pages 72-79] by necessity employed a combination of capitals, small capitals, and lowercase letters [see specifications, opposite below]. Because the lowercase a-e-m-n were not yet redesigned to fit so harmoniously in the same words with capitals, small capitals, and lowercase letters, a degree of aesthetic harmony was lacking in the original version. However, for *Inspirations 213* in 1960 [page 81] and *Inspirations 217* in 1962 [page 82] the large a-e-m-n letters were redesigned to fit with the uppercase fonts, and the small a-e-m-n letters were redesigned to fit with the small-cap fonts.

These first special characters for *Alphabet 26* in text sizes were cast by Lanston Monotype Machine Company and were at one time available in all text sizes of *Baskerville* type. The first special characters for larger sizes were produced by Photo-Lettering, Inc. Both were manufactured from drawings by the author.

Although only *Baskerville* letters were employed for text setting in these pages, the *Alphabet 26* plan is applicable to all type families. The choice of *Baskerville* to introduce *Alphabet 26*

93 *Alphabet 26,* opposite. This was the title page of *Westvaco Inspirations 180.*
It illustrates the plan as well as the way in which to specify it with two sizes
of type. The composing stick recalls the old world of metal type. 1950

aLPHaBeT 26

THROUGHOUT THIS ISSUE, ONLY ONE SYMBOL FOR EACH OF THE 26 CHARACTERS OF THE ALPHABET IS USED. ORDINARILY, 19 OF THESE CHARACTERS ARE REPRESENTED BY TWO SYMBOLS QUITE UNLIKE IN APPEARANCE. THE OTHER SEVEN CHARACTERS ARE ESSENTIALLY IDENTICAL IN BOTH UPPER- AND LOWER-CASE DESIGN. THIS EXPERIMENT IS BASED ON THE LOGIC, REPRESENTED BY THESE SEVEN LETTERS AND BY THE ILLUSTRATION AT RIGHT, THAT A SYMBOL OR TRADE-MARK OF ANY KIND, TO BE EFFICIENT, SHOULD BE CONSTANT.

IN OBSERVING THE EARLIEST READING EFFORTS OF CHILDREN TODAY WHO ARE TAUGHT TO RECOGNIZE WORDS EVEN BEFORE MEMORIZING INDIVIDUAL LETTERS OF THE ALPHABET, ONE MAY SEE A FALLACY IN SINGLE CHARACTERS HAVING TWO DESIGNS. [SEE BELOW.]

A PREVIOUS EXPERIMENT IN ISSUE 152 ENTITLED THE "MONALPHABET" SUGGESTED THE EXCLUSIVE USE OF THE LOWER-CASE DESIGN FOR ALL CHARACTERS. TO PROVIDE LARGE LETTERS PERFORMING THE FUNCTION OF CAPITALS, THAT PLAN REQUIRES THE REDESIGN OF TRADITIONAL LETTERS WITH ASCENDERS OR DESCENDERS TO ENABLE THEM TO FIT ON THE CUSTOMARY TYPE BODY. WITH "ALPHABET 26," AS THIS PRESENT EXPERIMENT IS CALLED, THE PROBLEM IS AVOIDED BY ELIMINATING DESIGNS HAVING ASCENDERS OR DESCENDERS. THE ALPHABET AT LOWER RIGHT EMPLOYS SOME UPPER-CASE AND SOME LOWER-CASE VERSIONS.

OF IMPORTANT CONSIDERATION ARE THE LETTERS "a, e, m AND n." THE LOWER-CASE DESIGNS ARE SELECTED BECAUSE THEY DO NOT

CONTINUED ON FOLLOWING PAGE

DESIGN AND TYPOGRAPHY OF THIS ISSUE: BRADBURY THOMPSON

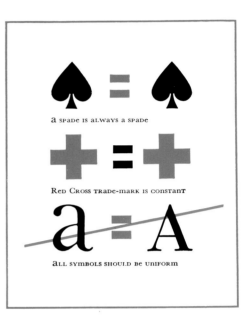

a SPADE IS ALWAYS A SPADE

RED CROSS TRADE-MARK IS CONSTANT

ALL SYMBOLS SHOULD BE UNIFORM

Run Pal.
See him run.
Go Pal.
See him go.

FROM THE ABOVE PAGE OF A FIRST READER, A CHILD LEARNS TO RECOGNIZE THE WORDS "Run" AND "Go" ONLY TO BE CONFUSED IN THE LINES BELOW BECAUSE THE SAME WORDS ARE DIFFERENT IN APPEARANCE, AS UPPER- AND LOWER-CASE "Rs" AND "Gs" ARE UNLIKE.

aBCDe
FGHIJK
LmnOP
QRSTU
VWXYZ

● UPPER-CASE DESIGN IS USED FOR THESE CHARACTERS
● LOWER-CASE DESIGN IS USED FOR THESE FOUR CHARACTERS
● ONLY ONE DESIGN EXISTS FOR THESE SEVEN CHARACTERS

*Alphabet 26 recommended
the use of only one symbol
for each of the 26 letters of the alphabet.
Our present alphabet contains 19 letters
that have two symbols each.*

in *Inspirations 180* was based upon tactical, historical, and practical reasons. To appeal to as broad a segment of readers as possible, it seemed prudent to present this radical change in our time-honored alphabet with a traditional typeface rather than an extreme one, such as *Futura*, or even a modern one such as *Bodoni*. An old style typeface such as *Garamond* would likewise be inappropriate.

Baskerville, a transitional typeface from our own contemporary point of view, seemed to be the right choice, especially when accompanied by the mid-eighteenth century engravings of the Diderot *Encyclopédie*, which date from the same period. It seemed appropriate, too, to honor John Baskerville himself, whose type design was considered innovative in his time. A purely practical reason for the choice was the fact that *Baskerville* type possessed a lowercase main body and a small-cap body that aligned with each other, a strongpoint not found in *Bodoni* and some other faces.

Since 1950 there has been scholarly evaluation of *Alphabet 26*, for example in *The Shaping of Our Alphabet* by Frank Denman (Alfred A. Knopf, 1957). Perhaps the most comprehensive article about *Alphabet 26* was published in *Type Talks* magazine (September-October, 1958). It was written by editor Martin Spector. Entitled *Bradbury Thompson's Simplified Alphabet*, excerpts from it are reprinted here:

"In our March-April 1958 issue, *Type Talks* was privileged to republish an article entitled 'How Old-Fashioned Is Our Alphabet?' by Frank Denman. In that piece, Mr. Denman wrote, 'Is it not time that the alphabet—the one major tool of civilization that has remained unaltered for a thousand years—be reforged into a more modern instrument?' The question was rhetorical, but actually designers, typographers, and phonetic scholars have been at work for years on the construction of a more streamlined alphabet. Many of these experiments, however, were too unfamiliar and unwieldy for public acceptance, or in the case of some of the proposed phonetic alphabets, too complicated in their design.

"One man who has been attacking the problem of a simplified alphabet is art director and typographer Bradbury Thompson. Mr. Thompson begins with the premise that there are actually two alphabets in English—an uppercase alphabet and a lowercase alphabet. There are only 26 letters in the language, yet there are 45 symbols for these letters. According to Mr. Thompson, this is an illogical and unnecessary state of affairs. But we are getting ahead of his story. Here's how— and why—Bradbury Thompson arrived at this unique design for *Alphabet 26*.

"Brad Thompson's experiments in designing a better alphabet began about fifteen years ago. The impetus for *Alphabet 26* was provided in 1949 as he watched his young son labor over his first reader. As he watched, he made a discovery. His son was able to read the first sentence, "Run Pal," but stumbled over the second sentence "See him run" [page 74]. Obviously the boy was confused because the symbol R in the first sentence became a totally different symbol 'r' for the same sound in the second sentence. Results: Learning to read is that much more difficult. The act of reading is that much slower.

"It was Mr. Thompson's idea to combine the best upper- and lowercase letters into one simplified, unified alphabet using only 26 symbols. If this proposal were to be accepted, it would [continued on page 79]

Opposite. This is a concise summary of *Westvaco Inspirations 180* published in 1950, the year in which the suggestion for *Alphabet 26* was first presented. It plainly illustrates the logic behind the proposal to employ consistent graphic symbols for each of the 26 letters of the alphabet. The page from a child's First Reader shows the possibility for confusion when letters are represented by two different symbols.

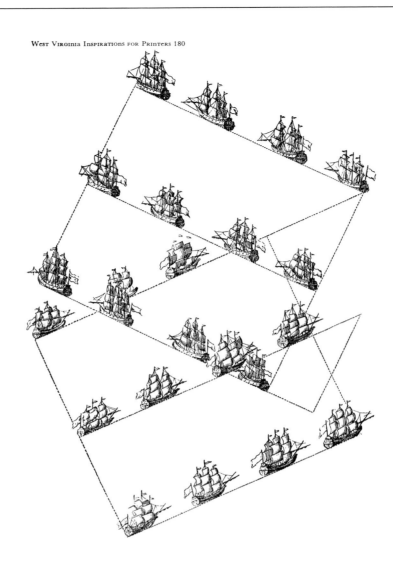

THE ART OF
Seamanship

SUPERIOR seamanship enables a naval force to out-maneuver its

foe during battle. Superior salesmanship gives every

business organization a position of advantage over competition.

When the consumer market is a target, printing will find

the accurate range for firing a salvo of sales messages.

It's smart tactics to use fine paper in every graphic operation.

Printed by Letterpress on Marva Satin Finish, 25 x 38 - 60

The Alphabet 26 plan is based
on a simple precept:
A graphic symbol, or any trademark,
should be constant,
and so too should letters of the alphabet.

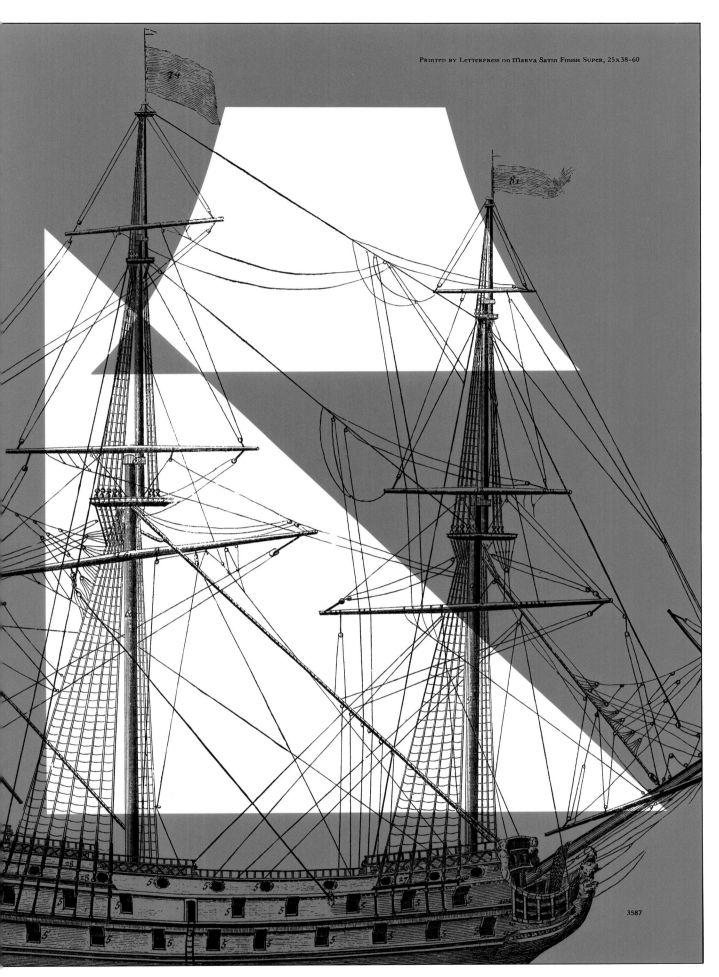

Printed by Letterpress on Marva Satin Finish Super, 25x38-60

94 *The Art of Seamanship.* The engravings throughout *Inspirations 180* are from
 the *Encyclopédie* of French philosopher Denis Diderot (1713-84), and the
 typeface is that of his English contemporary John Baskerville (1706-75).
 Although the mixture of *Baskerville* letters is somewhat unfamiliar, *Alphabet
 26* is aesthetically and historically compatible with the period engravings.

The Art of
Painting

Two men in 17th Century Holland added depth to the range of human vision. Leeuwenhoek, with his microscope, discovered the papillae of the inner skin. Rembrandt, with his brush and palette, disclosed man's inner self. An enlarged segment of the "Man with a Magnifying Glass" is evidence of Rembrandt's genius in laying bare the anatomy of the soul. The art of printing, like great painting, probes beyond the superficial and reveals the eternal values of truth and beauty.

Artist: Rembrandt van Ryn
Title: Man with a Magnifying Glass, detail, 1662-5
Museum: The Metropolitan Museum, New York
Publication: Ninth Graphic Arts Production Yearbook
Engraving, above and left: Four Color Process, 133 line screen
Engraving, right: Line Engraving, enlargements from four color process plates

Printed by Letterpress on Sterling Gravure, 25 x 38-80

95 *The Art of Painting.* The spread above uses a detail of a Rembrandt painting from the *9th Graphic Arts Production Yearbook*, which employed it in various ways and sizes on its cover, title page, frontispiece pages, and preface. 1950

96 *The Art of Music.* Graphic design brings together engravings of musical subjects from Diderot's *Encyclopédie* with the contemporary typeface of John Baskerville and a mid-17th century painting by Bartolommeo Bettera.

Printed by Letterpress on Sterling Gravure, 25 x 38-80

Artist: Bartolommeo Bettera
Title: Still Life with Musical Instruments, ca. 1650
Museum: California Palace of the Legion of Honor, San Francisco
Engraving: Duo Tone
Engraving: Four Color Process, 133 line screen

West Virginia Inspiration for Printers 180

The Art of
Music

Bettera's still life was painted in the 17th Century when a new melodic world was being explored through the development of the sonata form played by instruments. In those years, Amati and Stradivari, the Italian violin craftsmen, made stringed instruments that are worth a king's ransom today. A composer's ideas are expressed by the musician's talent and the instrument maker's skill. Similarly, a fine work of art is interpreted to the public by the craftsmanship of printer and papermaker. The artist and the craftsman, in every age, are real partners in the enrichment of life.

Printed by Letterpress on Maava Satin Finish, 25 x 38-60

Alphabet 26, continued from page 75

Type producers can make practical
the use of Alphabet 26
simply by altering the four letters a-e-m-n
to align properly with capital and small-cap fonts
of any existing alphabet.
Italic fonts can be made easily
by photographically producing an oblique alphabet
from a vertical one.

be the first step toward clarifying an alphabet that was designed by the Romans to express the sounds of Latin and became the staff of the English language.

"Bradbury Thompson's experiments were based on a simple precept. A graphic symbol, or for that matter any trademark worth its salt, to be efficient, should be constant [page 74]. Yet the present alphabet flagrantly violates that basic precept.

"No completely radical idea arrives full-bloom in the mind of the designer. A series of trials and errors must of necessity precede the solution. So it was with Thompson's *Alphabet 26*.

"It was through experiments such as those he conducted with *The Monalphabet* that Thompson finally arrived at the design he has named *Alphabet 26*. This is the way Bradbury Thompson describes his new alphabet:

'*Alphabet 26* is a basic plan to be used with all type families available. Under existing conditions it can be specified by designating caps and small caps, except for the exclusive use of the lowercase a-e-m-n. These four characters must, for the present, utilize type of a larger size than the other letters when they function as capitals.

'At first viewing, as with any new lettering or type design, there is a degree of unfamiliarity. However, all individual letters here have been in use through 500 years of printing. Is it not conceivable that, through common usage, *Alphabet 26* would be easier to read as well as simpler to teach and to set?'

"Mr. Thompson's previous experiments were concluded with an alphabet using exclusively the lowercase design for all characters. However, to provide large letters performing the function of capitals would require the redesign of traditional letters with ascenders or descenders to enable them to fit [continued on page 84]

97 *The Art of Horsemanship.* A painting of a horseshoe by William Harnett, entitled *Colossal Luck*, is brought together with an equestrian exercise diagram, a horse's halter, and horseflies to create a graphic design. 1950

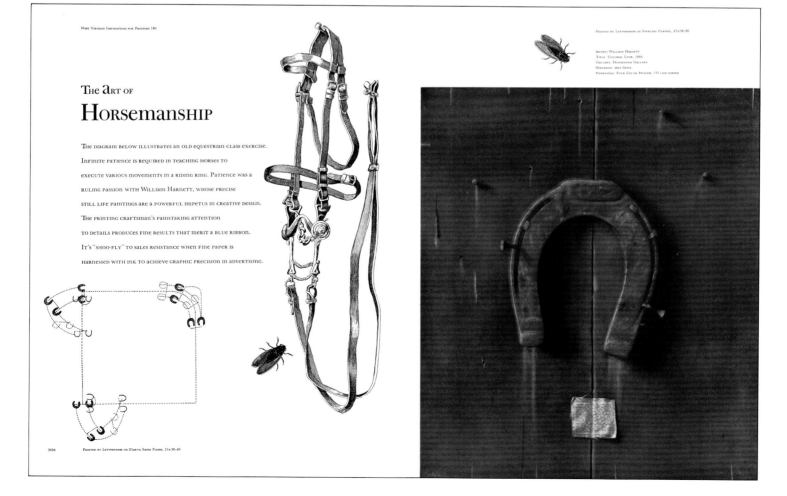

a e

B D F G H

C

I

O

J

S

K

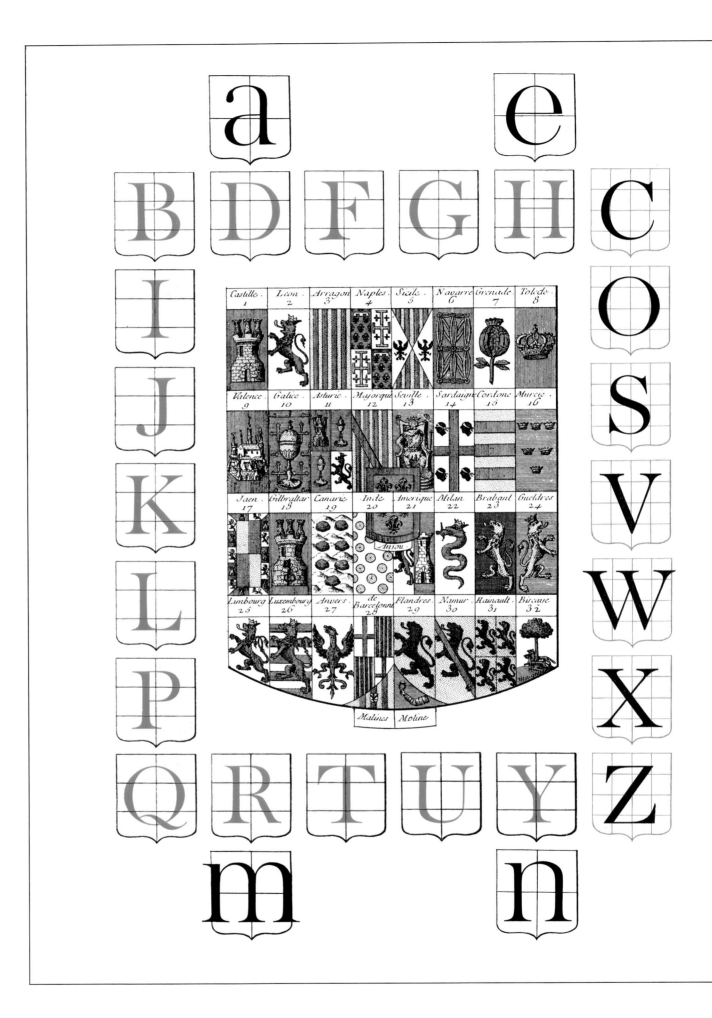

L

V

P

W

X

Q R T U Y Z

m n

At first viewing,
as with any new lettering or type design,
there is a degree of unfamiliarity.
After all, the same letter forms have been in use
throughout 500 years of printing history.

The Langlée paper plant near Montargis, France.
The main building was 450 feet in length.

1

An irresistible phalanx of ideas advanced
through the eighteenth century—
spearheaded by printing and papers.
The civilized world turned to
France and England in this Age of
Reason. France led in the manufacture
of printing papers while Great Britain
increased its paper output in 1722 to
three hundred thousand reams. A proud
French showplace was the famous
Langlée papermill, sixty miles south
of Paris, near Montargis. Depicted
above, this chateau-like mill is being
admired by sight-seers on a boat
which plied a canal system linking
the historical Seine and Loire rivers.

The Art and Science of

Papermaking

In the Eighteenth Century

One of the water wheels in the Langlée plant
which provided power to run the machinery.

2

98 *Papermaking.* You may compare the *Alphabet 26* letters above and opposite
from *Westvaco Inspirations 213* with those of the preceding pages. You will see
that key *Baskerville* letters have been redesigned in an effort to create a better
aesthetic relationship among all letters of the alphabet. Notably, the letters
'a' and 'e' have been redesigned so the middle horizontal lines throughout
align with the letters b-f-h-p-r in both the large and the small fonts. 1960

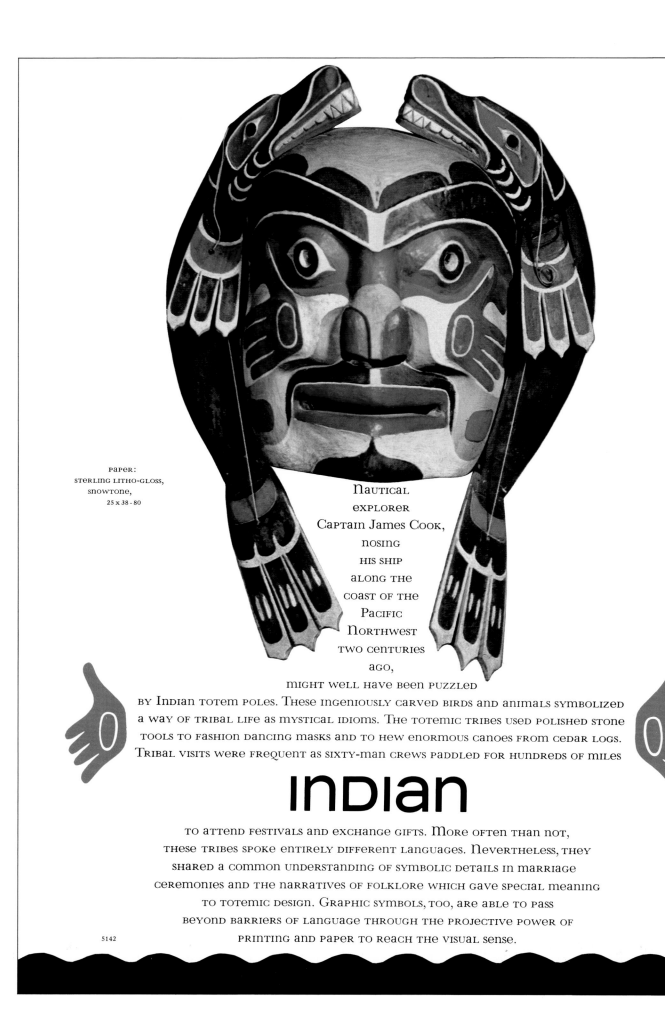

PAPER:
STERLING LITHO-GLOSS,
snowtone,
25 x 38 - 80

Nautical
explorer
Captain James Cook,
nosing
his ship
along the
coast of the
Pacific
Northwest
two centuries
ago,
might well have been puzzled
by Indian totem poles. These ingeniously carved birds and animals symbolized
a way of tribal life as mystical idioms. The totemic tribes used polished stone
tools to fashion dancing masks and to hew enormous canoes from cedar logs.
Tribal visits were frequent as sixty-man crews paddled for hundreds of miles

Indian

to attend festivals and exchange gifts. More often than not,
these tribes spoke entirely different languages. Nevertheless, they
shared a common understanding of symbolic details in marriage
ceremonies and the narratives of folklore which gave special meaning
to totemic design. Graphic symbols, too, are able to pass
beyond barriers of language through the projective power of
printing and paper to reach the visual sense.

5142

The Alphabet 26 plan
would combine the appropriate uppercase letters
and the appropriate lowercase letters
into one simplified, unified alphabet,
using 26 instead of the usual 45 symbols.

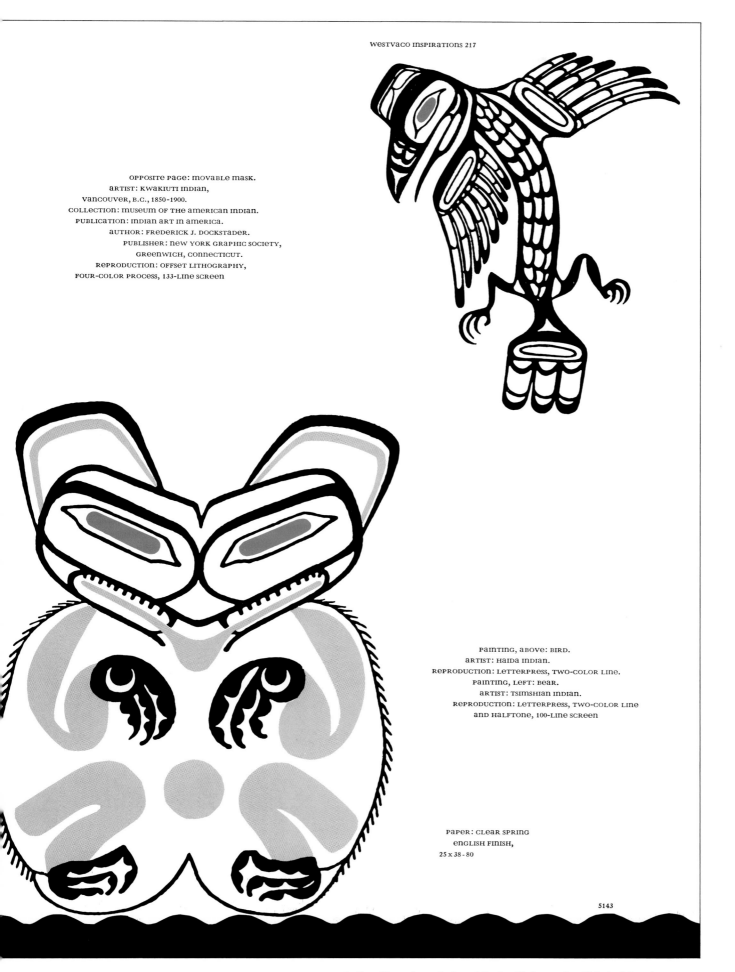

OPPOSITE PAGE: MOVABLE MASK.
ARTIST: KWAKIUTI INDIAN,
VANCOUVER, B.C., 1850-1900.
COLLECTION: MUSEUM OF THE AMERICAN INDIAN.
PUBLICATION: INDIAN ART IN AMERICA.
AUTHOR: FREDERICK J. DOCKSTADER.
PUBLISHER: NEW YORK GRAPHIC SOCIETY,
GREENWICH, CONNECTICUT.
REPRODUCTION: OFFSET LITHOGRAPHY,
FOUR-COLOR PROCESS, 133-LINE SCREEN

PAINTING, ABOVE: BIRD.
ARTIST: HAIDA INDIAN.
REPRODUCTION: LETTERPRESS, TWO-COLOR LINE.
PAINTING, LEFT: BEAR.
ARTIST: TSIMSHIAN INDIAN.
REPRODUCTION: LETTERPRESS, TWO-COLOR LINE
AND HALFTONE, 100-LINE SCREEN

PAPER: CLEAR SPRING
ENGLISH FINISH,
25 x 38 - 80

5143

99 *Indian.* Here, the redesigned *Baskerville* letters for *Alphabet 26* as shown on
the preceding pages were used again in *Westvaco Inspirations 217.* Also newly
designed sans serif *Alphabet 26* letters were used for headings. [Although
issue 217 was the most recently published, it is of a rare edition because it
is the only issue not preserved in the bound volumes from 1925 to 1961.]

Alphabet 26, continued from page 79

on the customary type body. With *Alphabet 26* the problem is avoided by deleting designs having ascenders or descenders.

"Type founders can make entirely practical the use of *Alphabet 26* through this comparatively simple adjustment: produce matrixes for the 4 lowercase letter designs a-e-m-n to align properly with the small cap and capital fonts."

Postscript: Including *Alphabet 26* in this volume provides the pleasant opportunity to reproduce some favorite graphic designs, honoring the arts of seamanship, painting, music, horsemanship, and papermaking [figs. 94-98].

Also it is sentimentally pleasant to recall that *Alphabet 26* provided an impetus in the fifties and sixties for lettering artists to enliven the typographic scene with the design of *biform* alphabets. These were unusual combinations of capital and lowercase letters within a single word or font, valued more for their visual interest and attention-getting qualities than for contributing to a simplified alphabet. More constructively, *Alphabet 26* provided designers with an immediate means to produce many useful trademarks.

Implicit in the republication of *Alphabet 26* is the hope that it might prompt typeface manufacturers to produce it for general use and trial. An equally important hope is that it might suggest a solution for another simplified alphabet in the future. Such a challenge could do no less than provide an enjoyable project for some young designer, as it did for the author thirty-eight years ago in *Westvaco Inspirations 180*.

100 *Symbols.* The essence of *Alphabet 26* is that in order to be efficient a graphic symbol (or any trademark) must be consistent. Our own alphabet with 26 letters contains 45 different symbols. Below is the frontispiece from *Westvaco Inspirations 217*. Incidentally, the round symbol of a dragon is a detail of a painting by Raphael through a die-cut hole from the following spread. 1962

The Art and Science of

Papermaking

An irresistible phalanx of ideas advanced through the eighteenth century—spearheaded by printing and papers. The civilized world turned to France and England in this age of Reason. France led in the manufacture of printing papers while Great Britain increased its paper output in 1722 to three hundred thousand reams. A proud French showplace was the famous Langlée papermill, sixty miles south of Paris, near Montargis. Depicted above, this chateau-like mill is being admired by sight-seers on a boat which plied a canal system linking the historical Seine and Loire rivers.

This paragraph from a 1960 setting of *Alphabet 26* in metal type provides an example for objective and constructive viewing. In words where the letters 'i' and 'n' appear together (in) there is a spacing problem sometimes causing the two letters to appear as the letter 'm'. This is eliminated in present-day computer typesetting where spacing between each pair of letters of the alphabet is optimized by the manufacturer.

7 Primitive art as graphic design

Prehistoric
Rock Artists

Rock paintings from the Libyan Desert

182

Copyright 1950 by West Virginia Pulp and Paper Company

Inspirations from

The Primitives

Primitive art is linked

through the centuries by the

urge of the untrained artist

to express life in contour

and color. Instinctively,

the Primitives find a direct

path to simple fundamentals

in design. This applies

to the cave man artist

2o,ooo years ago down to

Grandma Moses in our time.

7

Primitive art as graphic design

Inspirations for today from folk art,
prehistoric to contemporary

Introduction by Douglass Scott

Inspiration for graphic design can come from anywhere: listening to music, or sitting under an apple tree, walking through a building, or looking at painting or sculpture. The examples shown in this chapter honor primitive and folk art and their influence in the history of art and everyday life. Throughout the design of *Westvaco Inspirations*, Bradbury Thompson demonstrated the very qualities of simplicity, vitality, honesty, and craftsmanship which are inherent in primitive and folk art.

He recognized that these artists emphasized the overall decorative effect of a work of art while placing little importance on Renaissance one-point perspective. To achieve a similar feeling of pattern and surface decoration on the following spreads, he crossed lines of type in a title and ran type and images from the bottom to the top of the page.

In the exploration of primitive and folk art Thompson made each two-page spread cohere as a single visual field. The gutter was neither ignored nor over-emphasized. He used it as an active dividing element when necessary, and at other times extended type and images from the left page to the right as if it weren't there. This was a complex task, for *Inspirations* was printed and bound in such a way that, except for the center spread, a four-color page faced a one- or two-color page. To overcome this problem he linked facing pages by means of repeated elements and alignment. The shape of the text next to the pottery, the row of triangular decoration and its relation to the top of the adjacent illustration, and the Pennsylvania Dutch flower and church steeple below it [all on page 90] are clear examples of the connection of type and image and of how the shape and alignment can visually knit together elements on a spread.

Thompson also adopted from these artists use of bold and unmodulated color, a strong profile or object outline, and the spatial relationship of two or more profiles in a spread. The repetition of images on a page led him to explore the kinetic and narrative possibilities of graphic art as discussed in chapter two, "Graphics in Motion." A good example of this exploration is to be seen in this chapter [fig.106].

Critical to the success of *Westvaco Inspirations* was the choice of a typeface appropriate to the subject matter. Thompson's selection of *Futura* with its simple, geometric, and non-esoteric qualities complemented the adjacent examples of primitive art [pages 86, 88, and 90]. Similarly, in *Inspirations 184* [page 89] he chose to set all the type in lowercase in order to simplify the alphabet, which made it more sympathetic to the untutored nature of folk art.

The appeal and significance of primitive art for modern artists is of course apparent in the influence of African masks on Picasso or folk melodies on the music of Bartók. In the hands of Bradbury Thompson, the primitive arts teach us how people have interpreted the world, as well as how to understand the infinite possibilities of page design. His merging of content and form in witty, coherent, appropriate, and exciting ways is truly an inspiration for today's artist.

101 Opposite: *Inspirations from Prehistory.* The large prehistoric rock engraving of a cow as well as the smaller rock paintings of a fight between animal-headed bowmen are from the Libyan Desert. Modern printing revived them in 1950.

Douglass Scott teaches graphic design at Rhode Island School of Design and Yale University. He is a senior designer with WGBH public radio and television in Boston and he is a frequent lecturer on graphic design.

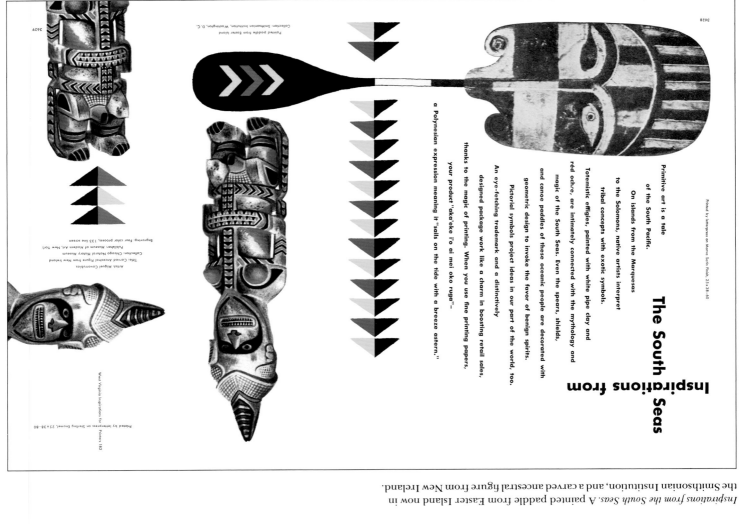

103 *Inspirations from the South Seas.* A painted paddle from Easter Island now in the Smithsonian Institution, and a carved ancestral figure from New Ireland.

102 *Inspirations from American Indians.* A Haida design from the northwest, representing a killer whale and in primitive manner both sides of the body, 1950

105 *Carousel.* This horse, also from *The Index of American Design,* is printed in four process colors and separately in blue, black, and red inks to suggest motion.

104 *All Aboard.* The nineteenth century toy locomotive was manufactured from tin and cast iron. It is reproduced from a work in *The Index of American Design.*

Artist: Robert Riggs
Art Director: Edith Jaffy
Advertiser: Wyandotte Chemicals Corporation
Agency: N. W. Ayer and Son, Inc.
Engraving: 4 color process, 120 line screen

Printed by letterpress on
Piedmont Enamel, 25 x 38 - 70

Inspirations from the primitives

Design: From an American Indian painting on buffalo hide

Printed by letterpress on
West Virginia Machine Coated 25 x 38 - 70

Art, according to some great artists, must forever imitate nature. Hence the children of nature, closest to her, are closer to nature's art. These men and horses are action incarnate, yet so simple in form. The buffalo roam in attitudes alive. There is a noble solemnity in this Indian chief that even a bank president might envy. The calumet or pipe of peace is a symbol just as familiar as the surrender signed on the dreadnaught Missouri in Tokyo bay! Peace is come to the world! Paper, printing, and consumer goods return to peacetime uses. The world hungers for art in all things, in all selling, and all things sold. Many pools of inspiration are ready. The first pool here is the primitive, and primitive means first. The first to quicken senses and desires when reproduced with printing!

3104

106 *Inspirations from Plains Indians.* The colorful figures of buffalo and warriors on horseback are from elk-hide paintings from the nation's central plains.

107 *Inspirations from Folk Art.* These decorations are from a nineteenth century Pennsylvania Dutch plate. The floral design is printed in colors overlapping.

Artist: Paul Y. Smith
Art Director: Jan Balet
Advertiser: Olin Industries, Inc.
Agency: D'Arcy Advertising Company
Engraving: 4-color process, 120 line screen

Inspirations from folklore

Design: From an eighteenth century
Pennsylvania Dutch plate

America's unschooled pioneer artists took what they pleased of design forms from high and low, from real life and the imaginary, and did what they wished with them. Theirs is a truly original art, inspiring in its freshness and honesty. He who dips into this pool, dips into America, and all America reacts to it with favor and with fervor. Print some of it with your product's story.

Printed by letterpress on
West Virginia Machine Coated 25 x 38 - 70

3117

8 The alphabet as visual art

AMERICA STANDS FOR A CONCEPT OF LIFE, SHAPED
BY A PEOPLE WHO HAVE BUILT A NATION
DEDICATED TO ENDURING PRINCIPLES. THESE PAGES
SUGGEST ASPECTS OF NATIONAL LIFE IN
PRIMER FORM. SPELLED OUT, EACH LETTER IN THE
WORD 'AMERICA' INTRODUCES A SALIENT
FEATURE OF OUR LAND IN TERMS OF GRAPHIC DESIGN.

WEST VIRGINIA INSPIRATIONS FOR PRINTERS | 92

AMERICA
AMERICA
AMERICA
AMERICA
AMERICA
AMERICA

8

The alphabet as visual art

Roman letters serve as
the graphic element on the printed page

It was quite natural to conceive a complete issue of *Westvaco Inspirations* with the alphabet assuming the leading design role, especially a sans serif type whose roman capital letters are so purely geometric and sympathetic to modernism.

At least part of the impetus to use the alphabet as a graphic component grew out of an earlier experience on *Inspirations 172*, in which a spread was designed with seven large lowercase *Futura* letters [page 68] that displayed the beauty of that typeface as a visual work of art (even though it is not considered a work of special readability in text usage). Arranged simply and with respect for the organic relationship of the letters, they produced a pleasing work of graphic design. The asymmetrical quality of lowercase letters encouraged an informal approach to design in the 1948 issue. In this *Inspirations 192*, published in 1953, the geometrical capitals encouraged more structured arrangements.

The roman alphabet lends itself to nearly endless design possibilities, as can be seen on the following spreads. The symmetry and simplicity of the letter I on page 101 seemed to require an asymmetrical arrangement to provide graphic interest. However, just opposite it on page 100, the asymmetrical letter R similarly inspired an asymmetrical design for its spread. Letters such as C and E that are thought of as asymmetrical letters in normal textual use suddenly become symmetrical when turned on their sides by the designer [fig. 114], or when the reader turns a layout on its side [fig. 111].

The concept of this chapter 8 illustrates that "type can be a toy" in the sense of pure design [figs. 109-115], while chapter 4 shows that "type can be a toy" in the sense of playful thematic arrangements of letters [figs. 54-59]. The pages near the end of chapter 8 also show how "type can be a tool" when the playful study and arrangement of alphabet letters were developed by the author into a few of the many practical trademark designs for corporations, institutions, publications, and societies [figs. 116 and 118].

To lend editorial interest to an issue dominated by letterforms, the word A-M-E-R-I-C-A was chosen as the thematic key to the issue, although the theme may have been appealing on its own to a large part of the publication's audience. Small reproductions of traditional American paintings and engravings and a nineteenth century typeface provided appropriate graphics for the theme and title. To further honor and explore the roman capital alphabet, it was used for every word of reading matter in the issue.

Visual arrangements of the textual matter throughout this issue are symmetrical or asymmetrical depending on the shapes and arrangements of the heroic-sized letters. You may compare the text type of the beginning letter A spread [pages 94-95] with that of the ending letter A spread [page 101]. Note how the asymmetrical flush-right and ragged-left arrangement of the former enhances the strong directional movement of the whole concept, and how the centered arrangement of the latter enhances its symmetrical plan. As visual art these arrangements are appealing, but for typography in quantity, flush-left and ragged-right style should be used universally for the sake of good readability.

108 Opposite: *America*, the frontispiece spread, serves as a visual introduction for the seven spreads reproduced on the following pages, which one by one echo the title A-M-E-R-I-C-A. The typeface is *Franklin Gothic*, in all capital letters. 1953

A STANDS
FOR
AMITY

PRINTED BY LETTERPRESS
ON STERLING ENAMEL COATED TWO SIDES,
25 x 38 - 80

PRINTER: THOMAS SULLY
PAINTING: MOTHER AND SON
COLLECTION:
THE METROPOLITAN MUSEUM OF ART, NEW YORK
PUBLICATION:
METROPOLITAN MINIATURES
ENGRAVING:
FOUR COLOR PROCESS, 133 LINE SCREEN

WEST VIRGINIA INSPIRATIONS FOR PRINTERS 192

3836

The letter A in textual use
is a symmetrical one with a stolid base,
but when turned on its side
it can become an asymmetrical, colorful symbol
and a vital design in motion.

PRINTED BY LETTERPRESS ON VELVO ENAMEL COATED TWO SIDES, 25 x 38 - 70

AMERICA IS A GREAT, BIG LAND. 3000 MILES FROM EAST TO WEST.

1200 MILES FROM NORTH TO SOUTH. FROM EVERY

SECTION OF THE LAND, DIVERSE SKILLS AND UNIQUE TRADITIONS

ENDOW OUR NATIONAL LIFE WITH INFINITE VARIETY.

FROM THE PUEBLOS OF NEW MEXICO TO THE SPRUCE-CRESTED

ISLANDS IN MAINE, FROM SNOW-CAPPED MOUNT

RAINIER IN WASHINGTON TO SUNNY BEACHES IN FLORIDA, THE

AMERICAN SCENE IS A DRAMATIC PAGEANT OF MANY ASPECTS.

YET THE BASIC CHARACTER OF AMERICAN LIFE

IS UNIFORM AND CONSISTENT. AMERICANS ARE ONE LARGE

FAMILY, POSSESSING A COMMON DESTINY.

PRINTING FUNCTIONS IN OUR NATION AS AN EXPRESSION

OF THIS DESTINY, FORGING A STRONG BOND OF

AMITY AND GOOD WILL FOR ALL THE PEOPLE OF THE UNION.

PRINTED BY LETTERPRESS ON VELVO ENAMEL COATED TWO SIDES, 25 x 38 - 70

109 *A Stands for Amity.* The text in the design above is set in flush-right
and ragged-left style to contribute to the forward movement of the
large letters in flight. Four-color printing was used on the left page
and two-color on right, yet the design has graphic integrity. 1953

PRINTED BY LETTERPRESS ON STERLING ENAMEL COATED TWO SIDES, 25 x 38 - 80

PAINTER: JOHN TRUMBULL

PAINTING: THE SURRENDER OF LORD CORNWALLIS, DETAIL.

COLLECTION: YALE UNIVERSITY ART GALLERY

ENGRAVING: FOUR COLOR PROCESS, 120 LINE SCREEN

3826

Letters of the roman alphabet
can be more than just useful servants of the writer and reader.
Each letter is based on a traditional geometric shape,
and when one is placed together with others of its kind,
new graphic designs come to life.

IN EVERY TIME, MEN OF PRACTICAL ABILITY HAVE SERVED

AMERICA. AS A FARMER, GEORGE WASHINGTON

PIONEERED IN METHODS THAT INCREASED THE YIELD OF

HIS PLANTATION. AS A SOLDIER, HE SOLVED

PROBLEMS IN LOGISTICS WITHOUT LEAVING THE SADDLE.

M STANDS FOR MEN

KNOW-HOW IS ESSENTIAL IN A SUCCESSFUL OPERATION.

THE PRINTING CRAFTSMAN, FOR EXAMPLE,

ALWAYS DRAWS ON EXPERIENCE AND SKILL TO ACHIEVE

OUTSTANDING GRAPHIC RESULTS. TAKE A

PRACTICAL TIP FROM YOUR PRINTER: USE FINE PAPERS.

PRINTED BY LETTERPRESS

ON VELVO ENAMEL COATED TWO SIDES, 25 x 38 - 70

110 *M Stands for Men.* Seldom is there logic in using two different styles of typesetting in a design. But here, to provide symmetrical relationship to symmetrical graphics, the type is set in centered style on the left page, while on the right page the text type is set in flush-right and ragged-left style to accompany asymmetrical graphics.

GROWTH OF AMERICA WAS MOTIVATED

BY A SPIRIT OF ENTERPRISE.

MARCHING ACROSS THE CONTINENT,

BANDS OF HARDY PIONEERS

MET THE CHALLENGE OF MIGHTY

RIVERS, PRAIRIE FIRES, AND

SUDDEN STORMS. THEIR QUEST FOR

OPPORTUNITY WAS REWARDED

BY THE CREATION OF GREAT THRIVING

PAINTER: GEORGE CALEB BINGHAM
PAINTING: DANIEL BOONE ESCORTING A BAND OF PIONEERS
COLLECTION: WASHINGTON UNIVERSITY, ST. LOUIS

PUBLICATION: MODERN AMERICAN PAINTING
PUBLISHER: DODD, MEAD AND CO., INC.
ENGRAVING: FOUR COLOR PROCESS, 120 LINE SCREEN

COMMUNITIES AND PROSPEROUS FARMS.

IN EVERY PART OF THE LAND,

THE SPIRIT OF ENTERPRISE FLOURISHES

AS PRINTED SALESMANSHIP

OPENS UP NEW VISTAS OF OPPORTUNITY.

NO MATTER WHERE YOU GO

IN AMERICA, INK AND FINE PAPERS

ARE EMPLOYED TO HERALD

AN INCREASED ACTIVITY IN BUSINESS.

PRINTED BY LETTERPRESS
ON VELVO ENAMEL COATED TWO SIDES, 25 x 38 - 70

A roman letter can include
a masterpiece painting as part of itself
and at the same time be reversed and repeated
in many sizes and colors
to form an integrated graphic design.

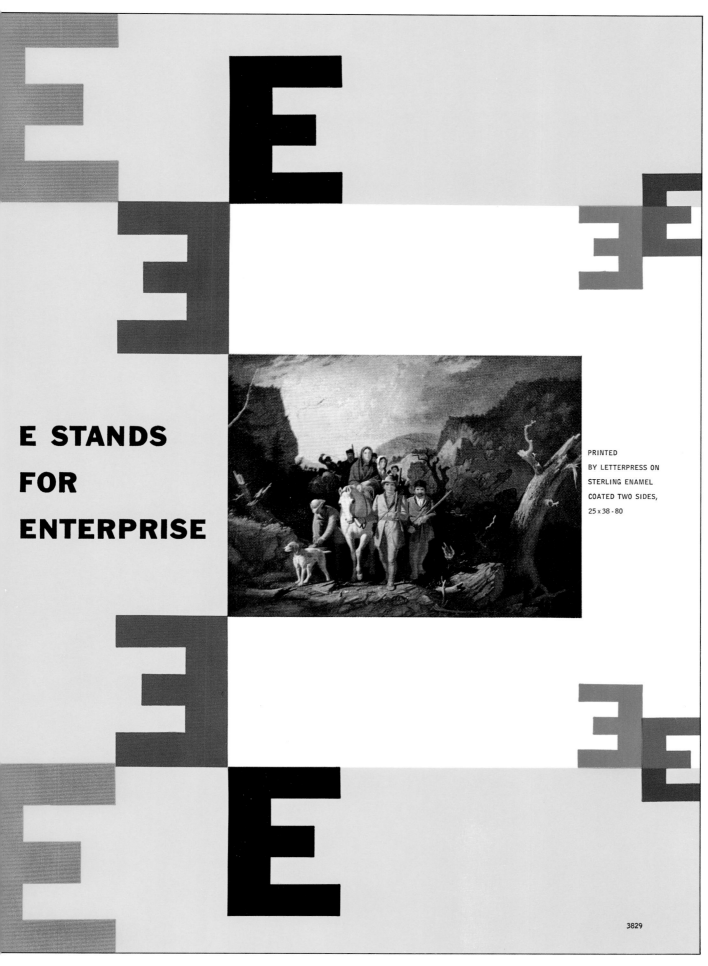

E STANDS

FOR

ENTERPRISE

PRINTED
BY LETTERPRESS ON
STERLING ENAMEL
COATED TWO SIDES,
25 x 38 - 80

3829

111 *E Stands for Enterprise. Franklin Gothic,* the vintage sans serif typeface
used throughout this issue of *Inspirations,* was chosen rather than a
more modern face such as *Helvetica* or *Univers* to relate appropriately
to the 19th century paintings and engravings printed along with it.

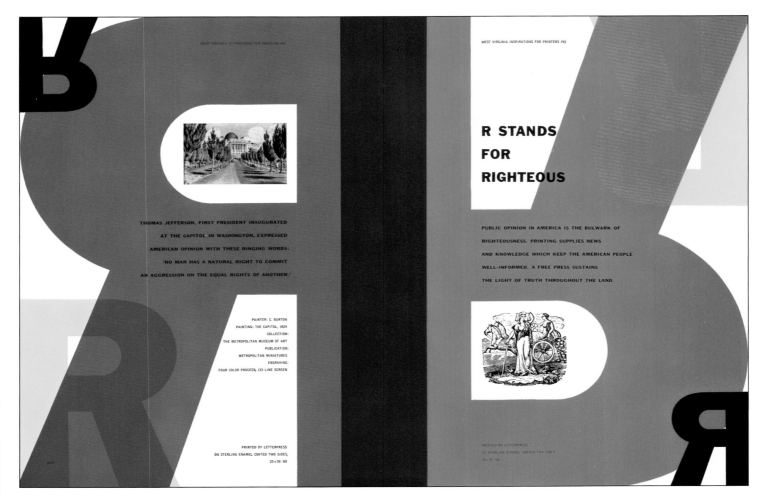

112 *R Stands for Righteous.* Here the letter R is used in normal position, reverse
 position, upside-down position, upside-down reverse position, and in color.

114 *C Stands for Constitution.* The letter C has many unexplored, intriguing pos-
 sibilities in design, with overlapping colors, tones, and spatial relationships.

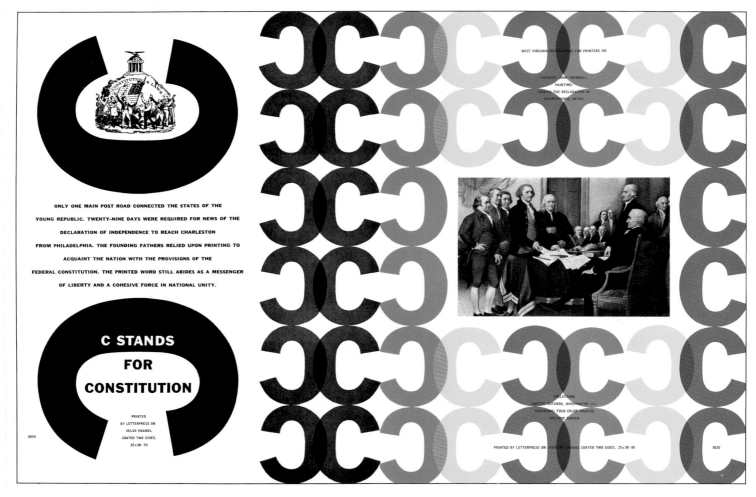

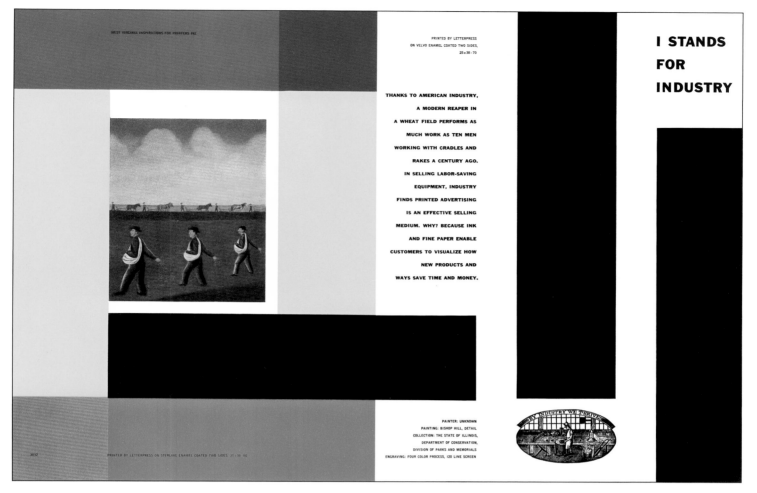

113 *I Stands for Industry.* The simplest letter in the alphabet can provide dynamic
 asymmetrical design, and with black printing only available on one of the pages.

115 *A Stands for Abundance.* Unlike the vital design in motion on page 94, the same
 letter A provides a symmetrical design in a colorful but stolid tranquility.

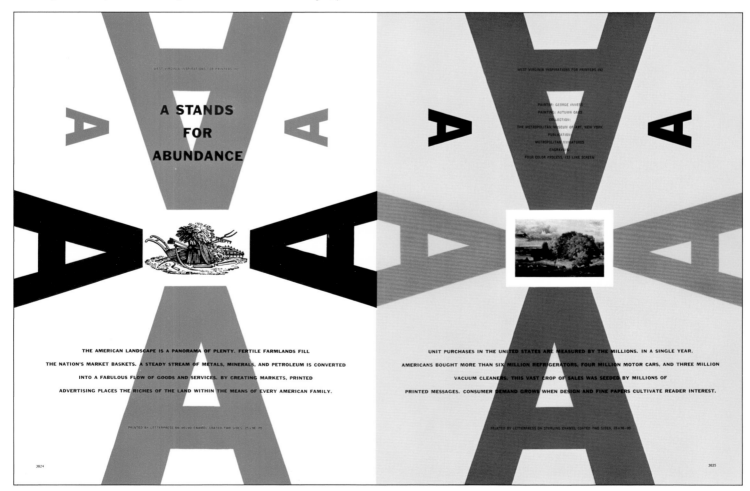

The alphabet as visual art, continued

The typographic explorations shown on the preceding pages influenced some designs on these last pages of the chapter.

Although part of the trademarks and symbols you see on the opposite page are not directly related to the Westvaco explorations, they do have typographic connotations. The Lindenmeyr trademark is derived from the printer's mark of Nicolas Jenson, the designer of the first successful roman typeface, and from Michelangelo's family mark. The symbol of the Menninger Foundation,* which actually identifies a division of the psychiatric foundation rather than its corporate image, is composed of the Greek letter *psi* in a similar arrangement as the A design on the preceding page. The SI mark of the Society of Illustrators symbolizes with contrasting letter shapes and hues the fluid, geometric, and color essences of art.

The marks for *Art News* and for *Westvaco* are simply their names in typefaces that embody significant qualities of identification. The design for the symbol of the College at Purchase SUNY bears only an abstract relationship to the geometric qualities of the roman alphabet. The trademark used to identify the entire program of the U.S. Postal Service Olympics stamps for the 1984 games is purely typographic, even the five rings of the Olympics symbol itself can be rationalized as the letter o. The *Washburn College Bible* symbol, composed of many basic geometric shapes with a cross in the center, is derived from a design known to be from mosaics of the mausoleum built about AD 350 by Constantine, the first Christian emperor, for his daughter.

Useful and memorable trademarks, and editorial pages with literal or playful significance, can be created with letters of the alphabet in the same spirit of enjoyment as the designs on the preceding pages.

116 *Symbols and Identification.* This trademark became in 1953 the symbol for West Virginia Pulp and Paper, now Westvaco. It derived from the preceding designs.

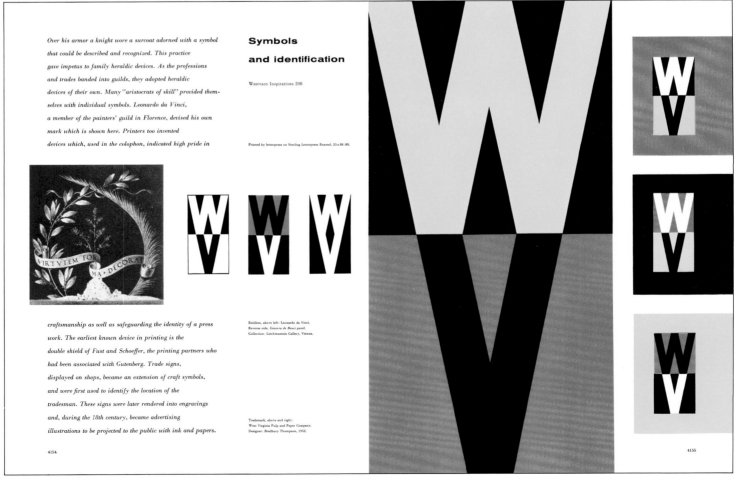

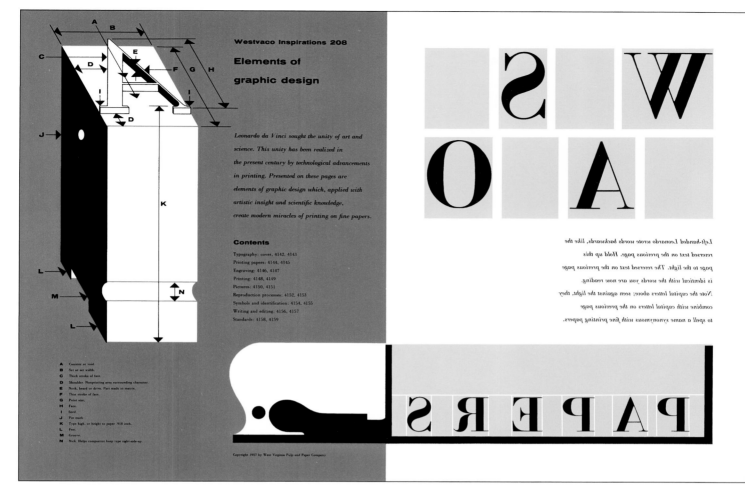

117 *Papers I.* This graphic design has an extra dimension. Turn the page to the next and hold it up to the light to make reading sense of four large reverse letters.

118 *Trademarks.* Letters of the alphabet are of course symbols, and out of them one can fashion trademarks. Words too by themselves can be unique trademarks.

Lindenmeyr Corporation, 1981	Art News, 1970	Society of Illustrators, 1960	Washburn College Bible, 1979
Olympics, US Postal Service, 1984	College at Purchase SUNY, 1970	Westvaco Corporation, 1968	*The Menninger Foundation, 1979

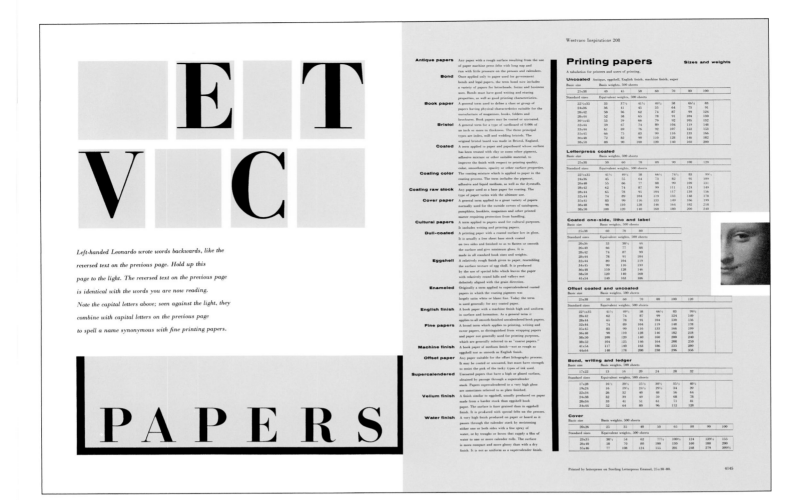

119 *Papers II.*The four letters E-T-V-C now have significance when this page is
 held up to the light to be read along with the four letters on the preceding
 page. (This device was the graphic invention of a nine-year-old son in 1957.)

120 *Inspirations 200.*This is the title spread for *Westvaco Inspirations 200*, dating
 from 1955. The large letter T is composed of early covers, including at top,
 the first one from 1925. Others are from the eclectic and art deco periods.

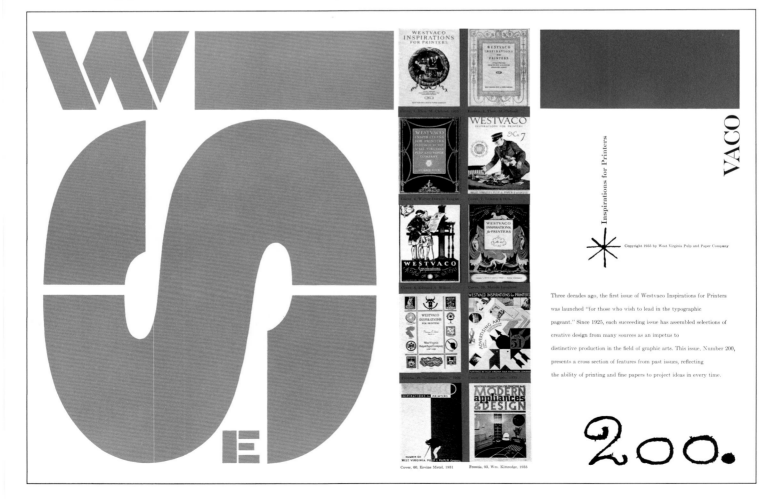

9 Classic art as modern graphics

Hope nothing from luck,

and the probability is that you will be so prepared,

forewarned, and forearmed,

that all shallow observers will call you lucky.

Cyril E. E. Bulwer

Advertising is a game of tactics and strategy, not chance. When you bid for public response, be sure to play the trump cards of effective design. With fine papers as a partner, your printing will score a grand slam.

121 *Luck.* A still-life masterpiece by Chardin and an engraving from Diderot's *Encyclopédie*, along with card symbols, inspired a modern design. 1953

Fortuny Inspirations for Printers. 194

Printed by letterpress on Sterling Enamel Coated Two Sides, 25 x 38 - 80

Painter: Jean Baptiste Siméon Chardin
Painting: The House of Cards.
Publication: Chardin, The Pitman Gallery
Publishers: Pitman Publishing Corporation
Collection: The National Gallery, London
Engraving: Four color process. 133 line screen

Printed by letterpress on
Clear Spring Offset, 25 x 38 - 80

9

Classic art as modern graphics

18th century engravings and paintings
are brought to life again in the 20th century

Introduction by D. Dodge Thompson

While postmodernism in the visual arts is commonly dated
from the publication in 1966 of Robert Venturi's influential
Complexity and Contradiction in Architecture, Bradbury Thomp-
son developed and evinced many of the same precepts in
his graphic design of the late 1940s and 1950s. During the
Second World War Thompson rediscovered and adapted for
his own purposes engravings and paintings of the eighteenth
and early nineteenth centuries. At this time, perhaps in
response to the more improvisational graphic design of the
European constructivists and surrealists, the designer sought
a more historical, classical frame of reference.

In 1943 the artist borrowed an engraving from *Herbarium
Amboinense* (London, 1747) to exhort the reader to plant a
Victory garden. Thus began his frequent adaptation of
antique engravings for twentieth century purposes. In 1944
the designer juxtaposed engravings from an eighteenth
century *Encyclopaedia Britannica* (Edinburgh, 3d edition,
1797) with paintings of related subjects throughout an issue
of *Inspirations* to create "an encyclopedia of advertising art."

After the war the designer continued to use engravings
and introduce them to other publications. In 1947 in the
fashion magazine *Mademoiselle* he occasionally enlivened the
layout with architectural details from the 1797 *Encyclopaedia
Britannica.* The same year he rediscovered the volumes of the
brilliant nineteenth century French illustrator J.J. Grand-
ville. He used Grandville's engravings in *Mademoiselle,* drolly
including the artist's self-portrait on the contents page
among photographic portraits of the modern contributors.

In 1949 Thompson acquired all eleven volumes of plates
accompanying Diderot's *Encyclopédie* and began to use them
as a pictorial resource in *Westvaco Inspirations.* Often the
designer used engravings in a playful fashion, startling the
reader with unexpected visual comparisons [fig.127].

The layouts became increasingly sophisticated, all the
while attempting to incorporate painting, engraving, and
literature of the same period [fig.121]. These experiments
with engravings were fruitful and opened up other doors of
exploration. Engravings were used, for example, with hinges
literally connecting two pages [figs.133-34]. Engravings
were manipulated to create motion [fig.34].

Not the least, the artist returned the engravings to their
original use, the illustration of fine books. (See chapter 15.)
In these limited edition volumes Thompson sought parallels
between the work of authors and artists who were contem-
poraries. He matched the writings of transcendentalist
philosopher Ralph Waldo Emerson with engravings by the
kindred American painter, Thomas Cole [fig.256]. And he
illustrated Henry James's novella *Daisy Miller* with a *fin-de-siècle*
portrait of an American expatriate by James A.M. Whistler.

Whether recalling America's musical heritage on a postage
stamp [fig.191] or creating a visual pun for the cover of a
Sunday newspaper supplement [fig.240], Bradbury Thomp-
son uses the fine arts to provide a link with the past. In a
larger sense, it is the designer's appreciation of the historical
continuity of the printed and illustrated page that renders
much of his own work in contemporary graphic arts timeless.

In this chapter the paintings, engravings, and typefaces are from the 18th
and early 19th centuries. The chapter presents selections from five issues of
Westvaco Inspirations that were published between the years 1945 and 1953.

D. Dodge Thompson
is Chief of Exhibition Programs
at the National Gallery of Art

*Eighteenth century engraved images
and oldstyle typefaces
demand a lively new interest
when presented in the colorful style and spirit
of the present age.*

122 *Mobile Mannequin.* The outline engraving of a human figure seemed
to come alive as the frontispiece spread of *Westvaco Inspirations 190*
by simply tracing it, reversing its original position, and making it into
a white on red silhouette. This and all but two of the engravings in
this chapter are from Diderot's mid-18th century *Encyclopédie.* 1952.

West Virginia Inspirations for Printers 190

A Volume

Devoted to the

Arts

All the arts have a certain

common bond of union and are connected

by blood relationship with one another.

Cicero

123 *The Art of Astronomy.* The *Caslon* typeface used on these and adjacent spreads is contemporary with the Diderot engravings and thus compatible with them.

124 *The Art of Architecture.* Classic buildings and typefaces can become a lively part of the present age with a fresh, modern approach to page design.

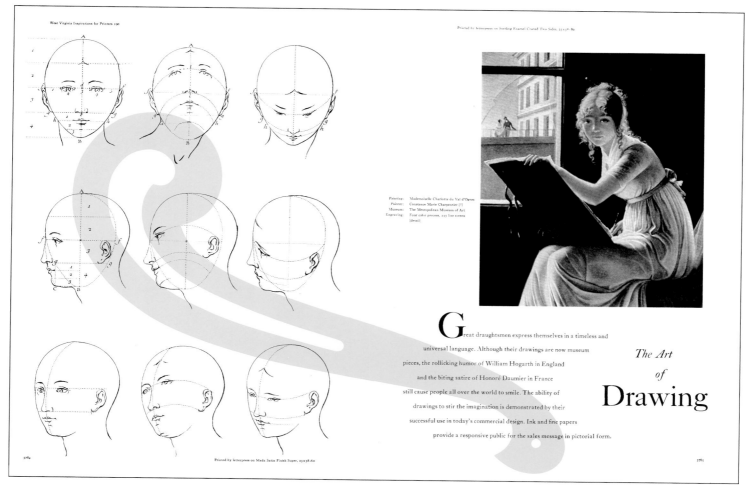

Painting: Mademoiselle Charlotte du Val d'Ognes
Painter: Constance Marie Charpentier [?]
Museum: The Metropolitan Museum of Art
Engraving: Four color process, 133 line screen
[detail]

Great draughtsmen express themselves in a timeless and universal language. Although their drawings are now museum pieces, the rollicking humor of William Hogarth in England and the biting satire of Honoré Daumier in France still cause people all over the world to smile. The ability of drawings to stir the imagination is demonstrated by their successful use in today's commercial design. Ink and fine papers provide a responsive public for the sales message in pictorial form.

The Art of
Drawing

Printed by letterpress on Mada Satin Finish Super, 25x38, 60

125 *The Art of Drawing.* Eighteenth century paintings, drawings, and typefaces are presented in the spirit and the style of modern graphic design.1952

126 *The Art of Defense.* This *Caslon* typeface of English origin is a more congenial symbol of our heritage than the warrior portrait of General Washington.

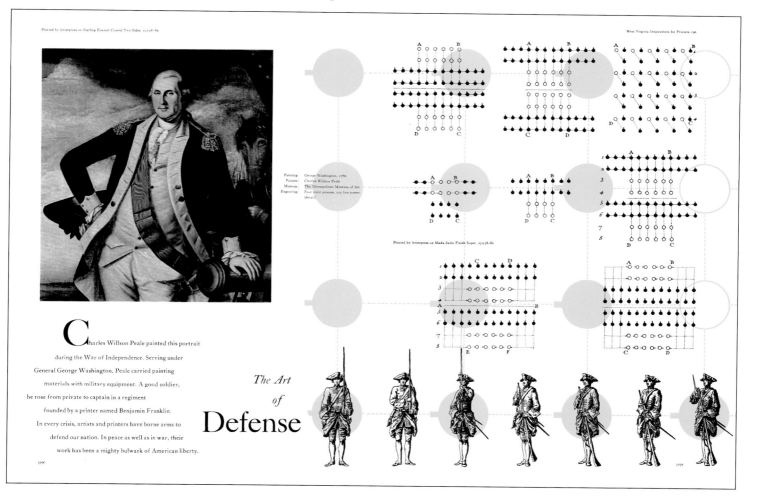

Painting: George Washington, 1780
Painter: Charles Willson Peale
Museum: The Metropolitan Museum of Art
Engraving: Four color process, 133 line screen
[detail]

Printed by letterpress on Mada Satin Finish Super, 25x38, 60

Charles Willson Peale painted this portrait during the War of Independence. Serving under General George Washington, Peale carried painting materials with military equipment. A good soldier, he rose from private to captain in a regiment founded by a printer named Benjamin Franklin. In every crisis, artists and printers have borne arms to defend our nation. In peace as well as in war, their work has been a mighty bulwark of American liberty.

The Art of
Defense

Design and Typography of This Issue: Bradbury Thompson

Organizations

Art News: 3795
Collection of the Former State Museums, Berlin: 3790, 3791
Mawritshuis Museum, The Hague: 3786
The Metropolitan Museum of Art, New York: 3785, 3796
Milch Galleries, New York: Cover
The National Gallery of Art, Washington, D.C.: 3795
Street and Smith Publications [Diderot's Encyclopedia]: Throug

Artists

Jean Baptiste Siméon Chardin: 3795
Constance Marie Charpentier [?]: 3785
Hans Holbein: 3790, 3791
Charles Willson Peale: 3796
Rembrandt Van Rijn: 3786
John Sharp: Cover
Artists of Diderot's Encyclopedia: Throughout

Engravings

Four color process, 133 line screen: 3785, 3795, 3796
Four color process, 120 line screen: 3786, 3790, 3791
Line engravings, from copperplate engravings in
Diderot's Encyclopedia: Throughout
Offset Lithography: Cover

West Virginia Papers

Inspiration Offset, 25 x 38-120: Cover
Mada Satin Finish, 25 x 38-60: 3787, 3788, 3793, 3794
Mada Satin Finish Super, 25 x 38-60: 3783, 3784, 3797, 3798
Sterling Enamel Coated Two Sides, 25 x 38-80: 3785, 3786, 378
3791, 3792, 3795, 3796

Type Faces: Headings, Caslon 540, ATF. Body, Caslon, Linoty

Cover Artist

John Sharp was born in Galesburg, Illinois, and was raised
in Eldon, Iowa. He studied at the State University
of Iowa, with Grant Wood at Stone City, and in New York
at the Art Students League and the National Academy
of Design School. He now lives and works in New Hope, Pa.,
and Nantucket, Mass. His oil paintings have
appeared in major art exhibitions and are in collections of
the Pennsylvania Academy of Fine Arts, the Dubuque
Art Museum, and the American Academy of Arts and Letters.

Copy of This Issue: M. J. McCosker

Classic images possess a lasting substance that
when presented in the graphic spirit
of a new age
impart fresh meaning and vitality
to the printed page.

West Virginia Mill Brand Papers

Blendtone Coated Two Sides
Clear Spring Higloss Litho
Clear Spring Offset
Clear Spring Plate
Clear Spring Super Plate
Clear Spring Text Laid
Clear Spring Text Wove
Covmont Tablet
Ideal Litho Coated One Side
Inspiration Bond
Inspiration Eggshell
Inspiration English Finish
Inspiration Envelope
Inspiration Index Bristol
Inspiration M.F. Poster
Inspiration Map Bond
Inspiration Offset
Inspiration Super
Inspiration Tablet
Mada Satin Finish
Mada Satin Finish Super
Mada Eggshell
Marva Satin Finish
Marva Satin Finish Super
Marva Super Rotogravure
Penink Mimeograph Wove
Piedmont Coated One Side
Pinnacle Gloss Coated One Side
Sterling Enamel Coated Two Sides
Sterling Cover Coated Two Sides
Universal Cover
Vac-Cup-Bac Poster
Velvo Enamel Coated Two Sides
West Virginia Bond
West Virginia Drawing
West Virginia English Finish Music
West Virginia English Finish Rotogravure
West Virginia English Finish School Book
West Virginia Extra Strong End Paper
West Virginia Hibulk
West Virginia M.F. Antique Laid
West Virginia M.F. Antique Wove
West Virginia M.F. Gumming
West Virginia M.F. Lining
West Virginia M.F. Litho
West Virginia Machine Finish
West Virginia Playing Card
West Virginia Post Card
West Virginia Super Litho
West Virginia Super Rotogravure
West Virginia Super School Book
West Virginia White Writing
West Virginia Machine Coated
West Virginia Bleached Cup and Container Stock
West Virginia White Converting
West Virginia File Folder

Asphalting Kraft
Bag Kraft
Converting Kraft
Envelope Kraft
Gumming Kraft
Impregnating Kraft
Multi-wall Sack Kraft
Waxing Kraft
Wet Strength Kraft
Counter Board
Insulating Board
Fourdrinier Container Board
Corrugating .009

West Virginia

Pulp and Paper

Company

127 *Life and War.* The silhouette of a soldier arranged together with an
engraving of his vascular system on a red background produced
this intimate reminder of human life and its relation to mortal
combat. The page of military formations is typical of the thorough
details of much subject matter presented in the *Encyclopédie.* 1952

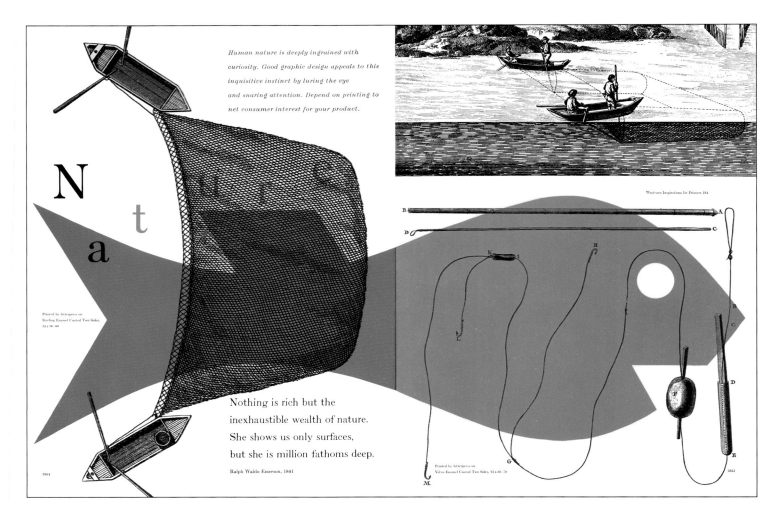

128　*Nature.* An 18th century engraving surprinted with a silhouette of a fish becomes modern graphic design, perhaps influenced by an earlier design [fig. 57].1953

129　*Go & Stop.* A highway cloverleaf is surprinted on a 1760's bridge; 'Go' is printed on the blue and yellow plates, 'Stop' on the red and black of a four-color reproduction.

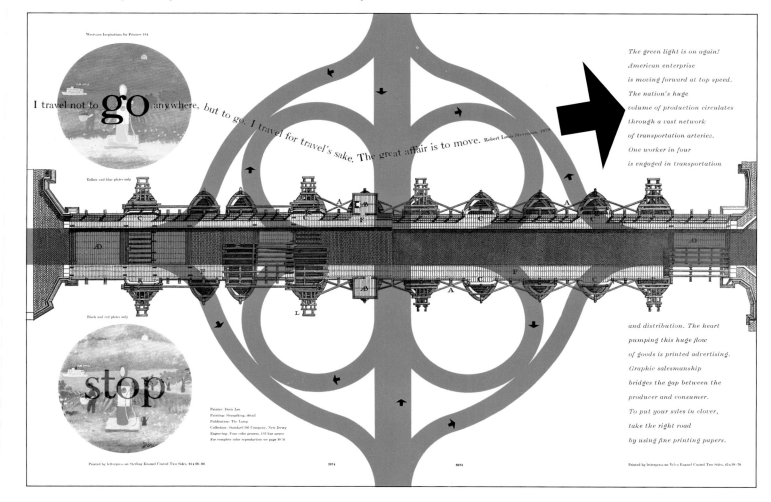

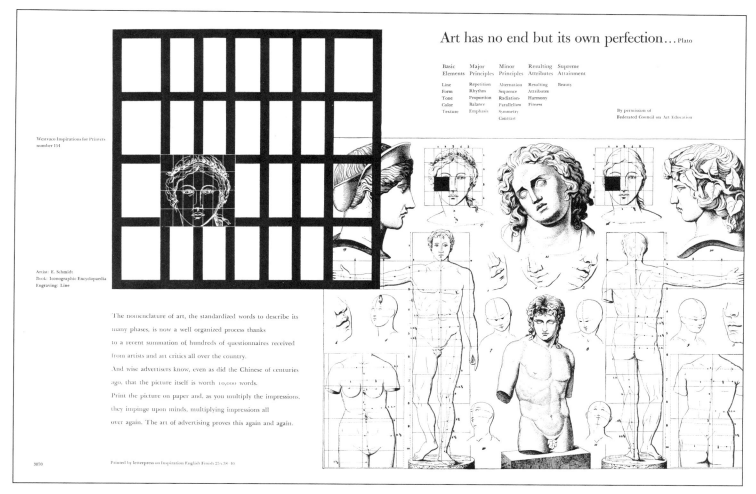

Art has no end but its own perfection... Plato

Basic Elements	Major Principles	Minor Principles	Resulting Attributes	Supreme Attainment
Line	Repetition	Alternation	Resulting	Beauty
Form	Rhythm	Sequence	Attributes	
Tone	Proportion	Radiation-	Harmony	
Color	Balance	Parallelism	Fitness	
Texture	Emphasis	Symmetry		
		Contrast		

By permission of
Federated Council on Art Education

Westvaco Inspirations for Printers
number 154

Artist: E. Schmidt
Book: Iconographic Encyclopaedia
Engraving: Line

The nomenclature of art, the standardized words to describe its
many phases, is now a well organized process thanks
to a recent summation of hundreds of questionnaires received
from artists and art critics all over the country.
And wise advertisers know, even as did the Chinese of centuries
ago, that the picture itself is worth 10,000 words.
Print the picture on paper and, as you multiply the impressions,
they impinge upon minds, multiplying impressions all
over again. The art of advertising proves this again and again.

3070 Printed by letterpress on Inspiration English Finish 25 x 38 40

130 *Art.* This design is based on a page from the early 19th century *Iconographic
Encyclopaedia.* The listing above defines basic elements of art and its principles.

131 *Basic Elements of Art.* As listed above, and graphically shown below on the title
page of *Westvaco Inspirations 154,* they are line, form, tone, color, texture. 1945

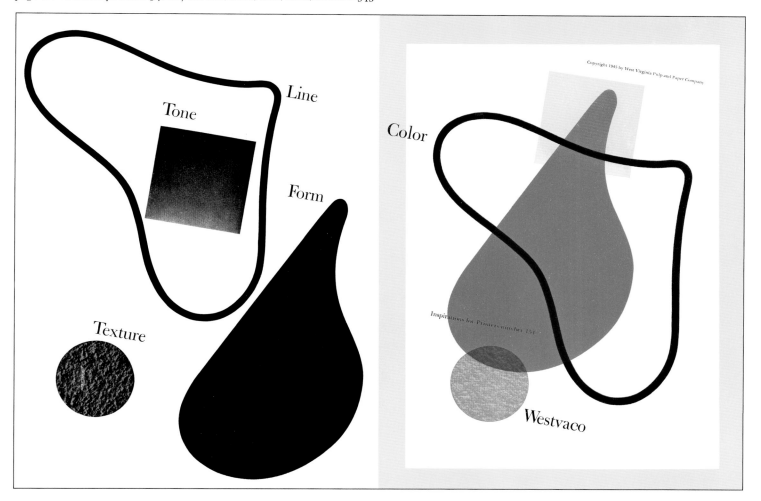

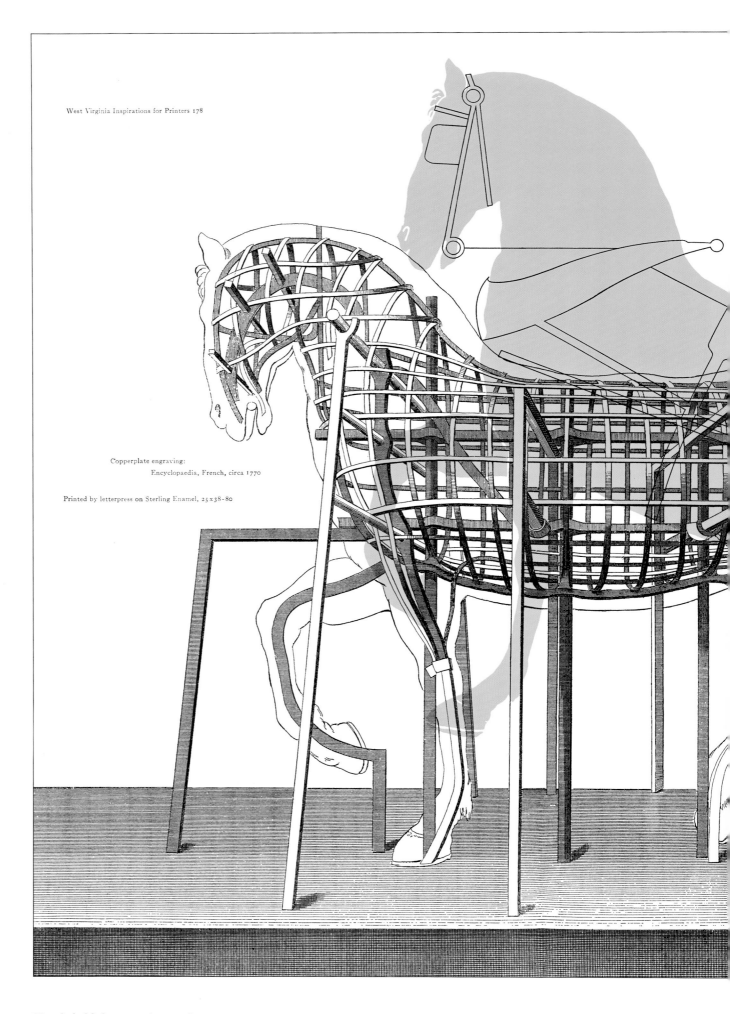

Copperplate engraving:
Encyclopaedia, French, circa 1770

Printed by letterpress on Sterling Enamel, 25 x 38 - 80

Simple bold shapes, color, motion,
and contrasting linear detail of old engravings
are key factors in bringing
a new element of sprightliness
to modern graphic design.

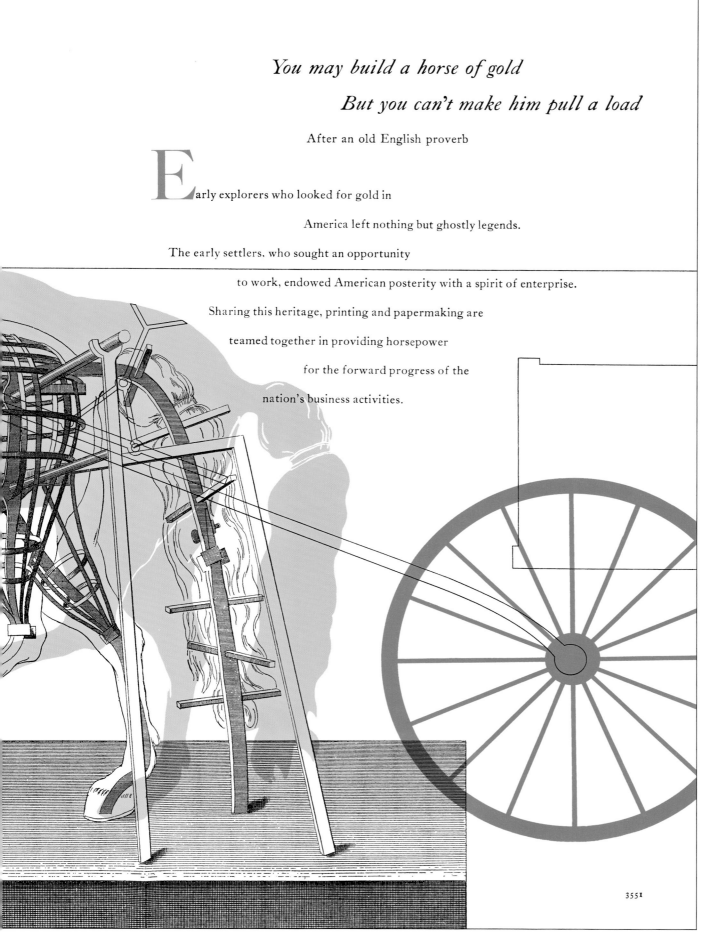

You may build a horse of gold

But you can't make him pull a load

After an old English proverb

Early explorers who looked for gold in

America left nothing but ghostly legends.

The early settlers, who sought an opportunity

to work, endowed American posterity with a spirit of enterprise.

Sharing this heritage, printing and papermaking are

teamed together in providing horsepower

for the forward progress of the

nation's business activities.

3551

132 *You May Build a Horse.* This support structure for the sculpture of a horse is
from Diderot's *Encyclopédie.* The horse is brought into the 20th century
in *Inspirations 178* simply by adding a silhouette copy of the horse, printing
it in yellow on an angle, with the suggestion of a wagon. It is not unlike the
design with human mannequin, which followed it three years later. 1949

133 *Enter.* Life-sized hinges, doorknob, and keyhole provide realism to a page
 posing as a doorway, for an issue entitled Magic House of Printing.1947

134 *Exit.* Again, hinges on the centerfold and a stairway from an 18th century
 encyclopedia identify this as the final spread of *Westvaco Inspirations 168*.

10 Printing and the designer

California Job Case.
By Bradbury Thompson

W E S T V A C O

Inspirations

208

Distributors:		
Westvaco Quality Papers		
Akron 8, Ohio	The Union Paper and Twine Co., 31 N. Summit Street	Knoxville 12, Tenn. — Graham Paper Company, 700 Dale Avenue
Atlanta 3, Ga.	S. P. Richards Paper Company, 326 Nelson Street, S.W.	Lima, Ohio — The Union Paper and Twine Co., 2016 Lakewood Avenue
Baltimore 2, Md.	The Arnold-Roberts Company	Louisville 1, Ky. — Graham Paper Company, 711-719 Brent Street
Birmingham 1, Ala.	Bradley-Reese Co., Inc., 433 Guilford Avenue	Lubbock, Texas — Graham Paper Company, 1824 Avenue G
Boston 10, Mass.	Graham Paper Company, 2329 First Avenue, North	Memphis 1, Tenn. — Graham Paper Company, 345 South Front Street
Buffalo 3, N. Y.	The Arnold-Roberts Company	Nashville 3, Tenn. — Graham Paper Company, 10 Cummins Station
Canton 3, Ohio	The Union Paper and Twine Co., 1452 Main Street	New Haven 8, Conn. — The Arnold-Roberts Company
Chattanooga 8, Tenn.	The Union Paper and Twine Co., 1215 Harrisburg Rd., N.E.	New Orleans 12, La. — Graham Paper Company, 228 South Peters Street
Chicago 1, Ill.	Graham Paper Company, 1232 East Main Street	New York 13, N. Y. — Baldwin Paper Company, Inc., 233 Spring Street
Cincinnati 25, Ohio	West Virginia Pulp and Paper Co., 35 East Wacker Drive	New York 12, N. Y. — Cross Sickert and Sons Inc., 207 Thompson Street
Cleveland 1, Ohio	The Chatfield Paper Corp., 2265 Colerain Avenue	New York 17, N. Y. — West Virginia Pulp and Paper Co., 230 Park Avenue
Columbus 9, Ohio	The Union Paper and Twine Co., 1614 East 40th Street	North Kansas City 16, Mo. — Graham Paper Company, 100 East 14th Street
Dallas 2, Texas	The Scioto Paper Company, 808 Rhoads Avenue	Oklahoma City 2, Okla. — Graham Paper Company, 106-108 E. California Avenue
Denver 17, Colo.	Graham Paper Company, 302-306 North Market Street	Pittsburgh 3, Pa. — The Chatfield and Woods Co. of Pa., S. 17th & Merriman
Detroit 26, Mich.	Graham Paper Company, 1625-31 Blake Street	Providence, R. I. — The Arnold-Roberts Company
El Paso, Texas	The Union Paper and Twine Co., 551 East Fort Street	Richmond 9, Va. — Richmond Paper Co., Inc., 201 Governor Street
Erie, Pa.	Graham Paper Company, 201-203 Anthony Street	St. Louis 2, Mo. — Graham Paper Company, 1014-1036 Spruce Street
Grand Rapids 2, Mich.	The Union Paper and Twine Co., 922 West 18th Street	San Antonio 6, Texas — Graham Paper Company, 130 Graham Street
Honolulu 2, Hawaii	The Grand Rapids Paper Co., 655-9 Ionia Avenue, S.W.	San Francisco 5, Calif. — West Virginia Pulp and Paper Co., 501 Market Street
Houston 10, Texas	Theo. H. Davies and Co., Ltd., 841 Bishop Street	Toledo 2, Ohio — The Union Paper and Twine Co., 15 South Ontario Street
West Virginia Pulp and Paper Company Indianapolis, Ind.	Graham Paper Company, 1403 Sterrett Street	Washington, D. C. — R.P. Andrews Paper Co., First and H Streets, S.E.
	The Chatfield Paper Corp., 22 West 24th Street	Wichita 2, Kans. — Graham Paper Company, 124-126 North Rock Island Street
Jackson, Miss.	Graham Paper Company, 750 Ricks Street	Youngstown, Ohio — The Union Paper and Twine Company, 7480 Market Street

135 *California Job Case.* This cover is a symbolic image but also a practical diagram showing the actual placement of letters, punctuation, and spaces. 1957

10

Printing and the designer

Exploring the hidden resources and
graphic potentials of the printer's domain

Text and captions by Edward M. Gottschall

One can think of printing as a means of expressing art, of multiplying it so that its message and spirit can be seen and felt and understood across the barriers of oceans and of mountains, of language and of time.

The designer is challenged to blend the visual elements of a printed message, the words and the pictures, into a unity that compels attention, stimulates readership, facilitates readability, enhances memorability, and elicits a predetermined reaction. To do so effectively, the designer must know how to manipulate the processes and how to choose and use the paper to best advantage.

On the following four spreads from *Westvaco Inspirations 208* [pages 122-23] Bradbury Thompson told the story of printing in visual terms by using familiar masterpieces of Leonardo da Vinci. On the succeeding spreads of this chapter, from other issues, he enlarged, dissected, and rearranged details of paintings to provide new directions for twentieth century designers and artists.

In full-color reproduction, the processes use four colors to achieve full-color effects. The so-called process colors – yellow (Y), red (R), blue (B) and black (K) – have been accepted as an ideal compromise between economy of reproduction and absolute fidelity to the original art.

The inks are transparent. When printed on white paper they act as color filters. Ideally, white paper reflects in perfect balance all the wavelengths of the visible spectrum, but no paper is 100 percent white. The inks that lie on the surface of

the paper both absorb certain light waves that reflect from the paper's surface and transmit others. The red (really a magenta) or the blue (really a cyan) are so-called because the combination of wavelengths transmitted causes us to see red or blue, respectively. When process colors are printed on top of each other, the effect is as if color filters were laid over the white paper. The combination of wavelengths they absorb, or subtract, from the full complement sent out by the paper, leaves light waves that create the color we see. This process is termed "subtractive color."

The tones of a picture, the many intermediate shades between absolute solid color and white, are achieved by breaking up a continuous tone picture into fine dots. There are the same number of dots per inch in the highlight and shadow areas. Between the dots the white paper can be seen. The dots in the highlight areas are small and the ratio of visible paper to ink is large; thus, a light gray or a light shade of color is seen as the viewer's eye and mind blend much white with a little black or color. The converse is true in the shadow areas.

Bradbury Thompson was the first artist to use the underlying mechanical processes of printing, such as process ink and halftone screens, to create altogether new compositions [fig.141]. His explorations in 1951 anticipated in process and form the experiments of the Pop artists in the 1960s, such as Roy Lichtenstein's dot paintings.

The importance of choosing the right paper is obvious when one realizes that the colors the reader observes are

Opposite: A symbolic picture of a printer's job case, the compartmented drawer in which the individual characters of a type font live. Today, descriptions of each character are stored as bytes on a magnetic disc.

Edward M. Gottschall is executive vice-president of International Typeface Corporation, editor of *Upper and Lower Case* magazine, author of articles on typographic design, and the former executive director of the AIGA.

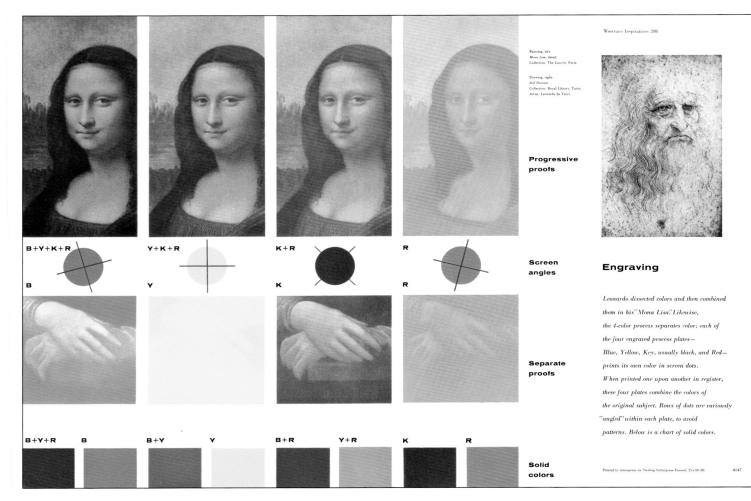

136 *Engraving.* Progressive proofs (top left) show how each color contributes
 to the total effect and pinpoint where the corrections must be made. 1957

137 *Printing.* In the magnification of the *Mona Lisa* detail, note how color
 dots overlap and filter out some of the light waves from the white paper.

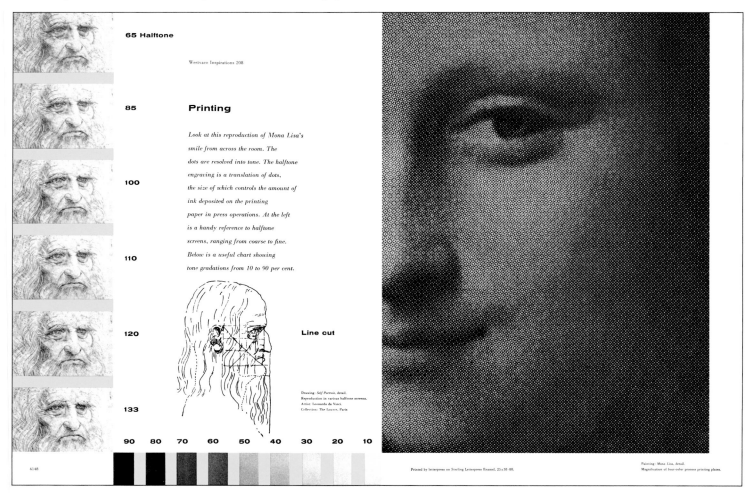

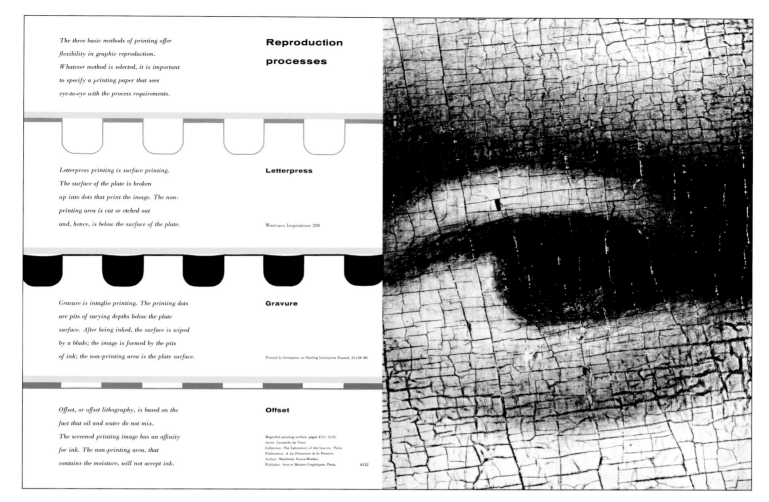

138 *Reproduction Processes.* In recent decades lithography has become the most widely used printing process. Each process requires use of a suitable paper.

139 *Pictures.* The fine halftone screen used here captures a subtler range of the tones and the finer details than would be possible with a coarse screen.

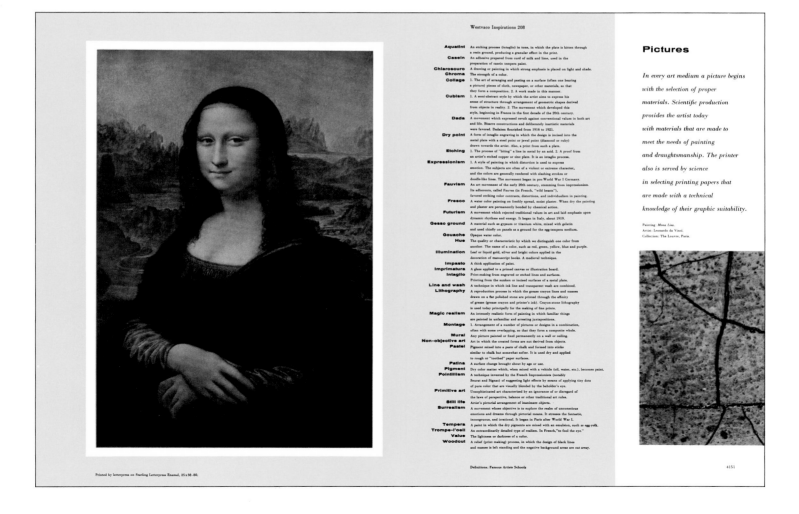

Printing and the designer, continued

dependent on the light waves the paper reflects to the eye.

Today's major printing processes differ in the way they transfer ink from a printing plate to the paper, and each employs a different method of making the plates. With letterpress, the non-printing areas are etched so they will not accept ink on the press. In offset lithography, the difference between image and non-image areas is chemical. The press plates are made so that non-image areas will accept moisture and repel ink, while the image areas will repel water and accept ink. On the press the plate is alternately moistened, then inked. The ink is placed on an offset cylinder, which transfers the ink to the paper on an impression cylinder.

In gravure the recessed, or etched down, areas carry the image. Some gravure platemaking techniques employ a halftone screen in which the dots vary in size, but the critical control of tone strength in gravure comes from the varying depth of the etched dots, which are literally ink wells. The gravure ink is translucent. A heavy deposit of ink from a deep well produces a dark dot. A shallow well produces a light dot.

The designer's role only begins at the drawing board. The test of the successful design is how well it presents the message it carries to the selected audience. The designer who understands what each process can and cannot do not only maximizes the quality of the reproduction, he or she can manipulate the processes and use them creatively as well.

On the preceding two pages
the story of printing was told in visual terms
by using familiar masterpieces
of Leonardo da Vinci.
On this and the following four pages
details of other paintings
were enlarged, dissected, and rearranged
to provide new directions
for twentieth century designers and painters.

140 *Magnifying 1.* Today these camera-produced process color effects are created electronically. Color plates that took weeks to make are now made in hours, with greater control over quality than was formerly possible. 1951

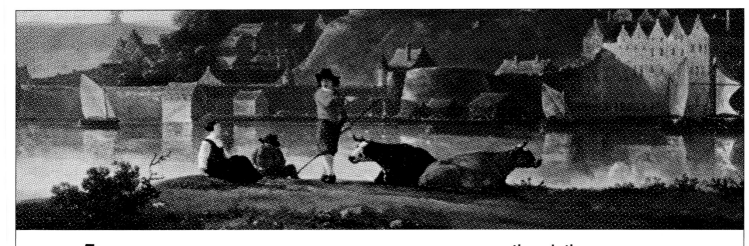

4

color process printing reproduced the painting at the right. the continuous tone in this printing was broken into hundreds of thousands of dots. this was accomplished by a camera method in which the tone values of the painting were translated to a negative through a screen. a 133 line screen was used to make this negative, providing a mesh of 17,689 apertures per square inch. the tone values of the image in the screen negative, a pattern of dots in various sizes and shapes, were transferred by photomechanical means to each of the four process plates. the four basic printing colors were separated by photographing the painting through their complementary color filters, once for each plate. the red-blue filter, for instance, permitted only the yellow values to pass through to the negatives. above is a view of the four color reproduction through the magnifying glass: these thousands of dots in black, blue, red and yellow depend upon fine paper for an effectively combined impression of their respective values.

west virginia inspirations for printers 186

through the
part two **magnifying glass**

painter: aelbert cuyp
title: the valkhof at nijmegen
collection: marmon memorial collection
museum: john herron art museum, indianapolis
publication: art news
engraving: four color process, 133 line screen

printed by letterpress on sterling enamel. 25 x 38 - 80 378

141 *Composition in Space.* These halftone magnifications show how small dots
produce light tones and larger dots create middle tones and shadows. 1951

140a *Magnifying 2.* Electronic scanners now correct the color and detail faster
and more accurately than the previous method of tooling or etching dots.

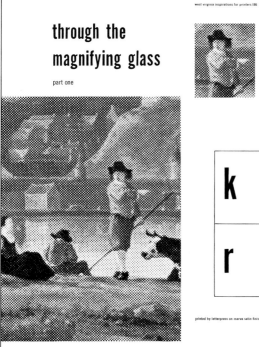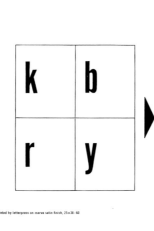

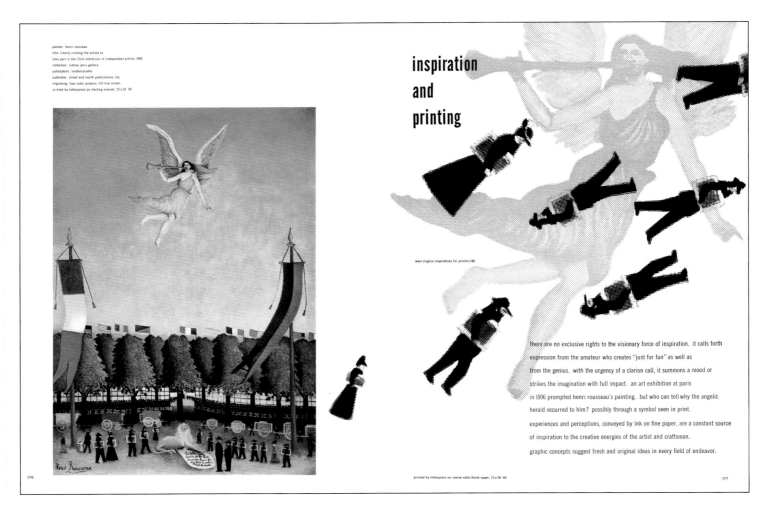

142 *Inspiration.* The art at right was taken from elements in the color plate, enlarged and repositioned. Knowledge of printing made it possible. 1951

143 *Enlarging.* Here too elements were extracted from the color plate to add interest and excitement to the spread, and with minimal additional cost.

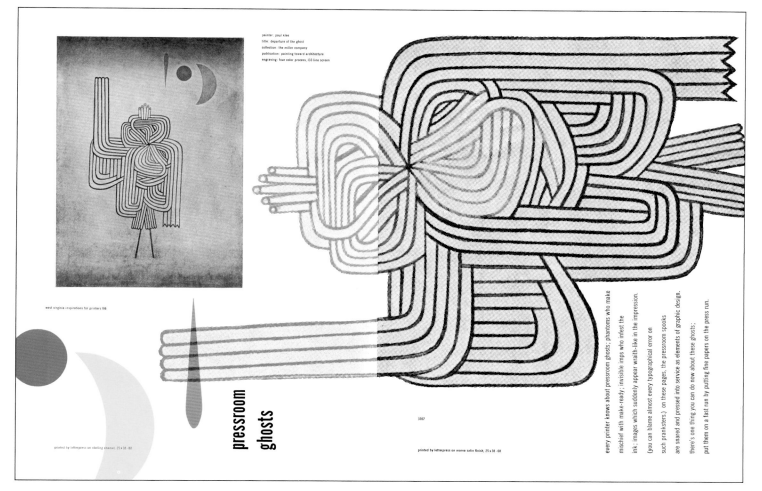

pressroom ghosts

every printer knows about pressroom ghosts; phantoms who make
mischief with make-ready; invisible imps who infest the
ink; images which suddenly appear wraith-like in the impression.
(you can blame almost every typographical error on
such pranksters.) on these pages, the pressroom spooks
are snared and pressed into service as elements of graphic design.
there's one thing you can do now about these ghosts;
put them on a fast run by putting fine papers on the press run.

144 *Ghosts.* Imagination and a knowledge of printing technology enable the
designer to boost the impact and cut the costs of a picture and a spread. 1951

145 *Magic.* Pressroom magic? More likely, use of the designer's mind that is
challenged to change the obvious and create something new under the sun.

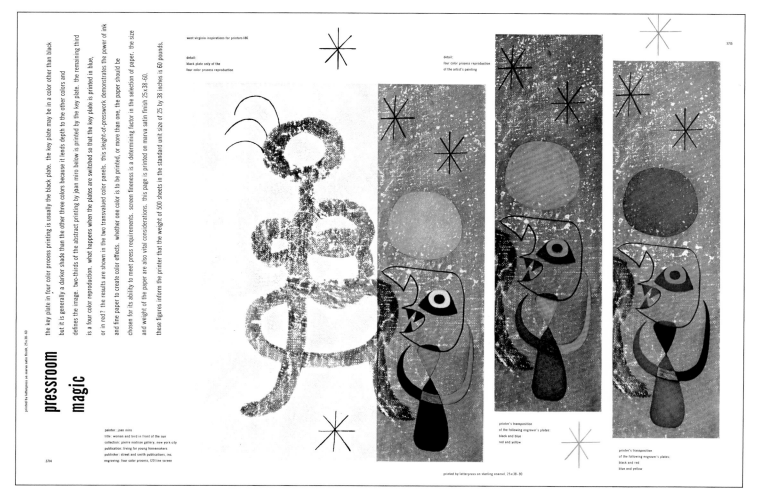

the key plate in four color process printing is usually the black plate. the key plate may be in a color other than black
but it is generally a darker shade than the other three colors because it lends depth to the other colors and
defines the image. two-thirds of the abstract printing by joan miro below is printed by the key plate. the remaining third
is a four color reproduction. what happens when the plates are switched so that the key plate is printed in blue,
or in red? the results are shown in the two transvalued color panels. this sleight-of-presswork demonstrates the power of ink
and fine paper to create color effects. whether one color is to be printed, or more than one, the paper should be
chosen for its ability to meet press requirements. screen fineness is a determining factor in the selection of paper. the size
and weight of the paper are also vital considerations. this page is printed on marva satin finish 25x38-60.
these figures inform the printer that the weight of 500 sheets in the standard unit size of 25 by 38 inches is 60 pounds.

pressroom magic

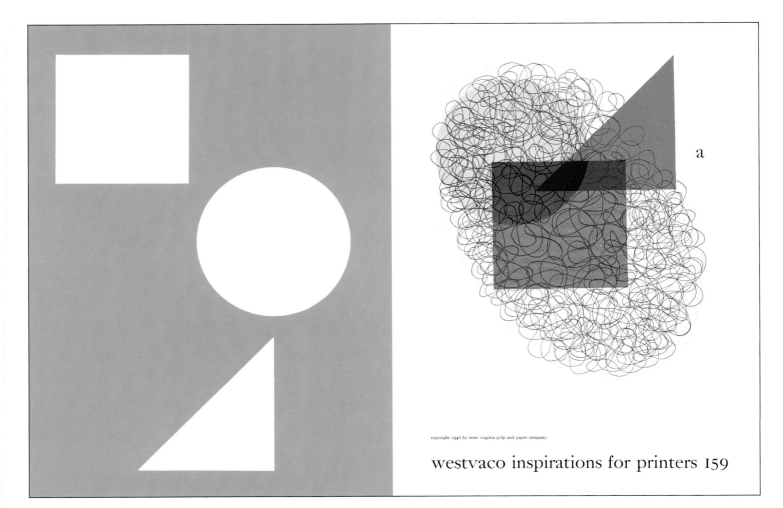

westvaco inspirations for printers 159

146 *Color.* These three basic shapes playfully demonstrate the interplay of transparent colors, lying singly or overlapped, in mass or in fine line. 1946

147 *Integration.* By punching holes in the color plates, one can visualize how the four process colors combine to create a full-color printed effect.

westvaco inspirations for printers 159

3164

3165

printed by letterpress on sterling enamel 25 x 38 · 70

painting:	robert riggs
art director:	walter reinsel
advertiser:	farnsworth television and radio corp.
agency:	n.w. ayer & son, inc.
engraving:	4 color process, 120 line screen

printed by letterpress on west virginia machine coated 25 x 38 · 60

red, yellow, blue! nature's three building blocks of color we can integrate, and so create an infinite variety of colors. integrate! to make into a smooth, efficient, satisfying whole. three colors into the majestic, the cosmic, or the commercial. integration on paper! creation in miniature on a printing press. yes, printing is an art in fact and not by flattery or courtesy. an art for all those who would ring bells in human minds, or in cash registers throughout the world.

integration integration integration in

11 Photography and typography

DESIGN

In photographic design you can demonstrate the functional use of merchandise. You can center the consumer's interest in a product when you point to its advantages through the personalized appeal of a superb reproduction on fine paper.

Westvaco Inspirations 204

Paper: Sterling Letterpress Enamel, 25 x 38; 80
Process: Letterpress, 120 line screen

4071

Westvaco Inspirations 204

Title: Human Composition
Photographer: Landshoff
Publication: Mademoiselle magazine

4070

DESIGN

In photographic design you can startle the eye
with incredible props. You can sweep
people off their feet with the visual impact of human
elements in print. Be sure to multiply
this effect by using the right printing papers.

11

Photography and typography

Through the art of graphic design
two older arts are interfused into one

Introduction by John T. Hill

From man's first pictures he made pictograms, ideograms, symbols, alphabets, and finally words. With wonderful solidity the early artist simultaneously fashioned both pictures and words. With a consensus of mind, eye, and hand, he made brilliantly cohesive works using simple tools. Mesopotamian seals, Egyptian bas-reliefs, and Chinese woodcuts form a part of our treasury of picture-word archetypes. In medieval manuscripts the collaboration of the scribe and the painter produced a tightly woven fabric, richly illuminated pages that are triumphant in unification of picture and word.

With the growth of literacy and the invention of movable type in the fifteenth century, we see the printed word begin to dominate the page. Printer replaced scribe and in a long succession gave birth to type designer and page designer.

With the emergence of photography and photomechanical reproduction during the past century, picture images have regained much of the space they had lost to the word. Constructivist, dadaist, and surrealist, all seem to have rediscovered the word-picture montage within a period of two decades. An exuberance and daring came out of the best of these constructions as they had centuries earlier in various fanciful medieval works. Today the designer must wed the five-hundred-year-old mechanical groom, typography, to the relatively young mechanical bride, photography. The typographer's task is to create a constellation of type with the exact position, the precise size, and the particular value to strike harmony with the picture image. It is the deceptively

simple and ancient process of the stonecutter and the scribe brought to contemporary page design. Photographs do not give the designer the sturdy linear illustration to fuse with type. A palette of optically drawn gradations of light makes a fragile partner for ranks of staccato type.

In 1910 the Russian artist El Lissitsky led the way in fusing the two media. Within ten years he was followed by a regiment of fellow artist-designers, including Rodchenko, Moholy-Nagy, Heartfield, Grosz, and in the 1930s Herbert Matter. Although rarely using photography, A.M. Cassandre was an early master in celebrating picture and word in one continuous stroke.

While Bradbury Thompson's fusion of photography and typography on the printed page was also revolutionary, his style marked a turning from the free-form relationships of the 1920s to a new classicism and respect for history. In his construction DANCE [fig.166], we see the playful interaction of type and photography reinforcing the literal message of the word. Liberties are taken to make letters and pictures bounce in a lyrical manner that defies both gravity and convention. The covers for *Westvaco Inspirations 198, 204,* and *210* are classic examples of a designer and photographer working closely to merge ideas and media arts into one [pages 132, 136, 140]. In it is a clear lesson of two artists exchanging thoughts and balancing talents to make a whole.

The visual duet of the "scribe" and the "painter" is a long and continuing history with countless shapes and forms.

148 Opposite: *Image & Word.* A photograph made originally for *Mademoiselle* by H. Landshoff to provide appealing pages for young buyers of fashion became graphic design with typography, in *Westvaco Inspirations 204* in 1956.

John T. Hill is a former director of graduate studies in photography and a teacher of graphic design at Yale University. He himself is a photographer and has produced books on the work of Walker Evans and Herbert Matter.

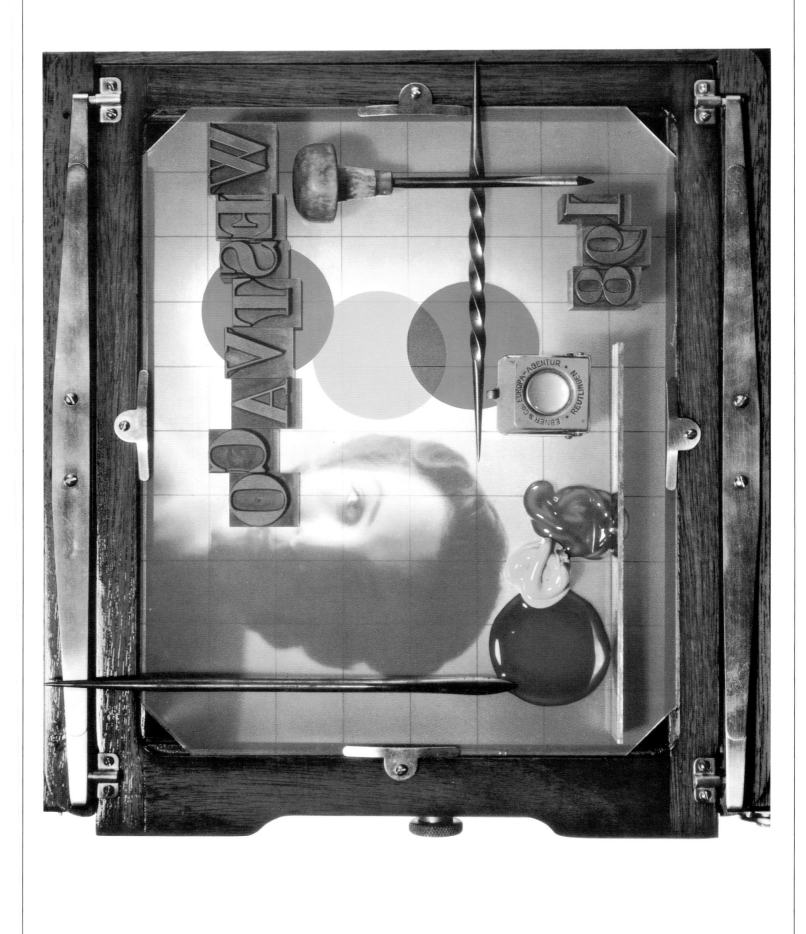

149 *Photography, Typography, and Printing.* This cover for issue 198 is a symbolic image
by Ben Somoroff integrating three arts on the ground glass of a camera. 1954

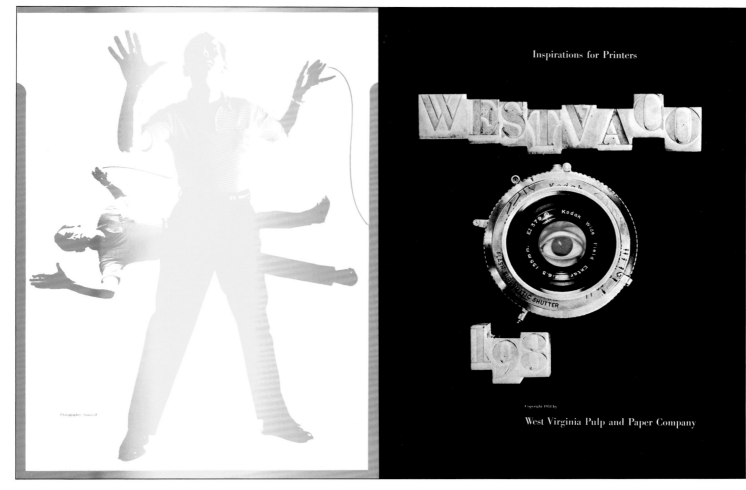

150 *Photo-Graphic Frontispiece I*. Above is the self-portrait of the photographer.
It was printed on a one-color press in three split-fountain ink colors. The eye is
peering through a die-cut hole in a camera lens from a following page. 1954

151 *Photo-Graphic Colophon I*. A diagram of printing processes faces a colorful
photogram by Sol Mednick. These three spreads from a *Westvaco Inspirations*
are examples of designer and photographer fusing thoughts and images.

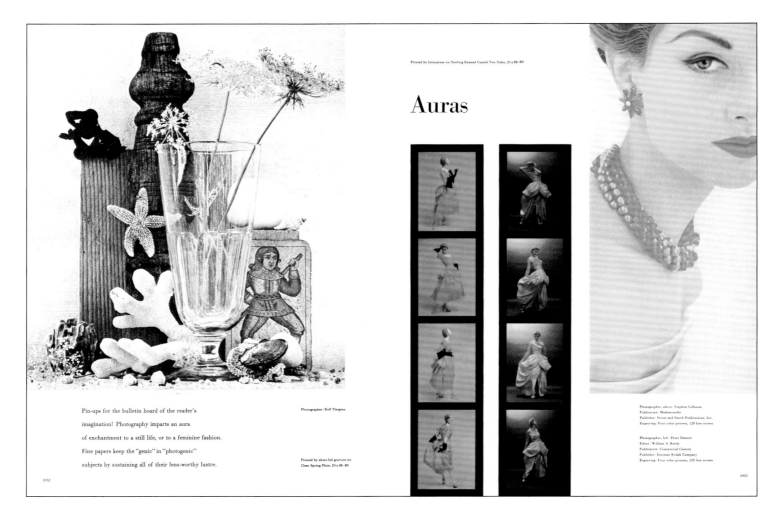

Printed by letterpress on Sterling Enamel Coated Two Sides, 25 x 38 - 80

Auras

Photographer: Rolf Tietgens

Pin-ups for the bulletin board of the reader's
imagination! Photography imparts an aura
of enchantment to a still life, or to a feminine fashion.
Fine papers keep the "genic" in "photogenic"
subjects by sustaining all of their lens-worthy lustre.

Printed by sheet-fed gravure on
Clear Spring Plate, 25 x 38 - 80

Photographer, above: Stephen Colhoun
Publication: Mademoiselle
Publisher: Street and Smith Publications, Inc.
Engraving: Four color process, 120 line screen

Photographer, left: Peter Dimitri
Editor: William A. Reedy
Publication: Commercial Camera
Publisher: Eastman Kodak Company
Engraving: Four color process, 133 line screen

152 *Auras.* At left, an enchanting still life by Rolf Tietgens interfaces with fashion
photographs in full color by Stephen Colhoun from pages of *Mademoiselle.*

153 *Humans.* Rowboat by Arthur Siegel and clown by Norman Rothchild. Photos
enable people everywhere to share human emotions and intimate moods.

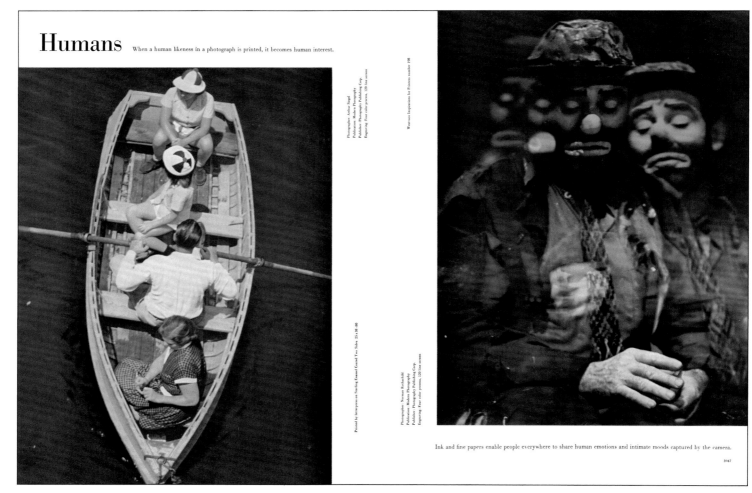

Humans When a human likeness in a photograph is printed, it becomes human interest.

Photographer: Arthur Siegel
Publication: Modern Photography
Publisher: Photography Publishing Corp.
Engraving: Four color process, 120 line screen

Warrior's Inspiration for Printers number 198

Photographer: Norman Rothchild
Publication: Modern Photography
Publisher: Photography Publishing Corp.
Engraving: Four color process, 120 line screen

Printed by letterpress on Sterling Enamel Coated Two Sides, 25 x 38 - 80

Ink and fine papers enable people everywhere to share human emotions and intimate moods captured by the camera.

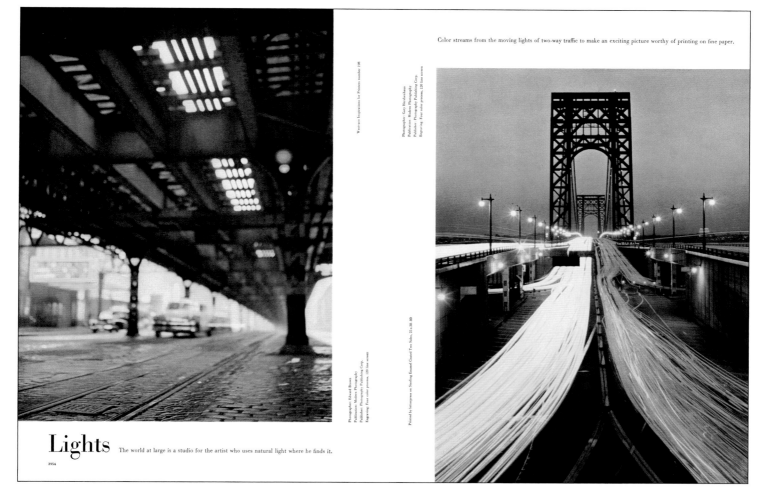

Photographer: Edward Brown
Publication: Modern Photography
Publisher: Photography Publishing Corp.
Engraving: Four color process, 120 line screen

Westvaco Inspirations for Printers number 198

Photographer: Gary Hershenhaus
Publication: Modern Photography
Publisher: Photography Publishing Corp.
Engraving: Four color process, 120 line screen

Printed by letterpress on Sterling Enamel Coated Two Sides, 25 x 38 -80

Color streams from the moving lights of two-way traffic to make an exciting picture worthy of printing on fine paper.

Lights

The world at large is a studio for the artist who uses natural light where he finds it.

3954

154 *Lights.* The old elevated recorded by Edward Brown and moving lights of traffic by Gary Hershenhaus show the world as a studio with superior light.

155 *Shapes.* Fence 6 by K. Helmer-Peterson, a lemon by Arthur Siegel, a photogram by Herbert Matter, a fly by Murray Laden, and autos by Louis Faurer.

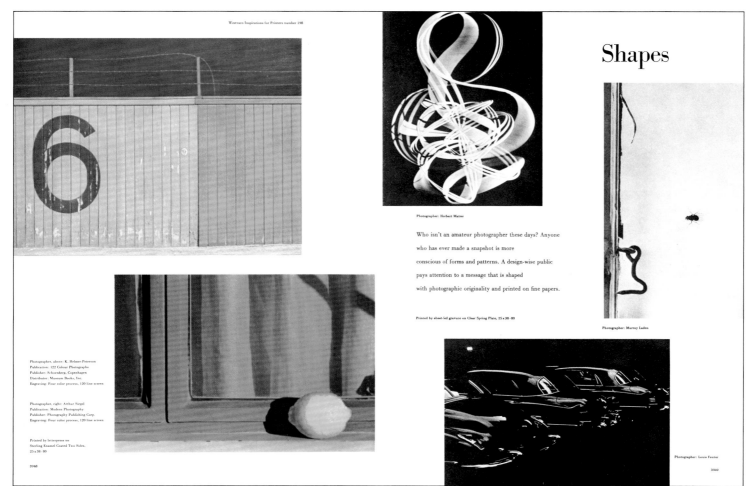

Westvaco Inspirations for Printers number 198

Photographer: Herbert Matter

Shapes

Who isn't an amateur photographer these days? Anyone who has ever made a snapshot is more conscious of forms and patterns. A design-wise public pays attention to a message that is shaped with photographic originality and printed on fine papers.

Printed by sheet-fed gravure on Clear Spring Plate, 25 x 38 -80

Photographer: Murray Laden

Photographer, above: K. Helmer-Peterson
Publication: 122 Colour Photographs
Publisher: Schønberg, Copenhagen
Distributor: Museum Books, Inc.
Engraving: Four color process, 120 line screen

Photographer, right: Arthur Siegel
Publication: Modern Photography
Publisher: Photography Publishing Corp.
Engraving: Four color process, 120 line screen

Printed by letterpress on
Sterling Enamel Coated Two Sides,
25 x 38 -80

3948

Photographer: Louis Faurer

3949

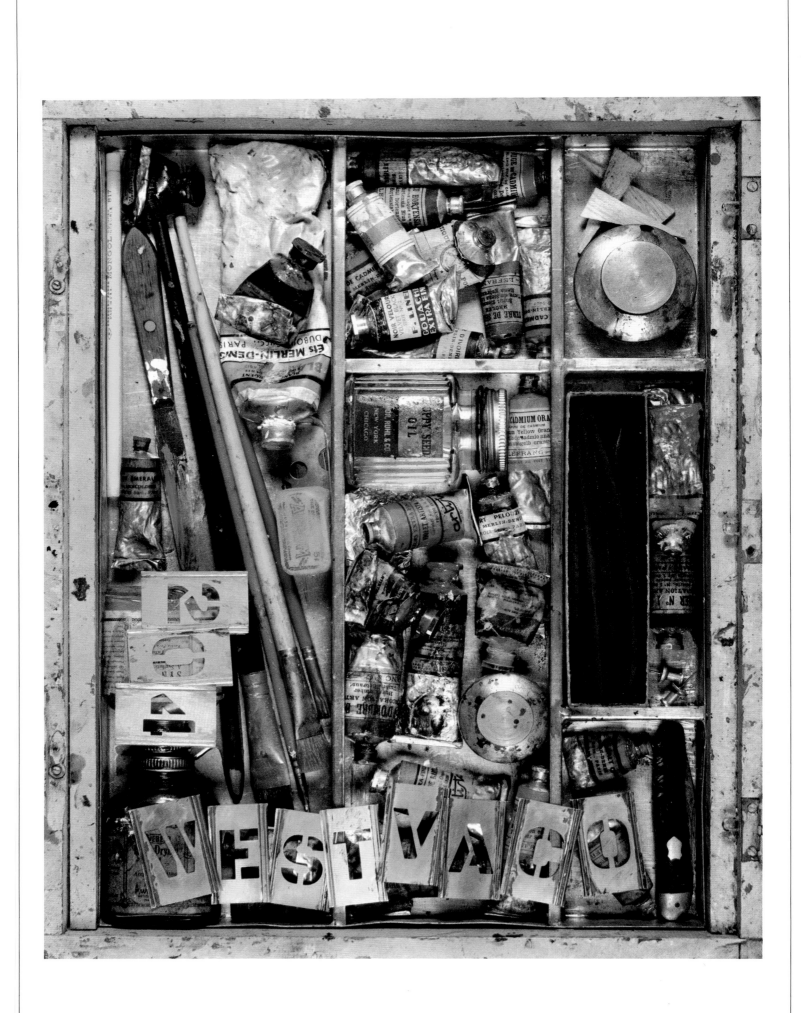

156 *Westvaco 204.* A photograph by Rolf Tietgens of a painter's studio drawer made into a homogenous cover, with the designer's brass stencils as logo. 1956

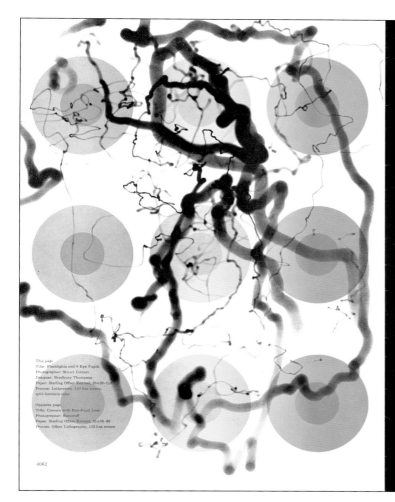

Printing:
The art preservative
of all the arts

Photography:
The art perceptive
of all the arts

PHOTOGRAPHY

157 *Photo-Graphic Frontispiece II.* The fluid black lines at left are a photograph by Stuart Gildart of drops of ink descending in water. They overprint repeated camera lenses in the split-fountain color technique of figure 150.

158 *Photo-Graphic Colophon II.* The background below was a photogram by Helen Federico reproduced as was figure 157. Also the large typeface, issue 204, was a photogram from the brass stencil alphabet on the cover, opposite. 1956

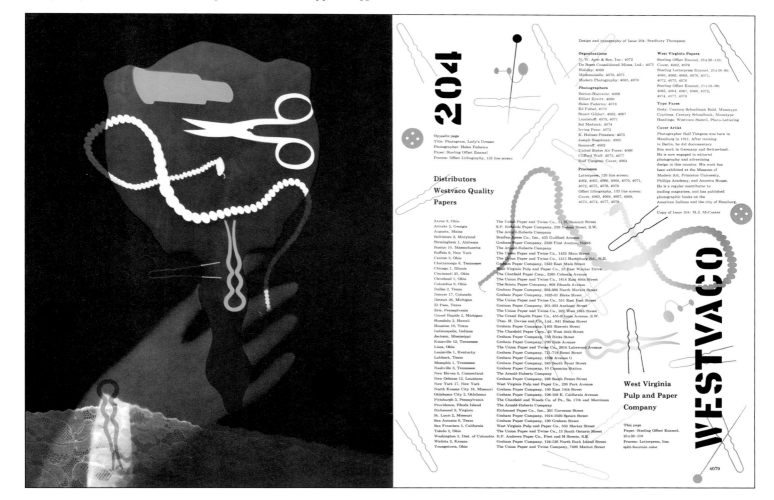

CHEMISTRY

Photography has made the scientific test, below, a familiar picture to everyone. Less awesome but more difficult to identify is the experiment at the right: a close-up of a drop of ink being spilled into water. Lens work, conveyed by printing and fine papers, interprets advances made by chemistry and other sciences. Photography is a vital source of communication.

This page
Title: Test of a Hydrogen Bomb
Photographer: United States Air Force
Paper: Sterling Letterpress Enamel, 25 x 38 - 80
Process: Letterpress, 120 line screen

Opposite page
Title: Drop of Ink in Water
Photographer: Stuart Gildart
Paper: Sterling Offset Enamel, 25 x 38 - 80
Process: Offset Lithography, 133 line screen

4066

159 *Chemistry.* The hydrogen bomb test photograph by the U.S. Air Force and the photograph by Stuart Gildart of inkdrops in water provide thematic contrast.

160 *Dance II.* The photograph of "dancers plus photogram" by Rolf Tietgens and "dancers in motion" by Joseph Siegelman present contrasting techniques.

The photographer provides perceptual power to augment enjoyment and understanding of the arts and sciences. Through the art of photography, for instance, one may discover the poetic patterns of a primitive dance or sense the synchronous movement in exercises performed by a pair of ballet dancers. It is worth noting that all pictorial material in this issue is photographic. Printed by either letterpress or offset lithography, the illustrations from cover to cover indicate the high level of artistry to be achieved when photography, presswork, and paper in the graphic arts are as well combined as choreography, music, and costume in the art of the ballet.

DANCE

Opposite page
Title: Dancers Through Fabric Plus Photogram
Photographer: Rolf Tietgens
Paper: Sterling Offset Enamel, 25 x 38 - 80
Process: Offset Lithography, 133 line screen

This page
Title: Dancers in Motion
Photographer: Joseph Siegelman
Publication: Modern Photography
Paper: Sterling Letterpress Enamel, 25 x 38 - 80
Process: Letterpress, 120 line screen

4065

GEOMETRY

Is that a puzzle in polygons at the left? Or an abstraction in modern art?
Actually it's a photogram: a picture of film holders made by the
action of light on photographic film without using a lens. Like the painter
and etcher, the photographer incorporates lines, surfaces, and
solids in a picture. He studies angles and constructs a window of interest
that beckons the eye to enter. In creating and reproducing pictures,
the use of good materials is an axiom accepted by both artists and printers.

Opposite page
Title: Photogram of Film Holders
Photographer: Sol Mednick
Paper: Sterling Offset Enamel, 25 x 38-80
Process: Offset Lithography, 133 line screen

This page
Title: Rooftops in Denmark, detail
Photographer: K. Helmer-Petersen
Publication: 122 Colour Photographs
Paper: Sterling Letterpress Enamel, 25 x 38-80
Process: Letterpress, 150 line screen

4075

161 *Geometry.* The sophisticated photogram of film holders by Sol Mednick both contrasts and harmonizes with mellowing rooftops by K. Helmer-Peterson.

162 *Architecture.* Classic imagery prevails in the sculptured head photographed by Becker-Horowitz and the Lincoln Memorial photographed by Elliott Erwitt.

This page
Title: Sculptured Head With Hair
Photographer: Becker-Horowitz
Paper: Sterling Offset Enamel, 25 x 38-80
Process: Offset Lithography, 133 line screen

Opposite page
Title: Lincoln Memorial in Reflecting Pool
Photographer: Elliott Erwitt
Publication: Holiday
Paper: Sterling Letterpress Enamel, 25 x 38-80
Process: Letterpress, 120 line screen

Tresses of hair sweep across the features
of a carven image. Stately columns
shimmer in the reflection of flowery waters.
Camera art unlocks the creative
warmth confined within the cold stone
of architectural form. The great
reproductive power of paper and printing
enables everyone to share in the
camera's discovery of unsuspected beauty.

ARCHITECTURE

4068

163 *Geometry & Color.* This cover with white geometric objects for *Inspirations 210* was by Stephen Colhoun using four different color-filter exposures. 1958

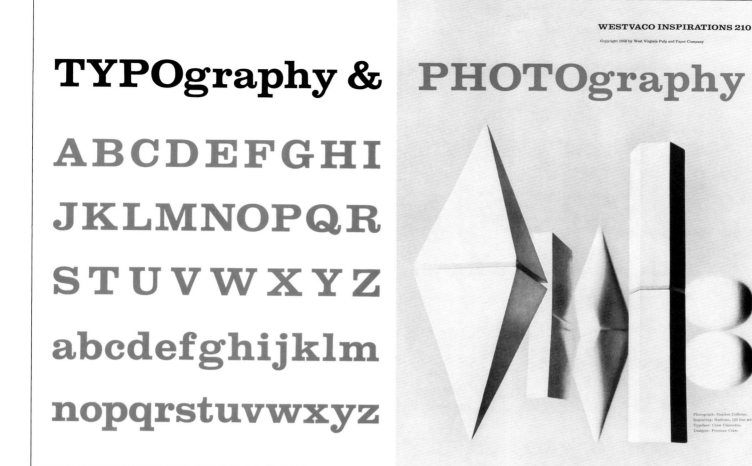

164 *Typo-Photo Frontispiece.* The white forms on the cover were photographed on a mirror for this spread. For an illusion the image was printed upside down.

165 *Alphabet as Eye Chart.* Two letters O surprinted on a human face adjacent to the alphabet create a clear pun to symbolize the meaning of graphic design.

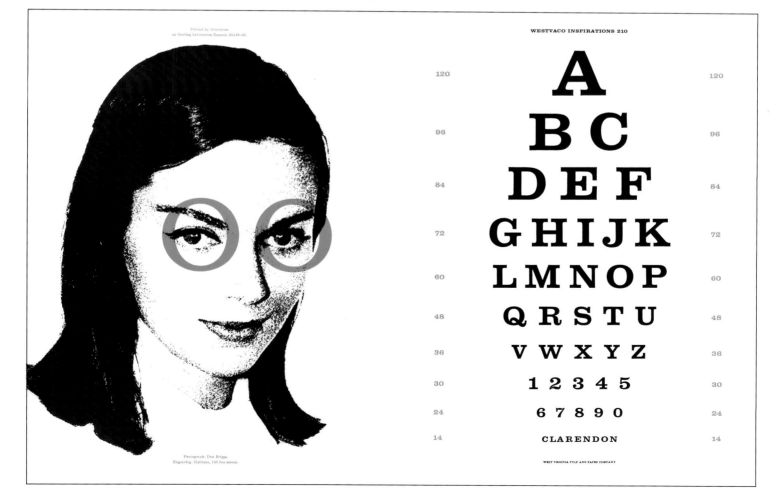

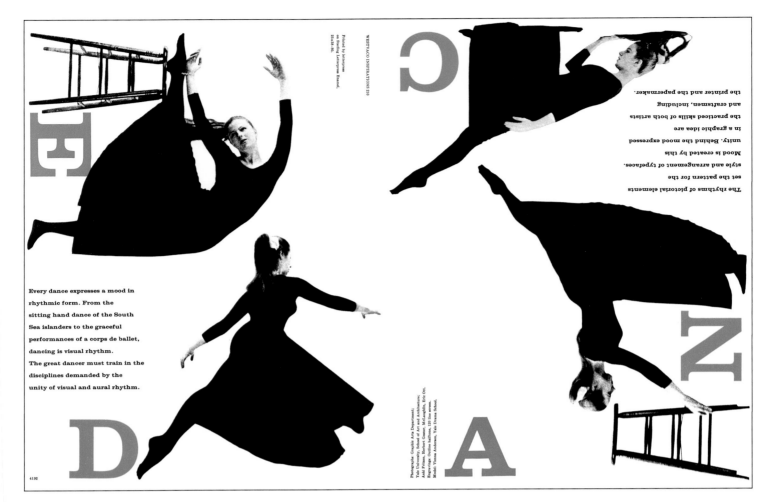

166 *Dance.* Photographs of a model and the letters D-A-N-C-E do literally dance
around the four edges of a two-page spread expressive of the art itself. 1958

167 *Photo and Type as Teammates.* Interfusing the two arts in graphic design can be
a playful as well as a serious game, as shown on the final pages of this chapter.

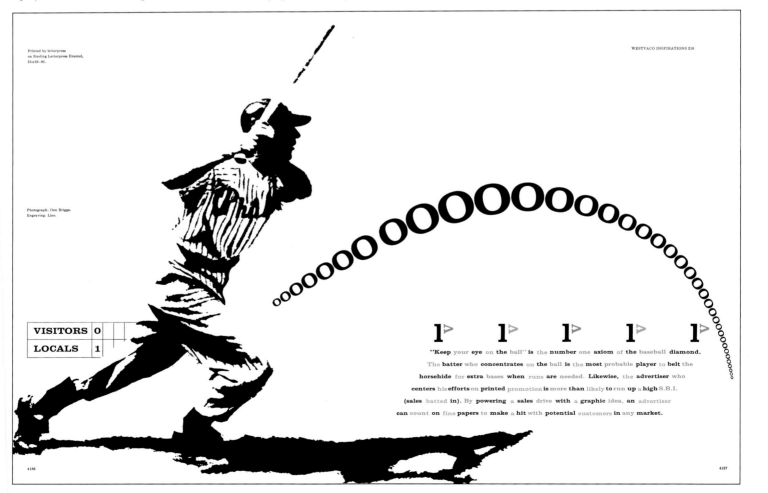

12 Learning and teaching

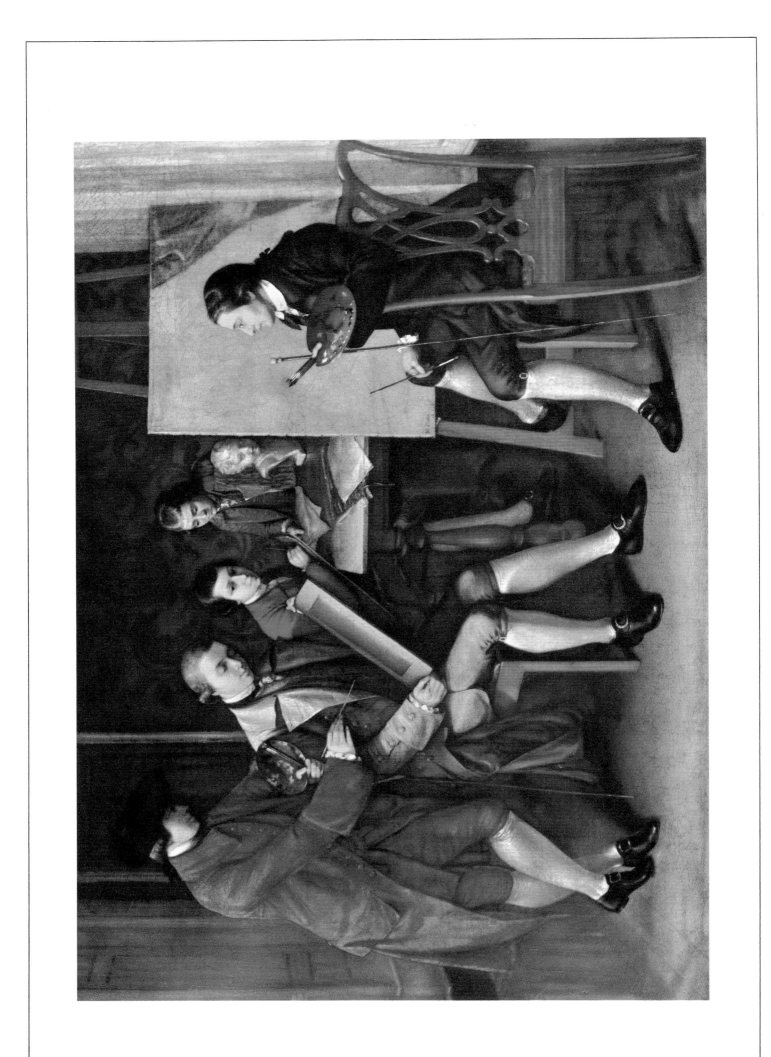

168 *The American School*, 1765, by Matthew Pratt, an art student of
Benjamin West, from the Metropolitan Museum of Art, New York.

12

Learning and teaching

Understanding and applying
five centuries of graphic design history

The theme of *Art News Annual* in 1945 was the 75th anniversary of the Metropolitan Museum of Art. This was the first issue for which Bradbury Thompson was the magazine's design director. The editorial structure of the publication divided the collections of this great museum into eight chronological chapters: Early Civilizations, The Classical World, Early Christian Art, The Middle Ages, The Renaissance, Baroque and Rococo, The Nineteenth Century, and Our Time.

It was as if Dr. Alfred M. Frankfurter, the scholar-editor of *Art News*, had conceived the perfect theme by which to reintroduce his new young designer to 5000 years of art history. It was especially instructive to view art history in these chronological divisions and further to contemplate the proper relationship of 500 years of typography within the specific periods of art.

Work on this issue of the publication was mainly with Dr. Frankfurter and Aline Loucheim Saarinen, then the managing editor. Other distinguished members of the staff during the designer's 27 years at *Art News* included Thomas B. Hess, later the editor of *Art News* and curator of modern painting at the Metropolitan Museum of Art, Henry A. LaFarge, Eleanor Munro, and Elizabeth C. Baker, later the editor of *Art in America*.

Especially close working and learning relationships were enjoyed with Alfred Frankfurter and Tom Hess. Editorial and design discussions with one or both of them took place on every story appearing in *Art News* and *Art News Annual*

from 1945 to 1972. While the financial remuneration was modest and the production budget limited, the learning experience was very large indeed.

Many printed rewards of the designer's *Art News* tenure were reflected in the art content of *Westvaco Inspirations*, *Mademoiselle* magazine, and the 8th and 9th editions of the *Graphic Arts Production Yearbook*.

In 1956 the learning experience on the 1945 anniversary issue for the Metropolitan Museum was applied directly to the concept and format of *Westvaco Inspirations 206*, the theme of which was the typography and related arts of the five centuries since Gutenberg. [Pages 146-52].

The text copy of issue 206 was written by Frank Denman, author of *The Shaping of Our Alphabet* (Alfred A. Knopf, 1957). The chronological listing of salient historical events throughout the issue was prepared by the designer.

Inspirations 206 had just been completed when Professor Alvin Eisenman, head of the graphic design program at Yale University, visited my studio at *Mademoiselle* in New York City with an invitation to teach a graduate course in his program. Quite naturally, the teaching concept of *Inspirations 206* found its way into my first course at the university. It has been taught there for three decades.

Each student was asked to select a theme of his or her choice on such subjects as architecture, transportation, love, war, medicine, or games. The student was then asked to originate seven booklet spreads [continued on page 152]

Learning and Teaching. Opposite, the cover for *Westvaco Inspirations 202* showing the great American-born painter Benjamin West, 1738-1820, in his London studio. His students included foremost American painters.

Paper:
Sterling Letterpress Enamel, 25 x 38 = 90.
Printed by letterpress.

Architecture:
Cathedral of Cologne, Germany,
1248-1880.
From the Bettmann Archive.

Gothic

art was the product of an age when time had little significance. Since this art usually served as an expression of religious feeling, its creation became an act of devotion, to which no craftsman dared give less than his best. Men dedicated years to copying and embellishing a single manuscript book; and a cathedral grew through the centuries. The magnificently illuminated manuscripts of the time were the models on which Gutenberg and his contemporaries patterned such monumental works as the 42-line Bible and the 1457 Psalter. Their letter forms seem strange to our unaccustomed eyes, but in the rich texture and fine proportion of their type pages, and the sharpness of their presswork, they stand as an inspiration to modern craftsmanship.

4104

Printer's mark:
William Caxton,
Westminster, 1421-91.

Typeface:
Cloister Black.
Derived from earliest movable types,
Germany, ca. 1450.

Crest:
Family of Johann Gutenberg,
Germany, ca. 1397-1468.

*Represented in this chapter are the major periods
in typographic art since Gutenberg's time.
Typefaces of each era are arranged together
with contemporary painting, architecture, and engraving,
yet the format is in the style of today.*

Printer's mark:
Fust and Schoeffer.
Mainz. 1457.

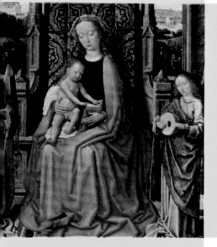

Painting:
Virgin and Child, detail.
By Gerard David. Flanders. 1460-1523.
From the Metropolitan Museum of Art.

Sculpture:
Holy Woman.
Flanders. 1450-1500.
From the Metropolitan Museum of Art.

B C D E F G H I
K L M N O P Q R
T U V W X Y Z

c d e f g h i j k l m

p q r s t u b w x y z

2 3 4 5 6 7 8 9 0

Chronology

1400 Chaucer dies.
 Wars of Italian city-states throughout
 century; Venice grows stronger.
1405 In Flanders papermaking first
 mentioned in this locality.
 Previous European papermaking first
 recorded in Spain in 1151, Italy in 1276,
 France in 1348, Germany in 1390.
 Origin in China, 105 A.D.
1415 Limbourg brothers complete Book of
 Hours for Duke of Berry.
1423 Beginning of block printing in Europe
 by use of ancient Chinese method.
1431 Joan of Arc is burned at the stake.
1446 First dated intaglio print by
 Master of the Year 1446.
 Other undated engravings believed
 executed a decade earlier.
1450-5 Johann Gutenberg's 42-line Bible
 produced in Mainz. The beginning of
 book printing in Europe and the use of
 paper on a comparatively large scale.
1453 End of Hundred Years War.
1457 Earliest known printer's mark of
 Fust and Schoeffer, Mainz.
1460 First illustrated books with woodcuts
 printed by Albrecht Pfister in Bamberg.
1465 Swepnheym and Pannartz migrate to
 Subiaco from Mainz to establish press.
1469 First book produced in Venice by
 John de Spire.

Continued on page 4107.

169 *Gothic.* The historical credits in the design above identify the typeface, painting, architecture, and printer's marks of Gutenberg's world. The chronological listing will assist in understanding the period from 1400 to 1470.

Painting:
The Annunciation.
By Leonardo da Vinci, Italy, 1452-1519.
From the Uffizi, Florence.

A B C D E F G H I J K L M
N O P Q R S T U V W X Y Z

a b c d e f g h i j k l m n o p q r
s t u v w x y z 1 2 3 4 5 6 7 8 9 0

Italy was separated from still-Mediaeval Germany by much more than a range of mountains. When Sweynheim and Pannartz carried the art of printing across the Alps, they found themselves not only in a different country, but in a different age. Here man had rediscovered the beauty and the wisdom of the classic era, and printing was exactly the vehicle he needed to spread his new-found culture. German printers found, too, that their Italian customers were familiar with different letter forms: the "humanistic" script which became our roman type face, and a less formal writing which became our italic. Upon these patterns Jenson, Aldus and others designed types that we are copying today.

Typeface:
Text, Cloister Old Style; heading, Centaur.
Derived from the types of Nicolas Jenson,
in the *Eusebius*, Venice, 1470.

Paper:
Sterling Letterpress Enamel, 25 x 38 - 90.
Printed by letterpress.

4106

The fifteenth century alphabets of Jenson and Aldus
can be as readable as present-day letters,
and when used with a Leonardo painting or a Bramante church,
the compatibility of Renaissance graphics
can produce pleasing artistic results.

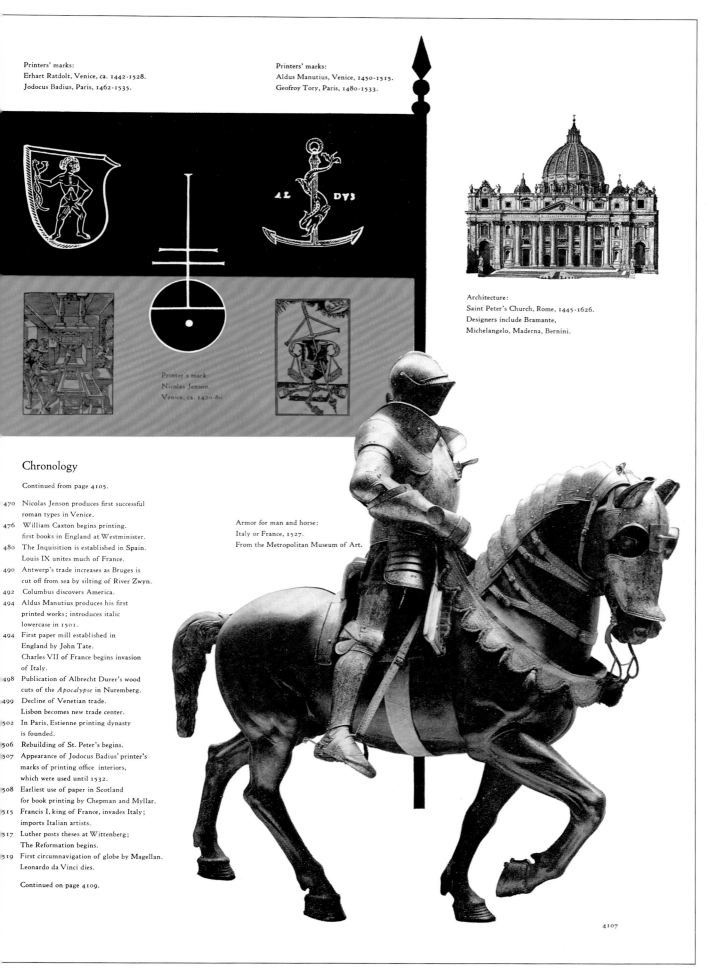

Printers' marks:
Erhart Ratdolt, Venice, ca. 1442-1528.
Jodocus Badius, Paris, 1462-1535.

Printers' marks:
Aldus Manutius, Venice, 1450-1515.
Geofroy Tory, Paris, 1480-1533.

Architecture:
Saint Peter's Church, Rome, 1445-1626.
Designers include Bramante,
Michelangelo, Maderna, Bernini.

Printer's mark:
Nicolas Jenson,
Venice, ca. 1420-80.

Armor for man and horse:
Italy or France, 1527.
From the Metropolitan Museum of Art.

Chronology

Continued from page 4105.

470 Nicolas Jenson produces first successful
roman types in Venice.

476 William Caxton begins printing.
first books in England at Westminister.

480 The Inquisition is established in Spain.
Louis IX unites much of France.

490 Antwerp's trade increases as Bruges is
cut off from sea by silting of River Zwyn.

492 Columbus discovers America.

494 Aldus Manutius produces his first
printed works; introduces italic
lowercase in 1501.

494 First paper mill established in
England by John Tate.
Charles VII of France begins invasion
of Italy.

498 Publication of Albrecht Durer's wood
cuts of the *Apocalypse* in Nuremberg.

499 Decline of Venetian trade.
Lisbon becomes new trade center.

502 In Paris, Estienne printing dynasty
is founded.

506 Rebuilding of St. Peter's begins.

507 Appearance of Jodocus Badius' printer's
marks of printing office interiors,
which were used until 1532.

508 Earliest use of paper in Scotland
for book printing by Chepman and Myllar.

515 Francis I, king of France, invades Italy;
imports Italian artists.

517 Luther posts theses at Wittenberg;
The Reformation begins.

519 First circumnavigation of globe by Magellan.
Leonardo da Vinci dies.

Continued on page 4109.

4107

170 *Renaissance.* The printer's marks of Jenson, Ratdolt, Aldus, Badius, and Tory
 are mingled with a masterpiece painting by Leonardo and classic architecture
 and craftsmanship of the era. *Bembo* type from the work of Aldus, although
 not shown here, is an appropriate representative face of this historic period.

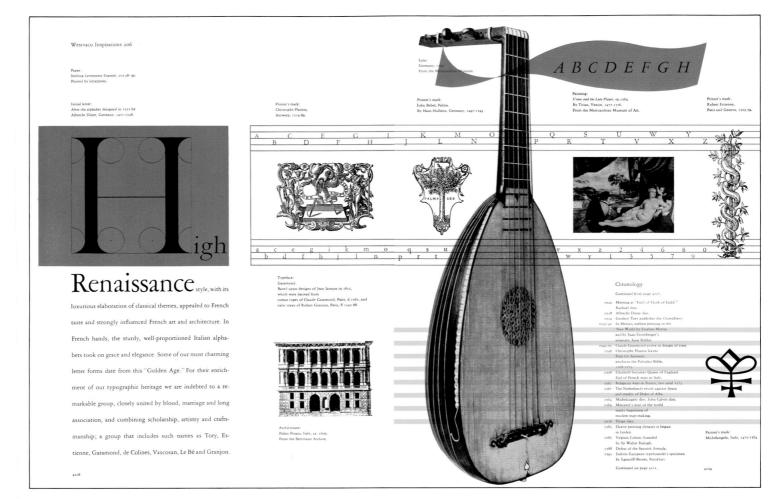

171 *High Renaissance.* The printer's marks of Plantin, Bebel, and Estienne are mingled with heroic painting, architecture, a precious lute, Michelangelo's family mark. The Titian painting is appropriately *Venus and the Lute Player.*

173 *Rococo into Neoclassic.* Master works of painting and architecture are mingled with the classic craftsmanship of Hepplewhite and Rittenhouse, the innovative typeface of Baskerville, and the typographic flowers of Caslon.

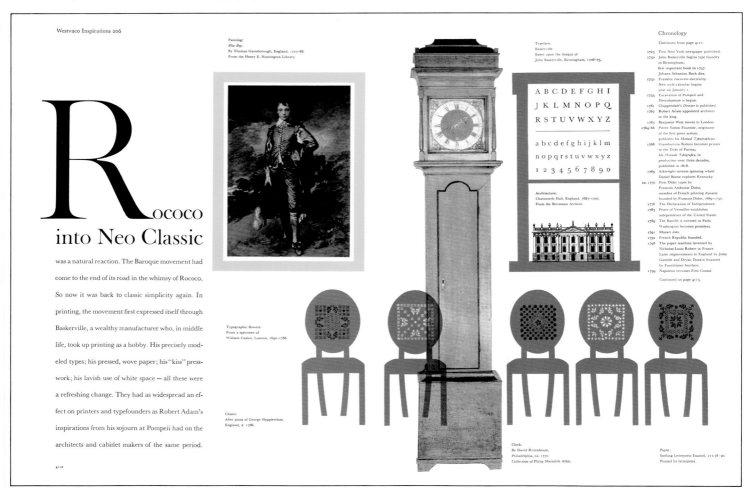

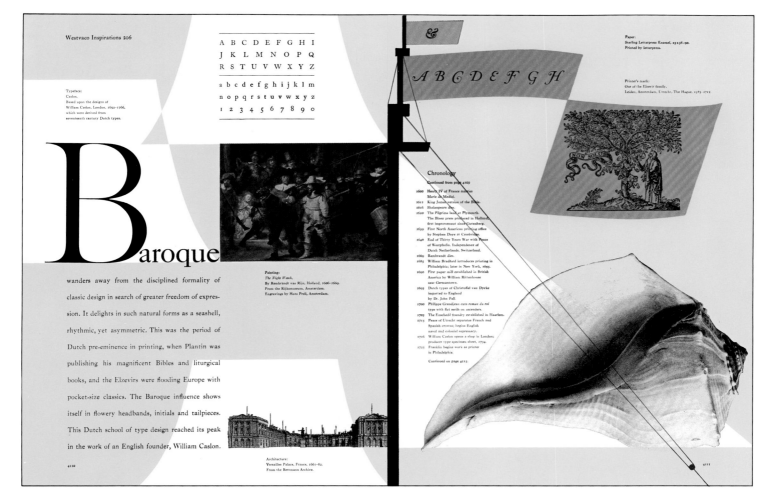

172 *Baroque.* The symbolic seashell and seafaring mast and sail are blended together with human masterpieces of painting, architecture, and typography of the Baroque world. The chronological listing covers 1600-1725.

174 *Modern.* The title refers to the period during the 1800s when "oldstyle" typefaces were being replaced through the influence of the more "modern" geometrical typographic designs of Bodoni in Italy and Didot in France.

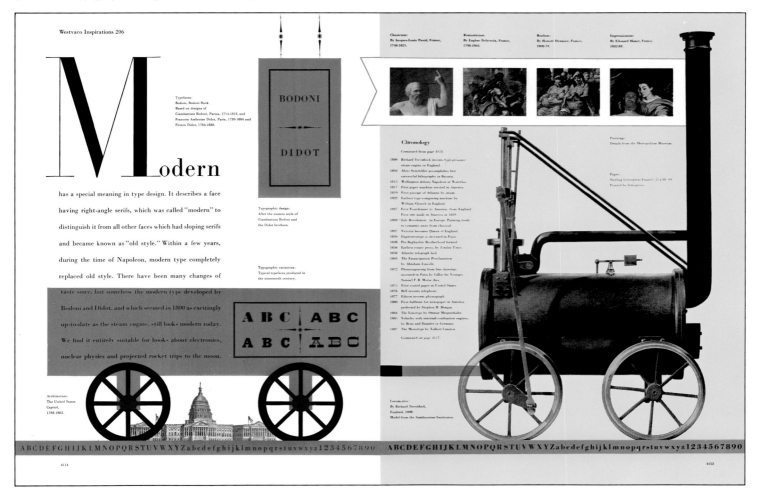

Learning and teaching, continued from page 145

in which the chosen theme was expressed in the typefaces and graphic images representative of each of seven historical periods: Renaissance, Baroque, Georgian, Neoclassical, Victorian, Art Deco, and Contemporary.

The student was also to provide approximately 150 words of copy, captions, and a heading. The text could be prose or poetry written by the individual or selected from appropriate thematic and historical sources. All typesetting was done by the individual designer-editor on the typographic equipment of the graphics department. The project demanded library research and selection and editing skills. Attention was paid to the design integrity of each spread as well as of the booklet as a whole, the size and shape of which was chosen by each student to fit the theme logically.

The spreads finally would be completed as a booklet with a cover, endleaves, title page, contents page, appendix, and colophon. The binding of the booklet was the responsibility of each student. This project was thoroughly reviewed at each of the seven successive stages.

While the student designer-editors worked with alphabets and images of past centuries, they were required to create the book in the spirit of their own time. A major objective in teaching this course has always been to inspire a personal sense of familiarity with the history of typography and all the visual arts – a familiarity comparable to the students' personal grasp of their grandparents', parents', and their own lives and times.

You tell me, and I forget.
You teach me, and I remember.
You involve me, and I learn.
[These words
by Benjamin Franklin
apply very well to the teaching
of graphic design]

175 *Present Century.* Here are new symbols of a vastly changing world of abstract art, skyscrapers, sans serif types, airplanes, and automotive interchanges. Science and technology were preparing for computer graphics.

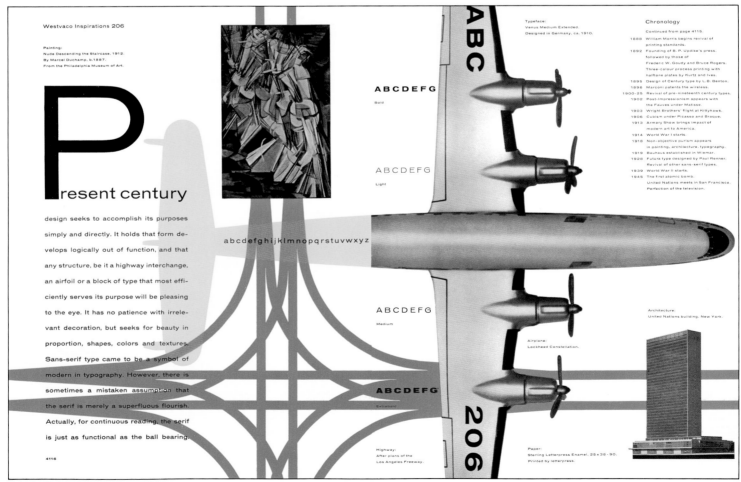

177 Ornate initials arranged according to chronology and terminology.

Gothic period
Example: Lombardic Capitals, Monotype.

Renaissance period
Example: Cloister Initials, American Type Founders.

High Renaissance period
Example: Tory Initials, American Type Founders.

Baroque period
Example: Baroque Initials, Photo-Lettering.

Rococo period
Example: Vogue Initials, American Type Founders.

Neo-Classic period
Example: Commercial Script, American Type Founders.

Victorian period
Example: Eldorado B (Umbra), Photo-Lettering.

Present century
Example: Prisma, Bauer Type Foundry.

176 Familiar typefaces arranged according to chronology and terminology.

German Black Letter
A B C D E F G
H I J K L M N
Example: Cloister Black.

Venetian Old Style
A B C D E F G
H I J K L M N
Example: Cloister.

French Old Style
A B C D E F G
H I J K L M N
Example: Garamond.

Dutch-English Old Style
A B C D E F G
H I J K L M N
Example: Caslon.

Transitional
A B C D E F G
H I J K L M N
Example: Baskerville.

Modern
A B C D E F G
H I J K L M N
Example: Bodoni.

Square Serif
A B C D E F G
H I J K L M N
Example: Ionic.

Sans Serif
A B C D E F G
H I J K L M N
Example: Venus Medium.

From a manual of the art of typography,
Westvaco Inspirations 206,1956

The art of typography, like architecture,
is concerned with beauty and utility
in contemporary terms.
It is devoted to the harmonious reproduction
of typefaces, illustrations and inks on fine paper.
Typography, furthermore,
is concerned with literature –
the presentation of fiction and fact,
the interpretation of the poetic and the prosaic.
The typographic designer must present
the arts and sciences of past centuries
as well as those of today;
he must work with a historical knowledge
of his own art and related human activities.
He knows the fifteenth century alphabet of Jenson
can be as readable as contemporary letters,
and when used with a Leonardo painting
or a Bramante church,
the compatibility of Renaissance design
can produce a pleasing artistic result.
And although he works
with the graphics of past centuries,
he must create in the spirit of his own time,
showing in his designs an essential understanding
rather than a labored copying of past masters.

On these pages of *Westvaco Inspirations*
are examples illustrating this philosophy.
Here is a summary
of the major periods in typographic art
since Gutenberg's invention of movable type
five hundred years ago [pages 146-53].
Typefaces of each era are arranged together
with significant examples
of painting, architecture, and engraving.
A chronological listing will demonstrate
the historical relationships of type design.
Classified charts will assist
in the recognition of typefaces [page 153]
and the periods in which they were created.
To be of practical use
the typefaces appearing in this manual
are the ones most widely available
in printing shops throughout this continent.

The illustrations relating to historical periods
of the past five centuries
are products of their own times.
The typographic presentation
is in the style of today.

The thoughts above in their original usage
applied to the designs and charts
on the preceding eight pages [146-53].

As graphic designers we have more than just
graphic images, the alphabet, and tools with which
to sustain our hopes and aspirations:
[From class discussions with graduate students]

A *Art*
 Affection
B *Beauty*
C *Commitment*
 Courage
 Craftsmanship
 Clarity
D *Determination*
 Draftsmanship
E *Excellence*
F *Fun*
G *Goodness*
 (Not Glory)
 (Not Greatness)
H *History*
 Humor
 Humility
 Hope
I *Integrity*
 Inspiration
J *Journalism*
K *Knowledge*
 Kindness
L *Literature*

M *Morality*
 Marketing
 Mathematics
N *Nature*
O *Order*
P *Perseverance*
 Patience
 Pride
 (In Work)
Q *Quest*
R *Research*
 Resolve
S *Sincerity*
 Self-reliance
T *Truth*
 Tenacity
 Time
U *Usefulness*
V *Venture*
W *Work*
X *(The unknown to pursue)*
Y *Yes*
 (Not No)
 Youth
 (Throughout life)
Z *Zest*

Paper and typographic design

The second issue of *Westvaco Inspirations* to have a
similar teaching purpose was published in 1959.
Republished here and on the following pages,
Inspirations 212 has as its thematic emphasis the history
of paper as well as typography and the related arts.
Similar to issue 206, it includes a complete chronolog-
ical listing of the important events of papermaking
from its invention by the Chinese scholar Ts'ai Lun in
AD 105 to the present. With a magnifying glass the
reader will be able to employ usefully both listings.

The cover painting of issue 212, opposite, is by
Ch'ien Hsuan, 1235-90, from the Detroit Institute of
Arts. The text below it provides an interesting, concise
history of papermaking. It and the other text copy
were written by M. Joseph McCosker, then the director
of the Atwater-Kent Museum in Philadelphia. The
chronological listings were by the designer.

Cover 212. Painting on paper by Ch'ien Hsuan, 1235-90, China. From the Detroit Institute of Arts.

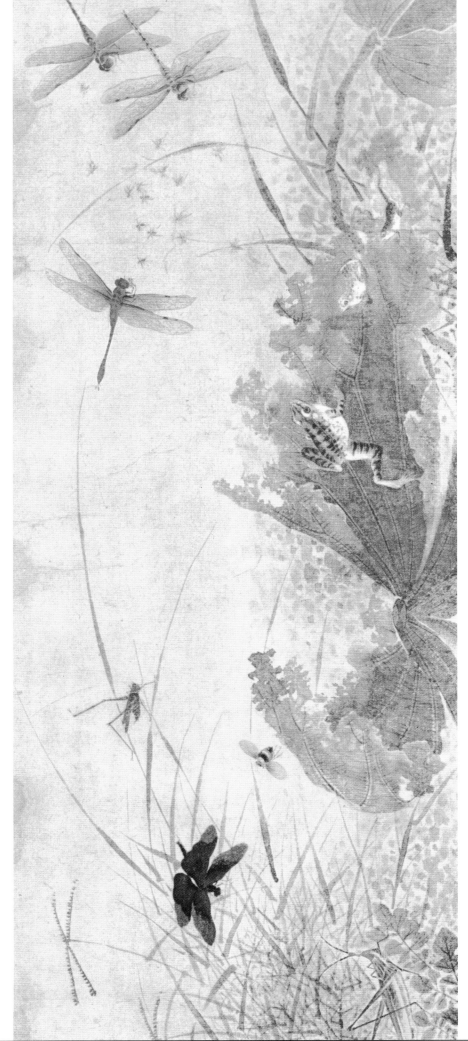

Westvaco Inspirations

212

History of paper

and typographic design

Paper was invented by the Chinese scholar, Ts'ai Lun, in the year 105 A.D. His method has remained basic in papermaking from that time to the present: organic fibres were beaten and reduced to pulp, plunged into pure water, and formed into a thin layer by a porous mould. In the Taoist philosophy that swept China in Ts'ai Lun's time, papermaking was an art achieved with 'yin' and 'yang'. The natural fibres and pure water were the passive 'yin' which responded so harmoniously with the dynamic 'yang' of man's creative skill. Paper provided a perfect element for Chinese creative ideas. For example, the 700-year-old painting on paper by Ch'ien Hsüan, on these triptych-like pages of cover, remains vital in expressing a harmonious relationship between the artist and Nature. The Chinese secret of papermaking fell to the Arabs when they conquered the East-West market place of Samarkand. Traveling from Samarkand to Baghdad and thence to Egypt and Morocco, papermaking ultimately obtained a foothold in Europe when the Moors established a paper mill at Jativa, Spain in 1150. The art of papermaking moved its way gradually through Europe. At the dawn of the fifteenth century, paper mills had been founded in Italy, France and Germany. Paper was now ready to assume its important role in the destiny of Western civilization. There remained only the invention of Gutenberg's printing press in 1440 for paper to become the prime carrier of man's greatest ideas.

Woodcut:
The Parchment Maker.
By Jost Amman.

Continued from inside front cover.

1147	Jean Montgolfier, a Crusader and prisoner of the Saracens, was forced to work in a Damascus paper mill. He returned and set up papermaking in Vidalon, France, 1157.
1150-5	Stamping mill for maceration of rags for papermaking started at Jativa, Spain.
1154	First use of paper in Italy.
1228	Paper mill at Fabriano, Italy, first mentioned.
1270	First paper mill in Germany.
1276	Watermarks first made in Europe, Italy.
1293	First paper mill at Bologna, Italy.
1304	Paper money issued in Tabriz, Persia.
1309	First use of paper in England.
1310-27	First use of paper money in Japan.
1322	First use of paper in Holland.
1337	First use in Europe of sizing of paper, using gelatin.
1348	First paper mill in Germany. France.
1390	First paper mill in Germany. Established at Nuremberg. The first recorded strike took place at this mill.
1405	Papermaking reached at Huy in Flanders.
1440	Date ascribed to invention of the printing press with movable types by Johann Gutenberg in Mainz, Germany.
1450-55	Gutenberg's 42-line Bible produced in Mainz. The beginning of book printing in Europe and the use of printing on a comparatively large scale.

Medieval manuscripts were the handiworks of scribes who developed the Gothic letter as pointed and angular as a cathedral spire. The lettering was inscribed by reed or quill on a parchment made from the split skin of sheep, or on vellum, a calfskin treated with lime and rubbed with pumice. In the year 1400, when European papermaking was under way, the demand for reproductions of books was on the increase. One Florentine bookseller alone employed as many as fifty scribes. It was inevitable that the potentialities of paper should call forth the invention of printing with movable types. When this event was achieved by Gutenberg in 1440, the earliest printed books resembled Gothic manuscripts. The wide margins were retained and the Black Letter types imitated Gothic script. Despite the adherence of printing to Gothic traditions, its replacement of parchment and quill with paper and type opened the way for original graphic design.

Paper and Gothic design

Page opposite: From the Gutenberg Bible, Mainz, between 1450-55.

Painting: Madonna and Christ, detail, 1445-55.
By Petrus Christus, Flanders. From the Nelson Gallery, Kansas City.

Paper, this page: Sterling Letterpress Enamel, 25x38-90.
Paper, opposite page: Pinnacle Offset, 25x38-120.

Type face: Cloister Black;
design derived from the earliest movable types, Germany ca. 1440.

179 *Gothic.* A page from the Gutenberg Bible, 1450-55. The text type is *Cloister Black* derived from types of the era. The painting is a detail of a work, 1445-55, by Petrus Christus, Flanders. The chronological listing is for 1147-1455.

180 *Renaissance.* A page from *De Praeparatione Evangelica*, 1470, the first book in Nicolas Jenson's roman type. The woodcut is the earliest known of paper-making, 1568. The painting is *St. Augustine* by Sandro Botticelli, 1444-1510.

Woodcut:
The earliest picture of papermaking, 1568.
By Jost Amman.

Paper chronology

Continued

1465	First mention of blotting paper, in England.
1470	First European printed poster, a bookseller's advertisement, issued by Peter Schöffer.
1476	William Caxton established printing office in Westminster, London.
1486	A schoolmaster-printer at St. Alban, England, issued first English book printed on paper in which colored inks were used for illustration. The Bokys of Hawking and Hunting by Juliana Berners.
1493	First picture of a paper mill used in European book, Nuremberg Chronicle.
1494	First paper mill in England established at Hertfordshire by John Tate.
1497	Paper used for the first time for a guide-book, Mirabilia Romae.
1508	Earliest use of paper in Scotland for book printing, by Chapman and Myllar.
1521	Earliest recorded use of rice straw in Chinese papermaking.
1535	First complete Bible in English.
1535	Myles Coverdale's translation, probably printed in Zurich. It had ten different watermarks.
1540	The glazing, or pressing-hammer, introduced in Germany.
1550	Paper first colored blue by use of dyes known as "smalts".
1550	Wallpaper introduced into Europe from China by Spanish and Dutch traders.

"The Gothic sun set behind the colossal press at Mainz," explained a great French author. This figure of speech was no exaggeration. Printing presses had been established in every country of Western Europe within fifteen years after the death of Gutenberg in 1468. Eight million books were printed in the fifty years that followed his invention of the press at Mainz. The Revival of Learning, centered in Italy, brought about the victory of the Roman letter over the Gothic, due to the influences of such men as Nicolas Jenson and Aldus Manutius in Venice. Even before the year 1500, paper mills operated from Poland to England as the demand for papers burgeoned. Most European papers were coated on each side with gelatine which enabled printers to print on both sides of the paper. This opaque paper, in contrast to the light Oriental paper, was well suited to metal types and heavy pressures of European presses.

Paper and Renaissance design

Page opposite: From De Praeparatione Evangelica of Eusebius, 1470, the first book in Nicolas Jenson's roman type.

Fresco: St. Augustine, detail, 1480.
By Sandro Botticelli, 1444-1510, Florence.
From Ognissanti, Florence; courtesy Skira, Inc., New York.

Paper, this page: Sterling Letterpress Enamel, 25 x 38-90.
Paper, opposite page: Pinnacle Offset, 25 x 38-90.

Type faces: Text, Cloister; Heading, Bembo. Derived from designs of Nicolas Jenson, 1470, and Francesco Griffi, 1490, Venice.

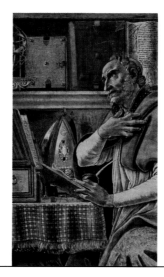

inter circulum æreum igneumque in superficie circumfusum serpentis accipitri formis figuram extendunt ut sit theta græce litteræ figura cōfimilis magnitudinem mūdi ac formam per circulum significantes: p ferpentem uero qui in circuli medio positus est bonum dæmona conferuatorem omnium cuius uirtute mundus contineatur oftendentes. Sed Zoroaftes quoq; magus i l·bro facro i quo ref pficas collegit: hæc ad uerbū fcribit. Deus caput accipitris habet: is fcorruptibilu primus eft fépiternus: ingenitus: expers partium: fibi ipfi fimillimus: bonorū omnium auriga: munera non expectās: optimus: prudétissimus: pater iuris fine doctrina tuftitia: pdoctus: natura pfectus: fapiés: facræ naturæ unicus inuentor: Ideo fimiliter ferpentibus ut cæteris diis immolabant deos maximos ac principes totius arbitrantes .

SEd PHOENICVM theologiam iam per auctores fuos expofuimus quam omīno ut peftiferam fugiendam & fanitaté tantæ infaniæ quærendā falutare prædicat euangeliū: quod autem non fabulæ dictæ funt aut poetarum figmenta altius quiddam quafi nucleum contegentia: fed fapientum prifcorum & theologu ut gentes dicerent uera certaq; teftimonia cunctis antiqora poetis ide patet: q̃ ufq; ad noftram memoriam i phœnicia ifti ipfi dii fic appellati: fic nati: fic educati: utdicti theologi tradiderunt dicūtur: Quare nihil agūt quom ad naturalia quædam turpitudiné occultātes refugiūt quom res fe ipfæ cerimoniæq; deorum una claraq; uoce phœnicum omnium ipfos redarguunt. Sed de phœnicum theologia fatis. Nunc ad ægyptiā tranfeamus ut etiā hinc uideamus rectéan contra gentilium nugas contempfimus & falutarem euāgelii doctrinā fecuti fumus: quā maxime nunc neglectis fuis fáctiffime colit ægyptis: Vniuerfam autem ægyptiorum hiftoriam & theologiam ipforum feorfū in libro quem facrum ifcripfit Manetus quidam ægyptius græca ligua exquifitiffime in mediū edidit. Sed Diodorus etiam ficulus uir clarus omnem ut diximus hiftoriam gentium diligenter breuiter ac ordinate congregatam côfcribens ab ægyptiorum theologia totius negotii fecit initiū a quo potius quafi ab illuftriore notioreq; græcis q̃ ab ægyptio Maneto: hæc ad uerbum fcribenda duximus. De ægyptiori theologia.

AFferunt igitur ægyptii in ter omnium originem hoïes primum

PAVLI IOVII NOVOCOMEN-
fis in Vitas duodecim Vicecomitum Mediolani
Principum Præfatio.

VETVSTATEM nobi-
liffimæ Vicecomitum fami-
liæ qui ambitiofius à præalta
Romanorú Cæfarum origi-
ne, Longobardífq; regibus
deducto ftemmate, repete-
re contédunt, fabulofis pe-
né initiis inuoluere viden-
tur. Nos autem recentiora
illuftrioráque, vti ab omnibus recepta, fequemur: có-
tentique erimus infigni memoria Heriprandi & Gal-
uanii nepotis, qui eximia cum laude rei militaris, ci-
uilífque prudentiæ, Mediolani principem locum te-
nuerunt. Incidit Galuanius in id tempus quo Medio-
lanum à Federico AEnobarbo deletú eft, vir fumma
rerum geftarum gloria, & quod in fatis fuit, infigni
calamitate memorabilis. Captus enim, & ad trium-
phum in Germaniam ductus fuiffe traditur: fed non
multo pòft carceris catenas fregit, ingentíque animi
virtute non femel cæfis Barbaris, vltus iniurias, patriâ
reftituit. Fuit hic(vt Annales ferunt) Othonis nepos,
eius qui ab infigni pietate magnitudinéque animi, ca
nente illo pernobili claffico excitus, ad facrú bellum
in Syriam contendit, communicatis fcilicet confiliis
atque opibus cú Guliermo Montifferrati regulo, qui
à proceritate corporis, Longa fpatha vocabatur. Vo-
luntariorum enim equitum ac peditum delectæ no-
A.iii.

Paper chronology
Continued

1530 Probable date of Persian invention of marbled papers.
1568 First illustration of a papermaker at work to appear in Europe. By Jost Amman in a book of trades published in Frankfurt am Main.
1570 Earliest extra-thin papers produced in Europe.
1576 Probable date of first paper mill in Moscow, Russia.
1575-80 First paper mill established in Mexico at Culhuacán, near Mexico City.
1580 First commercial pasteboard manufactured in Europe.
1586 Earliest mention of national papermaking in Holland. Hans van Aelst and Jan Luipart authorized to make paper, near Dordrecht.
1588 John Spilman, a German, established a papermill at Dartford, England. A year later, he was granted a patent which gave him a monopoly in collecting rags and the making of paper in England.
1590 Introduction of the Persian marbled papers to Europe. The first papers were of the "line combed" variety.
1592 Paper used in printing the first typefounder's specimen sheet in Europe at Frankfurt am Main.
1595 First "paste papers," decorated by the use of coloured rice paste, used in France, Italy and Germany.
1597 Mitsumata bark fibres first recorded as being used in Japan for papermaking.

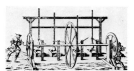

Engraving:
Macerating material for papermaking.
From a book by Jacques Besson, Lyon, 1579.

The Renaissance was an Age of Discoveries. The swift transition from the Gothic Age, effected with printing and paper, received impetus from a *dramatis personae* of genius. Within four decades after the invention of printing in 1440, Botticelli, Michelangelo, Leonardo, Columbus, and Copernicus were born, each destined to seek and find new horizons. The Age also celebrated the Individual. Although the papermaker had long identified himself and his product with a watermark, numerous artists, engravers, and cathedral builders had been anonymous in Gothic times. Now, an artist like Albrecht Durer not only set forth his name, but also made it a part of the composition in his renowned engraving of *Adam and Eve*. Books, in contrast to Gothic manuscripts, carried a title-page and the printer's device was a personal emblem of pride in his own craft.

Paper and Renaissance design

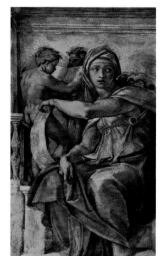

Page opposite: By Robert Estienne, Paris, 1549, in Garamond's type.

Fresco: The *Delphic Sybil*, detail.
By Michelangelo, 1475-1564.
From the Sistine Chapel, Vatican Palace.

Paper, this page: Sterling Letterpress Enamel, 25 x 38-90.
Paper, opposite page: Pinnacle Offset, 25 x 38-90.

Type face: Garamond; based upon designs of Jean Jannon in 1615 which were derived from roman types of Claude Garamond, Paris, d. 1561; and italic types of Robert Granjon, Paris, fl. 1545-88.

5027

181 *Renaissance.* A page designed by Robert Estienne, Paris, 1549, in the typeface designed by his contemporary Claude Garamond. The painting is a detail of a fresco titled *Delphic Sibyl* in the Sistine Chapel by Michelangelo, 1475-1564.

182 *Baroque.* A page from a book by Jan Jacob Schipper, Amsterdam, 1667, in type by Christoffel van Dycke. The text type is *Caslon*, which was influenced by 16th century Dutch types. The painting is by Rembrandt, 1606-69.

Paper chronology
Continued

1607 First picture of practical papermaking stampers appeared in European book, by Vittorio Zonca, Padua.
1609 The earliest newspaper with regular publication dates published in Germany, *Aviso Relation Oder Zeitung*.
1610 Papermaking at Wookey Hole, Somerset, England, recorded for first time.
1622 The first English newspaper issued in London.
1630 Paper cartridges first used by Gustavus Adolphus, of Sweden.
1634 First book to appear in China, text and illustrations on papermaking. *T'ien Jung Kai wu*, by Sung Ying-hsing.
1636 First English patent for the decorating of "paper for hanging" granted to E. and R. Greenbury.
1680 The invention of the "Hollander," or beater, used in maceration of fibrous materials in Netherlands.
1687 Earliest use of ochres, umbers and vermilion in coloring European paper.
1690 First paper money issued in Massachusetts.
1690 William Rittenhouse established first American paper mill, near Germantown in Philadelphia.
1691 First English patent pertaining to the coloring of paper issued to Nathaniel Gifford.
1693 A Jesuit priest, Father J. Imberdis, Claremont, published his observations on papermaking, *Papyrus sive Ars conficiendae Papyri.*
1696 It was recorded that there were 100 paper mills in England.
1697 A Philadelphia printer arranged to buy paper from the Rittenhouse mill at ten shillings a ream. This price prevailed until 1750.

Engraving:
The original European stampers.
From a book by Vittorio Zonca, Padua, 1607.

Commerce and growth of the middle class were stimulated by individual enterprise, motivated by the Renaissance. In Baroque seventeenth century, the mercantile center of Europe was Holland, whose merchant fleet was three times as large as all other countries. In this highly literate nation the renowned Dutch Calvinist, Louis Elzevir, founded the publishing dynasty that supplied all Europe with new works, including those of Descartes, Bacon, Pascal and Hobbes. The celebrated atlas by Mercator and maps issued by Hondius and Bleau in Amsterdam were masterpieces of typography and design. Ink and paper provided Holland's incomparable master of painting, Rembrandt, with the means of creating a new aesthetic dimension in the field of etching, proving that a fine print could now equal a great painting as an art form.

Paper and Baroque design

Page opposite: From a book by Jan Jacob Schipper, Amsterdam, 1667.
The type is by Christoffel van Dycke.

Painting: *Portrait of Johannes Elison*, detail.
By Rembrandt van Rijn, Holland, 1606-1669.
From the Museum of Fine Arts, Boston.

Paper, this page: Sterling Letterpress Enamel, 25 x 38-90.
Paper, opposite page: Pinnacle Offset, 25 x 38-90.

Type face: Caslon; based upon designs of William Caslon, London, 1692-1766, which were derived from seventeenth century Dutch types.

5028

COMMENTARIORUM
JOANNIS CALVINI
IN
EUANGELIUM
SECUNDUM JOANNEM
PRÆFATIO
Magnificis Dominis, Syndicis, Senatuique
Genevensi, Dominis suis vere observandis Joan. Calvinus Spi-
ritum prudentiæ & fortitudinis, prosperumque guber-
nationis successum à Domino precatur.

QUoties in mentem venit illa Christi sententia, qua tanti
æstimat quod hospitibus colligendis impenditur huma-
nitatis officium, ut in suas rationes acceptum ferat, simul
occurrit quam singulari vos honore dignatus sit, qui urbem ve-
stram non unius vel paucorum, sed commune Ecclesiæ suæ ho-
spitium esse voluit. Semper apud homines profanos non modo
laudata, sed una ex præcipuis virtutibus habita fuit hospitalitas:
ac proinde in quibus extremam barbariem ac mores prorsus effe-
ratos damnare vellent, eos ἀξένους, vel (quod idem valet) inhospitales
vocabant. Laudis autem vestræ longe potior est ratio, quod tur-
bulentis hisce miserisque temporibus Dominus vos constituit quo-
rum in fidem præsidiumque se conferrent pii & innoxii homines,
quos non sæva minus quam sacrilega Antichristi tyrannis è patriis
sedibus fugat ac dispellit. Neque id modo, sed sacrum etiam apud
vos domicilium nomini suo dicavit, ubi pure colatur. Ex his duo-
bus quisquis minimam partem vel palam rescindere, vel furtim
auferre conatur, non hoc agit modo ut nudatam præcipuis suis
ornamentis urbem vestram deformet, sed ejus quoque saluti ma-
ligne invidet. Quamvis enim quæ Christo & dispersis ejus mem-
bris præstantur hic pietatis officia, caninos impiorum latratus pro-
vocent, merito tamen hæc vobis una compensatio satis esse debet
quod è cælo Angeli & ex omnibus mundi plagis filii Dei benedi-

183 *Rococo.* A page from *Médailles sur le Regne de Louis Le Grand*, Paris 1702.
The type is by Philippe Grandjean, 1666-1714. The drawing is *Etude de Mains*
by Antoine Watteau, 1684-1721. The chronological listing is for 1704-50.

184 *Georgian.* A page from *Virgilius*, 1757, in type designed and printed by
John Baskerville, Birmingham, 1706-75. The portrait of Samuel Johnson by
Joshua Reynolds, 1723-92, shows only the hand and writing of the sitter.

185 *Neoclassic.* A page from *Manuale Typografico* by Giambattista Bodoni, Parma, 1818. The text type is *Bodoni Book* based upon designs by Bodoni and François Didot, Paris. The portrait is by Constance Marie Charpentier, 1767-1849.

186 *Victorian.* A page from *Book of Specimens*, MacKellar, Smith, and Jordan, Philadelphia, 1881. Typefaces are *Modern Number 8* and *20*. The painting is by Winslow Homer, 1836-1910. The engraving is of an 1898 paper machine.

Without dreams,
there is no need to work hard.
Without hard work,
there is no need to dream.

[Recorded while designing
a college yearbook
and contemplating the long hours
of editing and production needed
for its completion.
August 1931]

Learning and teaching: chapter 12

The author has a warm appreciation for the privilege to be involved with dedicated young men and women. He also has an appreciation of his own educational experience as a school boy and college student in Kansas. An interviewer for *Print* magazine asked how it was possible to learn about graphic design in the middle of the nation six decades ago....

About sophisticated magazines? The local drug store had all of them and the proprietor welcomed browsing. About New York and European graphic arts publications? The local libraries had many and offered a quiet setting for their contemplation. About learning typography, printing, photography, and technical art? Directly from kindly craftsmen and studio artists while producing school and college yearbooks.

About learning art history at a midwestern college? John Canaday was the teacher of art appreciation, and he of course later became the chief art critic of *The New York Times*. About the liberal arts? The author was busy but attendance at class provided the diversity of thought that is the true meaning of liberal arts. What about majoring in economics? Everyone needed to learn something about the practical requirements of existence, especially during a depression.

About personal expenses during high school and college? Employment in the drafting offices of professional civil engineers, winter and summer. What about healthy physical exercise? Walking and running from home to school or to college or to work afforded much of the conditioning to be able to compete four years in varsity track.

And what about the total experience? A complete college course was a microcosm, and in that sense a precious lesson about the whole of a lifetime to come.

187 *Today and Tomorrow.* The paper collage on this page is entitled *Musical Forms.*
By Georges Braque, 1882-1963, it is in the collection of the Philadelphia
Museum of Art. The typefaces are *News Gothic* and *Venus Bold Extended.* 1959

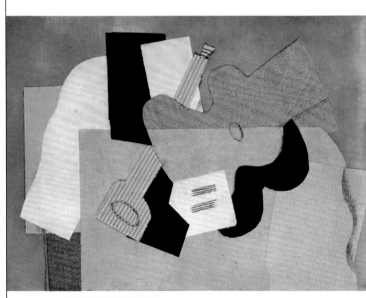

13 Contemporary postage stamps

189

190

188

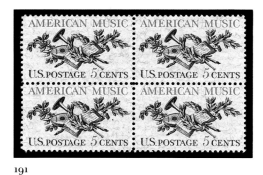

191

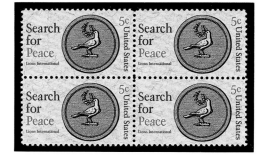

192

Continued from the opposite page

people reading or writing letters. The painters were selected from eight different countries. A phrase from a letter by the poet John Donne, "Letters mingle souls," was then added.

Thompson's fascination with type turns up prominently in his 1982 commemorative for the America's Libraries, above. Here he decided to symbolize libraries by our alphabet, which of course makes possible the dissemination of knowledge. The entire alphabet is represented by its first and last three letters, and the letter forms are taken from an alphabet drawn in 1523 by Geofroy Tory of Bourges, France, for *Champ Fleury*, a treatise on "the Art and Science of Roman letters." The Library of Congress, however, preferred a less abstract concept and opted instead for a stamp picturing the building itself [198]. The America's Libraries commemorative was issued without reference to the Library of Congress. For a 1984 stamp to publicize one of the Library's programs, "A Nation of Readers," [continued on page 164]

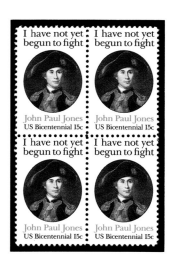

194

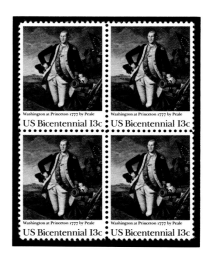

193

13

Contemporary postage stamps

Honoring the arts and humanities
of the nation

Text by Belmont Faries

Bradbury Thompson is the most prolific of American stamp designers, officially credited with more than ninety stamps.

But the design credits reflect only a small part of his influence on the United States stamp program. He also has guided the work of scores of other artists on stamps issued since 1969, and his own high standards of typography are reflected in nearly all of them.

His favorites include the American Architecture issues of 1979-1982 [figs. 208, 209], perhaps because they reflect his own method of teaching. For more than thirty years he has taught a design course to graduate students at Yale that covers the history of typography from Gutenberg to the present in segments of a dozen historical periods.

The stamps tell a similar chronological story of American architecture and honor sixteen principal architects from Colonial to recent times. Representative buildings are pictured in intaglio engravings based on Walter Richards' drawings. Informative inscriptions give not only building names but names and life dates of the architects.

The Postal Service's most popular issue ever was the 1982 State Birds and Flowers pane of fifty different stamp designs [204]. The art for the birds was provided by Arthur Singer and for the flowers by his son Alan.

Their colorful paintings were used in a typographical format designed by Thompson, with the name of the state in the largest type at top left. Below it, also flush left, he placed the denomination-country logo he had designed in 1975 for all United States stamps: USA 2Oc with no periods or spaces, the wider letter O for zero, and a lowercase 'c' instead of a cent sign. The two lines of type define the upper left corner of the stamp. The lower right corner of the stamp is defined by the name of the bird, flush right, and the flower, running up the right side, linked by an ampersand at the corner, all in italics.

For his type Thompson wanted the dignity of a classical roman face softened by the informality and readability of the combination capital and lowercase forms. He selected *Sabon Antiqua*, one of his favorite types, a modern version of the true *Garamond* cut by Claude Garamond of Paris in 1532. His italic, though called *Bembo*, is a modern face based on a Vatican chancery hand of the early 1500s.

Few of the people who loved the stamps knew or cared about type, but Thompson's choice of faces and use of type as a handsome frame helped turn a colorful design into an immensely popular one, offering a lesson on the importance of typography in stamp design.

Thompson designed the formats for the American Architecture and the State Birds and Flowers stamps as well as for a number of others including the American Wildlife pane of fifty stamps of 1987. The artists providing the drawings or paintings were credited as the stamp designers. Of the issues for which he was completely responsible, perhaps the most striking and effective was a block of eight large stamps for the 1974 centenary of the Universal Postal Union [205]. He assembled a compatible group of eight paintings of letters or of [continued on the opposite page]

Belmont Faries is a writer, editor, and authority on postage stamps who for thirteen years has been chairman of the Citizens' Stamp Advisory Committee in Washington. He has served eighteen years on the Committee.

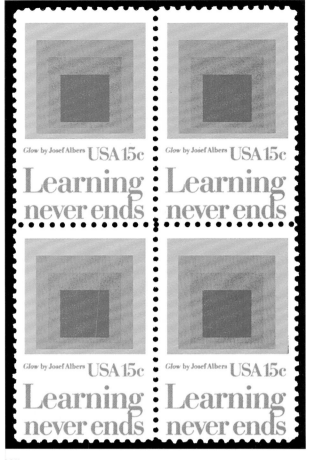

195

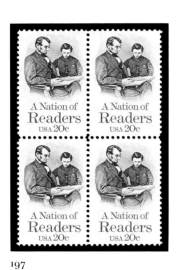

197

196

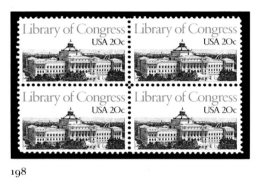

198

199

200

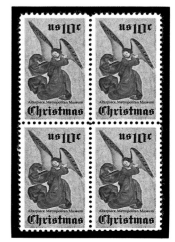

201

Postage Stamps, continued from page 162

Thompson used a Mathew Brady daguerreotype of President Lincoln reading to his son Tad.

Perhaps the most imaginative of all Thompson's designs was the Education stamp of 1980 [195] in which he combined the inscription "Learning never ends" with a vivid Josef Albers painting entitled *Homage to the Square: Glow* from the series of Albers studies about the independence and interdependence of colors.

The painting shows a red square surrounded by three more squares that progress through shades of orange from dark to light. The Secretary of Education was happy to interpret it as a symbol of the new department itself, "starting from a deep solid base and reaching out to more and more people each year, spreading a glow throughout American education." That seemed a long leap in interpretation for some, but it was indeed a handsome stamp.

Thompson has been the chief designer for several other series of stamps. The best known to the public are the Christmas stamps [200, 201], issued in both religious and secular designs since 1970. Since 1971 he has designed sixteen of the religious stamps, among them in recent years a Madonna and Child and a Christmas angel.

Thompson had been in charge of the popular Love series from the beginning, assigning and working with Robert Indiana on the first issue of 1973 and Mary Faulconer on her all-flower design of 1982. His own stamp in the series, issued in 1984 in an all-typographical design, featured the word 'LOVE' stacked five times, with the V replaced by hearts of different colors of the spectrum [207].

Among his stamps in other series are the Pennsylvania Toleware, Indian Art, and Wood-carved Figurines blocks of four in the Folk Art series [210-212]; the Nathaniel Hawthorne, Edith Wharton, and Herman Melville stamps in the Literary Arts series [189, 196, 199]; the Washington at Princeton, John Paul Jones, Bunker Hill, and Lafayette stamps in the Bicentennial series [193-94, 202-03]; and Benjamin West in the American Artists series [190]. His single commemorative stamp designs include strong portraits of Albert Einstein [214], Robert Kennedy, and Eleanor Roosevelt. He also worked closely with Ben Somoroff on the Photography stamp below. [Continued on page 166]

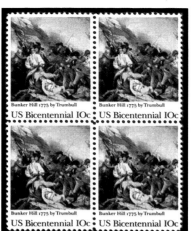

202

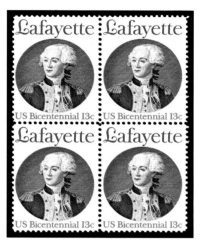

203

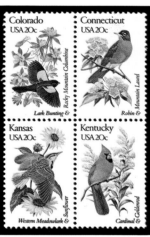

204

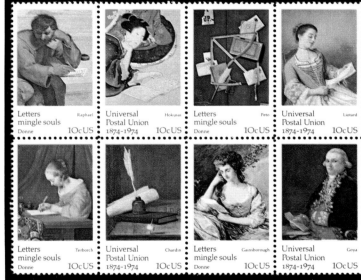

205

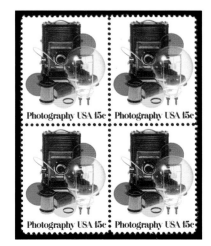

206

207

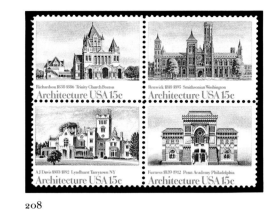

208

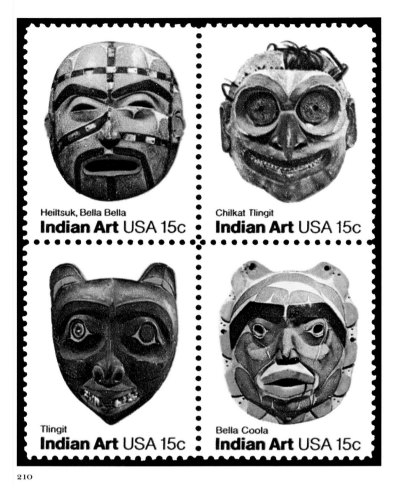

210

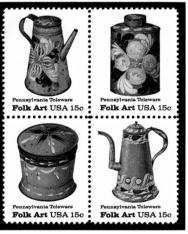

209

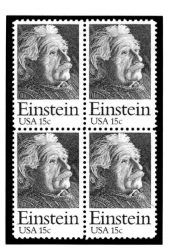

212

211

Postage Stamps, continued from page 165

In 1963 Thompson was invited to compete with his friend Josef Albers, Buckminster Fuller, Herbert Bayer, and Antonio Frasconi for a Science stamp design. Thompson's design was selected by the jury as "unquestionably the number-one choice of all concerned" but it was unfeasible to print it on existing press equipment. Nevertheless the Advisory Committee and postal officials decided that he was the only prospective stamp designer in the group, and it would be a great asset if he were advised to work within the limitations of the Giori press. His American Music stamp of 1964 and his Search for Peace, and Finland Independence stamps of 1967 were freshly original as well as printable [191-92, 213]; in 1969 he was appointed an art member of the Advisory Committee.

During his nineteen years of working with the Committee, postal officials, and stamp artists he has, by gentle but persistent persuasion, given United States stamps a new look. Typographically, they are the equal of any in the world.

213

214

14 The fascination of magazines

215 *AIGA Annual.* The jacket of the annual publication of
the American Institute of Graphic Arts, 1984, symbolizes
graphic design with familiar tools and principles of art.

14

The fascination of magazines

The pursuit of design
and the involvement with living events

Introduction by Steven Heller

Bradbury Thompson could hardly afford not to have a fine system of magazine design because since before World War II he has consistently worked on at least two different magazines at one time. Thompson was incapable of accepting constraints on his time or energy, and results of his intense labors attest not only to a fascination with magazines but to an unbridled passion for the form. He not only gave new life to the formats of *Mademoiselle* as art director, and to *Art News* and *Art News Annual* as design director, he also nurtured the magazines' editorial and visual contents (*Mademoiselle* for fifteen years and *Art News* for twenty-seven years). Despite his restrained, gentlemanly manner, he propelled *Mademoiselle* into head-on creative combat with *Vogue* and *Harpers' Bazaar* and gave *Art News* a unique visual cachet.

Thompson's system, however, was not rigid and changed according to need. While he was uncompromising with regard to the conventions of fine, legible typography, he never blindly mimicked the past. The diverse requirements of these magazines necessitated unique, contemporary approaches. With *Mademoiselle*, type and image were toys to be manipulated with childlike abandon, yet given its purpose to sell fashion, Thompson deliberately applied a salesman's logic to its design. For example, on the March 1950 cover he used a startling treatment: two sets of titles, coverlines, and photographs appearing topsy-turvy at both ends of the page actually increased newsstand visibility [page 173]. Another unconventional cover shows a model obliterating part of a wall of *Mademoiselle* logos; though obstructed, the hypnotic

pattern made by the title demands an immediate attention. While the design of *Mademoiselle* was characterized by its disciplined playfulness, *Art News* was defined by its elegant typographic unity. Using paintings and drawings by Seurat, Picasso, Matisse, and de Kooning, among others, Thompson was aware that design need only play a supporting role.

Appropriateness is the key to Brad Thompson's system. Knowing when to make loud or quiet graphic statements is the hallmark of a self-assured design director. Bucking trends in favor of what must be called an instinctively timeless pursuit underscores all his magazine designs. Change the clothing styles in *Mademoiselle* and the format would be appropriate today. Functionalism, free from the strictures of time and fashion, defines the nearly three dozen magazine formats Thompson has designed or redesigned to date. Despite the various waves of graphic styles that have doused contemporary magazine design, Thompson's formats for *Smithsonian* and *Harvard Business Review* are still intact. The reason: Thompson's approach to design marries intellect and aesthetics without tricks or artifice.

In our culture where a planned obsolescence today reigns supreme, there is no better tribute to a designer than to find that something he produced even a decade ago is still in use. There is no greater compliment than to note that a designer's work has passed the test of time. Bradbury Thompson's total magazine output therefore stands as a fitting tribute to one whose fascination and love of magazines is quite obvious.

The majority of designs shown in this chapter relate to magazines; three books and one poster are represented. The earliest design is from 1935, the latest is from 1984. They are not, however, in strict chronological order.

Steven Heller is a senior art director of *The New York Times*, the editor of the *American Institute of Graphic Arts Journal*, and a frequent writer and lecturer on design and illustration.

216 *Noel.* A childhood sentiment together with growing awareness of European simplicity inspired the airbrush cover that won this magazine's yearly national award. A $100 prize at twenty-four was a windfall. 1935

217 *World's Fair.* It was a joy to have been assigned the design of this New York World's Fair cover soon after arrival in Manhattan from the midwest. The design has the national shield and the fair's symbolic *Perisphere.* 1940

218 *Palette.* A growing appreciation of relationship of alphabet and image produced this cover design, where palette shapes are paired with similar typefaces for the national college art fraternity of Delta Phi Delta. 1936

219 *Know.* One of four related division pages of a Washburn College yearbook, this for a part on academic studies. It is a collage of earth and sky elements combined with book learning and mathematical theory. 1938

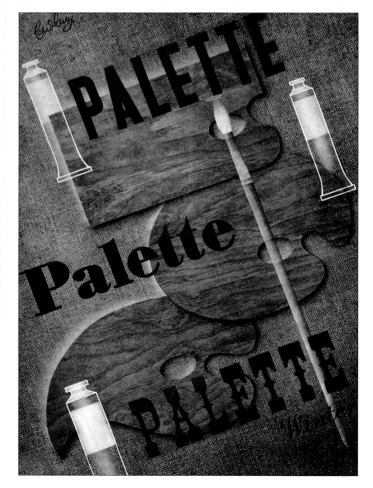

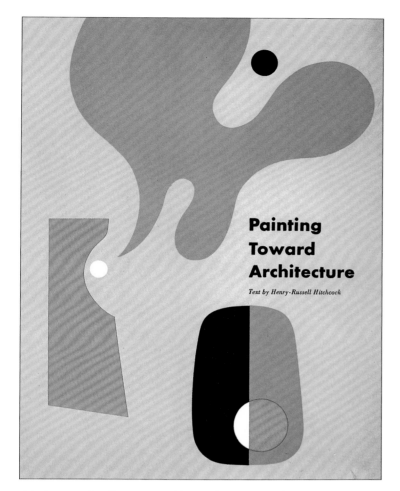

220 *Painting Toward Architecture.* For this book jacket shapes from the abstract artforms within the book itself were placed together in a collage with *Futura* type, which had been a favorite of the modernist artists of the period. 1948

221 *Paper.* This is a division page for publisher Leo Joachim's *Ninth Graphic Arts Production Yearbook.* An engraving from Diderot's 18th century *Encyclopédie* is synchronized against a background of a 20th century abstract image. 1950

222 *Eye.* The cover for the inaugural issue of Yale Arts Association's magazine in 1967. The word eye itself is a subtle symbol for the title. The magazine has exceptional photographs by John Hill and an original print by Norman Ives.

223 *The Earth.* A colorful globe, an annual report cover symbol for a company's growing expansion in worldwide trade. It is from one of the many reports designed for Pitney Bowes, 1958-82, and for Westvaco Corporation, 1949-83.

224 *Art News Annual.* A detail of a Picasso painting on one of the 27 covers for issues of *Art News Annual* while serving as the design director from 1945 to 1972 with editors Alfred M. Frankfurter and Thomas B. Hess. 1963

225 *Art News.* The cover of one of 265 issues of the magazine designed over a 27-year period. This sans serif title, which succeeded a *Didot* type heading, was especially compatible with the Matisse drawing of the human figure.

226 *Smithsonian.* A cover from the magazine which was originally designed in 1967 for publisher and editor Edward K. Thompson, former editor of *Life* magazine. The *Smithsonian* format using the *Baskerville* type is still in use.

227 *Progressive Architecture.* A cover from the magazine redesigned in 1971 with innovative use of ragged-right, sans serif typography. It was one of the early magazines to use photo-type. This format remained in use for a decade.

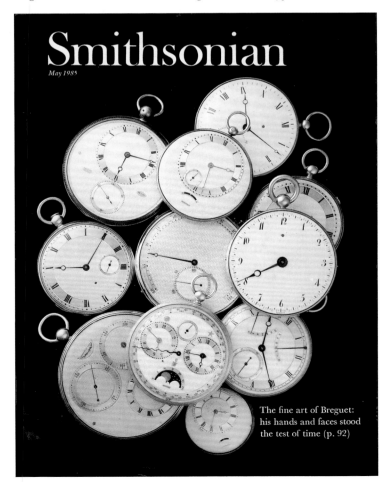

228　*Mademoiselle.* A cover design suggested by René Magritte's scintillating painting entitled *Female.* The model presents four fashion items. Magritte's painting is of a nude model, likewise showing four parts of the body. 1952

229　*Mademoiselle.* A magazine cover designed with two titles, two photographs, for two purposes: to intrigue a young woman interested in current fashion trends and, on the newsstand, to please the sales manager as well. 1950

230　*Mademoiselle.* The first magazine in history to present on its cover a purely linear black-and-white photograph. It was the work of Ben Somoroff, who also took the colorful photographs for the *Mademoiselle* covers above. 1952

231　*Mademoiselle.* Another cover enlivened with typography, the photograph by Mark Shaw. *Mademoiselle* was originated in the 1930s by Betsy Talbot Blackwell as a wholesome, sophisticated magazine for college and career women. 1950

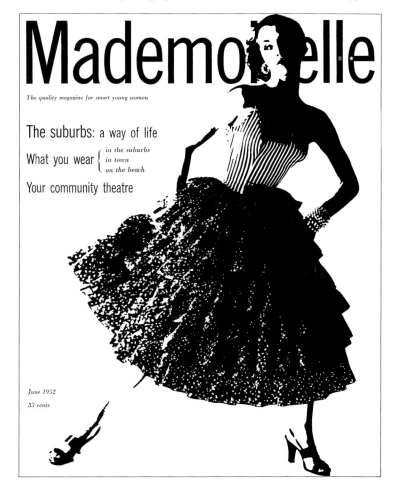

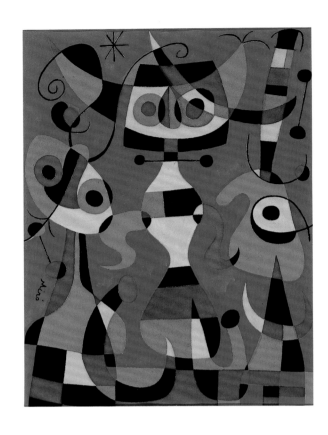

 Orphans

Under the apparent steadiness there was
a quaking bog of feeling that probably
went back to their childhood loss

Hilda Redmond lived across the road from us in Cork. She was a slight, fresh-complexioned woman with a long, thin face and a nervous, eager laughing manner. Her husband made a striking contrast with her because he was tall and big-built, good-looking but morose. I fancied him as a man who could never have been exactly gay, and he had a sort of fixation on the two children. You saw him every Sunday afternoon walking out to the country with them, one on either hand. They seemed to be a happy couple, even though whenever Hilda had set her heart on something he did not approve of she had to hurl herself on him like a toy dog worrying a Saint Bernard. He did not say much about her even when we were speaking in a friendly way, but once he did make fun of her sense of her own inadequacy to me in a way that showed how proud he was of her. Hilda, I imagine, is a sort of girl who will always feel inadequate; it is the way of women like her. Later, when I heard her story and his, I understood why it was that her sense of inadequacy struck him as so absurd.

Hilda, you see, had been brought up in a town in the North of Ireland, a small black bitter seaside town. She was an only child, earnest and rather humorless, the sort of girl who in other circumstances would have devoted herself to some great cause, but since there was no such cause to attract her she took it out in piety. She was always a devout girl, conscientious almost to a fault.

After reading Orphans *at his home in Barcelona, the great Miró agreed to illustrate it for us. Opposite,* MADEMOISELLE *proudly presents the brilliant result*

One evening during the war Hilda and another girl were out walking when they were accosted by two soldiers. Hilda had always been warned by her parents to shun soldiers, but as she had also been warned never to be rude she found herself in a fix. They were well-mannered boys, and she did not know how to get rid of them without being ill-mannered herself. The result might have been foreseen. Within ten minutes, through no fault of her own, Hilda was being escorted back to town by a young soldier called Redmond, talking to him as if she had known him all his life. He was a tall lad with a very bony face and high cheekbones, and he had a nice way of smiling with a front tooth that was not there.

He insisted on seeing her home, and this proved another trial because when they got there she felt it would be uncivil not to invite him in. She did so with terror in her heart and he accepted without a trace of embarrassment. He greeted her father and mother as if they too were old friends. Being reserved and quiet people, they were even more scared of him than Hilda was. Jim Redmond was a charmer, a bit of a playboy, and he had no trouble at all in putting them at their ease. He sat by the fire, bent over it and picked up the poker—a funny instinctive gesture that she frequently noticed in him later—and told them all about himself. He had been brought up in a Cork orphanage with his younger brother, Larry. He described how his ailing mother had brought them both to the orphanage door and left them in charge of a monk and how Larry had charged screaming after her, demanding to be taken home. "Sure I have no home [Continued on next page]

232 *Miró in Mademoiselle.* Fiction in *Mademoiselle* was illustrated by distinguished artists as well as yet unrecognized artists. This Miró painting was commissioned in 1956; the typography was influenced by an earlier design [page 62].

233 *Fashion and Fiction.* Fashion dominated *Mademoiselle* pages. Photographers included Gene Fenn, H. Landshoff, Mark Shaw, Peter Martin, Stephen Colhoun, George Barkentin, and Rolf Tietgens. Below, still life by Somoroff.

EDITOR'S NOTE: When MLLE published Speed Lamkin's first story last September, readers responded with praise and appreciation. This, his second story to be published—and his first novel, *Tiger in the Garden,* which will be out this month—place him among the most promising of the new young writers.

A short story
by Speed Lamkin

On a Friday afternoon in late June the note came. Johnny O'Harrity Amster was playing on the front side lawn, which was yellowy and poor from his playing there and quite unlike the rest of the three acres of soft summer grass. He was lining up his army of several hundred lead soldiers for parade.

The note, wrapped and tied around a medium-sized rock, hit the portico like a bomb. As soon as it hit, his heart beat faster. His small dirty pink fingers began to fly like hoppers over the yellow grass and his legs. He never used to act like this, but then ever since last Christmas everything about him had been changing. It made it twice as bad for the note to come while he was playing soldiers, with a Queen Elizabeth for general—a lead parachutist painted purple with water color—walking around inside a palace fence of matchsticks. His parents said he was too big for playing soldiers, at least the way he played with a Queen and a cigar-box palace and

Out by the country club

a royal garden of single verbena blossoms. He ought to have been playing catch' or throwing darts at the Chinaberry tree. Johnny didn't know whether to keep on playing or whether to run and get the note at once. He wiped his mouth, which was still overpink from cherry drops, on the sleeve of his shirt. He turned around to see if Jake, the yardman, had noticed. No, Jake had not seen the rock hit and he was not watching Johnny. But Jake, running the gasoline mower, was not more than twenty feet away from his kingdom. Johnny had been so busy playing that he was quite unaware how close the mower was.

He wiped his eyes, which burned from trying to keep from crying, and when he looked at his soldiers and his palace, it was like looking in a clouded mirror. His mouth was drawing together like after eating a green persimmon. He wondered if he would be able to walk. He had seen men in the movies who got so scared they couldn't move.

Johnny knew who the note was from. It was from Billy Houghton, who was one year older and who was even more changed than he was; who smoked behind Cape jasmines and arborvitae; who, Johnny secretly thought, was the handsomest boy he knew. Before ever seeing the note Johnny knew what the note would say, at least he knew that it would state the place and the time when they would meet to fight; to fight, Johnny thought, for no good reason at all; to fight just simply because Billy Houghton believed that a fight between them was necessary. He was always extra-nice to Billy Houghton. Hadn't he given him a dollar bill and his new baseball, and wouldn't he rather go to the [Continued on page 117]

Cut out for spring

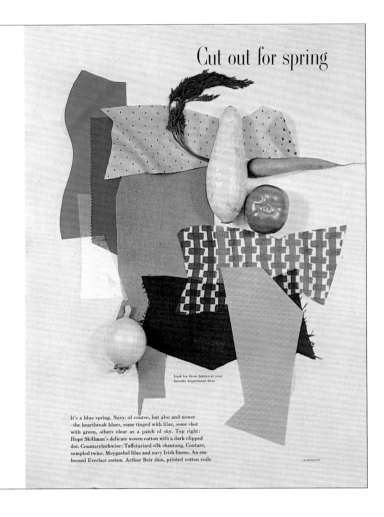

It's a blue spring. Navy, of course, but also and newer—the heartbreak blues, some tinged with lilac, some shot with green, others clear as a patch of sky. Top right: Hope Skillman's delicate woven cotton with a dark clipped dot. Counterclockwise: Taffetarized silk shantung, Couture, sampled twice, Moygashel lilac and navy Irish linens. An embossed Everfast cotton. Arthur Beir thin, printed cotton voile.

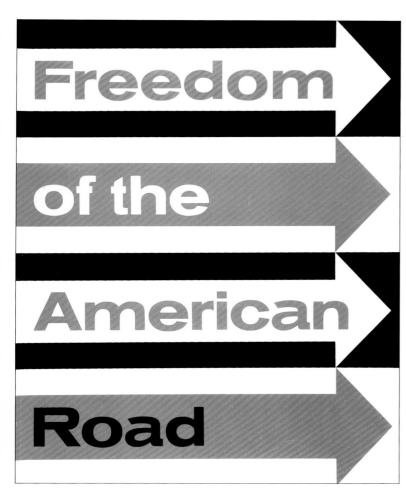

Freedom of the American Road. This large-format publication divided into three sections was produced by Ford Motor Company in 1950 for nationwide distribution. It gave attention to all the aspects of automotive improvement.

The Traffic. The publication was profusely illustrated with photographs and drawings. Part 2 was devoted to safe travel and to educating citizens about up-to-date, scientific management of street traffic in the urban areas.

235 *The Highway.* The format of this 124-page magazine was 10¼ by 12¼ inches. Part 1 explained the need for better highways, citizens' support of a wise fund expenditure, and the fundamentals of efficient highway management.

237 *The Driver.* Part 3 concerned safe driving habits. It explained how to gain the public support for education, the making of effective laws, and the gaining of respect for safety in all the interests of the automobile driver.

238 *USA and Victory.* Two widely different magazines designed for the OWI in World War II. They were directed to many nations and were in several languages. *USA* was a small digest, *Victory* a large picture magazine. 1942-45

239 *Harvard Business Review.* This is a cover of the magazine that was redesigned in 1967. The two-year design process was an interesting one, with full staff meetings at the Harvard Business School. The typeface is *Trump Mediaeval.*

240 *This Week.* From a series of covers for one of the influential Sunday supplement magazines of its time, this issue features new cars of 1964. The cover relates the most strategic parts of an automobile to an engraving of a horse.

241 *Dance 20.* A large poster designed for the 20th annual summer session of the Connecticut College School of Dance in New London. The all-oblique *Helvetica* type works in visual harmony with the central dancer in flight. 1967

15 A love of books

Photograph by H. Landshoff

178

15

A love of books

The design of classic literature
in contemporary format

This chapter consists of two major parts. The first presents choices from *Homage to the Book*, a portfolio published in 1968 by Westvaco that brought together the graphic concepts of distinguished book designers both here and abroad [pages 178-88]. The second part of this chapter consists mainly of selections from the American Classic Book Series published for three decades by Westvaco for friends at Christmastime [pages 190-98].

Facsimile pages from the introductory booklet of *Homage to the Book* appear on pages 180 through 188. Bradbury Thompson selected the statements honoring the Book by votaries from Plato, 50 BC, to Hermann Zapf in 1968. These are printed in typefaces from eight chronological periods and accompanied by related graphic images in a plan similar to that in chapter 12.

The foreword for the *Homage to the Book* was written by Frederick B. Adams, Jr., former director of the Pierpont Morgan Library in New York City. Because of its poignant message, it is republished in this volume by the designer:

"Paralleling a currently catchy religious question, we might ask, Are books dead? A simple answer is, Yes, to those for whom they never lived, and this is true for a distressingly large proportion of the world's population. It was always so, but we have been consoled by the belief that the percentage of the deprived has been slowly decreasing.

"A more compelling question is, are books dying? For the first time in the development of man's ability to communicate, we know how to deliver a message instantly to any part of the globe. What message? And we have the ability to record the communication in a wider variety of forms than ever before. What shall we choose to record, and how? The most spectacular advance in information storage and retrieval was made more than 500 years ago with the invention of typography, and fortunately at the time the technology of papermaking was already well developed. Now we are told, by a scientist looking at libraries of the future, that the book is a poor tool for displaying, retrieving, or even organizing information. But those who read books in nonscientific fields know that they contain more than classifiable information: they have powers to open the mind and stir the emotions, powers which will long be beyond the reach of computerized data stores and descriptor languages, no matter how ably programmed or at what disregard of expense.

"The book faces more insidious rivals than the computer and its accomplices in the reproductive processes. There are the new electronic media, which have the potential not only to convey messages but to be messages. Already they are being used in primitive fashion by the first generation of adults for whom television shaped their earliest impressions of 'the world beyond the family.' For those who regard rationalization as a waste of time or a positive bore, the sequential perceptions imposed by typography seem dim and laborious. The multimedia technique of bombarding and overwhelming the senses 'blocks out the analytical and judgmental faculties, and allows the [continued on page 189]

242 *Opposite*, the portfolio of *Homage to the Book* included fifteen broadsides, each conceived in a personal, original manner and on various kinds of papers. The title page with a listing of names of contributors is provided on page 180.

Sixteen Designers

Homage to the Book

Leonard Baskin
Joseph Blumenthal
Bert Clarke
Brooke Crutchley
Alvin Eisenman
Norman Ives
Joseph Low
Giovanni Mardersteig
Herbert Matter
Paul Rand
Roderick Stinehour
Bradbury Thompson
Georg Trump
Jan Tschichold
Carl Zahn
Hermann Zapf

Foreword by Frederick B. Adams, Jr.

Westvaco

Centaur type: After Nicolas Jenson, *Eusebius,* Venice, 1470 (note 1).
The italic is called *Arrighi,* after the originator, 1524.

Books are immortal sons deifying their sires.

Plato (427?–347? B.C.).

My books are always at leisure for me;
they are never engaged.

Cicero: *De republica*, ca. 50 B.C.

The book is doubly gifted:
it moves to laughter, and by its counsel
teaches a wise man how to live.

Phaedrus: *Fables*, early first century A.D.

And as for me, though my wit be light,
On bookës for to read I me delight,
And to them give I faith and full credence.
And in my heart have them in reverence
So heartily that there is gamë none
That from my bookës maketh me to goon.

Geoffrey Chaucer: *The Legend of Good Women*, ca. 1385.

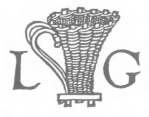

Take thou a book in thine hands
as Simon the Just took the Child Jesus into his arms
to carry him and kiss him.

Thomas à Kempis: *Doctrinale Juvenum*, 1473.

You, O Books,
are the golden vessels of the temple,...
burning lamps to be held ever in the hand.

Richard de Bury: *Philobiblon*, 1473.

When I get a little money, I buy books;
and if any is left, I buy food and clothes.

Erasmus: *Opus Epistolarum*, 1529.

ABCDEFGHIJKLMNOPQRSTUVWXYZ
abcdefghijklmnopqrstuvwxyz

ABCDEFGHIJKLMNOPQRSTUVWXYZ
abcdefghijklmnopqrstuvwxyz

Bembo type: After Francesco Griffo, Bologna (for Aldus Manutius), 1495
(note 2). Printers' marks: From fifteenth, early sixteenth centuries.

Printing: The art preservative of all arts.

(Ars artium omnium conservatrix.)
Inscription on a house at Haarlem, Holland,
once occupied by Lourens Janszoon Coster.
The inscription dates from ca. 1550 in the Latin.

Far more seemly to have thy study full of books,
than thy purse full of money.

John Lyly: *Euphues*, 1579.

He hath never fed of the dainties that are bred of a book;
he hath not eat paper, as it were; he hath not drunk ink:
his intellect is not replenished,
he is only an animal, only sensible in the duller parts.

Shakespeare: *Love's Labor's Lost*, ca. 1595.

Blest be the hour wherein I bought this book;
His studies happy that composed the book,
And the man fortunate that sold the book.

Ben Jonson: *Every Man Out of His Humor*, 1600.

The images of men's wits and knowledges,
remain in books, exempted from the wrong of time,
and capable of perpetual renovation.

Francis Bacon: *The Advancement of Learning*, 1605.

That place that does contain
My books, the best companions, is to me
A glorious court, where hourly I converse
With the old sages and philosophers;
And sometimes for variety, I confer
With kings and emperors, and weight their counsels.

John Fletcher and Philip Massinger: *The Elder Brother*, 1625.

ABCDEFGHIJKLMNOPQRSTUVWXYZ
abcdefghijklmnopqrstuvwxyz

ABCDEFGHIJKLMNOPQRSTUVWXYZ
abcdefghijklmnopdrstuvwxyz

Garamond type: After Claude Garamond (d. 1561), Paris, and Jean Jannon,
Sedan, ca. 1615 (note 3). Decoration: By Geofroy Tory, Paris, 1525.

Books should to one of these four ends conduce,
For wisdom, piety, delight or use.

John Denham: *Of Prudence*, 1650.

They are for company the best friends,
in doubts counsellors, in damps comforters,
time's perspective, the home-traveler's ship or horse,
the busy man's best recreation, the opiate of idle weariness,
the mind's best ordinary, nature's garden,
and the seed-plot of immortality.

Richard Whitelock: *Zoötomia*, 1654.

If all the crowns of Europe were placed at my disposal
on condition that I should abandon my books and studies,
I should spurn the crowns away and stand by the books.

François de Salignac de la Mothe Fénelon (1651-1715).

Books are a guide in youth,
and an entertainment for age.
They support us under solitude,
and keep us from becoming a burden to ourselves.
They help us to forget the crossness of men and things,
compose our cares and our passions,
and lay our disappointments asleep.
When we are weary of the living,
we may repair to the dead, who have nothing
of peevishness, pride or design in their conversation.

Jeremy Collier: *Of the Entertainment of Books*, 1698.

Books are the legacies that a great genius leaves to mankind,
which are delivered down from generation to generation,
as presents to the posterity of those who are yet unborn.

Joseph Addison: *The Spectator*, 1711.

ABCDEFGHIJKLMNOPQRSTUVWXYZ
abcdefghijklmnopqrstuvwxyz

ABCDEFGHIJKLMNOPQRSTUVWXYZ
abcdefghijklmnopqrstuvwxyz

Van Dijck type: After Christoffel van Dijck, Amsterdam, middle seventeenth century (note 4). Initials: From an Elzevir book, Netherlands.

Studious let me sit,
And hold high converse with the dead.

James Thomson: *The Seasons, Winter*, 1726.

The best companions are the best books.

Lord Chesterfield: *Letters to Lord Huntingdon*, 1749.

In proportion as society refines,
new books must ever become more necessary....
Books are necessary to correct the vices of the polite;
but those vices are ever changing,
and the antidote should be changed accordingly—
should still be new.

Oliver Goldsmith: *The Citizen of the World*, 1762.

After the basic necessities of life there is
nothing more precious than books.
The art of typography which produces them
thus renders countless vital services to society.
It serves to instruct, to spread progress in the sciences and arts,
to nourish and cultivate the mind and elevate the spirit;
the duty of typography is to be the agent
and general interpreter of wisdom and truth—
in short, it portrays the human spirit.

Pierre Simon Fournier (le jeune): *Manuel Typographique*, 1764.

There are but very few who are capable of
comparing and digesting what passes before their eyes
at different times and occassions,
as to form the whole into a distinct system.
But in books everything is settled for them, without the
exertion of any considerable diligence or sagacity.

Edmund Burke: *Thoughts on the Cause of the Present Discontents*, 1770.

ABCDEFGHIJKLMNOPQRSTUVWXYZ
abcdefghijklmnopqrstuvwxyz

ABCDEFGHIJKLMNOPQRSTUVWXYZ
abcdefghijklmnopqrstuvwxyz

Baskerville type: After John Baskerville, Birmingham, 1757 (note 5).
Flowers: William Caslon & Son specimen, London, 1763.

Food of the Spirit.

(Nutrimentum spiritus.)
Inscription on the State Library, Berlin, 1780.

No other art is more justified than typography
in looking ahead to future centuries;
for the creations of typography
benefit coming generations as much as present ones.

Giambattista Bodoni: *Manuale Tipografico*, 1818.

Books constitute capital.
A library book lasts as long as a house,
for hundreds of years. It is not then an article
of mere consumption but fairly of capital,
and often in the case of professional men,
setting out in life, it is their only capital.

Thomas Jefferson: *Letter to James Madison*, 1821

Your second-hand bookseller is second to none
in the worth of the treasures which he dispenses.

Leigh Hunt: *On the Beneficence of Bookstalls*, 1837

Let man, if possible, gather some books under his roof and
obtain access for himself and family to some social library.
Almost any luxury should be sacrificed to this.

William Ellery Channing: Address in Boston, 1838.

In Books lies the *soul* of the whole Past Time;
the articulate audible voice of the Past, when the body and
material substance of it has vanished like a dream....
Of all the things that man can do or make here below,
by far the most momentous, wonderful and worthy
are the things we call Books!

Thomas Carlyle: *On Heroes and Hero-Worship*, 1840.

ABCDEFGHIJKLMNOPQRSTUVWXYZ
abcdefghijklmnopqrstuvwxyz

ABCDEFGHIJKLMNOPQRSTUVWXYZ
abcdefghijklmnopqrstuvwxyz

Walbaum type: After J.E.Walbaum (1768-1837),Weimar; influenced by
G. Bodoni and F. Didot (note 6). Pages: *Manuale Tipografico*, 1818.

The intellect is a dioecious plant,
and books are the bees which carry the
quickening pollen from one to another mind.

James Russell Lowell: *Nationality in Literature,* 1849.

The pleasant books, that silently among
Our household treasures take familiar places,
And are to us as if a living tongue
Spoke from the printed leaves or pictured faces!

Henry Wadsworth Longfellow: *The Seaside and the Fireside,* 1849.

Books that purify the thought,
Spirits of the learned dead,
Teachers of the little taught,
Comforters when friends are fled.

William Barnes (1801-86): *My Books.*

Old books, as you well know, are books of
the world's youth, and new books are fruits of its age.

Oliver Wendell Holmes: *The Professor at the Breakfast Table,* 1860.

If a book is worth reading, it is worth buying.

John Ruskin: *Sesame and Lillies,* 1863.

There are books...which take rank in your life
with parents and lovers and passionate experiences.

Ralph Waldo Emerson: *Society and Solitude,* 1870.

Books are to be called for, and supplied, on assumption
that the process of reading is not a half sleep, but,
in the highest sense, an exercise, a gymnastic struggle;
that the reader is to do something for himself.

Walt Whitman: *Democratic Vistas,* 1871.

ABCDEFGHIJKLMNOPQRSTUVWXYZ
abcdefghijklmnopqrstuvwxyz

ABCDEFGHIJKLMNOPQRSTUVWXYZ
abcdefghijklmnopqrstuvwxyz

Modern Number 8 type: Middle nineteenth century, U.S.A. (note 7).
Decoration: MacKellar Smiths and Jordan, Philadelphia, 1881.

Books are the quietest and most constant of friends;
they are the most accessible and wisest of counsellors,
and the most patient of teachers.

Charles W. Eliot: *The Happy Life*, 1896.

The tendency of the best typography has been
and still should be in the path of
simplicity, legibility, and orderly arrangement.

Theodore Low De Vinne: *A Treatise of Title-Pages*, 1902.

What are my books? My friends, my loves,
My church, my tavern, and my only wealth;
My garden, yea, my flowers, my bees, my doves,
My only doctor, and my health.

Richard Le Gallienne (1866-1947): *My Books*.

A book consists of five elements:
the text, the type, the ink, the paper and the binding.
To create a unity from these five elements in such a way
that the result is not a passing product of fashion,
but assumes the validity of permanent value—
that should be our desire.

Giovanni Mardersteig: *The Apologia of the Officina Bodoni*, 1929.

When he sees the books that have delighted all generations
and begins to comprehend why they were great
pieces of typography, he is beginning to train his taste.
It is a process which once begun is fed from
a thousand sources and need never end.

Daniel Berkeley Updike: *Some Aspects of Printing, Old and New*, 1941.

One of the essential requirements for a successful
book designer is that he should be a book lover.

Bruce Rogers: *On Printing*, 1943.

ABCDEFGHIJKLMNOPQRSTUVWXYZ
abcdefghijklmnopqrstuvwxyz

ABCDEFGHIJKLMNOPQRSTUVWXYZ
abcdefghijklmnopqrstuvwxyz

Kennerley Old Style type: By Frederic W. Goudy, U.S.A., 1914 (note 8).
Decoration: Edward Burne-Jones, Kelmscott Press, London, 1896.

Book design is a severely circumscribed
form of applied art in which one consideration—
ease of reading—
is the absolute to which all other factors must yield....
It should have substance far beyond pleasing novelty.
It must have moral value, authority, and nobility.
It should have a sense of history,
of enduring through the ages.

Joseph Blumenthal: *Design Quarterly,* 1954.

Discipline in typography is a prime virtue....
Distinction of manner needs to be
won by simplicity and restraint.

Stanley Morison: Extract from *The Typographic Book,* 1963,
designed by Brooke Crutchley for *Homage to the Book,* 1968.

Perfect typography is certainly
the most elusive of all arts....
Sculpture in stone alone comes near it in obstinacy.

Jan Tschichold: *Homage to the Book,* 1968.

Thus, the thesis, has been put forward
that the modern book—
as compared to the book of former times—
no longer is an article of virtue.
I must argue that point emphatically.

Georg Trump: *Homage to the Book,* 1968.

In this electronic future, the responsibility of
the book designer will be even heavier.
No longer will he be an unnecessary cost factor:
he will direct the whole orchestra in which
any false note means additional cost and loss of time.

Hermann Zapf: *Homage to the Book,* 1968.

ABCDEFGHIJKLMNOPQRSTUVWXYZ
abcdefghijklmnopqrstuvwxyz

ABCDEFGHIJKLMNOPQRSTUVWXYZ
abcdefghijklmnopqrstuvwxyz

Univers type: By Adrian Frutiger, Zurich and Paris, 1957 (note 9).
Illustrations: By Joan Miró, Spain and Paris, ca. 1950.

information to go straight through as emotional input.' Shall we be content to live by such 'information' as we are allowed to feel? If not, the book will be the preserver of our sanity and of that liberty of choice for which men have often fought and died.

"Books have been burned or banned, their authors executed or exiled, for 2000 years and more. The printed word has inspired fear and courage; it has promoted ignorance as well as knowledge. Books are the basis of religious movements and social upheavals. The famous little red book of *Quotations* is being used in China today both as an ideological weapon and a symbol of conformity. 'Beware the man of one book' runs the Latin proverb; it should be translated into Chinese.

"Censorship is the last refuge of small minds. Yet it is one more tribute to the power of books. Let each man be his own censor and, if he will, despise the new vogue for novels that aim to shock and outrage, that spring more from the writer's genitals than his genius. There is no limit to the hunger for notoriety and sales.

"There is an ample literature celebrating the companionship of books. Introverts, the nearsighted, and intellectuals have special reasons to be attracted by books, but there are devotees of every kind and condition. The notorious book-collector, bibliographer, forger, and thief, Thomas J. Wise, expressed his sentiments in banal verses incorporated in his book-plates: 'Books are my friends Where'er on earth I be, Solace of solitude – Bonds of society!' and they are undoubtedly genuine. Books are companions that can be summoned at will and enjoyed at leisure. Some we read in, rather than through, and they make no objection. Others we test and find wanting. In this heyday of the disposable package and the nonreturnable container, we are grateful for the disposable book, the paperback. Such a book feels no insult if we pass it along or throw it away. There are many companions of youth who do not suit our old age.

"Bibliophily occurs in two intensive forms. The book collector is discriminating, and usually specializes in his acquisitions. The bibliomaniac amasses them compulsively in indigestible quantities. I was told recently of a man who took a job as a Pullman porter so that he could scour the country for second-hand books without paying anything for transportation, either for himself or his purchases. He filled his house so full of books that one wall of it col-

lapsed and his wife deserted him for the spaciousness of a hotel room. A year or so later he persuaded her to return home and she found he had built a new house, with not a book in it. When she looked out the kitchen window she saw why; he had moved the old house to the back of the lot, books and all.

"Books are admittedly used for strange purposes. They can function as weapons of assault, or as doorstops; they can be hollowed out to make boxes; balanced on the head, they can aid one's posture, they can serve as presses for flowers, or as hiding places for money and clues in mystery stories; unpaid bills can be put away in them and forgotten; and the family Bible can be used as a register of births and deaths. A wall of French eighteenth-century gilt red morocco bindings makes a particularly elegant background for furniture of the period, and nicely bound sets of unreadable authors bought by the yard give a touch of hominess to a funeral parlor. These are each in its odd way forms of homage to the book.

"Although it is too easily ignored by the common reader, the most effective and enduring tribute to the book is that paid by the artists and craftsmen who bring it to birth as a physical object: the designer, the papermaker, the illustrator, the binder; these and many others make their essential contribution to the completed artifact. This artifact may appeal to senses other than sight. The smell of a room lined with books has many nostalgic associations; the crackle of crisp rag paper is a special music; the feel of a binding, or of the impression of type on paper pleases the initiate; only the gratification of taste must be left to the insect rather than the human bookworm (except in the case of very young readers).

"The paramount appeal is to the sense of sight. Even if we recognize the probability of a gradual evolution away from the book as we know it (just as the codex form evolved from the roll, and the book printed in multiple copies on paper superseded the single copy handwritten on vellum), we can predict the book itself will survive both in fact (albeit more precariously) and in image. This image, which today is printed on paper and bound, will come to be reproduced on copying machines at many locations, by remote or local control, on demand. The persistence of the book image, from the far past to the remote future, and its irreplaceability as a stimulus to the mind and spirit and as a safeguard of freedom, compel our willing and continuous homage."

Notes relating to the typography, pages 180-188

Note 1: The type face on page 180 is *Centaur*. The roman is based on that used by Nicolas Jenson, Venice, in the *Eusebius*, 1470. The italic is derived from a chancery face used by Lodovico degli Arrighi, Rome, 1524. Bruce Rogers designed the roman revival, which was produced in 1916. Frederic Warde designed the italic, named *Arrighi*, which was cut in 1929. The decoration on page 180 is a detail of the 1476 Venetian page of Erhard Ratdolt, considered to be the first consummate title page.

Note 2: The type face on page 181 is *Bembo*. The roman is an interpretation of that cut by Francesco Griffo of Bologna for Aldus Manutius of Venice, and was first used in a treatise by Pietro Bembo in 1495. The italic is based on letters of Lodovico degli Arrighi. *Bembo* was produced in 1930 by The Monotype Corporation under the supervision of Stanley Morison. The printers' marks were used by William Caxton, Westminster, 1477; Erhard Ratdolt, Augsburg, 1486; Leonardus Gerla, Pavia, 1494; Engelhard Schultis, Lyon, 1491; Aldus Manutius, Venice, 1494.

Note 3: The type face on page 182 is *Garamond*. The roman is based on the punches formerly ascribed to Claude Garamond (d. 1561) of Paris, but actually cut by Jean Jannon of Sedan, ca. 1615. The italic is after a Granjon font cut in the middle sixteenth century. The version in this publication was produced in 1922. The decoration is a detail of a page by Geofroy Tory, Paris, 1525.

Note 4: The type face on page 183 is *Van Dijck*. It is based on the middle seventeenth century letters of Christoffel van Dijck, Amsterdam, a type-cutter for the Elzevir dynasty of printers. The initials are from Elzevir pages of the same period, printed in the Netherlands. The type revival, by Jan van Krimpen, was produced by The Monotype Corporation in 1935.

Note 5: The typeface on page 184 is *Baskerville*. It is based on the 1757 type of John Baskerville, of Birmingham, England. This Monotype version of the original was produced in 1923. The ornaments or flowers are from a William Caslon and Son specimen, London, 1763.

Note 6: The typeface on page 185 is *Walbaum*. Originally cut around the beginning of the nineteenth century by Justus Erich Walbaum (1768-1839) of Goslar and Weimar, it shows the influences of Giambattista Bodoni of Parma, and Firmin Didot of Paris. This Monotype version by the Berthold foundry was produced in 1934. The illustrations are pages from Bodoni's *Manuale Tipografico*, 1818.

Note 7: The typeface on page 186 is *Modern Number 8*. It is an example of middle nineteenth century cutting, used widely in the U.S.A., in which the "modern" style was carried to its fullest geometric expression. The "head and tail pieces" are from a specimen book of MacKellar, Smiths and Jordan, Philadelphia, 1881.

Note 8: The typeface on page 187 is *Kennerley Old Style*. Designed by Frederic W. Goudy (1865-1947), it was first shown in 1914. Its introduction in the U.S.A. reflected the influence of the Kelmscott Press of William Morris (1834-96) in England. The decoration is a detail of an engraving by Edward Burne-Jones, 1896.

Note 9: The typeface on page 188 is *Univers*. It was designed, 1952-57, by Adrian Frutiger of Zurich and Paris and cut in several variations of weight and width by Deberny & Peignot, the originators, and by The Monotype Corporation. The illustrations are from a book of graphic art by Joan Miró of Spain and Paris, ca. 1950.

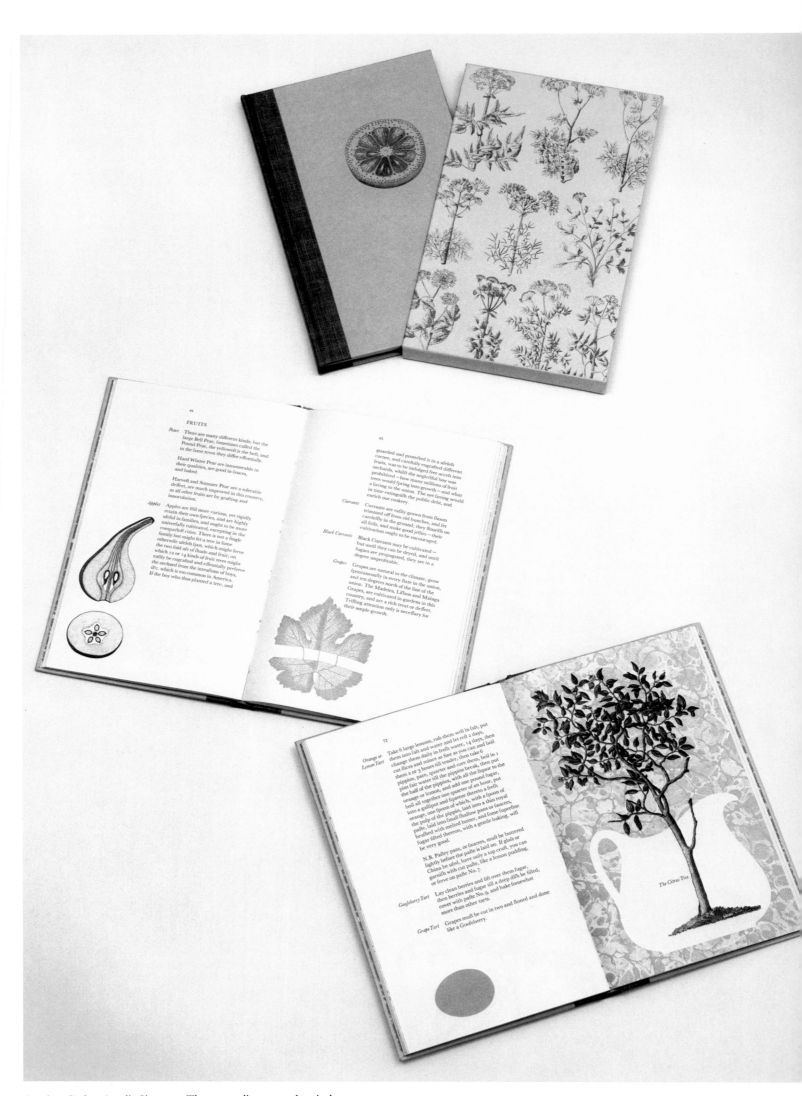

243 *American Cookery,* Amelia Simmons. The cover, slipcase, and typical pages.

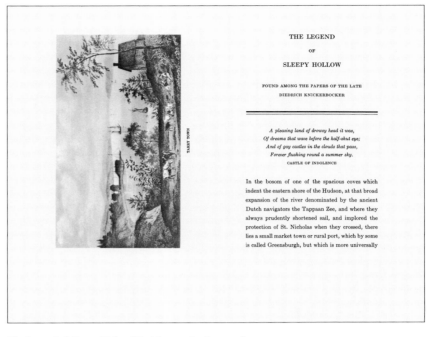

244 *The Legend of Sleepy Hollow*, Washington Irving, 1958.

Introduction by John C. Callihan

The first of Westvaco's American Classic Book Series in 1958 and the 25 volumes that followed annually were designed by Bradbury Thompson. Each edition, presented to Westvaco friends at Christmastime, has its own special appeal in the form of classic literature in a contemporary format.

Lord Bacon once said, "Some books are to be tasted, others to be swallowed, and some few to be read wholly, and with diligence and attention." Books designed by Bradbury Thompson present a menu for every literary palate—for short story lovers, *The Four Million* by O. Henry; for philosophers, *Emerson Essays*; for naturalists, *A Week on the Concord and Merrimack Rivers* by Thoreau; for seafarers, Melville's *Typee*, a voyage into the Polynesian life; for humorists, *Fables in Slang* by George Ade; and the anonymous *Decorum*, a treatise on etiquette and dress in 1879.

One might ask which book from Thompson's prolific repertoire ranks highest on the popularity list. Certainly *American Cookery* by Amelia Simmons [page 190-91] would be in the running as would *Healthy, Wealthy & Wise* by Benjamin Franklin [page 196], *Twenty*

John C. Callihan has written the forewords for books in the American Classic Book Series for a decade. He is vice president, public and government relations for Westvaco.

245 *The Celebrated Jumping Frog*, Mark Twain, 1959.

246 *American Cookery*, Amelia Simmons, 1963.

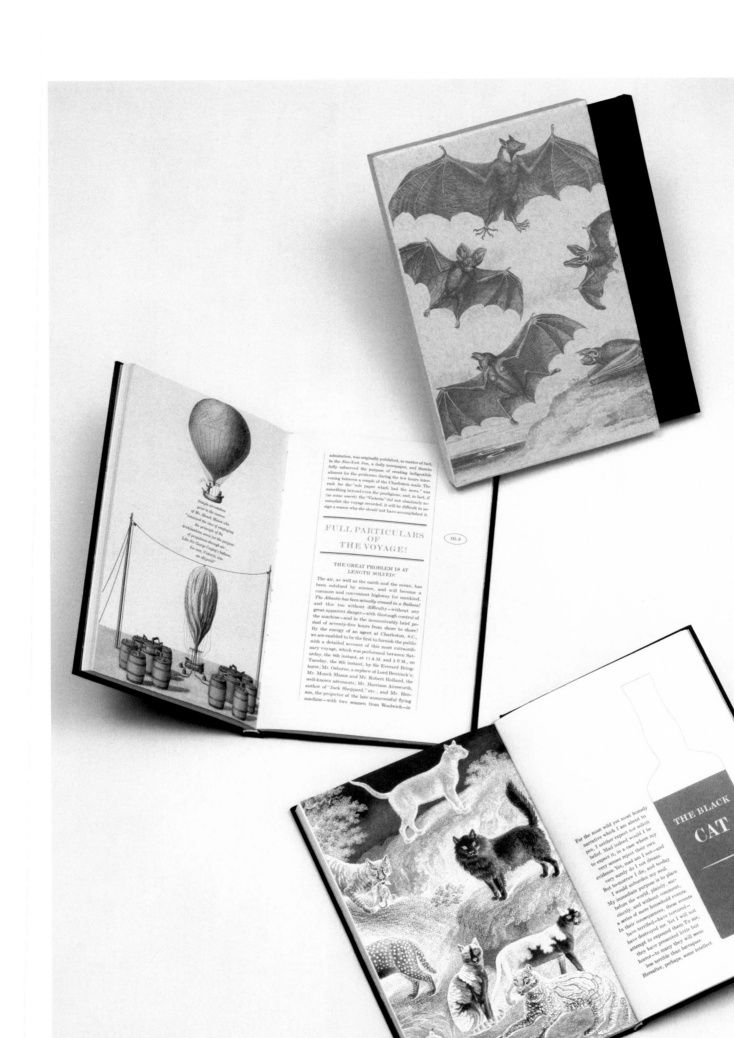

247 *Tales of Edgar Allan Poe*, 1964. The slipcase, cover, and title pages.

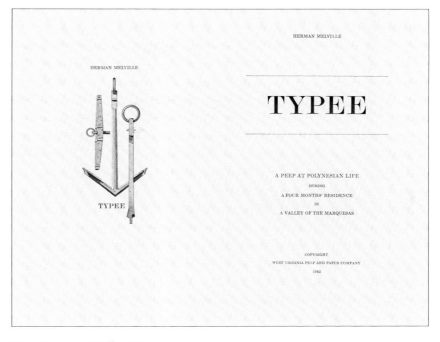

248 *Typee*, Herman Melville, 1962.

Tales by Nathaniel Hawthorne [page 197], and *Tales* by Edgar Allan Poe [page 192].

The Poe volume certainly proved to be one of the most ambitious designs undertaken by Bradbury Thompson. Here the designer managed to create an unusual treatment for each of Poe's most popular tales, which are quite diverse, and at the same time to maintain a harmonious balance in the book as a whole. This book, incidentally, won the gold medal in the prestigious Bienal International do Livro e da Arte Grafica, held in Brazil in 1965. This was the same exhibition which in 1963 had awarded its silver medal to *American Cookery*. These are only two of many graphic arts awards the books designed by Bradbury Thompson have received.

One of the most outrageous ideas he successfully executed was the bullet hole that penetrated Stephen Crane's *Red Badge of Courage* [page 194]. It was inspired by stories that Civil War soldiers' lives had been saved by bullets stayed by prayer books, playing cards, belt buckles, and other paraphernalia.

The designer encouraged a bookbinder to develop a way of drilling a hole to simulate a bullet's entry. Using a .45 caliber slug as a pattern, the bookbinder set up a jig that not only made the hole but discarded the waste

Photograph by H. Landshoff, opposite.

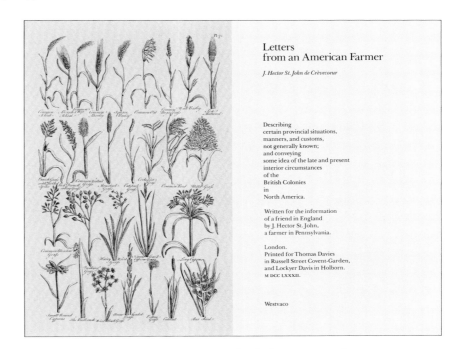

249 *Letters from an American Farmer*, J. Hector St. John de Crèvecoeur, 1976.

250 *9 Sketches*, Bret Harte, 1967.

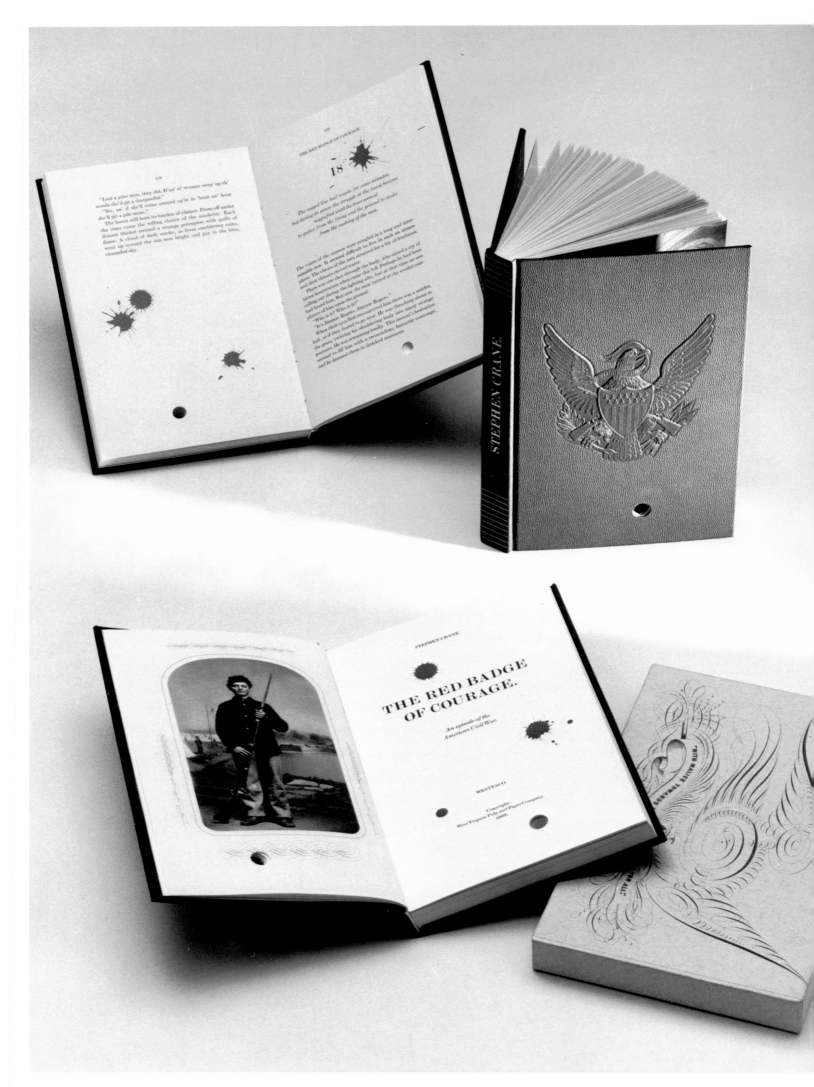

251 *The Red Badge of Courage*, Stephen Crane, 1968. The cover, typical pages, and slipcase.

252 *Monticello, Virginia, USA,* Thomas Jefferson, 1975.

253 *Voices from an Earlier America,* poetry anthology, 1980.

paper as well. Along with the bullet hole, drops of blood (the red badges of courage) appear as design elements throughout the text pages.

Although he is well known for his unusual graphics, Bradbury Thompson above all is a master of typography, a skill that he uses to great advantage. A typographic innovation contributed much to the volume of four essays by Ralph Waldo Emerson [page 197]. To enhance readability and comprehension, and to highlight the power of Emerson's thoughts, he set off the entire text in lines of type that in their phrasing emphasize the logic and poetic nature of Emerson's words.

In Henry James's story of *Daisy Miller* [page 195], which contains much conversation among its cast of characters, the arrangement of dialogue into verse-like phrases again enhances the pleasure of reading. The many conversational sections throughout are set in this manner to reflect the way the words are spoken. The narrative sections are arranged according to the conventional manner of typesetting. The story is illustrated with paintings by Henry James's contemporary, the expatriate artist James McNeill Whistler.

Consistency in the application of a graphics idea is a Thompson hallmark. In his last

Photograph by H. Landshoff, opposite.

254 *Daisy Miller,* Henry James, 1974.

255 *Healthy, Wealthy & Wise*, Benjamin Franklin, 1971. The cover, slipcase, and typical pages.

256 *Emerson Essays*, Ralph Waldo Emerson, 1978.

257 *Emerson Essays*, showing the text set in phrases.

volume, *Twenty Tales* by Nathaniel Hawthorne
[page 197], he demonstrated the power of
design synergism. Its cover displayed the 1983
United States postal stamp which Thompson
also designed, commemorating the life and
times of the author. The frontispiece featured
the same portrait in full-page format with
a border in perforated stamp motif. The
slipcase and the chapter division pages in-
corporated the *Crataegus Oxyacantha*, or the
hawthorn plant, also framed as a perforated
stamp, a typical Thompson visual pun. What
might not be as readily apparent is the
verbal pun, multiple use of the arabic "20,"
symbolizing both the 20-cent postage stamp
and the 20 tales. Even the headings are set
in 20-point type.

These are but some of the details of the
infinite care that has gone into the creation of
the books designed by Bradbury Thompson,
but they are illustrative of why the volumes
are now such treasures in the collections
of bibliophiles.

But the real worth of Thompson's con-
tributions to the art of book design extends
far beyond their representation as a high
mark of excellence. They represent a national
treasure which future generations will enjoy.

Photograph by H. Landshoff, opposite.

258 *Twenty Tales*, Nathaniel Hawthorne, 1983.

259 *A Young Patriot in the American Revolution.* Two sides of a division page, with similar images in an inverted manner, quickly and clearly express the patriot's point of view in a true recording of 1775-83 by John R. Greenwood. 1981

260 *The American Revolution: Three Views.* This is a volume published by the American Brands, Inc., in 1976 to celebrate the American Bicentennial. It contains essays, with the graphics from a 1797 *Encyclopaedia Britannica.*

261 *The Fifty Books.* A large casebound book catalogue, left, of the American Institute of Graphic Arts book show, 1968. At right is a spread from the catalogue honoring a volume for Cornell University, *The Quality of Life.*

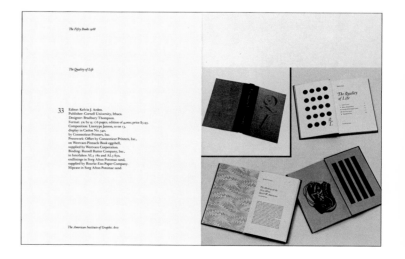

16 A Bible for this age

16

A Bible for this age

Sacred language made accessible and
more easily comprehended

Introduction by D. Dodge Thompson

In many respects the three-volume *Washburn College Bible*,
1979, is a *summa* of Bradbury Thompson's typographic and
graphic design explorations. From the outset of the project
in 1969 the designer determined to adopt the time-honored
aspects of earlier Bibles while identifying the best of con-
temporary materials, methods, and collaborators.

Since the time of Gutenberg, tradition has dictated that the
text of the Bible is commonly set in lines of equal length. This
convention has several awkward aspects: words must be
broken frequently and linked by end-of-line hyphens, and
spacing between letters and words must be manipulated or
"justified." Line breaks are less problematic in poetry or free
verse, where each line is a complete thought or phrase, in
a typographic pattern of "flush left and ragged right."

At least as early as 1941 the designer had recognized the
virtues of this flush-left ragged-right layout of text. Appreci-
ating the visual poignancy of the phrasing of Walt Whitman's
Leaves of Grass reprinted in *Inspirations 127*, Thompson set the
text of that entire issue in the unjustified lines typically used
for free verse. In considering the Bible format, Thompson
recognized that the poetic language of the translators of
the King James Version, contemporaries of Shakespeare,
would also be well-served by this new convention. The many
virtues of the *Washburn College Bible* are summarized in its
foreword, reproduced here on pages 211-13.

The designer asked J. Carter Brown, the director of the
National Gallery of Art, to select the Old Master images to
introduce the chapters. The art historian chose a chrono-

logical group of artworks remarkable for range and scope.

To ensure that the three volumes would be architecturally
distinct, the designer asked his Yale colleague Josef Albers
to create a unique frontispiece for each one. Through his
selection of a contemporary abstract artist, the designer was
of course emphasizing the 2,000-year continuity of the art
inspired by the Bible.

The choice of a typeface was another important decision.
In 1967 Thompson had invited the Swiss type designer Jan
Tschichold to contribute to a portfolio called *Homage to the
Book* [see pages 178-89]. Soon thereafter, Tschichold sent the
designer a sample of a new typefont he was developing which
he called *Sabon Antiqua*, based on the original typeface of
Claude Garamond, 1480-1561. Thompson immediately
appreciated the relevance and elegance of the revised letter
form. *Sabon* was developed for phototypography in 1972
specifically for the *Washburn College Bible*. It is now one of
the most popular typefaces in use.

The many individual innovations of the *Washburn College
Bible* make it easier to read and a joy to view. Thompson
placed priority on the integration of all the design elements,
creating a homogeneous entity that combined typographic
ingenuity with such disparate elements as ancient symbols,
modern abstract designs, and Bible-inspired art treasures.
In 1980 the new Bible was produced in a more affordable,
one-volume edition by the Oxford University Press. In its
respect for tradition as well as in its willingness to adapt, the
Washburn College Bible is a Bible for this age and tomorrow.

The print opposite by Josef Albers is the frontispiece for Volume I of
the *Washburn College Bible*. It is entitled *Introitus* (the opening ceremony of the
church). Captions for all illustrations in this chapter are on page 216.

D. Dodge Thompson
is Chief of Exhibition Programs at the
National Gallery of Art, Washington

Holy Bible

Modern Phrased Version

Authorized King James Text
Genesis to Nehemiah

Designed by Bradbury Thompson

Limited First Edition
Published by Washburn College
Topeka, Kansas

Genesis

1:1 In the beginning
God created the heaven and the earth.

2 And the earth was without form, and void;
and darkness was upon the face of the deep.
And the Spirit of God
moved upon the face of the waters.

3 And God said,
Let there be light:
and there was light.

4 And God saw the light, that it was good:
and God divided the light from the darkness.

5 And God called the light Day,
and the darkness he called Night.
And the evening and the morning
were the first day.

6 And God said,
Let there be a firmament
in the midst of the waters,
and let it divide the waters from the waters.

7 And God made the firmament,
and divided the waters
which were under the firmament
from the waters
which were above the firmament:
and it was so.

8 And God called the firmament Heaven.
And the evening and the morning
were the second day.

9 And God said,
Let the waters under the heaven
be gathered together unto one place,
and let the dry land appear:
and it was so.

10 And God called the dry land Earth;
and the gathering together of the waters
called he Seas:
and God saw that it was good.

11 And God said,
Let the earth bring forth grass,
the herb yielding seed,
and the fruit tree yielding fruit after his kind,
whose seed is in itself, upon the earth:
and it was so.

12 And the earth brought forth grass,
and herb yielding seed after his kind,
and the tree yielding fruit,
whose seed was in itself, after his kind:
and God saw that it was good.

13 And the evening and the morning
were the third day.

14 And God said,
Let there be lights
in the firmament of the heaven
to divide the day from the night;
and let them be for signs, and for seasons,
and for days, and years:

15 And let them be for lights
in the firmament of the heaven
to give light upon the earth:
and it was so.

16 And God made two great lights;
the greater light to rule the day,
and the lesser light to rule the night:
he made the stars also.

17 And God set them
in the firmament of the heaven
to give light upon the earth,

18 And to rule over the day and over the night,
and to divide the light from the darkness:
and God saw that it was good.

19 And the evening and the morning
were the fourth day.

20 And God said,
Let the waters bring forth abundantly
the moving creature that hath life,
and fowl that may fly above the earth
in the open firmament of heaven.

21 And God created great whales,
and every living creature that moveth,
which the waters brought forth abundantly,
after their kind,
and every winged fowl after his kind:
and God saw that it was good.

22 And God blessed them,
saying,
Be fruitful, and multiply,
and fill the waters in the seas,
and let fowl multiply in the earth.

23 And the evening and the morning
were the fifth day.

24 And God said,
Let the earth bring forth
the living creature after his kind,
cattle, and creeping thing,
and beast of the earth after his kind:
and it was so.

25 And God made the beast of the earth
after his kind,
and cattle after their kind,
and every thing that creepeth upon the earth
after his kind:
and God saw that it was good.

26 And God said,
Let us make man in our image,
after our likeness:
and let them have dominion
over the fish of the sea,
and over the fowl of the air,
and over the cattle, and over all the earth,
and over every creeping thing
that creepeth upon the earth.

27 So God created man in his own image,
in the image of God created he him;
male and female created he them.

28 And God blessed them,
and God said unto them,
Be fruitful, and multiply,
and replenish the earth, and subdue it:
and have dominion over the fish of the sea,
and over the fowl of the air,
and over every living thing
that moveth upon the earth.

29 And God said,
Behold, I have given you
every herb bearing seed,
which is upon the face of all the earth,
and every tree,
in the which is the fruit of a tree yielding seed;
to you it shall be for meat.

30 And to every beast of the earth,
and to every fowl of the air,
and to every thing
that creepeth upon the earth,
wherein there is life,
I have given every green herb for meat:
and it was so.

31 And God saw every thing that he had made,
and, behold, it was very good.
And the evening and the morning
were the sixth day.

2:1 Thus the heavens and the earth were finished,
and all the host of them.

Preface to the Washburn College Bible

This work brings together beauty and holiness. Beauty has suffered in recent centuries through the legitimate effort to disseminate the Bible by bringing the price within the range of the common purse. Cheap editions have been issued on paper which after a span of years crumbles at the touch, and the only merit of the type has been conventional legibility. This edition reverts to the time prior to the inevitable deterioration necessitated by mass production.

The medieval manuscript Bibles were artistic masterpieces. So also was the Gutenberg Bible, since the type imitated the written script even to the point of retaining the now needless abbreviations, and the paper was of a quality which after five hundred years suffers only from worm holes. The material of the present edition lacks the ingredients tasty for worms.

The setting of the type is directed not to the achievement of rigid regularity in length of line and column, but rather to the rounding out of sentences and phrases, so that the eye readily perceives and the voice readily conveys the meaning.

The total layout of the page is immensely pleasing. No more admirable edition can be recommended for pulpit use, because it is so thoroughly legible at the normal reading distance. Should the work be later issued in smaller compass, it will invite use for private devotions.

Roland H. Bainton
Titus Street Professor Emeritus
of Ecclesiastical History,
Yale Divinity School,
Yale University

Opposite:
One of the 66 masterpieces of religious art in the *Washburn College Bible*.
Complete captions for the six masterpieces reproduced in this chapter are on page 216.

significat. Nam & verbū est & racio.z supputacō:et causa uniuscuiusq̈; rei.p quā sūt singla que subsistūt:que uniuersa recte itelligimꝰ in xp̄o

Hoc doctus plato nesciuit.hoc demostenes eloquens ignorauit. Perdā inquit sapienciā sapienciū:et prudenciā prudenciū reprobabo. Vera sapiēcia perdet falsā sapiam:et quāq̈; stulticia p̄dicacōnis in cruce sit:tamē paulus sapiam loquit inter p̄fectos. Sapiam autē nō seculi istiꝰ.q̈ destruit nec princip̄ū:sed loquit dei sapiam in misterio abscondita:quā p̄destinauit deus ante secula. Dei sapiēcia.xp̄s est. Xp̄s enū dei virtus et dei sapiēcia. Hec sapiēcia in misterio abscondita est.de qua z noni psalmi titulus p̄notatur. pro occultis filij:in quo sunt omnes thesauri sapiēcie z sciēcie dei abscondi. Et qui ī misterio absōdit9 erat.p̄destinatus est ante sēc̄a:predestinar9 autē et p̄figurat9 in lege et p̄phetis. Vnde et p̄phete appellabātur videntes:quia videbant eū quē ceteri non videbant. Abraham vidit diē eius.z letat9 est. Apiebāt celi ezechieli:qui ipso primi clausi erāt. Reuela inqt dauid oc̄los meos:z considerabo mirabilia de lege tua. Lex enū spūalis est:et reuelacione opus ē ut intelligat:ac reuelata facie dei gloriā contemplemur. Liber in apocalipsi septem sigillis signatus ostendit:quem si dederis homini scienti lr̄as ut legat:respondebit tibi. Non possum. Signat9 ē enū. Quāti hodie putāt se nosse lr̄as:tenent signatum librū nec aperire possunt:nisi ille reserauit qui hc̄ clauē dauid:qui aperit et nemo claudit:claudit z nemo aperit. In actibus

apło̅ꝝ.scōs eunuchus.imo sanctꝰ vir. sit enū eū sc̄a scriptura agnominat:cū legit ysaiam p̄phetam.interrogatus a philippo.putasne itelligis que legis:respondit.Quō possum:nisi aliquis me docuerit? Ego ut de me loq̈r interim sanctior sū hoc eunucho.nec studiosior:qui de ethiopia id ē de extremis finibꝰ mūdi venit ad templū.reliquit aulam regiam:z tantꝰ amator legis fuit diuine sciencie.ut eciā in vehiculo lr̄as legeret sac̄s. Et tamē cū librū tenet et uba dm̄ i cogitacōne a̅ciper:lingua voluere:labijs p̄sonaret:ignorabat eum quē in libro nesciens venerabat. Venit philippꝰ:ostendit ei ihesū:qui clausus latebat ī lr̄a. O mira doctoris virtus. Eadem hora credidit eunuchꝰ:baptisat9 fidelis et sc̄s magister efficit de disc̄plo plus in deserto fonte ecctie:q̈ ī aurato synagoge teplo reperit

Hec a me p̄stricta sūt breuit:neq̈; enū eplaris āgustia euagari longius paciebatur:ut intelligeres.te in scripturis sacris sine puio z mōstrāte semitā.nō posse ingredi. Taceo de gramaticis.rethoricis.philosophis.geometricis.dyaleticis.musicis.astronomicis.astrologis.medicis.quoꝝ scīa mortalibꝰ satis vel utilissima est:z in tres partes scindit.i doctrinā.racionē. z usum. Ad minores artes veniā:et que non tā lingua q̈; manu administrant. Agricole.cementarij.fabri metalloꝝ.lignorūq̈; cesores.lanarij q̈; z fullones.z ceteri qui variā supellectilē et vilia opuscula fabricātur:absq̈; doctore esse non possunt qd cupiūt. Quod medicoꝝ est.p̄mittunt medici:tractant fabrilia fabri. Sola scripturaꝝ ars ē:

Foreword to the First Edition of the Modern Phrased Version

The Modern Phrased Version of the Bible is designed for easier reading and better comprehension, without modifying the time-honored language of the King James Version. The difference between this Bible and its predecessors is its typographic format, a visual reorganization of the text rather than changes in words and syntax.

This edition of the Bible reconsiders the fundamental traditions of typographic design. It represents the most thorough reassessment of the printed Bible format since Johannes Gutenberg used movable type to produce his masterpiece in the fifteenth century. Based upon a modern appreciation of readability and communication, these innovations enliven the venerable Biblical language and enhance the poetic qualities of the Old and the New Testaments.

Since the time of Gutenberg it has been traditional to set the text of the Bible in lines of type of equal length. The text of this Bible is set in lines of varying length, each accommodating a complete phrase, just as the words might be spoken. The result is a more natural type configuration, aligned at the left and irregular at the right. This new system eliminates several awkward aspects of conventional typesetting. No words are hyphenated at the ends of lines. Spacing between letters and words is uniformly consistent. Through the use of modern

computer-controlled phototype, refinements have been introduced to fit letters and punctuation marks more perfectly than is feasible with metal type. These many refinements are so minute that singly they are imperceptible to the eye, but the total creates a visual grace in the overall appearance of the page. This Foreword, the Preface, and the Introduction to the Illustrations are also set in lines of type of unequal length, but unlike the Bible text itself, this editorial matter is not presented in separate phrases but in contemporary prose style.

In addition to the aesthetic improvements which the new format brings to the Bible, the innovations add significantly to reading pleasure. For example, the phrase-length lines of type are rhythmic in nature. They create a cadence in the mind of the reader that heightens the emotional experience. This is particularly true of often repeated phrases. For example, in the first two pages of Genesis, the phrase, "And God said," appears seven times. In this edition, that phrase forms a single line at the beginning of each verse, a position that increases its rhetorical effect.

In earlier Bibles, the reader had difficulty in absorbing the lists of unfamiliar names of persons, families, and locations which appear in ponderous succession. In this Bible, with

Opposite:
Biblia latina (40-line Bible),
Johannes Gutenberg, Mainz, 1450-1455

its concept of phrase-length lines, this matter is arranged in understandable components. Genesis 10 and 11 provide an example of this organization and clarification.

The numbers identifying the chapters and verses are placed in the left-hand margin rather than in the text matter. This departure from the traditional treatment expedites the search for particular passages, and further reduces small intrusions that distract the reader. Also, by allowing the columns, as well as the lines of text type, to vary in length instead of prescribing an arbitrary bottom margin, it was possible to end each column with a complete verse and to avoid an interruption in reading.

Most of the modern revised versions of the Bible use quotation marks in the text to denote the beginning and end of a spoken passage. The format of this Bible, which places such phrases as "He said," and "Saying," on separate lines preceding the quotation, eliminates the need for quotation marks, which did not come into use until after the writing of the King James Version.

Fundamental to the appearance of this Bible is the choice of a legible typeface of noble origin, in use before the King James Version was first published in 1611. It was originally cut about 1532 in France by Claude Garamond, one of the early masters of type design. The typeface was updated for modern metal casting in 1967 in Switzerland by Jan Tschichold and was named *Sabon Antiqua*. It was developed for photo-typography in 1972 especially for this edition.

It is the judicious use of this typeface that accounts for the Bible's readability. New clarity and simplicity have been achieved through the consistent use of one body size. A generous fourteen-point type was specified for every word of the Bible except the main titles, which are set in an heroic size.

The entire text is set in roman letters. Italic type, used liberally in earlier Bibles, mainly to indicate words that did not translate purely into English from Hebrew or Greek, has been eliminated from the text. Italics, however, are used for running heads and subheads, a device which sets them apart from the body of the text.

The typography consistently employs upper- and lower-case letters in titles and headings as well as in the text, without resorting to less-readable all-capital characters used liberally in older Bibles. In this edition the only exceptions are the words LORD, Lord GOD, JEHOVAH, and God's words to Moses, I AM THAT I AM, and I AM, which appear in capital and small-capital letters.

Bradbury Thompson, the designer of this Bible, has created a homogeneous entity, combining his typographic innovations with such seemingly disparate elements as ancient symbols, modern abstract designs, and Bible-inspired art treasures.

The architecture of the format is structured by four horizontal grid lines that govern the placement of all type appearing on each page. The grid lines accommodate in an harmonious manner the text matter, half titles, titles, and captions for illustrations, and bring a unity to the whole of the Bible.

One of the decorative elements supporting the design is an ancient geometric pattern with a cross in the center, derived from a motif that transcends two millennia. This symbol identifies the Bible on the three covers, the end leaves, and half-titles.

The first record of this geometric pattern was among the mosaics of Santa Constanza, the mausoleum built about 350 A.D. for the daughter of the first Christian emperor, Constantine. The Renaissance architect and theoretician Sebastiano Serlio reproduced the motif in a 1540 treatise and it is his

drawing from which this symbol was developed. Architect Francesco Borromini transformed Serlio's two-dimensional drawing into the three-dimensional coffered dome for the church of San Carlo alle Quattre Fontane in Rome, 1638-41, and soon after it was applied to Carlo Maderno's aisles in the Cathedral of St. Peter. Architects since then have incorporated the design in many buildings for the church.

The symbol is employed as a part of this Bible in two different ways. On the cover it is isolated as it might adorn a medieval Book of Hours. On the end leaves it is repeated architecturally as it might adorn a baroque church ceiling. The former may be said to be a private and individual expression of Faith, the latter a public and plural manifestation of Faith.

As a part of the architectural plan, the designer also included original screen prints by the painter, teacher, and theoretician, Josef Albers, 1888-1976, which serve as frontispieces in each of the three volumes of the Bible. These prints were titled, numbered, dated, and signed for this edition by the artist shortly before his death.

Introitus, the frontispiece of Volume I, takes its name from an opening ceremony of the Church. It suggests with illusionary lines the interior of a great cathedral, receding from foreground to the altar area in the distance. The work takes its color from the first chapter of Genesis, "And God said, Let there be light: and there was light."

Seclusion, the frontispiece of Volume II, with its somber background and maze-like pattern, describes in graphic terms the melancholy wanderings of the tribes, as described in this part of the Old Testament. In *Ascension,* the frontispiece for the

New Testament, the graphic symbolism is especially brilliant, as Christ seems to rise in a radiant cloud of linear forms.

Reproductions of masterpieces of religious art precede each of the sixty-six books of the Bible. These illustrations, inspired by the Bible, were selected by J. Carter Brown, Director of the National Gallery of Art in Washington, from collections throughout the world. A caption for each illustration provides the Biblical text that inspired its creation, as well as factual information concerning the artist and the collection. Mr. Brown's Introduction to the Illustrations follows this Foreword.

The President and the Board of Trustees of Washburn College made possible the publication of this Bible with the inspiration and support of Olive White Garvey. Special recognition is made to John W. Henderson, President of the College; Warren W. Shaw, Chairman of the Board of Trustees; and Ruth Garvey Fink, Chairman of the Bible Committee; also Elliot H. White, Coordinator of the Bible Committee; and D. Clifford Allison, Charles Bennett, Doris Firestone Joss, Ray Morgan, and Barbara King Wilson, members of the Bible Committee.

World Book-Childcraft International, Inc. and the president of its World Book Encyclopedia, Inc. subsidiary, Floyd H. Kruger, Jr., initiated the Bible in 1969. Other members of the World Book-Childcraft organization who made special contributions were John Babrick, Henry Koval, Gordon Kwiatkowski, and Donald Ludgin.

Special editorial assistance to the designer was provided by Jean A. Bradnick, Gordon Carroll, Charlotte P. Heimann, Norman Ives, D. Dodge Thompson, and Deen Thompson.

Introduction to the Illustrations

The Bible has inspired much of Western man's greatest expression in the visual arts. Yet Bibles continue to be published with either no illustrations or a few pictures of no artistic significance. Slick commercial illustrations or vapid, sentimental late 19th-century paintings are used to accompany some of the most profound and enduring scenes in our cultural inheritance.

The works of art chosen for this edition of the Bible represent virtually all of the major schools of Western religious painting. The achievements of 55 artists are included, ranging over 17 centuries, from less than 300 years after the death of Christ to our own day.

The media represented have been limited to those in two dimensions, for a maximum degree of fidelity in reproduction on a flat page. They include the great tradition of wallpainting in Italy, from a catacomb of the 3rd century through the late medieval and Renaissance triumphs of Giotto, Masaccio, Uccello, and Piero della Francesca, and culminating in the High Renaissance achievements of Michelangelo and Raphael. The manuscript tradition is also represented, from the Early Christian *Vienna Genesis* of the 6th century, through Anglo-Saxon work of the 8th century, Byzantine illuminations of the 9th and 14th centuries, the rich late-Gothic French illuminations of the 15th century, and even a Persian manuscript of the sixteenth. The majority of pictures illustrated, however, are oil paintings conserved in museums, from Leningrad to Seattle. Not surprisingly, the preponderance of these reside in the great national galleries and museums in the capital cities of London, Paris, Madrid, Vienna, The Hague, and Washington, or in the former capital cities of Leningrad, Venice, Florence, Munich, and Berlin.

The choice of subjects to be illustrated was guided principally by the opportunity of having as many illustrations as there are books: 39 in the Old Testament, and 27 in the New. This allows the illustrations to take part in the architecture of the book, as it were, fulfilling an aesthetic role in the design of this edition, which has been realized with such skill by Bradbury Thompson as a work of art in itself.

The great themes of the Bible, however, do not appear in the text in a logical progression, one per book. The life of Christ is over after the first four books of the New Testament; and in the Old, the whole sweep of Jewish history from the Creation to the appearance of Moses, about 1225 B.C., is covered in the Book of Genesis. Readers of the Bible are familiar with the necessity of skipping around in it in order to piece together the chronology of the great events it portrays.

By J. Carter Brown
Director, National Gallery of Art
Washington

The List of Illustrations in this edition can therefore serve as a kind of shorthand summary of these sequential themes.

The earliest figures, Adam and Eve, Cain and Abel, Noah, followed by the dynasty of Abraham, Isaac, Jacob and Joseph, are illustrated in Volume I. Volume II begins with the Moses story and takes us through the historical trajectory dominated by Saul and David and later Solomon. Subsequently, the kingdoms of Israel and Judah suffered political misfortunes; but the period of roughly 750 to 550 B.C. was that of the great prophets, and their illustrations have been grouped accordingly.

In the New Testament, the opening verses of Matthew are illustrated with man's highest achievement in the medium of stained glass, the great Jesse window at Chartres. The life of Christ has been treated with major emphasis on the Nativity and Passion cycles, with indications of His ministry in between, and followed by reference to the spreading of the Gospel and the crucial role of Saint Paul, ending, with last things last, in Van der Weyden's hieratic vision of the Last Judgment.

It should be remembered that many of the most familiar religious subjects treated by artists do not appear in this text. Susannah and the Elders, the blindness of Tobit, Judith and Holofernes are all in the Apocrypha; the life of the Virgin does not appear in the New Testament; and the majority of illustrations of the lives of the saints obviously lie outside the scope of this Book.

However, even without them, it was agonizing enough to have to compress the visual tradition into so brief a compass. My own hope is that it will encourage and illuminate both the reading of this Book and a heightened awareness of the visual resources that form our common heritage.

Illustrations in This Chapter

Colophon

Bradbury Thompson: The Art of Graphic Design
Published by Yale University Press
and designed by Bradbury Thompson,
this first edition of ten thousand copies
was printed in the spring of 1988
at the Meriden-Stinehour Press, Meriden, Connecticut.
Typesetting was by Finn Typographic, Stamford, Connecticut.
Production assistance was by Anagraphics, Inc., New York City.
Binding was by Zahrndt, Inc., Rochester, New York.
The typeface is *Baskerville*, originally cut
by John Baskerville, 1706-75, Birmingham, England.
It is a transitional face that provides a neutral aesthetic context
for the many varied oldstyle and modern faces in this volume.
This updated *Baskerville* version was set with Linotype's
CRTronic 300 computerized system.
Text paper is *Celesta* Dull, 100 lb, by Westvaco.
Endleaf paper is *Tomohawk* Cover by Mohawk.
The volume is bound in pyroxylinized fabric
by Holliston Mills, Inc.

Illustration credits:
Every effort has been made
to trace the ownership
of all copyrighted illustrations
appearing in this book.
Grateful acknowledgment is made
to the following
companies and organizations
for their permission to reprint
illustrative material:

American Brands.
American Dance Festival.
The American Institute of Graphic Arts.
Art News Magazine.
The Condé Nast Publications, Inc.
Ford Motor Company.
Harvard Business Review,
©1968 by the President and Fellows
of Harvard College.
Lindenmeyr Paper Corporation.
The Menninger Foundation.
The Miller Company.
Ninth Graphic Arts Production Yearbook,
Colton Press, Inc.
Pitney Bowes, Inc.
Printing News.
Progressive Architecture,
Reinhold Publishing Co., Inc.
Photographer: David Morton.
Smithsonian Magazine,
Smithsonian Institution,
Photographer: Stephen Pitkin,
Rockford, Illinois.
Society of Illustrators.
State University of New York at Purchase.
This Week Magazine.
United States Olympic Commission.
United States Postal Service.
Washburn College.
Westvaco Corporation.
Yale University School of Art.